# DATE DUE

| | | | |
|---|---|---|---|
| | | | |
| | | | |
| | | | |
| | | | |
| | | | |
| | | | |
| | | | |
| | | | |
| | | | |
| | | | |
| | | | |
| | | | |
| | | | |
| | | | |
| | | | |
| | | | |

DEMCO 38-296

*W Eugene Smith and the Photographic Essay* is an in-depth study of the work of one of the most important and gifted photojournalists of the postwar period in America. Glenn Willumson begins by examining the antecedents for the photo-essay, a genre that developed in unison with the halftone reproduction and the illustrated weekly periodical. He goes on to analyze closely four works that W. Eugene Smith produced for *Life* magazine, and for which he is best known: "Country Doctor," "Spanish Village," "Nurse Midwife," and "A Man of Mercy." In his study of these works, now acknowledged to set the standard by which the photo-essay is judged, Willumson explores the conception, history, political context, and public and critical reception of the essays. Analysis of previously unknown details surrounding the completion of each assignment demonstrates Smith's commitment to the photographic essay as a vehicle for social change.

Celebrated for his dramatic, individual photographs, Smith was a serious artist who made efforts to link his visual interpretation with an appropriate text, whose multiple meanings the author unravels. Smith also struggled to exercise control over the selection, sequence, and layout of his photographs. Frustrated by the tradition of investing authorial control in the hands of editors, Smith demanded increasing authority over the presentation of his photographs. In 1954, however, *Life* editors published Smith's photo-reportage of Albert Schweitzer against the wishes of the photographer. Smith, at the height of his fame, resigned from *Life* magazine in protest. The result of his decision was immediate and personal, plunging him into an abyss of self-doubt that haunted him until his death in 1978. Willumson's narrative traces the history of this conflict and its implications for photojournalism.

# W. EUGENE SMITH

## AND THE

## PHOTOGRAPHIC

## ESSAY

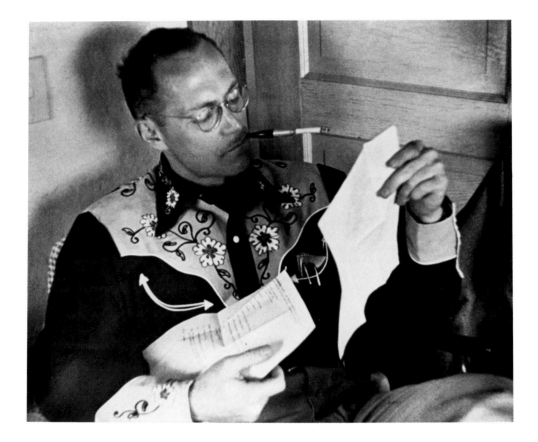

# W. EUGENE SMITH

## AND THE

## PHOTOGRAPHIC

## ESSAY

### GLENN G. WILLUMSON

 CAMBRIDGE
UNIVERSITY PRESS

**Published with the Assistance of the Getty Grant Program**

Published by the Press Syndicate of the University of Cambridge
The Pitt Building, Trumpington Street, Cambridge CB2 1RP
40 West 20th Street, New York, NY 10011-4211, USA
10 Stamford Road, Oakleigh, Victoria 3166, Australia

First published 1992

Printed in the United States of America

*Library of Congress Cataloging-in-Publication Data*
Willumson, Glenn Gardner.
W. Eugene Smith and the photographic essay / Glenn G. Willumson.
p.   cm.
Includes bibliographical references and index.
ISBN 0-521-41464-4
1. Photojournalism.   2. Smith, W. Eugene, 1918–1978.   I. Title.
TR820.W53     1992
770′.92 – dc20                    91-30529
                                              CIP

A catalog record for this book is available from the British Library.

Joseph B. Del Valle, Designer

ISBN 0-521-41464-4 hardback

# CONTENTS

# ILLUSTRATIONS

# ACKNOWLEDGMENTS

An undertaking that attempts to describe the editorial practice of an institution like *Life* magazine and the work of a photographer like W. Eugene Smith is only possible with the support of many individuals and institutions. An immense debt is owed to the librarians, curators, collectors, researchers, and photographers who made their materials available for my study. Particular mention must be made of the staff at the Center for Creative Photography, University of Arizona: I am especially grateful to Amy Rule, who guided me through the labyrinth of the W. Eugene Smith Archive; to Victor La Viola for his assistance in locating particular prints in the Center's collection; and to Diane Nilsen for her help with the photographic reproductions. Special thanks go to Professor Keith McElroy of the University of Arizona for his professional advice and personal hospitality during my research at the Center for Creative Photography.

I am indebted to many individuals for their kindness in sharing information with me about W. Eugene Smith and about photo-essay production at *Life* magazine. A partial list would include Edward K. Thompson, *Life* managing editor, and Dick Pollard, *Life* picture editor, who explained to me the complicated process by which the photographic essay was produced; Ted Castle, Smith's assistant for "Spanish Village," who provided valuable insight and specific details regarding the assignment; and Bob Harrah, Smith's assistant for "Country Doctor," who also shared important information about Smith's reportage and his own insights into Smith's attitude toward photojournalism in 1948.

I must also acknowledge with great appreciation those *Life* magazine professionals who were willing to discuss the photographic essay with particular attention to Smith's work: Barron Beshoar, chief of the Den-

ver Time-Life office; Maitland Edey, Robert Elson, and Sidney James, assistant managing editors at *Life;* George Karas, director of the *Life* photography lab; Earl Kersh, assistant art director at *Life* magazine; John Loengard, picture editor at *Life;* Wayne Miller, free-lance *Life* photographer; Michael Phillips, assistant art director at *Life* magazine; Peggy Sargent, *Life* contact sheet editor; Bill Sumits, director of the *Life* photography lab; and Joseph Thorndike, managing editor of *Life.* For providing information and commentary I want to thank Daniel Berley, Howard Chapnick, Tim Druckery, Neville Grant, Ed Hannigan, William Johnson, Stefan Lorant, John Morris, Christopher Phillips, Berni Schoenfield, C. Zoe Smith, Kevin Eugene Smith, Margery Smith, John Szarkowski, Leslie Tiecholtz, and David X. Young. I want to single out especially the contributions of William Johnson. Not only was he willing to discuss Smith's work with me, but his seminal publications of Smith's papers – particularly *W. Eugene Smith: Master of the Photographic Essay* (1981) and *W. Eugene Smith: A Chronological Bibliography* (1980, 1981, 1984) – served as a foundation for my study.

For his guidance and consistent enthusiasm for this book, I would like to thank Professor Ulrich Keller of the University of California, Santa Barbara. My work has benefited immeasurably from his insight. Professors Beatrice Farwell, Helmut Gernsheim, and Alfred Moir also lent valuable assistance, particularly during the initial stages of my project. Other scholars who commented on specific sections of my text include Sheryl Conkelton, Kathryn Horste, William Johnson, and Mike Weaver. Their comments were particularly helpful in my struggle to articulate precisely the complexity of the photographic and editorial enterprises in the mass media. My colleagues at the Getty Center – particularly Lois White and Chris Jahnke of the Interlibrary Loan staff and Don Williamson, John Kiffe, and Jobe Benjamin of Photographic Services – lent considerable support during the final stages of production.

My research was enhanced by research grants from the Samuel Kress Foundation and from the University of California. This assistance allowed me to do extensive study in the Smith Archive and to interview the *Life* magazine professionals who knew and worked with Eugene Smith. The critical final stages of the text revision were made possible by the support of the administrators of the Getty Center for the History of Art and the Humanities. They generously granted me leave to prepare the manuscript for publication.

This project, dealing with the publication of photographs in the mass media, presented a succession of copyright problems. I would like to thank all those who allowed me to quote from documents in the W. Eugene Smith Archive: Walter Censor (for Time Warner Inc.), Robert Frank, Walter McCloud (for the South Carolina Department of Health and Environmental Control), Miriam Rogers, Mirian Ronan (for the New York Theological Seminary), Kevin Smith (Representative of the Heirs of W. Eugene Smith), Edward Salmon (for the Episcopal Diocese of South Carolina), Edward K. Thompson, and Gus Weiman. Permission for the illustrations used in this book was among the most difficult issues in the publication process. For their help I would like to thank Kevin Smith (Representative of the Heirs of W. Eugene Smith), Debra Cohen (for Time Warner Inc.), Julie Harrah, Barbara Hoffman (counsel for College Art Association), and Mr. Thomas Rockwell (for the Norman Rockwell Family Trust). Despite these people's generosity, the high copyright costs would have prohibited the publication of the book were it not for the support of a J. Paul Getty Publication Grant. For her assistance through all these problems and for her unflagging support and enthusiasm for my work, I must thank Beatrice Rehl, fine arts editor at Cambridge University Press.

Finally, I dedicate this book to Peggy Moore Willumson. Her patience and encouragement sustained my efforts. In particular, her understanding during the extended hours that this book kept me away from my family was a critical element in the successful completion of my project. This book would not have been possible without her.

# INTRODUCTION

W Eugene Smith is acknowledged to be the master of the photographic essay.[1] In the latest edition of his celebrated *History of Photography*, Beaumont Newhall uses a Smith picture to introduce his chapter on photojournalism and praises Smith for the aesthetic qualities of his photographs.[2] Naomi Rosenblum, in *A World History of Photography*, devotes a special section of her text to a discussion of Smith's work and reproduces "Spanish Village" in its entirety.[3] More recently, John Szarkowski, in his survey of 150 years of photography, selects Smith's "Country Doctor" as the example of the photo-essay form. In Szarkowski's judgment Smith produced photo-essays "that stand among the most memorable examples of the attempt to produce a new kind of journalism out of the wedding of photographs and words."[4] While Smith's importance in the history of photography thus appears unassailable, the time may have come for a reexamination of traditional assumptions such as the "timelessness" of pictures and the status of their maker as supreme artist and genius.

Smith's chosen genre of expression, the photographic essay, represents a form of pictorial discourse which was fundamentally shaped by, and developed in unison with, the halftone reproduction and the illustrated weekly magazine. In format, the photo-essay consists of a narrative sequence of photographs accompanied by minimal text. The most developed and elaborate examples of the genre are found on the pages of *Life* magazine during the postwar period. With its aesthetically and politically preformed word/picture packages, *Life* exerted a tremendous influence over public opinion, reaching over 20,000,000 readers in America and Europe in the late 1940s and the 1950s.[5] This tremendous audience and the public reception of the photographs were of utmost importance to Eugene Smith.

Contrary to the beliefs of his hagiographers, Smith gave his photo-
graphic work an immediate purpose and meaning. Each of his photo-
essays was a personal response to a pressing social problem in a spe-
cific historical situation. Smith was a man who was an advocate, who
fought for causes, who had personal messages, and who actively inter-
preted events. *Life* editors, however, also had a message, often requir-
ing a masking of the photographer's emotional advocacy in favor of an
editorial narrative. Smith fought against this interference and for an
authorial voice for the photographer.[6]

Although the fact was masked by the practice of crediting a partic-
ular photographer, it is important to understand that the photographic
essay was not the work of a single individual. At *Life*, photo-essay
production represented a group creation rather than an individual
expression. The genre catered to a mass audience rather than a cul-
tured elite, and consequently served as a vehicle for ideological mes-
sages much more than for photographic aesthetics. Eugene Smith is
unique among his peers in that he understood the complexity of pho-
tographic production and the challenge posed by the privileging of
secondary editorial control over primary reportage. In fact, it must be
recognized that Smith's insistence on "authoring" both the narrative
and the moral force of his photographic reportage was an attack, not
only on his editors, but on the traditions of photojournalism. Since the
beginning of the picture magazine, ultimate authorial control had be-
longed to the editors who selected, sequenced, and laid out the illus-
trations. Stubbornly, though in the end unsuccessfully, Smith at-
tempted to erode this control in the interests of direct communication
with his audience.

A close reading of Smith's most acclaimed photo-essays – "Country
Doctor," "Spanish Village," "Nurse Midwife," and "A Man of Mercy"
– demonstrates the ways in which he fought the battle against editorial
control, and injected into his photographs personal statements of so-
cial and political advocacy. Reading each photo-essay twice – once as
*Life*'s implied reader and once as a reader critically scrutinizing the
editorial strategies employed – one sees the complex moral and aes-
thetic dimensions of an art form that had an important social function
in postwar America.[7] The initial, narrative reading of each photo-essay
presents the most obvious and "natural" meaning of the pictures, but
braided into these aesthetic and narrative aspects are ideological im-
plications that the contemporary reader must have unconsciously ab-

sorbed – and that historical analysis must bring to the surface of critical discussion.

Smith was concerned with precisely this problem of the embedding of his reportorial picture narrative with cunning editorial subtexts. He wanted his photographs to be effective in the immediate sociohistorical context, and this meant that he had to struggle for authorial control over the variant readings of his images. As we shall see, Smith's courageous efforts were successful in that he forced his editors to compromise; yet in the end, he was unable to gain the complete control he sought. The corporate apparatus proved too formidable an opponent for a maverick individual. In October 1954, when his reportage on Albert Schweitzer was printed in the face of his adamant objections, Smith resigned in protest. It was a decision that would have disastrous personal consequences, but one that buttressed his exceptional status in the mass media and in the history of photography.

# CHAPTER I

# *LIFE* MAGAZINE AND THE PHOTOGRAPHIC ESSAY

November 1954 marked a turning point in the life of W. Eugene Smith. His photo-reportage about Dr. Albert Schweitzer had been published despite his objection. The fact that Smith had invested tremendous personal significance in the Schweitzer project only exacerbated the problem. He had pushed the idea on the editors and had begun his research, including reading and annotating over one hundred pages of typescripts, months before he departed. While awaiting final approval, he reread Schweitzer's translated writings, bought books about Schweitzer's life in Lambaréné, French Equatorial Africa, and attended an exhibition of photographs depicting Schweitzer in Africa. On location in Lambaréné, Smith extended his stay to three months as he struggled to refine his visual presentation of Schweitzer in Africa.

When he returned to the United States, Smith was granted a great deal of influence over the arrangement of photographs. He was allowed to make the initial selection of pictures and was given over three months to complete the finished prints. He wrote an interpretive text that accompanied his picture choice and worked closely with art director Berni Quint on the final selection of photographs and on their arrangement on the magazine page. When disagreements emerged the plans for publication were put aside.

This power to influence the publication of pictures was unusual for a magazine photographer. It was granted to Smith because of his unparalleled success with the photo-essay and because of the insistence of the photographer that the publication reflect his authorial voice and personal interpretation. Despite assuming these editorial prerogatives, however, Smith did not control the publication of his photographs. Smith's photo-reportage was reconsidered for publication in October 1954. This time Smith's protests did not stop the publication process. Hoping that a dramatic gesture would halt the editorial mechanism, Smith loudly resigned from *Life* magazine on November 2. Nevertheless "A Man of Mercy" was published by *Life* on November 15, 1954.

Smith's actions were neither hasty nor unconsidered. He had never been completely happy at *Life*. His early frustrations over what he considered insignificant assignments had led him to resign once before, in 1942. He had returned to the magazine during World War II but his conflicts with editors continued. They intensified after 1948, as Smith battled over the published form of his photo-reportage. Gradually he won concessions but, as "A Man of Mercy" proved, Smith was

ultimately impotent in the face of editorial power. As a careful examination of these conflicts between photographer and editorial staff shows, his demands for the authorial voice in his published photo-essays was a radical departure from photojournalistic tradition. Historically, the picture story and the photo-essay had no single author; it was a group product of the photographer, the writer, and an editorial committee.

## The Art Form

The forerunners of *Life* magazine were illustrated newspapers that published pictures depicting important events of the day.[1] Traditional histories of photojournalism take as their project individual pictures and, at the same time, focus on the history of technical reproduction.[2] As a result, such histories address technical changes in camera, film, and reproduction capacity but ignore the mechanisms and practices that produced the pictures. My project is a different one: to trace the institutional history of the editorial mechanisms and establish the historical context for an understanding of Smith and his photo-essays.

The editorial use of sequenced photographs was unusual in the first decades of photojournalism. Although newspapers and broadsides were illustrated before the invention of photography, lavishly illustrated newspapers and the public appetite for them did not appear until a few years after the public announcement of the new process.[3] Despite this coincidence between the discovery of photography and the emergence of a worldwide illustrated press, photography was only sparingly used in the early years of the illustrated press.

In most cases picture production began with an artist-reporter who sketched the event and sent the pictures to his publisher. The artist's representations varied in character from quick, on-the-spot, linear depictions to reworked studio drawings. Like the later photo-essays, the production of picture stories in the mid-nineteenth century involved the work of a team – a reporter on the scene, an engraver, an editor, and an art director.[4] The reporter's drawings were interpreted by the engraver who, following editorial instructions, "worked up" the sketch, often dramatizing the image to titillate popular taste.

In most early picture stories, editors lavished attention on individual images rather than picture sequences.[5] Pictures might be organized along simple chronological lines, such as before and after, but

rarely were more than two photographs involved in a chronological sequence.[6] For example, the written narrative accompanying "En Route for China" is structured around a simple chronology describing the travels of the reporter.[7] The accompanying illustrations, however, must have been of less editorial interest as they follow no narrative, chronological, or thematic organization. Thee are used arbitrarily as single illustrations of particular locations referred to in the text.

During this prehistory of the picture story, editors had only a secondary interest in the possible relationships between text and image or in the structuring of picture sequences. Instead, they exercised their power over pictorial meaning by altering the translation of the photographs or sketches when they were engraved on the printing plate. For example, an illustration of the surrender of Sedan published in the *Illustrated London News* on September 17, 1870, was so dramatically altered that it bore little relationship to the reporter's sketch (figs. 1, 2).[8]

The malleability of this process concerned contemporaries. The executive committee of the New-York Historical Society criticized the illustrated newspapers: "the testimony of parties engaged shows that these representations, when they are not taken from photographs, are not always reliable."[9] Representations based on photographs were not reliable, either. One contemporary account was remarkably candid:

> Hence the first pictures of distant happenings must be made in the newspaper offices and the legend "drawn from telegraphic discriptions" – becomes familiar. The reporter can, without spoiling his story, leave out some of the details which he does not know; the news-picture is valueless unless specific. So the details must come from somewhere. In a word, the temptation to "fake" pictures is considerably stronger than the temptation to "fake" news itself, and it is yielded to with proportionately greater frequency by those papers which make the pretence that their pictorial chronicle is anything like as complete as their news service.[10]

This direct picture manipulation changed in the latter part of the nineteenth century with the invention of the halftone screen.

The halftone process allowed editors to reproduce photographs directly with type.[11] By the 1890s, the hand-worked engraving plate had been replaced by the machine-processed halftone screen.[12] The halftone process was universally adopted because it offered lower costs,

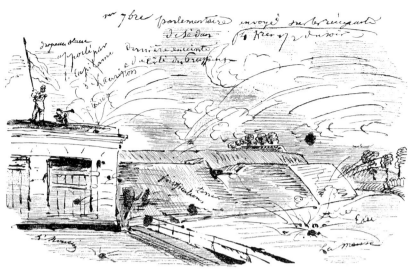

FACSIMILE OF SKETCH: SURRENDER OF SEDAN.

*1. Reporter's sketch of the French surrender of Sedan.*

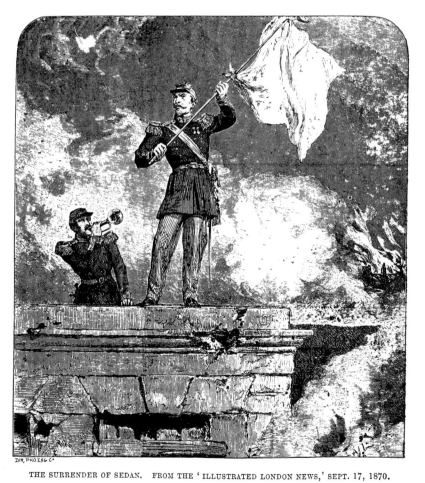

THE SURRENDER OF SEDAN. FROM THE 'ILLUSTRATED LONDON NEWS,' SEPT. 17, 1870.

*2. The published engraving of the French surrender of Sedan
(September 17, 1870).*

as sketch artists and engravers were replaced by photo-agencies and mechanical reproduction. It presented, however, certain problems that called for a restructuring of the editorial enterprise.

The invention and commercial use of the halftone screen meant that editors no longer needed to be "constantly on the watch, as a protection against the carelessness or forgetfulness of the artist, and, it may be, to suggest alterations in his drawings."[13] Although the halftone process in some ways liberated the editor, it also removed their traditional methods for controlling pictorial impact. With the mechanization of the reproduction process, editors could no longer directly alter images for publication. What evolved was a practice that controlled picture narratives through selection and sequence.

Acquiring photographs was the first priority of the picture editor. In the late nineteenth century editors had two sources available. The first was staff photographers. As reporters' sketches were replaced by photographers' prints, journalists specializing in photography replaced the "sketch artist." Although there were not many such privileged cameramen, those who were chosen became media "stars" as magazines late in the century competed for the fastest and most informative photo-reportage.[14] Despite obvious similarities between the sketch artist and the staff photographer, there were significant differences.

In traditional practice the sketch artist acted as the reporter and filed a lengthy text with his drawings. This practice changed with the replacement of the sketch artist by the photographer, who was considered little more than a machine operator. Most photographers were required to travel with a magazine reporter who supplied the reportorial text.[15] The photographer's presence was important to the editor, however. Having a staff photographer at a dramatic news event gave the publisher exclusive rights to the photographs and control over their publication.

Despite these seeming advantages, staff photographers were rare. Far more photographs came from photo-agencies. These organizations acted as middlemen, acquiring negatives from photographers and selling the prints and reproduction rights to interested periodicals and newspapers.[16] The use of photo-agencies allowed editors to select from a wide variety of photographs. This selection process began the editorial shaping of the "meaning" of the photographs. The greater the abundance of photographic imagery available to the editor, the more likely that editorial selection could affect picture "meaning." In the

late nineteenth and early twentieth centuries editors began to experiment with picture sequences that suggested photography's potential to move beyond literal reportage.

Under this new editorial system, there were also subtle changes in the use of photographs as illustrative material. Increasingly, attention was paid to the ability of pictures to carry a narrative; as a result, editors were more aware of the composition and sequence of the picture-story. In the latter years of the nineteenth century, with few exceptions, pictures and text were brought together on the same page. For the most part, however, picture arrangements were uncomplicated, linear progressions. Seldom were photographs used out of temporal sequence and even more rarely sized so as to emphasize one aspect of the story over another.

In the early years of the twentieth century, however, this changed. Editors began to organize photographs as self-sufficient elements that could convey ideas as well as narratives.[17] At its most sophisticated, these editorial techniques were used to make moral statements that were precursors to *Life*'s mature photographic essays. An example of such an attempt is "Snapshots of a Race," photographed by Lewis Hine and published in *Collier's* magazine on May 8, 1909 (fig. 3).[18]

These pictures are portraits of the black residents of Washington, D.C., and the environment in which they live. Selection and arrangement of the photographs and text demonstrate an editorial intention that explicitly alerts readers to the poverty of black Americans and implicitly seeks change. The photographs are arranged like a collage, one picture on top of the other. The picture around which the others seem to be gathered is the round bust portrait of a white-haired black man. The other photographs, with their subjects smaller in scale, revolve around this ennobled face and the brief text above it. The two sentences beneath the title describe the thematic context of the pictures. They "show what the alleys, byways, mean streets, tenements, roofs, doorways, and shanties of the National Capital are producing in the way of a race."

The captions limit the intended reading of each photograph. For example, the center photograph on the far left shows a heavyset black woman with a pipe in her mouth leaning against a doorway. The caption personalizes the image and undercuts the stereotyped visual representation. "A woman, once a slave, who opposed the education of her grandson because the schooling of her own children, counteracted

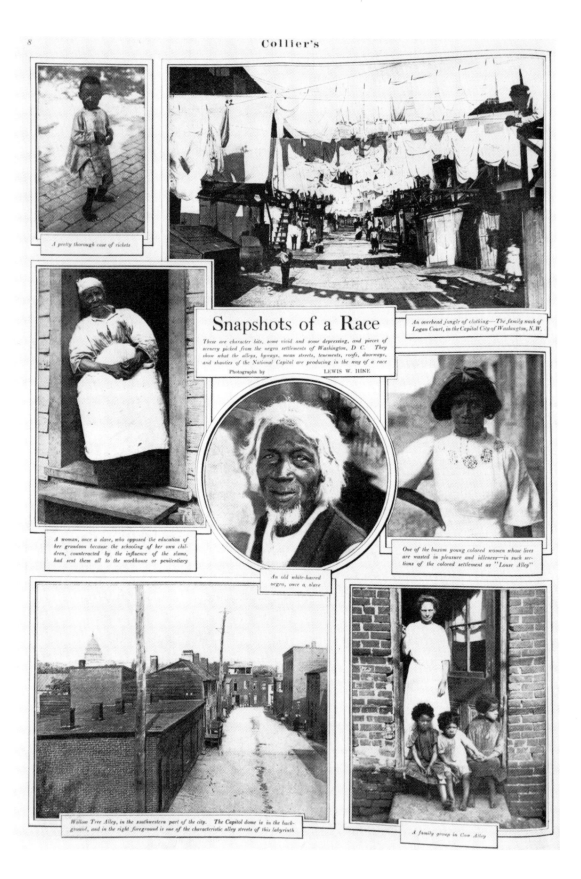

A pretty thorough case of rickets

An overhead jungle of clothing—The family wash of Logan Court, in the Capital City of Washington, N.W.

# Snapshots of a Race

These are character bits, some vivid and some depressing, and pieces of scenery picked from the negro settlements of Washington, D. C. They show what the alleys, byways, mean streets, tenements, roofs, doorways, and shanties of the National Capital are producing in the way of a race

Photographs by                LEWIS W. HINE

A woman, once a slave, who opposed the education of her grandson because the schooling of her own children, counteracted by the influence of the slums, had sent them all to the workhouse or penitentiary

An old white-haired negro, once a slave

One of the buxom young colored women whose lives are wasted in pleasure and idleness—in such sections of the colored settlement as "Louse Alley"

Willow Tree Alley, in the southwestern part of the city. The Capitol dome is in the background, and in the right foreground is one of the characteristic alley streets of this labyrinth

A family group in Cow Alley

by the influence of the slums, had sent them all to the workhouse or penitentiary." Picture meaning is also manipulated visually. At both the top and the bottom of the page pictures of small children are paired with larger pictures of their environment. This juxtaposition explicitly attempts to enlist the reader's concern and sympathy, and implicitly seeks help for these children whose environment severely limits their opportunities.

The next breakthrough in the editorial experimentation with photo-reportage occurred in Europe when, during the 1920s and 1930s, European editors, particularly those at the *Berliner Illustrirte Zeitung*, the *Münchner Illustrierte Presse*, and *Vu*, experimented with unusual picture content and layout.[19] Editors for these periodicals produced photo stories that moved away from traditional newsworthy events and toward human interest stories that featured the lower and middle classes.[20] This change in content demanded a certain "type" of picture: one that was instantaneous and intimate.

There were very few photographers on the staff of the German illustrated magazines. Editors effected changes in subject matter and the way it was represented by exercising their right of selection.[21] This control was made possible by the highly developed superstructure of photojournalism in the latter part of the 1920s and the 1930s. For example, in 1929, when Stefan Lorant was the Berlin editor of *Münchner Illustrierte Presse*, there were seven Berlin photo-agencies from which he could choose pictures, as well as a new wave of free-lance photographers.[22] The newest photo-agencies, Dephot and Weltrundschau, offered a choice of single pictures or complete photo stories. Agencies would even act as generators of ideas, suggesting stories to magazine editors.

If special reportage was required, editors could commission it from a photo-agency or choose from a wide variety of excellent, young, free-lance photographers. These free-lancers welcomed assignments and sold their prints to editors when they returned. Because of his right to refuse the commissioned work, the editor's expectation was a formative influence on the photographer's approach to a story. In the case of Lorant, his criteria for selection were well known:

> That the photograph should not be posed; that the camera should
> be like the notebook of the trained reporter, which records con-
> temporary events as they happen without trying to stop them to

make a picture; that people should be photographed as they really are and not as they would like to appear; that photo-reportage should concern itself with men and women of every kind and not simply with a small social clique; that everyday life should be portrayed in a realistic unselfconscious way.[23]

Editors used their control to explore systematically a photographic interpretation of a theme rather than a chronological depiction of an event. In Germany, editors of the two most popular and innovative magazines, the *Berliner Illustrirte Zeitung* and *Münchner Illustrierte Presse*, emphasized the entertainment aspects of pictures and, in general, ignored the social unrest prevalent in the early 1930s.[24] In France, on the other hand, *Vu*, the leading photographically illustrated weekly, highlighted the sociopolitical agitation of the 1930s.[25] Regardless of their commercial or sociopolitical intentions, European editors of the 1930s relied on selection and picture layouts that were both imaginative and expressive and that established important precedents for *Life* magazine's later manipulation of image and text.

*Life* magazine would not be published until later in the decade but American publishers were well aware of the success of the European illustrated magazines. In addition to the European models of commercial success, the public appeal of the rotogravure section of the Sunday newspaper and of the filmed newsreel encouraged editors to consider the commercial possibilities of a magazine devoted to photographic imagery.[26] There were several modest attempts to popularize a picture magazine in the United States, but it was not until 1936, when Henry Luce put his publishing empire behind the project, that a picture magazine was commercially successful.[27]

## The Magazine

Photo-essays are not autonomous products; they are embedded in the pages of magazines. It is, therefore, important to examine carefully the mechanisms that produced *Life* magazine. Henry Luce began preliminary planning for a picture magazine in 1934, assigning a writer, a researcher, and a *Time* magazine editor to the project. Several months later he abandoned the experiment, but Daniel Longwell, an editor at

*Time*, continued to push the idea.[28] Longwell's work on the pictorial supplements in *Time* magazine had convinced him that pictures could be a useful, interesting, and profitable way to convey the news. In February 1936, he persuaded Henry Luce to reopen consideration of a picture magazine.

In early 1936, Longwell organized an experimental editorial team and produced a picture book, *Four Hours a Year*.[29] It was based on Time, Inc.'s successful film newsreel *The March of Time*, and was a thematic prototype of *Life* magazine. The book contained a wide variety of stories within its seventy-two pages — news, gossip, humor, sensation, all the elements that later *Life* editors would use with success. After seeing the presentation of photographs in *Four Hours a Year*, Luce authorized dummy issues of a new picture magazine to be printed and offered to advertisers. He hired Kurt Korff, former editor of *Berliner Illustrirte Zeitung*, as a special consultant.[30] Korff and Longwell laid out three prototype issues that were favorably received and advertising space sold quickly.

Korff, drawing on his experience in Germany, provided the editorial model for *Life* magazine.[31] In an outline of "a new illustrated magazine" for Henry Luce, Korff made specific suggestions, some of which became the standard procedure at *Life*.[32] He also detailed the arrangement of the picture archives and files and described how *Life* could make good use of photo-agencies as resources for their pictures. It is likely that Korff was also responsible for the editorial organization that *Life* adopted. This is important because his experience was with a corporate, committee organization, rather than with the personal editing style used by other European magazines.[33] Based largely on Korff's suggestions, the first *Life* magazine issue was published on November 23, 1936.[34]

One way in which *Life* magazine distinguished itself from its European antecedents was its use of pictures. For the most part, German editors had relied upon serialized novels to keep circulation high. Picture stories were limited to a two- or three-page spread of photographs. At *Life*, pictures were the centerpiece of their enterprise and they were willing to carry ten pages of photographs on a single theme.[35] The early issues of *Life* magazine, however, were uneven, as editors experimented with different formats trying to find the blend of stories that would most interest the public.

*Life* was a commercial success from the beginning but Henry Luce was stung by criticism of the magazine as sensational and salacious.[36] One critic who attacked the magazine listed topics like "the private life of Darryl Zanuck" and "the man who lives off fleas" as typical *Life* stories.[37] Luce shared this feeling that the magazine lacked respectability.[38] For him, the photographic essay became the vehicle to ameliorate the situation. In an advertisement entitled "The Camera as Essayist" he stated:

> When people think of the camera in journalism they think of it as a reporter – the best of reporters: the most accurate of reporters: the most convincing of reporters.
>
> Actually, as *Life* has learned in its first few months, the camera is not merely a reporter. It can also be a commentator. It can comment as it reports. It can interpret as it presents. It can picture the world as a seventeenth-century essayist or a twentieth-century columnist would picture it.
>
> A photographer has his style as an essayist has his. He will select his subjects with equal individuality. He will present them with equal manner. The sum total of what he has to say will be equally his own.
>
> Above in sharp reduction is Alfred Eisenstaedt's essay on Vassar as it appeared in *Life* for February 1, 1937. Together these twenty-four pictures give an impression of that college as personal and as homogeneous as any thousand words by Joseph Addison.[39]

This credo guided the photo-essay into maturity and it is important to restate its primary tenets. The passage makes explicit an understanding of sequenced photographs as rhetoric and suggests that photographs are like written language that can be manipulated and that can interpret events. Henry Luce's specific concern for the interpretive, moral aspects of the photo-essay is shown in his allusion to Joseph Addison, the eighteenth-century writer and acknowledged social moralist.[40]

In a 1938 memo Luce wrote about his special interest in "The Essay," which he considered a dominant part of the magazine. He said that *Life* had two "rhythms": the alert news magazine and the more reflective essay. He wanted *Life* to blend these two, and he made some specific recommendations regarding the photo-essay. He suggested that photographs be directed toward a specific point of view, a stance he felt should include an element of surprise and a moral component.[41]

He also felt that *Life* on the whole should be positive, "to be *for* things."[42]

The man responsible for *Life*'s delicate balancing act of appealing to a mass audience and at the same time setting a high moral tone was the managing editor. The first managing editor was John Shaw Billings (1936–1943), a former text editor for *Time*, hand-picked by Luce to bring some coherence to *Life*'s first issue. Billings had little previous experience with pictures, but he possessed excellent organizational skills and institutionalized the editorial structure of *Life* magazine. He delegated all aspects of picture production but insisted on selecting, sequencing, and laying out the pictures himself.[43] Later editors would delegate more authority for specific tasks, but this organizational model of the managing editor as the final authority remained.

Billings presided over several department heads whose responsibility was generating stories and story ideas. Once accepted, an outline for the story was given to the picture editor who assigned the photographer and insured that the assignment was properly carried out. The finished prints were then sent to Billings. He, perhaps in consultation with an art director who specialized in layouts or with the head of the department that suggested the story, selected, sequenced, and laid out the photo-essay.

Billings's approach to the sequencing and arrangement of photographs was also influential. He sequenced pictures in the same way one would sequence literary prose: in a linear narrative progression with a beginning, a middle, and an end. He emphasized facts and he used both staff photographers and photo-agencies to construct informational photographic essays. "Vassar: A Bright Jewel in U.S. Educational Diadem," the story used by Henry Luce to define the photo-essay, is a good example of the photographic essays produced by Billings.

For "Vassar," twenty-three photographs are laid out on four double-page spreads.[44] Small blocks of single-paragraph text can be found on each page but, for the most part, the words do little more than identify picture content. Photographs dominate the page and convey the narrative "story line." The editor sequences the pictures and lays them out with an understanding of time and place, moving the reader from left to right and top to bottom – above the school, through the entrance gate, and into the president's office. The introductory picture spread presents the geographical and intellectual context of Vassar. In these early years of *Life*'s picture use, the editor supplemented his photog-

rapher's reportage. This photo-essay, although for the most part the work of Alfred Eisenstaedt, includes on this first page photographs from three different sources.[45]

The succeeding pages are the "body" of the photo-essay. A narrative reading of the photographs, particularly a comparison of the opening and closing picture spreads, shows that the pictures shift psychologically – from the public exterior to the private interior of the lives of Vassar undergraduates. The moral aspects of the photo-essay are less visually obvious but are implied by the introductory text:

> Of few things is the U.S. more proud than of its vast educational system. In the matter of women's colleges this pride is well-placed because no other country can match the U.S. combination of Bryn Mawr, Smith, Wellesley, Vassar, Radcliffe, Mount Holyoke, and sister schools.[46]

Like Joseph Addison's essays on social customs, these sequenced photographs present Vassar College as a positive model of education and Vassar coeds as models of female behavior.[47]

The form of the photo-essay did not change significantly when John Billings was promoted to editorial director and Daniel Longwell assumed the post of managing editor in 1943. Maitland Edey, assistant editor of *Life*, characterized Longwell's essays as "ersatz Billings."[48] Longwell's replacement, Joseph Thorndike (1946–1949), however, did make significant changes that influenced the stylistic development of the photographic essay.

Thorndike, who as a young man participated in the planning of *Life*, reorganized the magazine and delegated the creation of the photographic essay to the departments from which they originated – News, Culture, and Modern Living. Thorndike did not want to see the raw picture material, as had Billings; he left that to the department editors. They selected, sequenced, and laid out the photo-essay, then brought the final arrangement to Thorndike, who tacked them on the wall, discussed the story with the editor, and suggested changes.

Thorndike's willingness to share responsibility for the production of the photo-essay had a lasting effect on its form. His decentralization of the construction of the photo-essay allowed department editors to affect the way in which their ideas took pictorial shape. As a result,

more photo-essays were laid out under Thorndike than under the Billings system of direct control. Even though many of these efforts were never published, they provided valuable experience for departmental editors who began to think in terms of the completed photo-essay rather than simple story ideas.[49] This system also had the advantage of raising the standards of the photo-essay as department editors competed with each other for magazine space.

Thorndike also shifted the magazine's policy away from straight news stories and toward feature ideas. He felt *Life* should express the spirit of its time and he characterized *Life*'s role as that of a teacher and popularizer. This attitude fit in perfectly with Henry Luce's original intention to make the photo-essay a moral force of public persuasion. Along with the shift to feature stories, the magazine began to deal more with political and social issues in American life. One example of this is a 1948 photo-essay on an American labor union.

In this photo-essay the Amalgamated Clothing Workers of America is selected for photo-coverage because of its effectiveness in solving problems with management.[50] This point is dramatically conveyed by a concluding image that covers the entire page. It shows a labor arbiter, small in scale, sitting alone at the end of a long table. Despite this positive message, today's reader must remember that labor–management peace was a rarity in the postwar United States. Between 1946 and 1948, there was one crippling strike after another and President Truman called out the National Guard during more than one of these labor walkouts. The photo-essay, then, served a political purpose.

Coming in an election year, "The Clothing Workers' Union" called attention to the ineffectiveness of the Truman administration in its labor relations and provided a visual example of what President Truman had been unable to accomplish, labor peace. This political preference for Republican candidates was shared by *Time* magazine and its publisher, Henry Luce. Despite a shared political philosophy, however, Thorndike's relationship with Luce was strained. Luce's gradual erosion of Thorndike's power as managing editor forced his resignation in 1949.[51]

His successor was Edward K. Thompson, the man credited with *Life*'s greatest success. Thompson's prior experience was a blend of both words and pictures that, in many ways, paralleled the development of *Life* magazine. He began his career as a newspaper reporter

and was hired by *Life* in 1937 as an assistant to picture editor Wilson Hicks. He progressed rapidly and, under Thorndike's laissez-faire managerial scheme, Thompson originated and completed many of the magazine's photo-essays.

As a managing editor, Thompson had a clear idea of what he felt *Life* magazine should be. He outlined his plans in a letter to publisher Henry Luce:

> I once thought that it would be impossible to improve the promise of the prospectus, "to watch the faces of the poor and the gestures of the proud; to see strange things . . ." Now, though, I will stop saying "me too" long enough to state my strong belief that we mustn't be that detached. We must make the reader feel that his 20 cents gives him something more than a seat in the bleachers, he should feel a sense of participation in what the editors see and think.[52]

Thompson took a more personal interest in the construction of the photographic essay than had Thorndike. He actively involved himself in the sequencing and arrangement of pictures, at the same time relying heavily on the capabilities of his art directors, particularly Charles Tudor and Berni Quint. Under Thompson's watchful eye the art directors were encouraged to experiment with the photo-essay form.[53] They emphasized the content of pictures in a variety of ways and established a mood for each photo-essay.

As should be evident from this brief institutional history, the photographic essay, as developed by *Life* magazine editors, was an increasingly complex and subtle form of communication. Formally, the photographs became more intimate and emotional, and layouts were more consciously artistic. Editors selected and sequenced photographs to relate a narrative, create a mood, and convey a message. Their assistants in this process were the staff photographers.

As the photographic staff increased during World War II, fewer agency photographs were needed. The emergence of staff photographers as the primary picture source demanded editorial structures for controlling the photographic essay. These structures masked the role of the editor and conferred an anonymity on the final publication. Under the new system the production of the photo-essay relied on a team that organized sequential photographs within a rhetorical structure. In order to understand the complexity of the *Life* magazine organization,

it is important to examine the responsibilities and the roles played by each team member.

Henry Luce's statement about the photo-essay did not reflect the editorial practice at *Life* in one critical area. Luce implied that the photo-essay was the photographer/author's interpretation of subject matter. This was demonstrably untrue. Although *Life* was a magazine whose commercial success was directly linked to photography, the magazine's photographers retained their traditional status as technicians who supplied the raw material, while editors supplied the intellectual interpretation.[54] Wilson Hicks, *Life* picture editor between 1937 and 1950, acknowledged this discrepancy in a speech to newspaper editors in 1950. He asked rhetorically:

> How many of your photographers are members of that exclusive club which centers in your and your city editor's and news editor's desks – are they a part of your editorial operation in the same way the reporters and rewrite men are? Here, gentlemen, in my humble opinion, is the most pressing problem about pictures today – the raising of photographers in general to the same level of prestige as writers. It is *Life*'s No. 1 problem and forgive me if I suggest it is yours, too.[55]

Hicks's assessment was correct. *Life* editors, most of whom were former writers, considered *Life* to be their magazine and, while writers were trained in different phases of the magazine production, photographers were rarely given responsibility for any work other than their own.[56] It can be argued that in making a photograph, the photographer was "authoring" a particularized view of the situation, but the message communicated was significantly affected by the editorial process.

Although it varied with each managing editor, the process of building the photo-essay remained consistent.[57] Story ideas would be discussed by departments and then presented to the managing editor during a weekly story conference. If the story showed promise it was assigned to a researcher and a picture script was written. The picture editor read the script and selected a photographer who specialized in that type of story. He gave the photographer the editor's suggestions and reviewed the assignment with him. This discussion of the shooting script established the scope of the story. The photographer fulfilled the details of the script but knew that following it too closely would result in a series of single photographs without a sense of visual coherence.[58]

Photographers were, therefore, expected to establish their own narrative context. During the tenure of Wilson Hicks, however, the shooting script was used to control editors as well as photographers.

Overtly, it allowed the editor to control the photographer's approach to subject matter in a way that he could not control the pictures received from the photo-agencies. Covertly, in the early years of the magazine, it made Wilson Hicks one of the most influential men on the *Life* editorial staff. Wilson Hicks's power came largely from the fact that he matched photographer and story.[59] Hicks used this power to stop some stories and to promote others. The shooting script was an important tool in this process. Before the acceptance of formal shooting scripts, Hicks insisted that editors justify their projects by writing out their objectives in advance. Over time, this list of objectives became the shooting script. If Hicks did not like a story, he simply did not assign it. If he was challenged by a particular editor about an unassigned story, Hicks responded by lecturing him about the poor quality of his shooting script.[60]

Once the assignment was completed, the *Life* organization required that, while on location or immediately upon return, the photographer turn over his undeveloped film to the *Life* photo lab where the negatives were developed and printed. Lab processing of the film evolved with the changing circumstances. Before World War II the photo lab made prints of all printable negatives and sent them to managing editor John Billings. As *Life*'s photographic staff increased, this procedure became impractical. In response to the exponential growth of photographs sent in by staff photographers during World War II, *Life* editors assigned Peggy Sargent to the job of contact editor. Now, instead of making prints, the *Life* lab made contact sheets. These were carefully reviewed by Sargent in consultation with the shooting script or with the written caption material. This initial selection did not edit subject matter as much as select the best single image in a sequence of variant negatives. On average she had about one out of every seven negatives printed in 8 × 10 or 11 × 14 format.[61]

Under Joseph Thorndike's leadership these prints were submitted to the picture editor and were checked against the shooting script, then sent to the department editor, where they were sequenced, laid out, and submitted for final approval. For an important story, Edward Thompson often had the printed photographs brought to him for selection, sequence, and layout. He conducted this process in consultation

with the department editor who had originally suggested the story and the art director who was to arrange the pictures. Most photo-essays went through several photostated layouts as editors refined the selection of the pictures and built relationships between images.[62] After the photographs were arranged on the page, a writer was given the story research and asked to write text for the space available. The photo-essay was then ready for publication.

When and if the story was published was the result of a variety of factors. The managing editor considered first the balance of a particular issue. During John Billings's tenure as managing editor, for example, *Life* developed a formula for each issue: "a generous portion of news, information, variety, several changes of pace, visual excitement, and some humor."[63] This formula changed with each managing editor, but generally they tried to publish stories that carried different emotional weight and that offered a variety of topics in order to interest the widest cross section of readers.

The magazine filled up gradually over a six-week period.[64] For technical reasons the first pages to close were the color pages, six weeks before publication. Three weeks before the issue was to come out the major text articles were assigned magazine space. On the Tuesday before publication, the ad layout was brought to the managing editor. This determined the space available for stories and, for example, the number of pages allowed for the photographic essay. On Wednesday or Thursday the photo-essay was inserted into the magazine, and by Friday there were only sixteen pages that had not been filled. These were saved until the last minute for late-breaking news.[65] The completed magazine was printed on Sunday and Monday and was on the newsstands Tuesday.

As is obvious from this description of *Life*'s editorial practice, avenues of influence for the photographer were few. Once he or she turned the undeveloped film over to the *Life* lab the photographer could not directly affect the interpretation of the pictures. Therefore, a reconsideration of Henry Luce's metaphor of the photographer as an eighteenth-century essay writer is necessary. We must recognize that in the *Life* system the photographer acted more like a thesaurus than an author. It was the editor who selected the pictorial "words," combined and arranged them into double-page "paragraphs," and sequenced them into a coherent "essay." The photographer could ask Peggy Sargent to include certain images, and he or she might be able

to influence picture selection through the department editor. Sequence and layout might be affected by consultation with the art director, but over the final arrangement and publication of the pictures the photographer had little control.

In the final analysis few photographers were allowed even this indirect influence over the publication of their photographs. The photographer's authorial control over the moral component of the photo-essay was in direct proportion to the amount of pressure he could place on his colleagues. This pressure was circumscribed by the photographer's status in the *Life* magazine organization. No photographer sought more self-consciously to promote himself and to increase his authorial control than W. Eugene Smith.

## The Man

W. Eugene Smith was born on December 30, 1918, in Wichita, Kansas, the second of two sons in a comfortable, middle-class home.[66] Eugene Smith's mother, Nettie Caplinger Smith, was a formidable woman who came from a wealthy Midwestern family and played an important and continuing role in her son's life. She was an amateur photographer and was serious about the craft. She had a darkroom set up in the family home and sent her photographs to salon exhibitions. Undoubtedly, she introduced Eugene to photography and encouraged experimentation with it. A convert to Roman Catholicism, she sent both Eugene and his brother Paul to parochial schools. It is in this early religious education that one sees the beginnings of the intense moral stands of Smith's later life.

Eugene Smith's serious interest in photography began in high school, and by 1934, his photographs of local sports events were being published in the city newspaper, the *Wichita Eagle*. In the same year, at the age of fifteen, *The New York Times* published one of his photographs of the Midwestern drought. The years of the Great Depression, however, brought tragedy as well as triumph. Smith's father, a hitherto successful grain dealer, faced bankruptcy when grain prices dropped dramatically. In early 1936, after writing a suicide note to his son, W. H. Smith drove to a parking lot and killed himself. This was the first of a series of tragedies that would haunt Eugene Smith throughout his life.

In the fall of 1936, Smith was awarded full tuition and a $1000

scholarship to Notre Dame University. He earned the grant by acting as a university photographer at official events. Writing to his mother about one of these assignments – to photograph a speech by Msgr. Fulton Sheen – Smith conveyed his early understanding of the potential of photography:

> My station in life is to capture the action of life, the life of the world, its humor, its tragedies, in other words life as it is. A true picture, unposed and real. There is enough sham and deceit in the world without faking life and the world about us. If I am shooting a beggar, I want the distress in his eyes, if a steel factory I want the symbol of strength and power that is there. If I want a picture of some joyous one I want a smile of pure joy, not a set smile for the camera. I can't seem to put it into words, the feeling, my outlook on photography. I no longer take pictures for the pure joy of taking them, but like many of the old masters of the paints, I want them to be symbolic of something.[67]

Eugene Smith had no formal training in photography until February 1937, when, after a semester of college and at the age of eighteen, he left Notre Dame to study photography at the New York Institute of Photography. Later that year, at her son's suggestion, Nettie Smith moved to New York to care for him and to act as his photographic assistant. Within a year, Smith had secured a job with *Newsweek* magazine. Although he was released by the magazine, supposedly for continuing to bring in 35 mm negatives when the editors insisted on large-format $2\frac{1}{4}$ inch negatives, Smith continued to find work as a free-lance photographer, completing assignments for Newsphotos and Black Star, two New York City photo-agencies.

Smith's first stint with *Life* magazine began in 1939 when the picture editor, Wilson Hicks, impressed by Smith's "Picture of the Week," offered him a retainer for two weeks of work every month. This recognition must have been a tremendous encouragement to Smith.[68] Barely twenty-one years old, he had been retained by the most prestigious publisher of photo-reportage. He also sold his free-lance work to Crowell-Collier, publishers of *American Magazine*, *Collier's*, and *Woman's Home Companion*. Between 1940 and 1942, *Collier's* published, with his credit line, over seventy-five articles illustrated with Smith's photographs.

The situation seemed ideal. Smith could have his work regularly published in the prestigious *Life* magazine and at the same time submit

photographs for worldwide distribution through the Black Star picture agency, which he had joined in 1938. Smith, however, quickly became disillusioned with his work for *Life*. He felt that he was seldom given the opportunity for extensive photographic coverage of a subject. Worse, his photographs were often not even used by the magazine. For example, although he was sent on over 170 assignments between 1939 and 1942, only eighty-one articles using his photographs were published, and these articles were often mundane and routine.[69] In 1942, as the outbreak of the war made his assignments seem increasingly trivial, he resigned from *Life*.

Smith wanted to participate in the war. Soon after war was declared he tried to join Edward Steichen's Navy photo unit. When he went for his physical, however, he was turned down because of a broken eardrum and poor eyesight. He contributed to the war effort by doing a series of photo stories for the new Sunday supplement *Parade*. In each issue *Parade* printed three or four picture stories, often using fifteen to twenty captioned photographs and only a minimal text. It was during this period of frequent publication that Smith honed his narrative approach to photo-reportage.[70]

The *Parade* photo-essays were, for the most part, propaganda pieces, as can be seen from the titles: "Union Station: The Capitol's Railroad Terminal Holds the Pulse of a Nation at War," "They Look for Trouble: The Subs Have Accounted for Most of the Damage Done to Axis Shipping in the Far East," and "13-Year-Old Veteran: How Jackie Ran Away and Joined the Navy."[71] These photo stories demanded that Smith photograph narrative sequences with a particular ideological message: support America's involvement in World War II. Although he learned about the importance of selection and sequencing of photographs while working for *Parade*, Smith became disenchanted with the publication.

Surprisingly, given his strong antiwar stance after World War II, he did not object to the ideological impact of the publication of his pictures. Smith was concerned about the similarity of the pictorial problems he encountered on these assignments. He wrote in his diary:

> In part (and this reasoning is merely a sketch and certainly not completed) I believe it is the result of trying to compromise my own wants and beliefs, to make them fit into the now stylized and routine *Parade* and yet retain some depth and originality. And as I compromised myself right into a deep, stilted, unimaginative rut.

. . . But whatever the reason I am horribly depressed. . . . I must get across; the change of scene, the enormous difficulties and the downright challenge of such an assignment I feel would bring me back onto an upward road.[72]

This passage highlights Smith's driving ambition, his uneasiness with success, and his constant struggle for perfection. These personality traits dominated his life, both in his disagreements with editors and his intense self-criticism. His experiences in World War II, however, sparked in Smith another aspect of his photography: a commitment to moral, humanistic ideals.

In July 1943, he was offered a job as a war correspondent by Ziff-Davis Publishing Company. Assigned to make photographs for *Flying* magazine, Smith was commissioned to cover the war from aircraft carriers in the Pacific. He left with eagerness and enthusiasm. As he was leaving San Francisco for the Pacific, Smith wrote gleefully to his wife about buying a hand-forged hunting knife "good for Japs, underbrush, or steak."[73] His experience of the war, however, soon turned his bravado into a personal crusade to show the horrible slaughter of humankind and to communicate a doctrine of universal humanity.

Smith's desire to experience the war was not fulfilled by his Navy assignment. For the first month he was not allowed to fly combat missions, but even when this restriction was lifted he continued to be dissatisfied with his work. He wrote of his frustration:

> I had covered the early pounding of Tarawa and D-Day from the air, and this hour was utilized to shoot just as much damage assessment as was possible. . . . Heavy shadows were an honest representation of the burning sun that hurried the rotting of human bodies until the stench was strong even in a plane several hundred feet above the island.
>
> That I was not there at the right time, was in the air when the hell was breaking loose, is my very great regret — for when I arrived with the first planes, the climax of the ground fighting was of course over. And after a battle there is a horrible serenity — a dead island covered with dead trees and with dead or exhausted bodies can be very serene. . . .[74]

As he would do so often, Smith internalized and personalized the anger generated by his idealism. He wrote to his family in late 1943:

Dear Bums,

The great tragedy of [my] wasted time has been the years of the war, starting with the Spanish Civil war, the testing grounds for the murder that is now. And think of the lost history in the magnificent complete struggle of the Russian sphere of war, and the early days of the fall of France and the staggering of England. I suppose I can weakly find reasons for forgiving myself for sitting these out. People who have failed usually have almost undebatable reasons instead of results. . . . I have in the past been a washout, have veered far from what should have been my destiny. . . .

This easy living Navy isn't the story that must be told.[75]

In April 1944, Smith returned to New York on leave; while there he resigned from Ziff-Davis in order to accept a commission to cover Marine invasions for *Life* magazine.

One of Smith's first *Life* assignments was to photograph the invasion of Saipan. There he confronted directly the human tragedy of the war – in particular the deaths of the innocent. He wrote to his wife:

I saw my daughter, and my wife, and my mother, and my son, reflected in the tortured faces of another race. Accident of birth, accident of home – damn the rot of man that leads to wars. The bloody dying child I held momentarily in my arms while the life fluid seeped away and through my shirt and burned my heart into flaming hate – that child was my child. And each time I pressed the release it was a shouted condemnation hurled with the hopes that it might survive through the years. . . .[76]

These strong beliefs were not welcomed by the Navy censors in Hawaii. His most brutal photographs so graphically depicted the inhumanity of war that they were not released by the Pentagon. Even some of his milder photographs were censored. For example, his photographs of the Army's treatment of civilian prisoners on Saipan were intended, by the Army editors, as part of a specific propaganda effort to show that civilians were being well treated. Smith, however, photographed the failures as well as the successes of the program. Not surprisingly, even the mildest criticism was edited out of the final publication.[77] His photo-reportage became what Smith bitterly characterized as "managed news."[78]

In mid-April 1945, Smith was with the troops in Okinawa photographing the prolonged battle for control of the island. He had become

committed to his moral quest to communicate *his* experience of the war
and his moral beliefs. He wrote:

> I want it understood once and for all that I will not be compromised
> with my beliefs or with the taking of subjects in which I find no
> reason – no point. I will not. I will never change this attitude, I
> will never go commercial. . . . I would rather call the whole thing
> off, go completely to pieces, and become a worthless bum. There
> is no middle path with me, as long as I must go through life on
> keyed up nerves to overcome my head, I must reach out and up,
> for without this search for the perfect – the ultimate – for the
> symphony which Beethoven was reaching for, I will not have the
> strength to combat the other and therefore will slip completely.[79]

*Life* assigned him to photograph a human interest story about a foot
soldier. "A day in the life" story with "all those little details that Ernie
Pyle made famous," they cabled.[80] He chose infantryman Terry Moore,
but while following him, Smith was seriously wounded by a mortar
explosion. Iron fragments hit his upper back and left hand and struck
his lower jaw and broke through the roof of his mouth. Smith was
rushed to a field hospital where he received blood transfusions. Two
days later, on May 24, 1945, he was flown to the Naval Hospital on
Guam.

Smith was already well known among his fellow war correspondents;
his injuries brought him national attention. *Life* ran Smith's story on
the infantryman three weeks after his injury. The editors concluded
the story with a picture of the wounded photographer.[81] Later, *Time*
published portions of a letter Smith had written the day before he was
wounded.[82] Smith's wounds were extremely painful and it is likely that
it was during his two-year convalescence that he became addicted to
Benzedrine and alcohol – addictions that he would carry with him the
rest of his life.

During his recovery Smith continued on *Life*'s payroll and returned
to work very gradually. In 1946 he undertook only six theater assign-
ments – work that he enjoyed and that required little strenuous effort.
He stayed active, however, enrolling in night classes, taking courses
in professional writing and in directing for stage, movies, and tele-
vision, and acting as president of the American Society of Magazine
Photographers. In May 1946, the Camera Club of New York exhibited
his World War II photographs. They received unstinting praise. The

editor of *Popular Photography* wrote to Smith: "Your pictures are true
and horrible and agonizing, but they also have a moving beauty of their
own. . . . Having seen your pictures I will not forget them for the rest
of my life."[83] Smith undertook more assignments in 1947 but did not
resume full-time work until 1948.

After agreeing to a financial settlement with Time-Life, Smith left
New York in February 1948 for his first extended reportage. The pro-
posed essay was one of a series that featured the tourist attractions of
particular states. Smith was assigned to photograph New Mexico. Far
from the cold New York winter, it was to be a combined vacation and
photography assignment with his wife, Carmen, accompanying him.
Smith's photographs were never published, but his March photo-
reportage on folk singers was selected for publication, and by later
that year he seems to have resumed his normal workload.[84]

Smith's new photographic work was significantly affected by his war
experiences. He continued to struggle for what he believed was a moral
response to human suffering. His camera and his photographs were his
weapons. In a 1946 interview he stated:

> I was after a set of pictures so that when people looked at them
> they would say, "This is war" – that the people who were in the
> war would believe that I had truthfully captured what they had
> gone through. . . . I worked in the framework that war is horrible.
> I want to carry on what I have tried to do in these pictures. War is
> a concentrated unit in the world and these things are clearly and
> cleanly seen. Things like race prejudice, poverty, hatred and big-
> otry are sprawling things in civilian life, and not so easy to define
> as war.[85]

In this passage we see the depth of Smith's empathy, his desire to
use his camera as a crusading weapon capable of righting injustice.
This became the credo of his postwar photo-essay production at *Life*.
In his future photo-reportage Smith became personally involved with
the people he was photographing.[86] This deep, personal involvement
increased his sense of responsibility, exacerbated his conflicts with
editors, and amplified his guilt over any possible misinterpretation. It
was, therefore, particularly frustrating when, because of *Life*'s edito-
rial structure, he was unable to control the layout and text of his pho-
tographic essays. A critical examination of his four most famous photo-
essays shows Smith's battles in his struggle for authorial control.

# CHAPTER 2

# "COUNTRY DOCTOR"

*4–14. "Country Doctor: His Endless Work Has Its Own Rewards,"*
Life, *XXV/12 (September 20, 1948), pp. 115–126. W. Eugene Smith,*
Life *magazine, copyright 1948, Time Warner, Inc.*

# COUNTRY DOCTOR

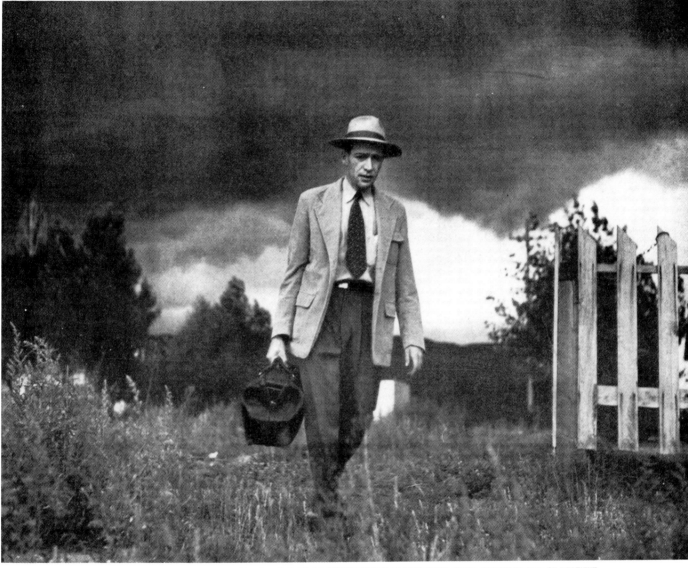

THROUGH WEEDS GROWING RANK IN AN UNKEMPT DOORYARD, DR. ERNEST CERIANI OF KREMMLING MAKES HIS WAY TO CALL ON A PATIENT

## HIS ENDLESS WORK HAS ITS OWN REWARDS

PHOTOGRAPHS FOR LIFE BY W. EUGENE SMITH

The town of Kremmling, Colo., 115 miles west of Denver, contains 1,000 people. The surrounding area of some 400 square miles, filled with ranches which extend high into the Rocky Mountains, contains 1,000 more. These 2,000 souls are constantly falling ill, recovering or dying, having children, being kicked by horses and cutting themselves on broken bottles. A single country doctor, known in the profession as a "g.p.," or general practitioner, takes care of them all. His name is Ernest Guy Ceriani.

Dr. Ceriani begins to work soon after 8 o'clock and often continues far into the night. He serves as physician, surgeon, obstetrician, pediatrician, psychiatrist, dentist, oculist and laboratory technician. Like most rural g.p.s he has no vacations and few days off, although unlike them he

has a small hospital in which to work. Whenever he has a spare hour he spends it uneasily, worrying about a particular patient or regretting that he cannot study all of the medical journals which pour into his office. Although he is only 32 he is already slightly stooped, leaning forward as he hurries from place to place as though heading into a strong wind. His income for covering a dozen fields is less than a city doctor makes by specializing in only one. But Ceriani is compensated by the affection of his patients and neighbors, by the high place he has earned in his community and by the fact that he is his own boss. For him this is enough. The fate of thousands of communities like Kremmling, in dire need of "country doctors," depends on whether the nation's 22,000 medical students, now choosing between specialization and general practice, also think it is enough.

CONTINUED ON NEXT PAGE

# HE MUST SPECIALIZE

**THE DAY'S FIRST OFFICE CALL** is made by a tourist guide and his baby, who have come to Kremmling from an outlying ranch. Ceriani's patients are of all ages and income groups and come from doctorless areas as far as 50 miles away.

**HOME CALL** at 8:30 a.m. starts Ceriani's day. He prefers to treat patients during office hours at the hospital, but because this printer had a fever and symptoms of influenza Ceriani thought it would be unwise for him to get up and make the trip.

**MINOR EMERGENCY** disrupts Ceriani's office routine. This 60-year-old tourist, suffering from a heart disturbance aggravated by a trip through an 11,000-foot pass in the Rockies, came to the hospital to get an injection of morphine.

**ANOTHER HOME CALL** turns up a feverish 4-year-old suffering from acute tonsillitis. Although a large proportion of his patients are children, Dr. Ceriani still inexperienced in pediatrics and studies it whenever he has an opportunity.

# N A DOZEN FIELDS

**-RAY PICTURE** is explained to a rancher by Ceriani, who developed the negative himself. In addition to the X-ray machine, the hospital contains about 0,000 worth of equipment, including a $1,500 autoclave and an oxygen tent.

**ROKEN RIBS,** the result of an accident in which a horse rolled on this patient, are bound with adhesive tape by Ceriani. Many of his hardy patients walk with injuries which would make city dwellers call at once for an ambulance.

**ROBLEMS OF AGE**—in this case a slight deafness complicated by deposits ear wax—are daily brought to the doctor. Here, in an operation chiefly important for its effect on the patient's morale, Ceriani removes the wax with a syringe.

**WOES OF YOUTH** fill Ceriani's office with noise. Above: he examines stitches in the lacerated hand of a squalling 7-year-old. Below: he uses a rubber tube to remove the mucous which clogs the throat of an infant he has just delivered.

CONTINUED ON NEXT PAGE

# AN ACCIDENT INTERRUPTS HIS LEISURE

Dr. Ceriani's moments of relaxation are rare and brief. Last month, taking a chance that he would not be missed for three hours, he asked two employes of the Denver and Rio Grande to take him out on a railroad gasoline car to Gore Canyon. There he fished alone in the rapids of the Colorado, working expertly over the white water for almost 30 minutes. Suddenly he saw the car coming back up the canyon far ahead of time, and automatically he commenced to dismantle his fishing rod. Ceriani had no feeling of resentment at the quick end of his excursion; he merely stood still waiting for the car to reach him, wondering what had happened and hoping that it was not serious. When the car arrived Chancy Van

Pelt, the town marshal, hopped off and said, "Little girl at the Wheatly ranch got kicked in the head by a horse. Can you come now?"

Lee Marie Wheatly, aged 2½, was already in the hospital when Ceriani arrived. While her parents watched he looked for signs of a skull fracture, stitched up a great gash in her forehead and saw that her left eyeball was collapsed. Then he advised the Wheatlys to take their child to a specialist in Denver for consultation on removal of the eye. When they left Ceriani was haggard and profoundly tired. He did not remember that he had been fishing at all until, on his way out of the emergency room, he saw his rod and creel lying in the corner where he had thrown them.

**AT 4:15** two friends start to give fisherman Ceriani a ride to Gore Canyon in a railroad motor car.

**AT 5:00** Ceriani begins his day's fishing in the boiling, trout-filled rapids of Colorado River.

**AT 5:30** Kremmling's town marshal has come after Ceriani and they start back to take care of an emergency case.

**THE CHILD'S PARENTS** watch in anguish (*left*) while Ceriani examines their daughter. The hospital's two nurses, one of whom is on duty in the hospital at all hours, had tried to check the flow of blood from her forehead and had given her a dose of phenobarbital while Ceriani was on his way back from fishing trip.

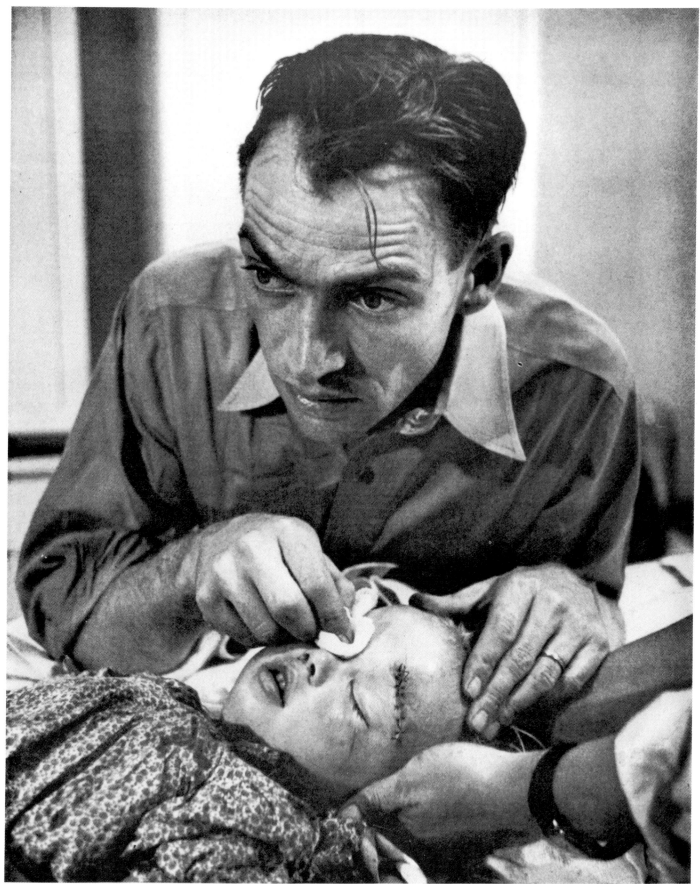

**HAVING DONE HIS BEST** for the child, Ceriani is worn out and tense as he completes the emergency treatment. He has stitched the wound in her forehead so that she will have only a slight scar, but already knows that nothing can be done to save her eye and tries to think of a way to soften the news for her parents

# HE SETS A BADLY DISLOCATED ELBOW

Young Robert Wiggs had a dislocated left elbow. He had been to a rodeo in nearby Granby, had a few beers and tried to ride a wild horse. When he was brought by his friends to the hospital, he was in great pain and swearing loudly. "Don't tell my mother," he said.

Dr. Ceriani X-rayed the arm. Then, because it was necessary to give Wiggs ether, he questioned him about the beer he had drunk. Wiggs said, "Only a few," and the operation proceeded. The boy's friends and a nurse held him while Ceriani set the joint and made a cast for it (*opposite page*).

As the effects of the ether began to fade, Wiggs began groggily to repeat, "Don't tell my mother.". At this Ceriani glanced across the table. There stood Mrs. Wiggs, who had been notified of the accident and had rushed to the hospital in time to hold her son's hand during the last of the operation. Ceriani grinned at her, trying to convey two ideas. One was that her son would be all right. The second was that Ceriani himself was a man who might not long ago have had a few beers and tried to ride a wild horse, and therefore did not think this affair was one of the utmost gravity.

CERIANI HELPS CARRY THE PAINFULLY INJURED BOY INTO THE HOSPITAL

HE PULLS AT THE BOY'S ARM TO BRING THE ELBOW JOINT BACK INTO PLACE

# ...AND AMPUTATES A GANGRENOUS LEG

Old Thomas Mitchell had a gangrenous left foot. He was 85, and when he was brought to the basement emergency room three months ago it seemed unlikely that he would live long. But he survived, and when Dr. Ceriani came to tend him he would say, "I want to see the mayor. When is the mayor coming?" as though such a visit would clear up the trouble.

For a long time Dr. Ceriani postponed the inevitable amputation, afraid that the old man could not survive it. Twice he told the nurses, "Tomorrow I will do it," but when tomorrow arrived Mitchell had grown weaker.

Finally the old man rallied and Ceriani hastily made his preparations. With great gentleness he carried his patient (*opposite page*) up to the operating room, gave him a spinal anesthetic and cut off his left leg below the knee. The old man, conscious but with his vision blocked by a screen, was not aware of what was being done and did not discover that his leg was gone until long after. He continued to say, "My foot hurts," while Dr. Ceriani, busy now with other cases, sighed in relief. Last week the old man was much improved and asking with increased spriteliness to see the mayor.

BEFORE THE AMPUTATION CERIANI CHECKS MITCHELL'S BLOOD PRESSURE

IN THE OPERATING ROOM THE OLD MAN RECEIVES A SPINAL ANESTHETIC

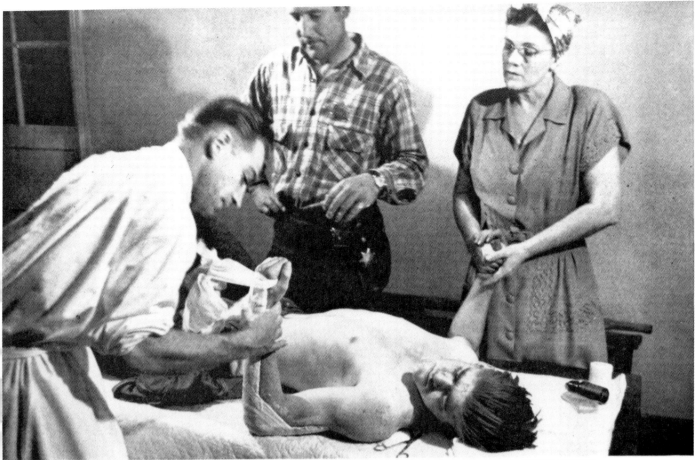

THEN CERIANI APPLIES A CAST WHILE THE HALF-CONSCIOUS BOY MURMURS, "DON'T TELL MY MOTHER," NOT REALIZING HIS MOTHER IS HOLDING HIS HAND

BECAUSE THE HOSPITAL HAS NO ELEVATOR, CERIANI PICKS UP HIS PATIENT IN THE BASEMENT WARD TO CARRY HIM UPSTAIRS TO THE OPERATING ROOM

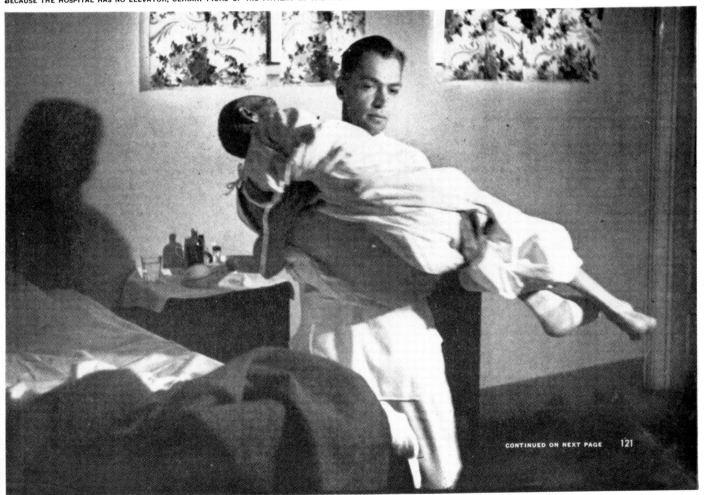

CONTINUED ON NEXT PAGE

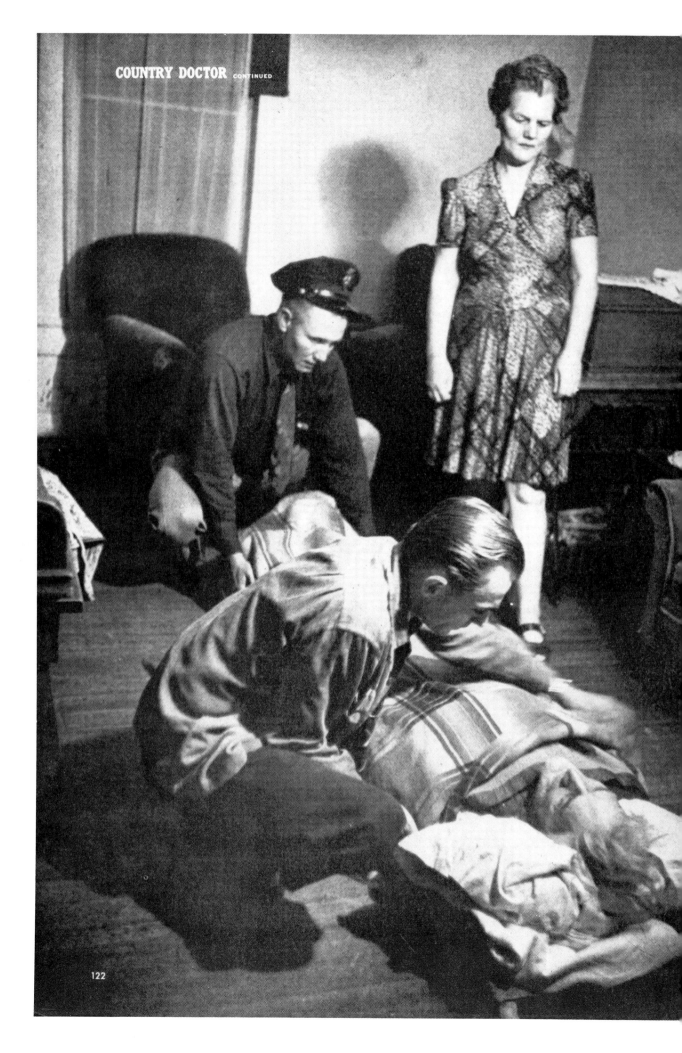

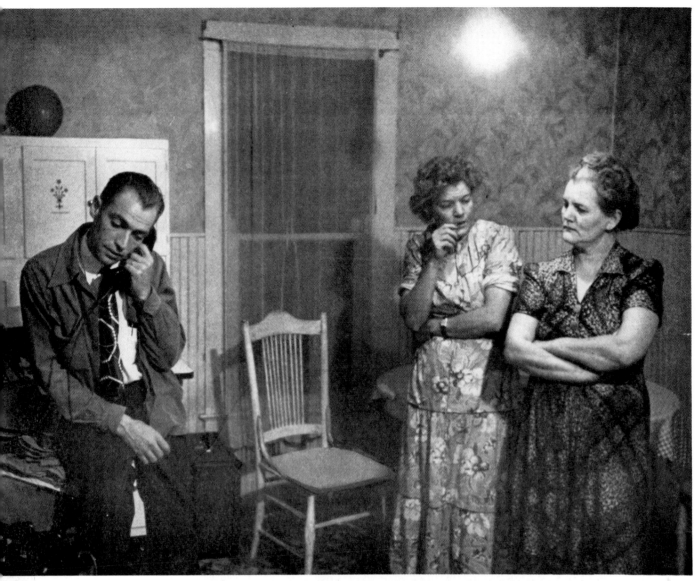

THE KITCHEN, WHILE THE WOMEN WHISPER, CERIANI TELEPHONES THE PRIEST TO TELL HIM THAT THE OLD MAN WILL NOT LIVE THROUGH THE NIGHT

# AN OLD MAN
# DIES AT NIGHT

A few minutes before midnight the people in the Jesmer's house called Dr. Ceriani to tell him that Joe was very sick. Ceriani put on a cloth jacket, went over there quickly and found 82-year-old Joe dying after a heart attack. He was still conscious, but in his pain and bewilderment he felt that he was somehow trapped and needed rescuing. He continually said, "Please, please let me out of here."

Ceriani and Chancy Van Pelt got Joe onto a stretcher (*opposite page*), while Helen Watson, a roomer in Joe's house stood watching quietly and without tears. Ceriani called the priest, asking him to come to the hospital. Chancy and he carried Joe out to the ambulance and drove off. There was nothing Ceriani could do except make Joe comfortable and watch him die. At about 2:30 it happened. He left the hospital then and went home, finding his wife asleep and his own house as quiet as all the rest in town.

**IN THE PARLOR** Ceriani tucks a blanket around the dying man before taking him out into the night.

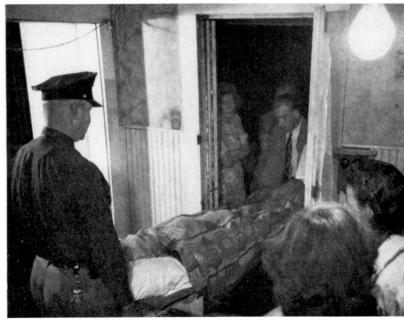

AT MIDNIGHT JOE JESMER'S WOMENFOLK STAND SILENTLY AROUND THE DOOR TO SEE HIM TAKEN AWAY

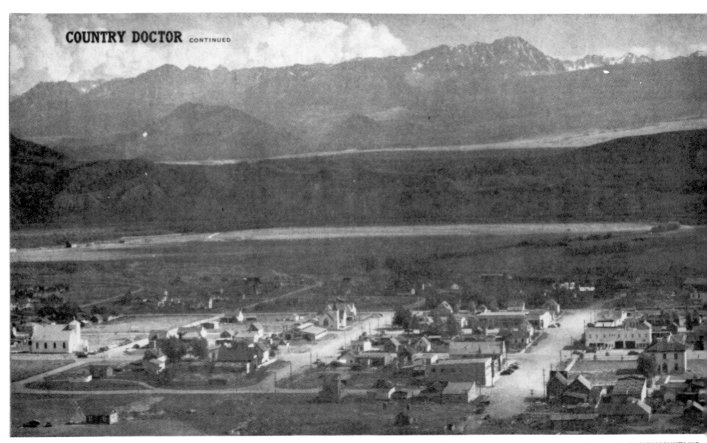

THE HOMELY WOODEN BUILDINGS AND WIDE TREELESS STREETS OF KREMMLING STAND ON A 7,000-FOOT PLATEAU BENEATH THE TOWERING ROCKY MOUNTAINS

THE DOCTOR AND FAMILY watch a parade in Kremmling. Ceriani holds 11-month-old Gary, while wife Bernetha steadies 3-year-old Philip on the rail.

# COMMUNITY ABSORBS MOST OF HIS TIME

Kremmling lies on a 1½-mile-high plateau on the edge of the Rockies. Tourists and transcontinental travelers find the country beautiful, as does Ceriani, who also finds it advisable in bad weather to take chains, blankets, an ax and a can of beans with him on trips to ranches in the hinterland. The town itself consists of about 150 small buildings, including the hospital (*below*), and a few old log cabins. Mrs. Ceriani, who came from rural Colorado, was already familiar with this environment and adjusted easily to it. She faithfully reminds him to send out his bills—which are far lower than those of an urban physician—and has long since grown used to emergencies at all hours and to the sudden collapse of her plans to see a movie or play bridge. She has learned to accept all the problems of her husband's career except one. Even after four years of marriage, she is still unable to reconcile herself to the fact that his time is not his own. She and her two young sons must see him at unpredictable intervals, on special occasions (*left*) or simply fall asleep waiting for him to finish his work.

THE HOSPITAL, one block away from Ceriani's house, is a neat white wooden building with three separate wards which can accommodate a total of 14 patients.

124

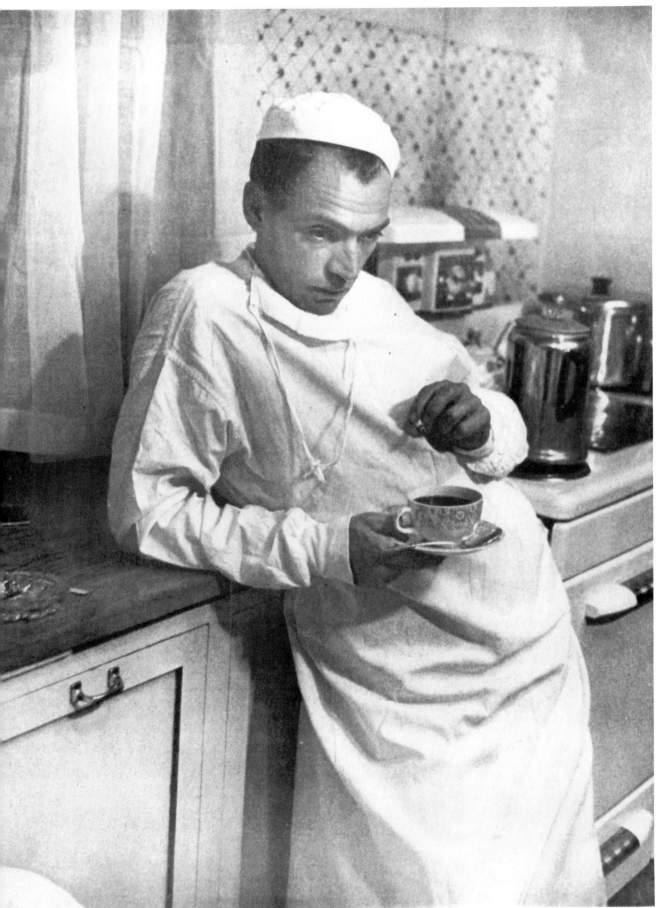

**AFTER MIDNIGHT,** after an operation which lasted until 2 a.m., Ceriani has a cup of coffee and cigaret in the hospital kitchen before starting home. The nurses constantly admonish him to relax and rest, but because they are well aware that he cannot, they keep a potful of fresh coffee simmering for him at all hours.

**CONTINUED ON NEXT PAGE**

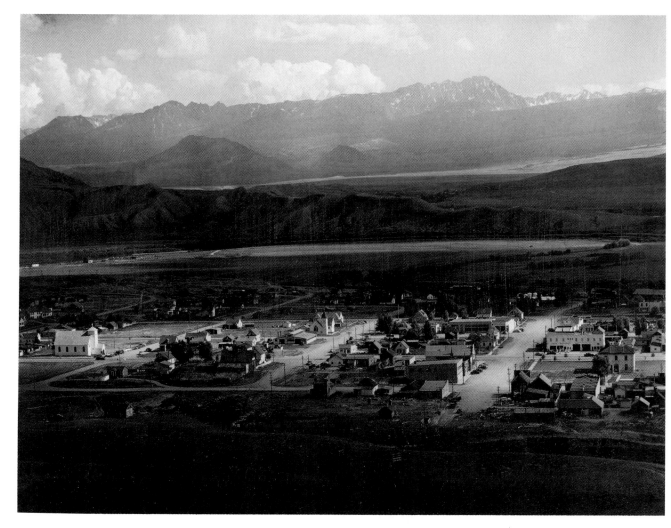

*15.  Photograph of Kremmling, Colorado. 1948. W. Eugene Smith,*
*copyright the heirs of W. Eugene Smith.*

## Concept and Publication

The appointment of Joseph Thorndike to the position of managing editor in 1947 turned *Life* magazine increasingly toward feature stories with a strong human element.[1] "Country Doctor" was the kind of story that Thorndike favored and the process leading to its publication was typical of photo-essay production at *Life* magazine. The suggestion for a story on a country doctor was presented by an editor, probably either Edward K. Thompson, who oversaw the Science Department of the magazine, or Wilson Hicks, the *Life* picture editor. It was approved at a general editors' meeting, and in spring 1948, regional Time-Life offices were asked to suggest candidates.

The sponsorship of a major photo-essay by a regional office was a considerable accomplishment; Barron Beshoar, the bureau chief of *Life*'s Denver office, carefully considered his choice. He turned to the Colorado Medical Association for advice and was directed to the towns of Montrose and Kremmling. Beshoar visited both communities and interviewed the doctors before deciding on Dr. Ernest Ceriani of Kremmling, a small town 115 miles west of Denver. He submitted a lengthy report promoting his selection to the main *Life* office in New York.

Even though Colorado was not one of the seven or eight rural states in greatest need of doctors, there were several factors that favored Beshoar's choice.[2] One advantage was the picturesque location of Kremmling, nestled in the Rocky Mountains (fig. 15). In addition, Dr. Ceriani was young and photogenic.[3] When Beshoar was informed that his candidate had been selected, he conducted more extensive interviews, from which he constructed a narrative and wrote a shooting script.[4]

In New York, while Beshoar was completing the research, picture editor Wilson Hicks assigned W. Eugene Smith to be the photographer. To cover the story Smith and his assistant, Robert Harrah, drove west from New York City; in Indiana their trip was interrupted by a car accident.[5] Staying on schedule, Smith flew to Denver while Harrah waited for the car to be repaired and then drove it and their equipment to Colorado.

In Denver, Smith and Harrah were briefed about the story and given the shooting script by Barron Beshoar (fig. 16).[6] Despite all his preparation, Beshoar had no official control over Smith's photo-reportage. He could attempt to persuade Smith to favor one approach or another but he was not present during the photographer's shooting, nor did he see the photographs until they were published in the magazine. He did, however, send to the New York office exhaustive written reports which became the basic written research for the published photographic essay.[7]

For the most part the shooting script suggested set-up tableaux typical of a country doctor's life.[8] It was Smith's job to add the emotional qualities that made the doctor's life interesting to the general public. In its initial stages, then, the story of the country doctor was a blending of the background research of the Time-Life Denver office chief, Barron Beshoar, and the photographic interpretation of the photographer.[9]

Smith and his assistant, Robert Harrah, stayed in Denver for four or five days photographing a story about new medical techniques being used at the Hebrew Hospital.[10] After completing the assignment the two men drove to Kremmling and had dinner with Dr. Ceriani and his family. They explained their intentions to the doctor and discussed possible photographic motifs. They began by shooting hundreds of candid photographs in an effort to make residents comfortable with their presence. For his reportage Smith used three different camera formats — 4 × 5, 2¼, and 35 mm. The large-format view camera (producing a 4 × 5 inch negative) was sparingly used for specific, scripted pictures, for example, the photograph of the town. A hand-held camera, producing a 2¼ inch negative, was used for other set pieces such as the doctor heading off to work. The more spontaneous, dramatic scenes were shot with a small 35 mm camera.[11]

The shooting of the photo-essay was intended by the editors to take between ten days and two weeks, but Smith stayed in Kremmling for almost four weeks. During his twenty-three-day stay, Smith was a constant companion of the doctor, insisting on being awakened for midnight emergencies as well as routine rounds. He photographed both the doctor's public life and his private life — showing him as a father and husband as well as a doctor. Smith developed an admiration for the doctor, whom he came to understand as a selfless servant of the community.[12] Before he was finished Smith had shot over two thousand negatives for the story. He recorded typical situations — treating pa-

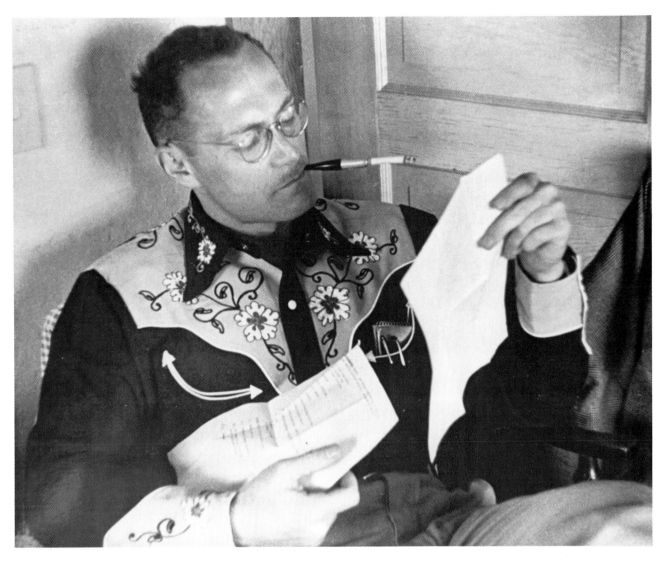

*16. Photograph of Eugene Smith reading shooting script for "Country Doctor." 1948.*
*Robert Harrah, printed with permission of the family of Robert S. Harrah.*

tients and going on rounds, for example; but he was especially drawn
to the dramatic scenes – hospital emergencies and late-night calls.

While still in Kremmling Smith sent his undeveloped negatives to
New York where they were printed on contact sheets and sent back to
the photographer.[13] This procedure had two purposes: to allow Smith
to see how his subject was portrayed on the film and to allow the
picture editor to check the photographs against the shooting script and
make suggestions for the story. These might include new motifs, re-

shooting some aspect of the doctor's life, or using a new format for layout specifications.

After Smith completed the story, he sent his negatives to New York and went to Santa Fe, New Mexico, for a two- to three-day assignment. From Santa Fe, Smith flew back to New York City while his assistant drove their car across country. At the New York *Life* office, Peggy Sargent chose photographs from contact sheets for their expressive details — the expression in the doctor's eyes or the tilt of his head.[14] The finished prints were then submitted to picture editor Wilson Hicks who checked them to make sure all aspects of the script had been included in this initial selection.

Once he was satisfied, Hicks passed the prints along to the department editor, who selected, sequenced, and laid out the photographs. In the case of "Country Doctor" the photo-essay was organized by a future managing editor, Edward K. Thompson, and an assistant art director, Michael Phillips. At the same time that this review of the photographs was taking place, Barron Beshoar's research was being reviewed by the *Life* research staff. This process usually generated more questions that were then sent to the field reporter, Beshoar, for follow-up. After this extensive screening "Country Doctor" was published on September 20, 1948.[15]

## Narrative and Aesthetic Reading

On a wall label for his exhibition *The Photo-Essay*, John Szarkowski called "Country Doctor" a pivotal photo-essay. He analyzed it as

> an unresolved mixture of past and future styles. In its text and layout it looked backward to the literal reportage of earlier years — it might have been titled "*Life* Visits a Country Doctor." But the best of the photographs of W. Eugene Smith dealt not simply with what the doctor did, but in the most profound sense, with who he was. With this example the photo essay moved away from narrative, toward interpretive comment.[16]

Szarkowski's praise of "Country Doctor" as an artistic breakthrough certainly represents one level of its meaning, but not the only level. An analysis of the photographic essay's complexity demonstrates that

"Country Doctor" can be read on two different levels: first, the aesthetic and narrative; and second, the political and ideological. In the case of "Country Doctor," the aesthetic and narrative elements were of great importance to Smith.

The most immediate influence on the photo-essay seems to have been the competition in which Smith was engaged with fellow *Life* photographer Leonard McCombe. McCombe's twelve-page photographic essay "The Private Life of Gwyned Filling" was published in May 1948, a month before Smith began working on "Country Doctor."[17] McCombe's photo-essay was an intimate portrayal of a day in the life of a single young woman beginning a career in New York City. Although the narrative structure was unoriginal, McCombe's technique was immediately recognized by professionals as an important photojournalistic breakthrough.

What was remarkable about "The Private Life of Gwyned Filling" was the seemingly transparent presence of the camera. In comparing it to earlier photo-essays such as "A Practical Man of God" – a photo-essay typical of *Life*'s early treatment of a single person as subject – one sees this stark pictorial contrast.[18] Whereas Alfred Eisenstaedt's pictures of a Midwestern minister are posed and only nominally related to each other, McCombe's photographs are candid and narratively connected. Furthermore, as we continue into the body of the photo-essay we find reader interest heightened by the emotional content of the pictures. Unlike the detached, carefully directed shots of "A Practical Man of God," McCombe's photographs for "Gwyned Filling" appear to be spontaneous snapshots of a reality unmediated by the cameraman.

McCombe's artistic success was recognized immediately. Maitland Edey, assistant managing editor at *Life* in 1948, has commented: "If it [McCombe's photo-essay] does not startle today, it is because McCombe's techniques were quickly picked up by others. What was then a remarkable innovation later became commonplace."[19] Eugene Smith recognized the quality of McCombe's photographs, praising them as some of the best ever published by *Life*.[20] At the same time Smith expressed his jealousy: "He [McCombe] had more pages, twelve to my ten, and he had the cover in addition. Space counts more than numbers."[21] Smith was challenged by McCombe's success and was determined to outdo him. He soon got his chance.

In "Country Doctor" a large, dramatically lit photograph is used as an attention-grabbing introductory device (fig. 4). It visually states the

themes that are repeated by the text and that are further developed in the body of the photo-essay. The photograph shows a well-dressed man with a doctor's bag walking through an open field. He is centered in the composition and the corners are darkened to make him stand out. As he moves into the foreground of the picture, we notice that he is careworn and tired; his shoulders are slumped, his face lined, and his eyes downcast. We also notice, however, that he ignores his fatigue and walks purposefully forward. Artistic interpretation is evident in the use of a low camera angle that serves to emphasize the doctor's stature and to suggest his burdens by silhouetting him against the dark, brooding sky.

The title tells us who the man is: a hard-working rural doctor whose compensation comes from personal satisfaction in serving his community. The caption highlights certain details in the photograph and provides the narrative context of the image. It reads: "Through weeds growing rank in an unkempt dooryard, Dr. Ernest Ceriani of Kremmling makes his way to call on a patient." The two-paragraph text beneath the picture gives us further information about the geographical location, the doctor's daily routine, and the paucity of his salary. It goes on to tell us that money is not as important to him as his status within the country town. This first page, then, introduces us to the themes that the body of the photo-essay will develop: the hard work of the doctor and his value to the community.

The body of the photo-essay begins with a double-page spread (figs. 5–6). The bold title of the layout, "He Must Specialize in a Dozen Fields," gives coherence to nine diverse and otherwise unrelated photographs. Looking at the two pages we recognize, first, that the pictures provide a visual list of the various medical challenges for the country doctor. In figure 5, the large photograph of the cowboy and baby first captures the reader's attention – the whiteness of the blanket directs us to the baby's amusing expression, and the hat hanging from the tip of the man's boot adds a local, homespun touch. In the remaining photographs of the spread the doctor is shown in traditional motifs, sitting at a patient's bedside, cradling a child's chin, and delivering a baby. We can see as well that he serves a wide generational range of patients and works in a variety of locations. The editors have conveyed these narratives by selecting pictures that place the doctor in the spatial middle ground, emphasizing his actions rather than his personality.

These images also introduce an interpretive aspect of this photo-essay; they portray the doctor as dedicated and noble. We see him as able – he explains the rancher's X-ray and delivers a baby – and, at the same time, gentle and caring – he cradles a little girl's chin, and, in a morale-building procedure, carefully removes wax from an old man's ear. This characterization of the caring general practitioner is extended in the next double-page layout.

This next picture spread (figs. 7–8), which begins a sequence of narratives about emergency situations, tells of the doctor being specially summoned to treat a badly injured two-year-old girl. The layout of the photographs moves from small-scale documentary pictures of the doctor fishing to the large-scale emotional statement of the doctor's face hovering above the injured girl's head. In figure 8 the drama has been heightened in the darkroom. By a careful bleaching of the area around the girl's forehead and on the doctor's fingers, our attention is focused on the wound and on the doctor's healing touch.

The photo-essay continues with two narratives sharing the same spread (figs. 9–10). On the top of the pages and read from left to right is another emergency, a dislocated elbow; and on the bottom, an operation to save an elderly man's life. The large photographs in figure 10 are dramatically lit to convey the drama of the moments. The visual movement of the bottom image, showing the doctor carrying the patient to his operation, leads us out of the picture and invites us to continue further into the body of the photo-essay. The last narrative, "An Old Man Dies at Night," occupies an entire spread and introduces us to an ever-present element in a doctor's life – the constant threat of death (figs. 11–12). In these pictures artificial light is used to illuminate the interior and to intensify the light and shadow contrasts. For example, in the large photograph on the left, stark tonal contrasts convey a sense of foreboding. In addition to their narrative function, these photographs reinforce our understanding of the competence and importance of the doctor. He is a man who is in control of all situations; others stand by awaiting his directions.

The last double-page spread of photographs is divided into a continuation of the body of the photo-essay (fig. 13) and the pictorial conclusion (fig. 14). This sequence of four pictures begins by showing us the geographical location of the doctor's practice. The photographer has selected a panoramic viewpoint that sets the town of Kremmling against the backdrop of the Rocky Mountains. He has also waited for the mo-

ment when the sun has broken through the clouds to highlight the town. The other photographs on the left move away from an examination of the doctor's professional life to give us a glimpse of his personal life: the doctor and his family watching a local parade, and the small wooden hospital that is a block from his home.

The concluding image (fig. 14) restates the implications of the introductory photograph: the doctor tired and leaning heavily on a counter, seeming to carry the weight of the world on his shoulders. Aesthetically, this large, intense picture serves to bring the photo-essay to a resounding conclusion. The harsh lighting and white surgical gown bathe the doctor in white, a color traditionally associated with purity and sanctity. As in the introductory image, the light tonality of this concluding photograph is an interpretation of the doctor's selflessness and higher calling.

It should be pointed out that the photo-essay concludes with a seven-paragraph text on the next page.[22] The inclusion of this lengthy text was unusual for a photo-essay and was most likely ignored except by the most careful readers.[23] Nevertheless it is important to note that *Life* included it. This was a serious essay, not simply superficial entertainment. Both *Life* editors and the photographer Eugene Smith made this clear by emphasizing information. The text gives the reader details about Dr. Ceriani's medical training and his reasons for settling in Kremmling. It concludes with a plea for young doctors to forsake big-city, specialized medicine and embrace general practice in a rural location.

This narrative and aesthetic reading of the photographs shows "Country Doctor" to be a photo-essay that holds up the vocation of the country doctor as a kind of secular sainthood and invites others to follow Dr. Ceriani's example. Braided along with these aesthetic and narrative strands, however, are a number of hidden implications that the contemporary reader must have subconsciously absorbed – and that historical analysis must bring to the attention of the present-day reader.

## Political and Ideological Reading

Although *Life* was not strictly a news magazine, like *Time*, its editors found it imperative that stories be topical.[24] In the case of "Country Doctor" topicality was provided by the issue of national health care.

In July 1948, the British government socialized their medical practice and in the same year the Canadian government proposed a compulsory health insurance plan.[25] Of immediate interest to *Life* readers, however, was the debate in the United States over national health care. Health care was a major political issue and particularly so in the U.S. presidential campaign of 1948. Democratic incumbent Harry Truman made it a focal point of his campaign, urging Americans to "vote yourself a Fair Deal," a package of social benefits that included a program of compulsory health insurance.

In May 1948, at about the same time "Country Doctor" was assigned, Truman established a special task force to report on the state of the nation's health; and in September, the same month "Country Doctor" was published, Oscar Ewing, Truman's Secretary of the Federal Security Administration, announced a plan for national health insurance. Ewing's speech was vehemently attacked by the American Medical Association, which branded the proposal "socialized medicine" and compared it, unfavorably, to the recent British socialization of their medical practice.

The debate was summarized in August 1947 by *U.S. News*.[26] Identifying U.S. health care as a major problem, the article isolated the two antagonists: the Truman administration, which felt that the medical crisis was due to an overall doctor shortage, and the American Medical Association, which contended that the country's medical problems were the result of the poor distribution of physicians.[27] Relating this debate to rural America, compulsory medical insurance meant health care for all levels of American society. It stood to reason that with the increased need for health care there would be more doctors entering general practice; this was particularly promising to the rural populace. With the increase of doctors and with fees guaranteed by the federal insurance program, rural residents assumed more doctors would be willing to leave lucrative urban practices and settle in the country.

The American Medical Association, however, objected to the idea of increasing the number of doctors. They insisted that a redistribution of current physicians would solve existing health care problems. To accomplish this redistribution they suggested an improvement of existing health programs and an encouragement of individual initiative. The A.M.A. was keenly aware of the importance of public opinion in this debate. To convey their message to the widest possible audience,

in 1946 they sponsored radio broadcasts and organized a speakers'
bureau. Two years later a physicians' committee distributed 25,000,000
leaflets bearing the Luke Fildes painting *The Doctor* accompanied by
the caption: "Do you want the government in this picture?"[28] Their
cause was supported by *Life* magazine.[29]

Echoing the A.M.A. tactics, a September 1947 *Life* editorial com-
pared compulsory health insurance with the impending socialization
of medicine in Great Britain.[30] *Life* endorsed a plan put forward by the
New York Academy of Medicine and recommended that communities
take responsibility for attracting doctors by using their cooperatives to
provide housing or a hospital.[31] Addressing doctors, the *Life* editorial
appealed to their social conscience and encouraged them to leave their
urban practices and move to the country. *Life* concluded its endorse-
ment by contrasting what it called "the common sense American atti-
tude toward health service," exemplified in the New York Academy
report, with "the British way" – that is, socialized medicine.[32] It should
be noted that by characterizing federally sponsored compulsory health
insurance as "socialized medicine," the A.M.A. and *Life* magazine
shifted the debate onto ideological ground. Given the politics of the
cold war, socialism was equated with Communism in the minds of most
Americans, and within this ideological framework, compulsory health
insurance was viewed as a threat to American freedom.[33]

The photographer's feelings about this issue are not so clear. It seems
likely, given Eugene Smith's acknowledged liberal political attitude,
that he would have been in agreement with federal support for extend-
ing medical care. His assistant for "Country Doctor," however, states
flatly that politics did not enter into their photographic documentation
and that their intention was simply to record the daily life of a country
doctor.[34] If this is true, the photographer was unaware of the broader
implications of his essay. Its political context, however, was clearly
understood by some from the beginning, as can be seen from a reex-
amination of the circumstances surrounding the selection of Kremm-
ling and of Dr. Ceriani.

When, in spring 1948, *Life* editors cabled their regional offices for
suggestions for a country doctor story, Barron Beshoar, the son of a
Colorado physician, turned to the Colorado Medical Association for
advice. Undoubtedly one of the major figures giving that advice was
Dr. Arthur Sudan, a former president of the Colorado State Medical
Association and Kremmling's first doctor. Dr. Sudan served the com-

munity of Kremmling for twenty years before retiring to Denver in 1946. More significantly, he was the American Medical Association's "Family Doctor of the Year" in 1948, the same year that "Country Doctor" was photographed and published.[35] While serving as medical association president, Dr. Sudan "stumped the state" fighting for improved public health, "talking to young doctors, showing them that by putting their social consciousness to work they'll avoid socialized medicine."[36] Dr. Sudan also understood the usefulness of the media in conveying the medical association's message.

During his tenure as president, the Colorado State Medical Association responded to "the estrangement of public opinion from the medical profession" by voting a major increase in professional dues in order to finance, over a five-year period, "a public relations program."[37] This was a revolutionary idea and one that the National Council of the American Medical Association would adopt three years later.[38] Considering his sensitivity to the public perception of the medical community, it is certain that Dr. Sudan carefully considered the opportunity offered by *Life* and influenced, in whatever way he could, *Life*'s selection of a country doctor (fig. 17, nos. 4–10 show Dr. Sudan posed with Dr. Ceriani during Smith's photo-reportage).

In essence, then, the *Life* magazine photo-essay became an extension of the medical association's public relations project. In recommending Kremmling and Dr. Ceriani, Dr. Sudan was doing more than selecting a town about which he could supply a great deal of information; he was presenting a model of what the American Medical Association commission called for: a community that had raised private monies to build a small hospital and hire nurses in an effort to attract a doctor. Rather than directing attention to the training of physicians, as had *Collier's* and *Look*,[39] *Life* magazine endorsed the political position of the A.M.A.: that U.S. health care inadequacies were a matter of poor distribution rather than an inadequate supply of doctors. By choosing as an example a young doctor who had turned his back on specialized, big-city medicine, *Life* hoped to encourage a redistribution. This intention can be demonstrated by a second reading of "Country Doctor."

As you will recall, the opening and closing photographs (figs. 4, 14) represent the country doctor and his long, exhausting hours; but, if one reads the photo-essay in its broader political context one realizes that *Life* tried to make a second point. What we see contrasted in these

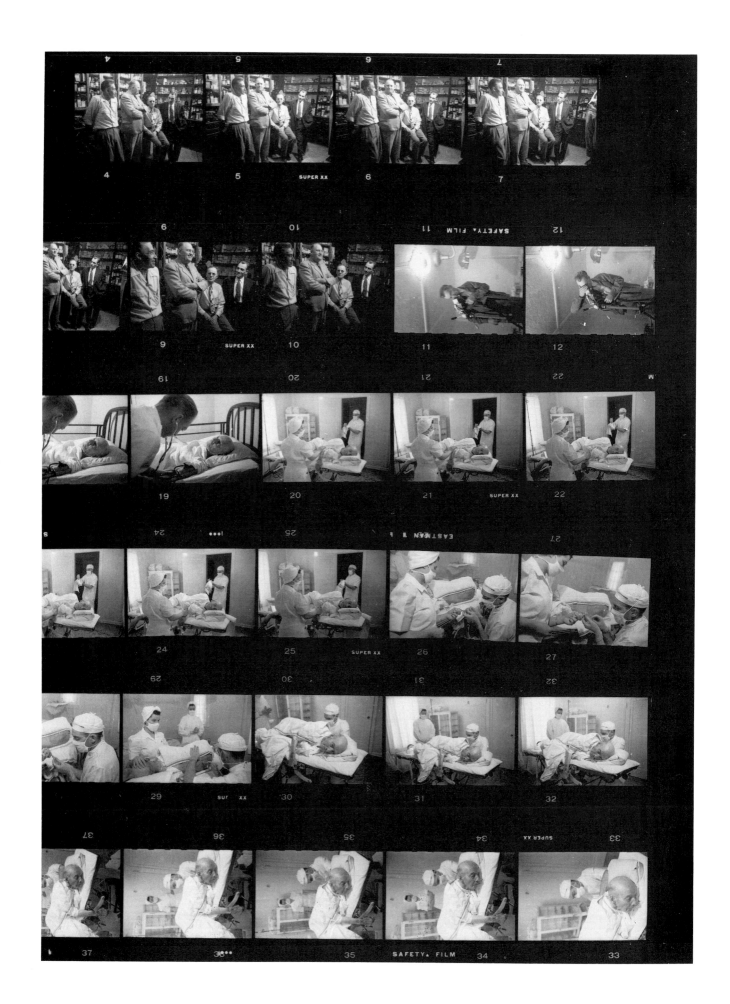

two images is the traditional vs. the modern country doctor. The introductory photograph shows Dr. Ceriani making a housecall, something that was becoming increasingly unusual by 1948. Furthermore, the iconography of the black doctor's bag, the rural location, and the dark brooding sky all suggest a traditional country medical practice. In contrast, the white surgical gown indicates the modernity of his practice – not housecalls, but hospital operations. While on the one hand appealing to the romantic mythology about country doctoring, *Life* editors updated the subject by casting him as a young, modern contemporary.

In fact, *Life* editors broke new ground in selecting a young and very contemporary doctor as the focus for their story. For example, in a *Saturday Evening Post* article of 1947, we see represented a more traditional model of the country doctor – an elderly, kind man who is experienced and wise (figs. 18–21).[40] Although Smith's photographs repeat certain motifs found in the *Saturday Evening Post* pictures, the objects represented by Smith tell us that Dr. Ceriani's medical practice is modern. With few exceptions his patients meet him at the hospital where he is assisted by two nurses and where he uses up-to-date equipment to help make his diagnoses. The captions inform the reader that the hospital, despite its rural location, contains $10,000 worth of the latest equipment.[41] Furthermore, unlike the isolated rural physician of the past, he can call upon the town's ambulance service in emergencies and can send his most serious cases to nearby Denver specialists.

*17.* OPPOSITE *Contact sheet from "Country Doctor" showing Dr. Sudan in Kremmling during Smith's photo-reportage. 1948. W. Eugene Smith, copyright the heirs of W. Eugene Smith.*

*18–21.* OVERLEAF *"Norman Rockwell Visits a Family Doctor,"* Saturday Evening Post, *CCXIX/41 (April 12, 1947), pp. 30–33. Norman Rockwell, copyright the Norman Rockwell family trust.*

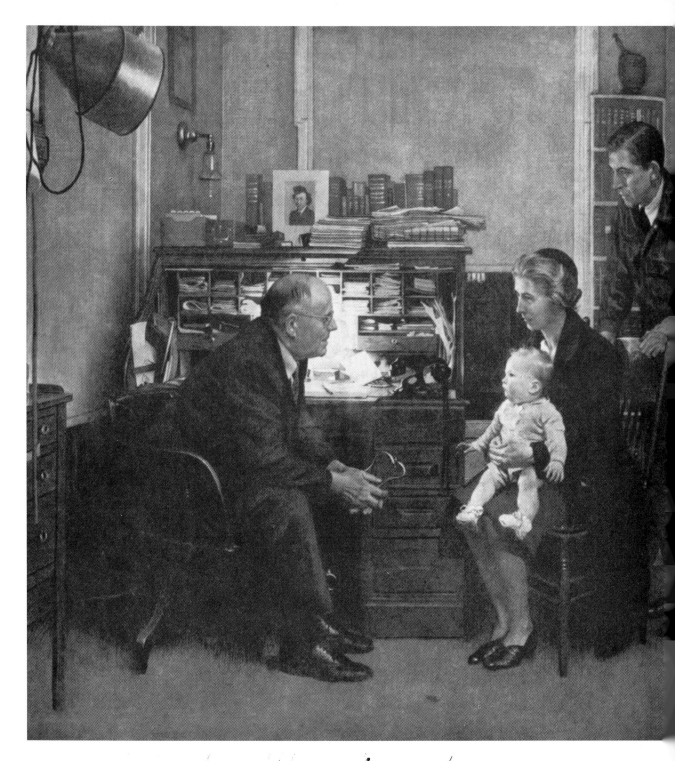

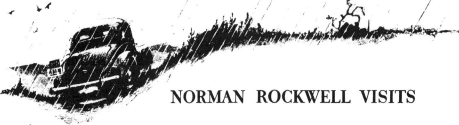

## NORMAN ROCKWELL VISITS

# A FAMILY DOCTOR

A YOUNG doctor who had opene[...] office in Northern Vermont had [...] to Poughkeepsie, New York, [...] Overnight he stopped in Arlin[...] mont, putting up in a pre-Revolutiona[...] was an old town, flourishing long bef[...] Allen's Green Mountain Boys were bor[...] American as pewter. The traveler liked[...] of the place so well that he resolved to s[...] He has become an all but indispensable[...] leading physician and a wheelhorse in to[...] His hard-used car has answered man[...] Norman Rockwell's house, for this town[...] the artist's home, and now the famous [...] a professional call on the doctor with [...] pencil. For in Rockwell's opinion, Dr. [...] Russell, M.D., personifies a whole ban[...]

30

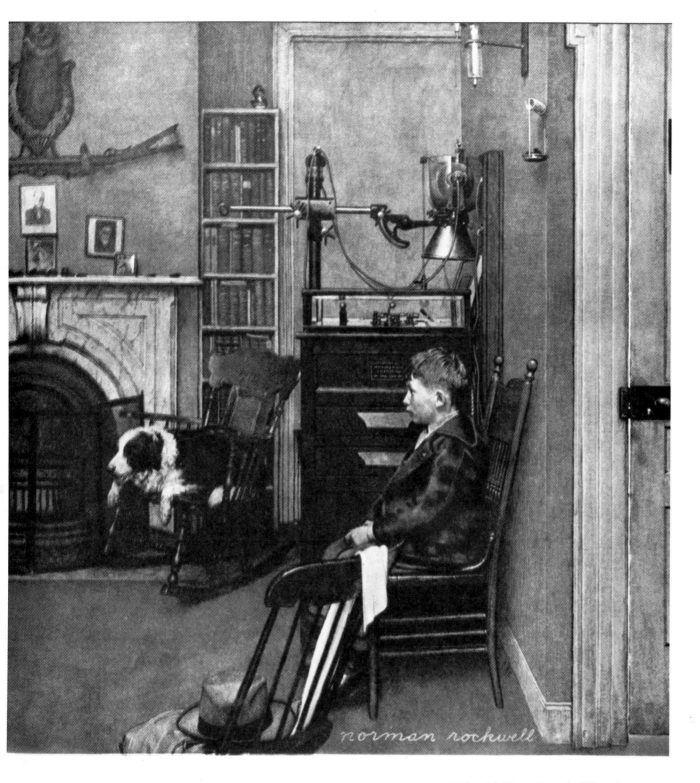

norman rockwell

men who deserve well of the republic—the
doctors.

fame is not horizontal and national, but
and local. In an age of specialists, here are
lists," expected to battle everything from
citis to zonulitis, which, along with being a
example of an ailment beginning with z,
ye trouble affecting the "zone of Zinn."
many another man to any community" was
ue the great Sir William Osler set on the
ained sensible family physician." Arlington
like this: "We couldn't do without Doctor
He's one man the town couldn't spare."
ty-three years—he spent three overseas in
War I—he has dosed, bandaged and splinted
ut the accident victims together, delivered
ies, treated the measles and mumps, and

stitched up the town's cuts. (When they were log-
ging the woods, bloody accidents were common.)
He is the school doctor, the railroad doctor, and
in his consulting room has treated almost everyone
in town and the countryside around.

On the cluttered desk stands a portrait of his
daughter, an Army nurse; near by hangs the diploma
he won from the University of Vermont, paying his
way by running a streetcar in Boston of summers;
his dog Bozo usually is around. In this room he has
heard a quarter century of troubles; doctors like this
know everything about everyone, and it is fortunate
that they are not easily scandalized and are
professionally silent.

The Yankee doctor is a kindly, tolerant man with
a reassuring manner and a good disposition. As
forthright as castor oil, he delights Rockwell by an

occasional shrewd bull's-eye diagnosis. "The only
trouble with you," he told one woman during the
cool Arlington summer, when city folks come to
visit, "is that you have too damn many guests."

Illness doesn't wait because roads are sheathed
with ice, and a doctor called to treat pneumonia
often risks getting it on the way. This is a rugged
job, especially at thirty below, and to see it faith-
fully performed would have heartened the late
Damon Runyon. "My old man," he wrote, "said
that whenever his faith in humanity commenced
to falter, he just contemplated the character and
works of the doctors he knew, and that bolstered
him up right away." We didn't ask Rockwell if a
Vermont doctor leaps into action gladly even on
behalf of a Democrat or a York Stater, but appar-
ently he feels his friend would pass even that test.

**CONTINUED ON NEXT PAGE**

School doctor. He treats all ages—from portal to portal, a wag said.

A quiet evening unbroken
by sick calls is a rarity; so
is a night's unbroken sleep.

All-night vigil—when a doctor's presence
during a crisis may be the best medicine.

The waiting room. The office is part of his
fine old colonial house on the main street.

OFFICE
HOURS
1 & 8

His prescription for relaxation: Aq. Fluv. (river water) with trout.

Hideout—a mountain camp with a trout stream and no phone.

Consultation. It may be bad news: "One more day like this and you can go back to school."

In town meeting, his opinions carry weight.

His collection of Vermont historical material fills four book-lined rooms.

In any consideration of the iconography of the photographic essay, what is not selected is as revealing as what is chosen. For example, photographs of the doctor on horseback were printed but were not used in the final layout (fig. 22); nor were photographs of him and his wife dining and dancing in a log cabin hall, although these, too, were available to *Life* editors (fig. 23). While using some nostalgic symbolism, for the most part *Life* editors chose to ignore certain rustic realities of the doctor's life.

The reason for this updating of the country doctor theme seems clear: only by getting rid of dusty, romantic clichés could the profession of the country doctor be made appealing to young doctors, many of whom, like Dr. Ceriani, were also recent armed-forces veterans. The conclusion of *Life* magazine's text makes this appeal explicit. It reads:

> Annually the nation's medical schools send a majority of their graduates into specialization. The current of need runs in the opposite direction. Two things can help turn back this current: a reformation on the part of the schools, which as a rule present specialization as a glamorous occupation and general practice as the thankless chore of a drudge, and an effort on the part of small communities to attract general practitioners by following the example of Kremmling.[42]

Seen in the light of contemporary politics, such an appeal must be acknowledged as support for organized medicine's contention that local communities could solve their own problems without government interference. A column in the Kremmling newspaper states this intention directly. Describing the presence of the *Life* magazine team of researchers and photographers, the local writer explained:

> The purpose of these pictures is to demonstrate in picture form the extent to which a small community of an area such as Middle Park can go toward developing their own local medical facilities without benefit of outside help (federal or state). . . . In addition to this main purpose, they propose to show both the advantages and disadvantages that confront a doctor who chooses such a position, particularly the relationship of the old horse and buggy days with the modern methods medicine.[43]

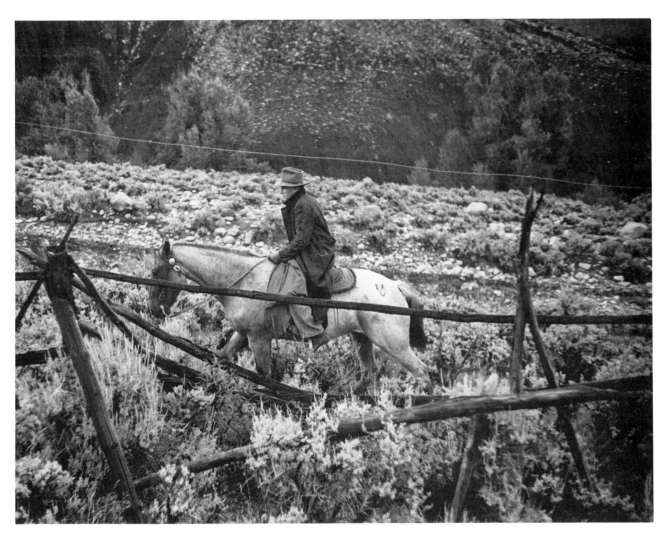

*22.  Photograph of Dr. Ceriani on horseback. 1948. W. Eugene Smith,*
*copyright the heirs of W. Eugene Smith.*

Politically, this must be understood as offering an alternative to government involvement in private medical practice and as a rejection of Truman's plan for compulsory health insurance.[44] This conservative slant, however, did not stop the newly elected Truman administration from reusing the *Life* photographs a few years later to further its ends.

## Public Reception

The excellence of "Country Doctor" was recognized immediately. Joseph Thorndike, in an office memorandum dated September 21, 1948, called it one of the best photo-essays *Life* had ever printed.[45] Eugene Smith's fellow photographers were equally impressed. Wayne Miller praised the emotional understanding conveyed by the photographs and Leonard McCombe cabled his congratulations.[46] A Time-Life memorandum dated September 21, 1948, mentioned requests from advertisers for reprints of "Country Doctor."[47] The praise was not confined to the Time-Life offices. Earlier, on September 19, Kurt Szafranski, a pioneer in the use of photography in journalism, cabled the New York office of Time-Life to offer his congratulations on the photoessay.[48] In 1951, nine of the published photographs were exhibited at the Museum of Modern Art.[49] "Country Doctor" 's success was overwhelming.[50]

The only negative comments the photo-essay received came from the participants themselves and from the Colorado State Medical Association. Dr. Ceriani felt that the photographs made his work seem too hard and one of his nurses wrote that there were complaints among the townspeople that the story had made the town "seem like a dump."[51] For its part the A.M.A. was disturbed that Dr. Sudan was not mentioned in the article. Barron Bashoar wrote congratulating Smith on "one of the best [photo-essays] ever published in LIFE," but mentioned the state medical association's complaint:

> The medical society is pleased with the story with one exception. They are on their ear at the complete omission of any reference to Dr. Sudan. . . . They have been on Ceriani's neck, I understand, and have been busy writing letters to the AMA justifying their past position on Sudan as the outstanding country doctor. They asked the AMA to issue congratulatory letters, but NOT make a blanket endorsement of the story because Sudan is not mentioned. All this was in a letter to the AMA. The society's wire to LIFE made much less of this issue.[52]

As even this criticism makes clear, while the state medical association may have been concerned about justifying the selection of Dr. Sudan as family doctor of the year, the A.M.A. understood the value of the photo-essay in addressing larger political issues. That sociopolitical

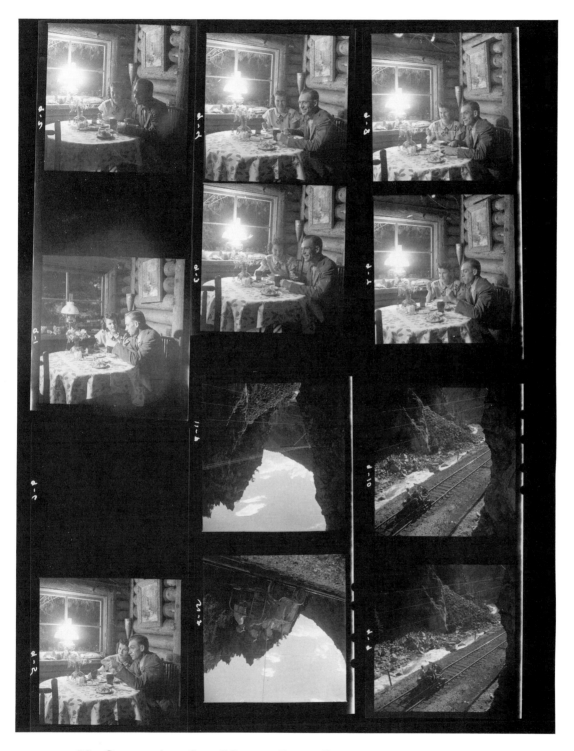

*23. Contact sheet from "Country Doctor." 1948. W. Eugene Smith,
copyright the heirs of W. Eugene Smith.*

issues were subject to editorial interpretation is made even more evident if we examine a republication of "Country Doctor."

Approximately three years after *Life*'s publication, the photo-essay was reprinted by the United States State Department in its magazine *Amerika*.[53] *Amerika* was published for distribution in the Soviet Union and was, in size and format, a duplication of *Life* magazine. The State Department characterized *Amerika* as

> designed with a "people to people" approach – to bring the United States as close as possible to Russians who could never go there – it contained many pictures, including color photographs on the cover and inside. Paper and printing typified the best American typographical standards.[54]

As a regular feature, *Amerika* presented profiles of average Americans – an Iowa farmer; a steelworker in Gary, Indiana; a woman with a white-collar job in Chicago; an Oklahoma oil worker; and, in this particular case, a country doctor in Colorado.[55] It is interesting to analyze this second publication because it shows that the same pictures can be given a different shade of meaning simply by changing the editorial presentation. This dramatically highlights the fact that the photo-essay is a communication form that is only in part determined by the photographer/artist; editorial input is at least equally important and can be used to alter the overall message.

Although the format and photographs used for *Amerika* were the same as were published in *Life*, there were significant differences between the two versions of the photo-essay. *Amerika*'s republication of "Country Doctor" used fewer photographs – thirteen instead of *Life*'s twenty-eight – and four fewer pages. Some of the more didactic photographs, about the doctor's family and the town, for example, were not reproduced, but most *Life* narratives were retained. Considering the photo-essay in general, one recognizes that *Amerika* editors followed a formula of retaining the introductory and concluding photographs for each narrative and discarding the intermediate, "point" pictures. For the most part, the photographs are sequenced similarly and the *Life* text is repeated. It should be noted, however, that there were some interesting exceptions.

In the introduction, for example, title and photograph are identical with those published by *Life*, but the caption replaces the phrase "Through weeds growing rank in an unkempt dooryard" with the in-

nocuous "Towards the end of a long day" (figs. 24–25). The lengthy text opposite the photograph is a combination of *Life*'s introductory and concluding remarks; although no new phrasing is added, it, too, omits some significant passages. It leaves out the *Life* plea for more young general practitioners and excludes two specific facts: that this is one of the few rural communities to have a hospital and that country doctors make significantly less money than big-city specialists. These changes are indicative of *Amerika*'s systematic elimination of any critical reference to life in the United States. By slightly altering the verbal framework, the reading and meaning of the pictures were modified and rendered entirely affirmative.

The *Amerika* variation of "Country Doctor" organizes the *Life* photographs on both full- and half-page spreads (figs. 26–27). Titles are reproduced within the black-bordered box that also encloses a photograph. The first full-page spread uses photographs to demonstrate the generational range of the doctor's practice, a fact explicitly mentioned by the text. We must also recognize that the photographs show a very personalized medical practice. Unlike the *Life* version, the *Amerika* edition changes picture size and layout to emphasize the doctor's housecall to the flu victim (fig. 26). The caption omits information offered by the *Life* text, namely that Dr. Ceriani "prefers to treat patients during office hours at the hospital. . . ." Excluding this information and increasing the size of this particular picture implies that housecalls are common practice for the American country doctor.

The second part of the body of the photo-essay contains two of the dramatic emergencies published by *Life:* the little girl who had been kicked by the horse and the boy who had dislocated his arm (figs. 28–29). Looking first at figure 28, one can immediately see differences from the *Life* version. The photograph in the upper left, of the mother and father, is cropped to exclude the doctor and the girl on the operating table. The photograph to the right, equally sized, shows the doctor's face over the injured girl. This juxtaposition and the altered scale add to the sense of dramatic tension and to the monumentalized presence of the doctor.

*24–31.* OVERLEAF "Derevenskij Vrac. Prijnatel 'nost' bolnyx –
nagrada za bolshoj trud" *("Country Doctor. The gratitude of patients –
the reward for his hard work"),* Amerika Illjustrirovannyi svurnal (America Illustrated),
*no. 54 (no date, ca. 1951), pp. 3–9.*

Деревянные постройки и широкие, незатененные деревьями улицы г. Кремлинга расположены на возвышенности, поднимающейся на 2.135 метров у подножья Скалистых гор (на предыдущей стр.).

# ДЕРЕВЕНСКИЙ ВРАЧ

*Признательность*

*больных — награда за большой труд*

Город Кремлинг (штат Колорадо), расположенный в 185 километрах к западу от Денвера, насчитывает тысячу жителей. В окружающем его районе, на территории примерно в 1.036 квадратных километров, занятой скотоводческими фермами, уходящими далеко в Скалистые горы, живет еще тысяча человек. Все население обслуживает один из тех врачей, которых в медицинской профессии называют врачами общей практики. Имя этого доктора — Эрнест Гюи Черпани.

Отношения, связывающие деревенского врача с его пациентами, своей теплотой и сложностью напоминают брачный союз. Между доктором Черпани и городом Кремлингом такой союз возник около трех лет назад.

Черпани родился 35 лет назад в штате Вайоминг, на скотоводческой ферме, и там усвоил язык, хорошо понятный скотоводам и ковбоям Кремлинга. Окончив в 1942 году Медицинскую школу в Чикаго, Черпани в течение года работал практикантом в больнице Св. Луки в Денвере, женился там на медицинской сестре Бернете Андерсон и был мобилизован в Военный флот США. В 1946 году, после демобилизации, он год работал в больнице Св. Луки, затем поступил ассистентом к известному хирургу. Вначале их совместная работа, шла как будто вполне успешно. Черпани следовало быть толковым и спокойным ассистентом в течение примерно пятнадцати лет, и он получил бы возможность — после ухода хирурга на пенсию — унаследовать прекрасную практику. Но уже через два месяца стало очевидно, что из их сотрудничества ничего не выйдет. Черпани часто убеждался, что он лишен возможности использовать в такой работе свои знания и способности. Его не удовлетворяла также узкая специальность хирурга. Он стал искать выхода из положения и столкнулся, — как приходится сталкиваться каждому студенту-медику или молодому врачу — с рядом неблагоприятных фактов. Он выяснил, например, что его доход, как деревенского врача, будет меньше дохода специалиста, практикующего в городе. Далее, условия жизни и работы специалиста, обычно, лучше тех, в каких живет и работает врач общей практики. Лечение дерматита или воспаление геймеровой полости можно вести амбулаторным путем, в определенные часы приема, но острые желудочные заболевания или несчастные случаи нельзя предвидеть заранее и помощь нужно оказывать безотлагательно во всякое время дня и ночи. Кроме того, врач-специалист, пользуясь инструментами, требующимися лишь в его области, часто приобретает их без особых финансовых затруднений, а большинство врачей общей практики, которым приходится делать все, должны без конца пополнять свой набор инструментов.

В то время, как доктор Черпани искал путей для преодоления возникших перед ним трудностей, город Кремлинг стремился к разрешению своих проблем. В 1946 году врач, практиковавший в Кремлинге, ушел на пенсию. Оставшийся в городе фармацевт Клиффорд Берд мог оказывать лишь первую помощь или рекомендовать лекарство против той или иной обычной болезни. Жители Кремлинга неоднократно пытались пригласить нового врача, но безуспешно. Отдаленное местоположение города, отсутствие необходимого медицинского оборудования обескураживали молодых врачей. По мере того как время шло, нужда в медицинской помощи становилась все острей и жители Кремлинга решили действовать энергичней.

В начале 1947 года был организован комитет по сбору фондов, возглавляемый кассиром городского банка. Благодаря пожертвованиям и аукционам, на которых верховая лошадь покупалась за 265 долларов (1.060 руб.), а самодельные коробки для завтраков за 45 долларов (180 руб.), было собрано 35.000 долларов (140.000 руб.). На эти деньги комитет купил дом старого врача, переоборудовал его в больницу на четырнадцать коек и снабдил медицинскими приборами, насколько позволяли средства. Были приглашены две медицинских сестры, которые в свободное от обязанностей время, убирали помещение и красили деревянные части дома. Таким образом г. Кремлинг приготовил своего рода «медицинское приданое» и стал ждать. Ждать пришлось не долго. С запада, из Денвера, через перевал Бертуд, поднимающийся на 3.355 метров, приехал, вместе с семьей, доктор Черпани.

Союз доктора Черпани и г. Кремлинга оказался взаимно выгодным, так как благодаря ему разрешаются почти все проблемы, возникающие перед городом, с одной стороны, и перед врачом — с другой. Время от времени Черпани жалуется, что ему нужен ассистент; в одном случае из ста он находит, что его знания недостаточны и направляет пациента к специалисту в Денвер. Даже когда у доктора Черпани выдается свободный час, он не умеет его использовать: то он беспокоится о каком-нибудь пациенте, то спешит просмотреть получаемые больницей медицинские журналы. Хотя доктор еще сравнительно молодой человек, он уже слегка согнулся; во время обхода, когда он торопится от одного больного к другому, он идет немного наклонясь вперед, как будто против сильного ветра. Но Черпани чувствует себя вознагражденным признательностью своих пациентов и соседей, тем положением, которое он занимает в городе, и сознанием, что он сам себе начальство. Этого для него достаточно.

3

Большинству врачей общей практики приходится делать все — от операций до лабораторных анализов.

Рабочий день доктора Черани начинается обычно около вось часов утра и нередко продолжается до поздней ночи. Ему прих дится совмещать обязанности терапевта, хирурга, акушер педиатра, вентилятора, дантиста, окулиста и лаборанта. Как многие другие деревенские врачи, Черани имеет очень мало св бодных дней. У доктора лечатся люди всех возрастов. Многие них живут в восьмидесяти километрах от города. Выносливы пациенты доктора Черани нередко приходят в больницу всяк с такими повреждениями, какие городского жителя заставили б вызвать скорую помощь. В городке, где практикует Черан насчитывается, приблизительно, 150 построек, включая бол ницу, которая находится на расстоянии одного квартала от е дома. Это белое деревянное строение вмещает три отдельны палаты на четырнадцать коек. В больнице имеется рентгенов ский кабинет и кислородная палатка. Отправляясь навеща больных на отдаленные ранчо в плохую погоду, доктор обыкн венно берет с собой цепи для колес автомобиля, теплое одеял топор и банку консервированных бобов.

*Доктор навещает больного гриппом типографа.*

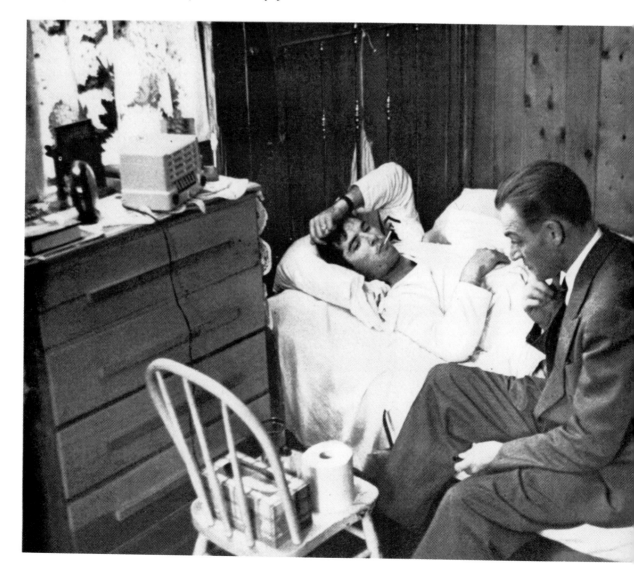

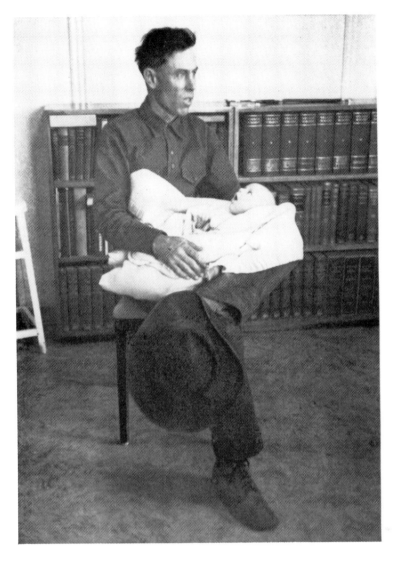

*Первым на прием пришел проводник с ребенком.*

*Доктор Чернаи промывает уши больному старику.*

*Плачущая мать и отец пострадавшей девочки.*

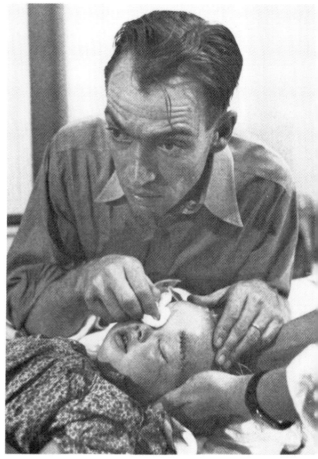

*Доктор знает, что глаз ребенка не удастся спасти.*

**Несчастный случай прерывает рыболовную экскурсию врача.**

Минуты отдыха доктора Чериани редки и коротки. Однажды, надеясь, что в течение ближайших трех часов его никто не потребует, он попросил двух своих знакомых железнодорожников отвезти его в Гор-Каньон. Там, в полном уединении, он мастерски забрасывал удочку в пенящиеся воды порогов реки Колорадо. Вдруг он увидел, что машина возвращается значительно раньше назначенного срока и машинально начал сматывать удочку. Быстрый конец рыболовной экскурсии не вызвал у доктора Чериани чувства недовольства. Он спокойно ждал, когда подъедет машина, раздумывая, что могло произойти, и надеялся, что ничего серьезного не случилось. Из подъехавшей машины выскочил начальник городской полиции Чанси Ван Пелт.

«На ранчо Уитли лошадь разбила голову маленькой девочке. Можете вы ехать сейчас же?» — спросил Пелт.

Двухлетняя Ли Мери Уитли была уже в больнице, когда Чериани приехал. Родители ребенка наблюдали, как он осматривал голову девочки, чтобы выяснить, нет ли признаков повреждения черепа, зашил огромную рассеченную рану на лбу и, увидев, что левое глазное яблоко впало, порекомендовал родителям отвезти ребенка к специалисту в Денвер посоветоваться относительно удаления глаза. Когда они уехали, доктор почувствовал сильное изнурение и усталость. Он совсем забыл о том, что удил рыбу и вспомнил об этом лишь тогда, когда вышел из операционной и увидел удочку и корзину для рыбы, брошенные им в угол.

Доктор вправляет

тяжелый вывих.

Молодой Роберт Уиггс вывихнул локоть левой руки. Он участвовал в конных состязаниях «родео» в ближайшем поселке и хотел проехаться на необъезженной лошади. Когда товарищи принесли его в больницу, он испытывал страшную боль, громко ругался и требовал:

«Не говорите ничего моей матери».

Доктор Черниани взглянул через стол. По другую сторону стояла мать Уиггса. Ей сообщили о случившемся, она бросилась в больницу и пришла как раз тогда, когда нужно было подержать руку сына во время операции. Доктор Черниани улыбнулся и попытался внушить ей две мысли: во-первых, ее сын будет вполне здоров, во-вторых, он сам, доктор Черниани, недавно хотел проехаться на необъезженной лошади и не думает, чтобы это было так уж страшно.

-р Черниани накладывает гипсовую повязку на руку юноши.

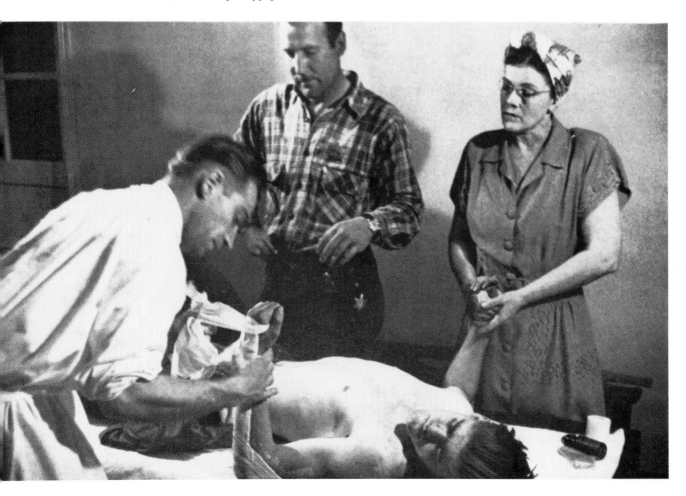

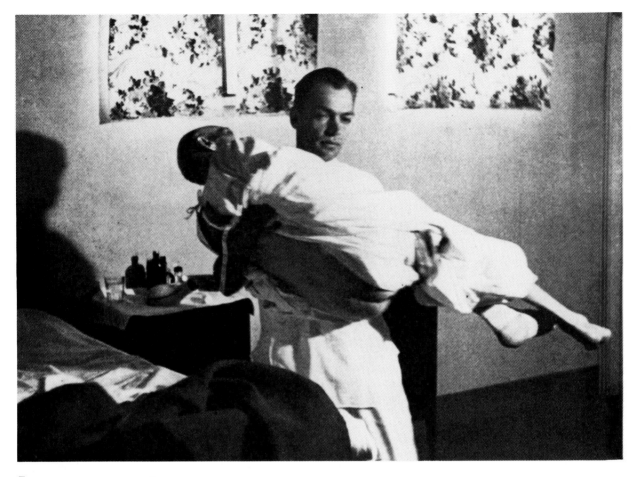

*Доктор сам переносит больного в операционную.*

Доктор

ампутирует

гангренозную ногу.

У старого Томаса Митчелла началась гангрена левой ноги. Ему было восемьдесят пять лет. Три месяца назад его привезли в больницу и казалось, что он проживет недолго. Но он выжил, и когда доктор Чериани приходил осматривать его, Митчелл неизменно говорил:

«Я хочу видеть мэра. Когда он придет?» — как будто благодаря посещению мэра все могло устроиться.

Долгое время Чериани откладывал неизбежную операцию, так как боялся, что старик не перенесет ее. Дважды он говорил сестре:

«Завтра я его оперирую».

Но когда приходило завтра, у Митчелла наблюдался еще больший упадок сил. Наконец он почувствовал себя лучше, и доктор Чериани в срочном порядке сделал все нужные приготовления. С большими предосторожностями он перенес больного в операционную, ввел в спинной мозг анестезирующий препарат и отнял ногу ниже колена. Старик был в полном сознании, но экран мешал видеть ему происходящее и лишь много времени спустя он узнал, что у него нет одной ноги. После операции Митчелл снова пожаловался: «У меня болит нога», доктор Чериани, занятый уже другими больными, вздохнул с облегчением. Через неделю старик чувствовал себя значительно лучше и с еще большей настойчивостью выражал желание увидеть мэра.

*После операции усталый доктор подкрепляется кофе и папиросой*

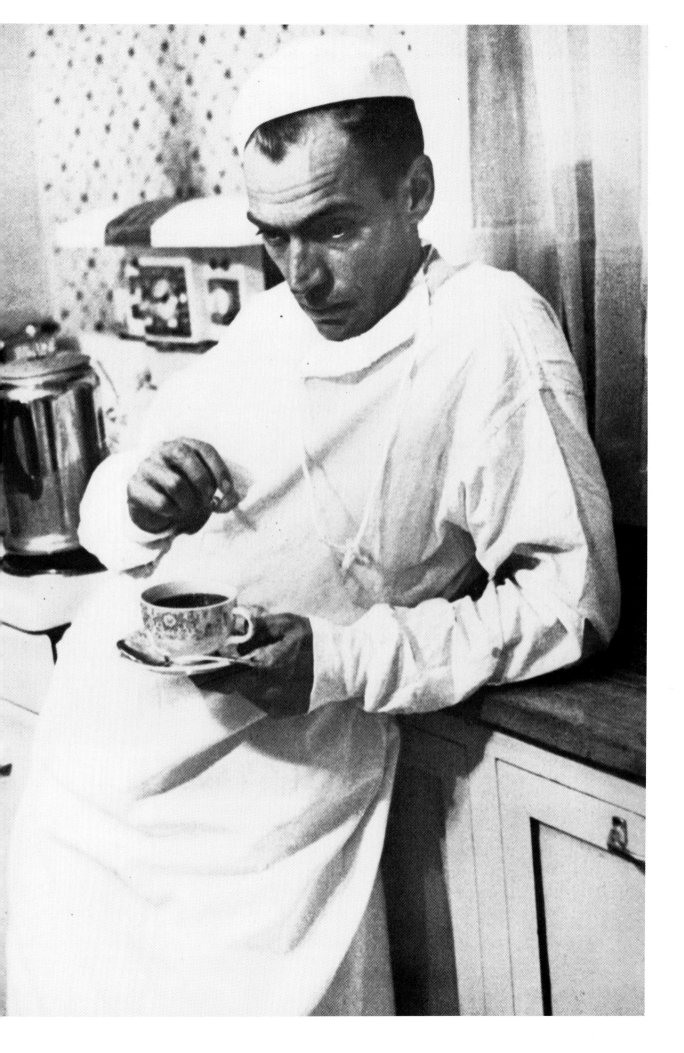

In figure 29, the pictorial narrative is read from top to bottom: the top photograph shows the doctor helping to carry the stretcher while the larger photograph shows him attending to the boy's injury. The text for the narrative, however, significantly changes the facts of the patient's situation. In the *Life* version it is strongly implied that "a few beers" impaired the boy's judgment when he decided to ride a wild horse — the dislocated arm was a result of this foolhardy act. In the *Amerika* publication, the text omits any reference to drinking; it simply says that the boy was participating in a rodeo when he fell and dislocated his arm.

The concluding sequence of the *Amerika* photo-essay shows the doctor carrying a patient to the operating room and resting after an operation (figs. 30–31). The accompanying text duplicates that in *Life*, giving the reasons for the operation. The caption for the photograph in the upper left of figure 30, however, again excludes information, in this case, the fact that the doctor is carrying the patient because the hospital has no elevator. In addition to being another example of the elimination of negative details, this omission has the positive effect of establishing the doctor as hard-working and proletarian. He does not wait for others to do the physical labor but assists in carrying the stretcher (fig. 29) and carries the patient himself to the hospital operating room (fig. 30). The concluding photograph (fig. 31) is the same as in the *Life* photo-essay, but here it is reversed, establishing a relationship with the photographs on the left, and it is more closely cropped, emphasizing the doctor's labor and exhaustion.

In summary it must be recognized that the photographic essay, because of its narrative structure and its formation through a confluence of different individual contributions, raises the possibility of multiple interpretations. The artist/photographer provides the raw material and, to some extent, the aesthetic and narrative elements. Editors select, sequence, and lay out the photographs within a political and ideological framework. In "Country Doctor," for example, one can see the complexity of this process in the two readings of the photo-essay. From a narrative and aesthetic viewpoint the photo-essay is a document of both the doctor's special calling as a healer and the special needs of rural America. On the political and ideological level, the photo-essay's call for the relocation of existing doctors to rural communities must be understood as a challenge to the Truman administration's plan for national health insurance.

Both *Life* and *Amerika* editors sought seamless image and text combinations that could be quickly absorbed by the public without conscious awareness of the loaded meanings inherent in the photo-essay. In this particular essay W. Eugene Smith's intentions to monumentalize and deify the doctor were supported by editorial intentions. Such harmony became increasingly rare as Smith's understanding of the nuances of the photographic essay evolved and as he became increasingly concerned with the sociopolitical effect of this reportage. As Smith photographed his stories in greater and more subtle depth, alteration of his photo-reportage and, by extension, his authorial voice, frustrated his artistic expression and his moral commitment to his story. This sociopolitical clash was particularly acute over the publication of "Spanish Village."

# CHAPTER 3

# "SPANISH VILLAGE"

OVERLEAF

*32–41. "Spanish Village: It Lives in Ancient Poverty and Faith,"* Life, *XXX/
15 (April 9, 1951), pp. 120–129. W. Eugene Smith,* Life *magazine, copyright
1949, Time Warner, Inc.*

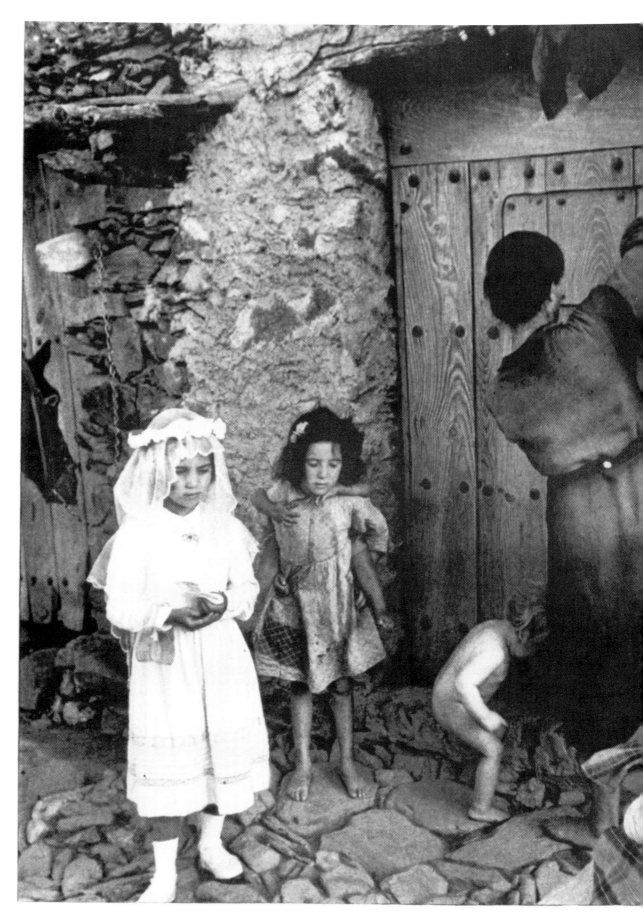

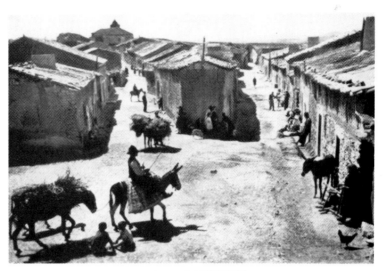

ON THE OUTSKIRTS
At midmorning the sun beats down on clustered stone
houses. In the distance is belfry of Deleitosa's church.

# Spanish Village

## LIVES IN ANCIENT POVERTY AND FAITH

The village of Deleitosa, a place of about 2,300 peasant people, sits on the high, dry, western Spanish tableland called Estremadura, about halfway between Madrid and the border of Portugal. Its name means "delightful," which it no longer is, and its origins are obscure, though they may go back a thousand years to Spain's Moorish period. In any event it is very old and LIFE Photographer Eugene Smith, wandering off the main road into the village, found that its ways had advanced little since medieval times.

Many Deleitosans have never seen a railroad because the nearest one is 25 miles away. The Madrid-Sevilla highway passes Deleitosa seven miles to the north, so almost the only automobiles it sees are a dilapidated sedan and an old station wagon, for hire at prices few villagers can afford. Mail comes in by burro. The nearest telephone is 12½ miles away in another town. Deleitosa's water system still consists of the sort of aqueducts and open wells from which villagers have drawn their water for centuries. Except for the local doctor's portable tin bathtub there is no trace of any modern sanitation, and the streets smell strongly of the villagers' donkeys and pigs.

There are a few signs of the encroachment of the 20th Century in Deleitosa. In the city hall, which is run by political subordinates of the provincial governor, one typewriter clatters. A handful of villagers, including the mayor, own their own small radio sets. About half of the 800 homes of the village are dimly lighted after dark by weak electric-light bulbs which dangle from ancient ceilings. And a small movie theater, which shows some American films, sits among the sprinkling of little shops near the main square. But the village scene is dominated now as always by the high, brown structure of the 16th Century church, the center of society in Catholic Deleitosa. And the lives of the villagers are dominated as always by the bare and brutal problems of subsistence. For Deleitosa, barren of history, unfavored by nature, reduced by wars, lives in poverty—a poverty shared by nearly all and relieved only by the seasonal work of the soil, and the faith that sustains most Deleitosans from the hour of First Communion (*opposite page*) until the simple funeral (*pp. 128, 129*) that marks one's end.

PHOTOGRAPHED FOR LIFE BY W. EUGENE SMITH

FIRST COMMUNION DRESS
za Curiel, 7, is a sight for her young neighbors as
its for her mother to lock door, take her to church

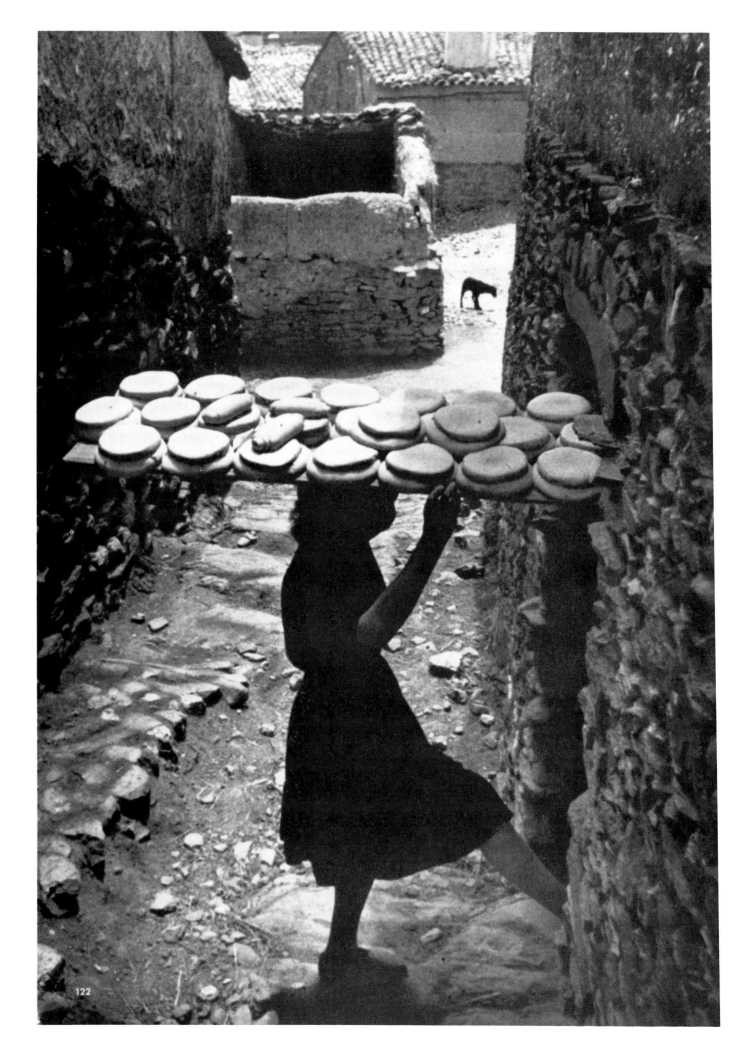

"EL MEDICO"

Dr. José Martin makes rounds with lantern to light patients' homes. He does minor surgery, sending serious cases to city of Cáceres, and treats much typhus.

SMALL BOY'S WORK

The youngest son in the Curiel family, 5-year-old Lutero, sweeps up manure from the street outside his home. It is carefully hoarded as fertilizer, will be used on the eight small fields the family owns or rents a few miles out of town.

"SENOR CURA"

Out on a walk, the village priest, Don Manuel, 69, passes barred window and curtained door of a home. He has seldom meddled in politics—the village was bloodily split during the civil war—but sticks to ministry. Villagers like that.

◄—YOUNG WOMAN'S WORK

Lutero Curiel's big sister Bernardina, 18, kicks open door of community oven, which the village provides for public use. At least once a week she bakes 24 loaves for the family of eight. The flour comes from family grain, ground locally.

## Spanish Village CONTINUED

### DIVIDING THE GROUND

At harvesttime many of the villagers bring unthreshed wheat from their outlying fields to a large public field next to town. Here they stake out 5-by-12-yard plots where they spread the full stalks, thresh grain as forefathers did.

### HAGGLING OVER LOTS

Sometimes luck gives one family stony ground for threshing, another smooth. This brings arguments since the smooth ground makes for easier threshing—a process begun by driving burros over stalks with a drag that loosens kernels.

## SEEDING TIME

Beans planted, the villager presses hard on his flattened plow as it scrapes the dry soil back into furrows. A neighbor woman leads donkeys, one borrowed.

## WINNOWING GRAIN

With the straw already broken away, wheat kernels are swept into a pile and one of the women threshers tosses them up so the breeze can carry off the chaff.

**CONTINUED ON NEXT PAGE**

## GUARDIA CIVIL

These stern men, enforcers of national law, are Franco's rural police. They patrol countryside, are feared by people in villages, which also have local police.

## VILLAGE SCHOOL

Girls are taught in separate classes from the boys. Four rooms and four lay teachers handle all pupils, as many as 300 in winter, between the ages of 6 and 14.

◄   FAMILY DINNER

The Curiels eat thick bean and potato soup from common pot on dirt floor of their kitchen. The father, mother and four children all share the one bedroom.

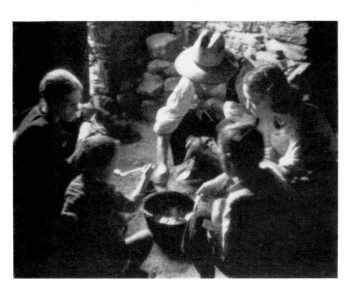

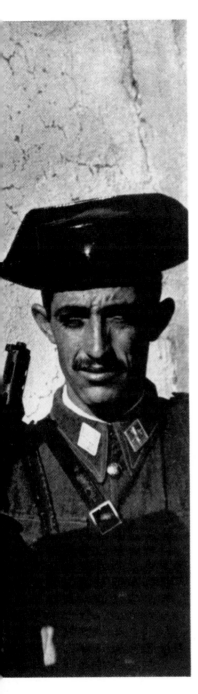

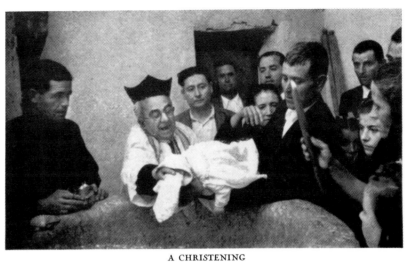

**A CHRISTENING**

While his godfather holds him over a font, the priest Don Manuel dries the head
of month-old Buenaventura Jimenez Morena after his baptism at village church.

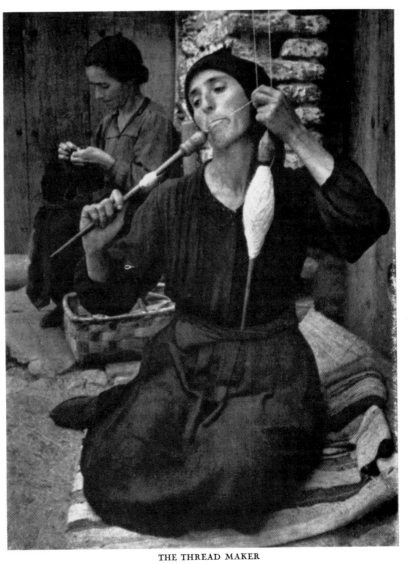

**THE THREAD MAKER**

A peasant woman moistens the fibers of locally grown flax as she joins them in a
long strand which is spun tight by the spindle (*right*), then wrapped around it.

CONTINUED ON NEXT PAGE

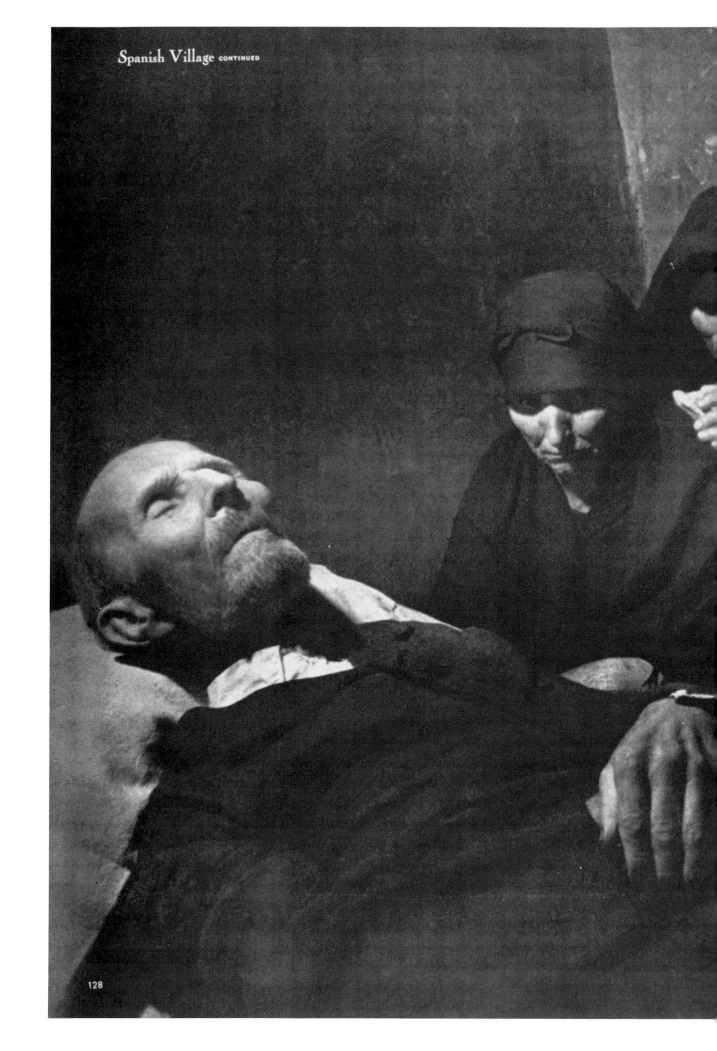

HIS WIFE, DAUGHTER, GRANDDAUGHTER AND FRIENDS
HAVE THEIR LAST EARTHLY VISIT WITH A VILLAGER

## Concept and Publication

In late 1949, W. Eugene Smith was sent to Europe by *Life* magazine. Smith's assignment had three objectives: to examine the state of British industry, to cover the parliamentary elections, and to photograph a story on Spain.[1] Why Smith was selected for this story is not altogether clear, but it seems most likely that he requested the overseas assignment and *Life* editors concurred. This is plausible for personal as well as professional reasons. In a letter to his mother he wrote:

> I have a guilty conscience, but I also know that my nervous turmoil at present would do more harm than good. As for Pearson, I am deeply in love with her, . . . yet for right over emotions and need, I deliberately tried to smash that beyond all repair in December, ended up by almost smashing myself, deliberately engineered this European trip in trying to hold on and come back, and intend to stay until I have it under control and that I can do what I feel is right for four people against two.[2]

Smith was alluding to an affair with the young woman whom he had featured in his *Life* photo-essay "Hard Times On Broadway."[3] The European assignment gave him an opportunity to remove himself from this personal entanglement. The opportunity to do photographic reportage in Spain, a country that had fascinated him since his youth, was also an important inducement.[4]

Smith arrived in England on January 3, 1950; his assistant, Ted Castle, arrived a day later. They began their assignment in Wales in mid-January, making photographs of the lives and work of coal miners. This first assignment had little personal significance or news value; it was selected because Henry Luce believed that Britain's economic woes and political turmoil could be solved by improving the efficiency of its industrial operations.[5] He wanted to use *Life* magazine to articulate this belief. Smith was not the first photographer to undertake this assignment; during the postwar years a series of *Life* photographers tried to convey Luce's ideas in photographs.

Smith's interpretation of the assignment contrasted the old and the new. In figure 42, for example, we see a horse-drawn cart in the foreground, obstructing an automobile and railroad tracks. Smith repeated

this motif later when he selected a spot and hired a herd of cows, a truck, and a driver. He then organized these elements to show the herd of cows in the foreground, blocking the truck's way (fig. 43).[6] In both of these arranged compositions, Smith created a pictorial representation of Luce's belief that an inefficient nineteenth-century society was impeding the progress of modern industrialization.

Luce's concerns had directed Smith to the "backwardness" of British industry, but Smith took his photo-reportage beyond the illustration of this simple idea. His contact sheets reveal that during his assignment, he took pictures of the homes and documented the lives of the people in the industrialized slums adjacent to the huge factory complexes (fig. 44). The humble living conditions of the industrial poor must have been shocking to a man who had just left the prosperity and the consumer culture of postwar America. This interest in economic poverty was a theme to which Smith would return.

In February, Eugene Smith photographed Clement Attlee and the Labour Party campaign in Birmingham, Glasgow, Edinburgh, and London (fig. 45). Smith sent the negatives directly to Time-Life where editors selected photographs from his contact sheets and published them as part of *Life*'s lead news story on February 20, 1950.[7] Although the story focused attention on the upcoming British elections, Smith's photographs of the Welsh mining towns were also included in *Life*'s coverage. A follow-up article appeared two weeks later and featured as its lead photograph Smith's picture of a gloomy Clement Attlee watching the returns of the election, which Labour narrowly won.[8] After the election Smith left Ted Castle, his assistant, in England and went to Paris.

*Life*'s Paris bureau played an important role in Smith's story on Spain. The bureau compiled articles and newspaper clippings and secured permission for Smith to enter the country and photograph it. He received this permission in part because the *Life* bureau chief, William Lang, told the Spanish embassy that the magazine wanted to do a story on the food shortage in Spain. The Spanish government allowed the story because they hoped that it would help sway public opinion in favor of a wheat agreement with the United States.[9] Lang also did some specific research, suggesting names of towns and villages for Smith to visit.[10] While in Paris, Smith renewed acquaintances with old friends, began his research on Spain, and took at least one trip to photograph

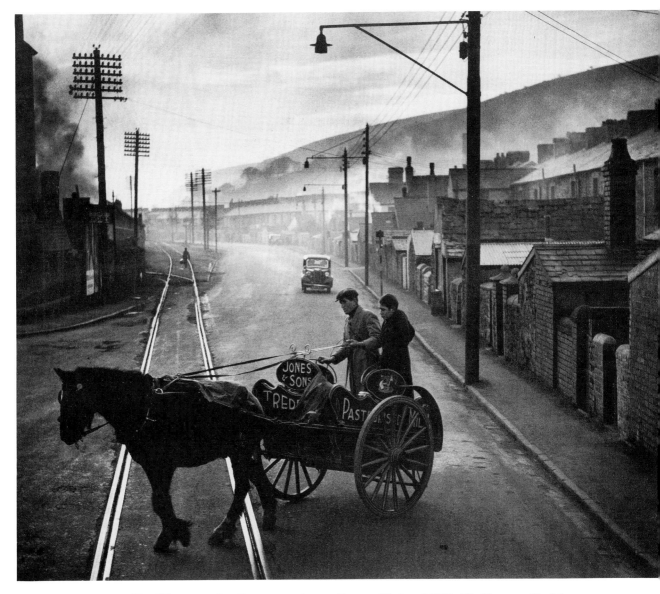

*42. Photograph of cart crossing railway, Wales. 1950. W. Eugene Smith,*
*copyright the heirs of W. Eugene Smith.*

*43.* OPPOSITE *Photograph of cement truck and herd of cows, Wales.*
*1950. W. Eugene Smith,*
*copyright the heirs of W. Eugene Smith.*

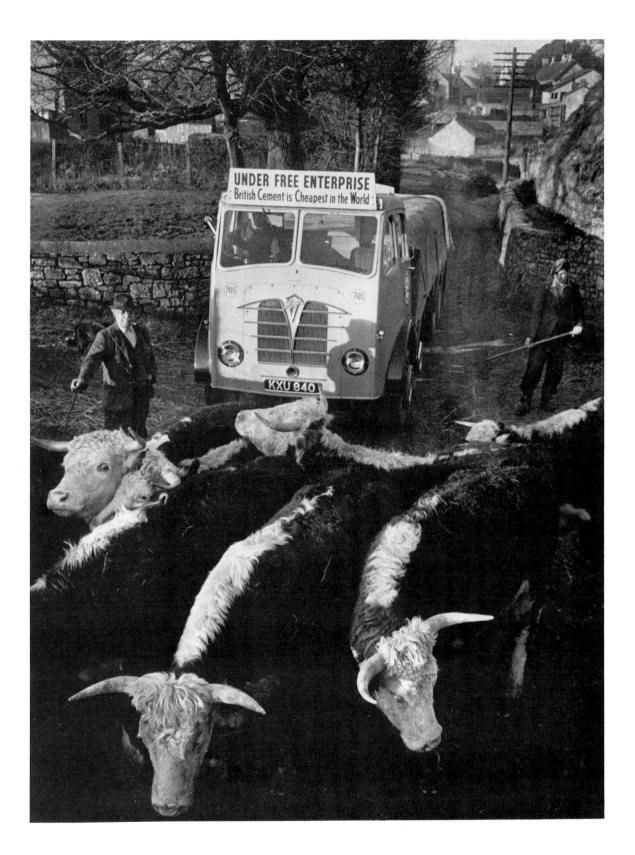

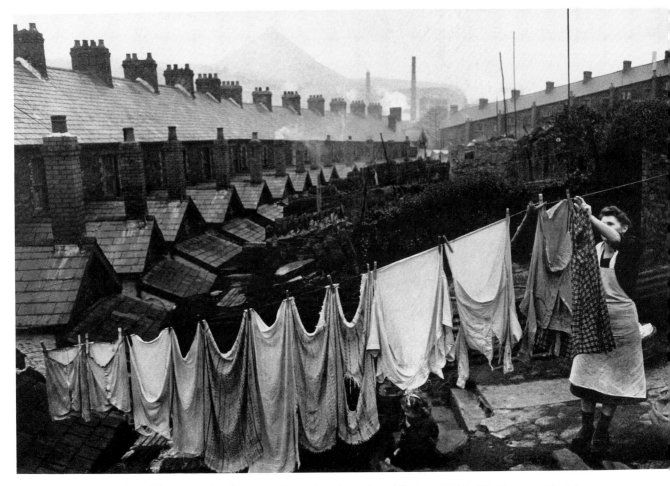

44.  *Photograph of woman hanging laundry, Wales. 1950. W. Eugene Smith,*
*copyright the heirs of W. Eugene Smith.*

45. OPPOSITE *Photograph of British political campaign speech. 1950. W. Eugene Smith,*
*copyright the heirs of W. Eugene Smith.*

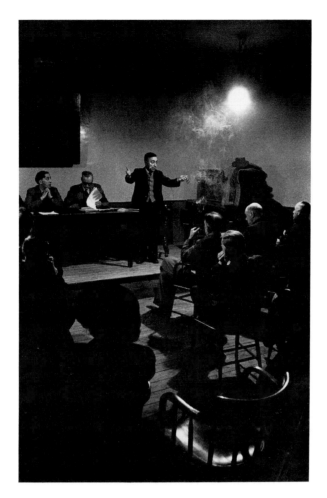

the French countryside. This small body of work, approximately 300 negatives, concentrated upon the portrayal of the French peasantry. Smith returned to London on March 18, but four days later flew back to Paris. Toward the end of March he became ill and was hospitalized. He left the hospital on April 14 and began, again, to read through the *Life* research and to make preparations for his trip to Spain.

The exact contents of *Life*'s research file are not known, but judging from what was retained by Smith, much of the research was unfavorable to Spanish dictator Francisco Franco. For example, four articles from the Paris edition of the *New York Herald Tribune* introduced the possibility of U.S. aid to Spain, and drew the reader's attention to the moral dilemma faced by the United States: Spain was a fascist state which had leaned toward America's enemies during World War II, but its geographical position was thought to be of military importance.[11]

Another of the articles in the *Herald Tribune* series was titled "20,000 Protestants in Spain Treated as 2nd Class Citizens." The appropriation of the Catholic Church by the Spanish government was underscored by another research document, a typescript of a Catholic catechism which clearly showed the infusion of political ideology.[12] This research, however, was not a formative influence on Smith's story; it reinforced the bias Smith had before he left. From his two-room flat in London he had written to his mother:

> At the moment life is almost worth living for I have an assignment to go into Spain and to try to show what living is like under the heel and the police of a dictator. It is an impossible story to do, but one that challenges me like no story has in a very long time. I must give it everything, and a little bit more.[13]

Although *Life* provided research and suggestions of areas to photograph, Smith enjoyed a good deal of independence from the magazine.[14] For example, he felt confident enough to ignore *Life*'s suggestion that he curry official favor by waiting to hire a translator until he was in Spain. Instead, he hired a young girl in Paris named Nina Peinado, the daughter of an expatriate Spaniard.

Smith returned to London on April 29, 1950, at which time he rejoined his assistant and began the journey to Spain. On May 2, Time-Life arranged for a letter of introduction from the Spanish consulate, intended to facilitate the transfer of Smith's camera equipment across the border into Spain. Soon after receiving visas and the letter of transit, Eugene Smith, Ted Castle, and Nine Peinado left Paris, and on May 5, 1950, they crossed the border into Spain.

Smith had formed the idea behind his photo-reportage before he entered Spain. In early May, he wrote a letter to his mother about his project:

> Five years ago today I was speaking from my camera soapbox when a heckling shell exploded into my body and temporarily muffled but did not silence me. This afternoon, at the anniversary minute of a quarter of four, I was crouched in horse dung on a street in Spain trying to translate my indictment of the Guardia Civil (and powers above) into photographic image.
>
> So I am working. My story is the struggle for food, with political overtones. . . .[15]

Smith was correct in his understanding of the story as a political one. Any story about Spain's shortage of wheat had an important political dimension. During the time Smith was photographing Spain, the U.S. Congress was debating the first foreign aid bill to include funds for Franco's dictatorship. Smith's understanding of the Spanish wheat shortage was also political; for Smith it was the direct result of fifteen years of fascist rule.

Smith's first impressions of Spain were of poverty. He wrote in a small pocket notebook:

> Stop for food at Devor? (*sic*) lettuce, steak, tender, on wall to right behind Ted [Ted Castle, Smith's driver and assistant] was picture, mirror to left gave me view of window behind back, three silent, children and staring, outstretched palms, stuck the third bite in our throat, sickened our stomachs. The hungry were polite, the oldest split with her younger sister and brother. . . .[16]

Smith's lengthy notes about seeing Spain for the first time are full of the contrast between the beauty of the countryside and the poverty of the people. At times his observations were eloquent.

The second day, as they headed south toward Barcelona, Smith wrote of his first encounter with a small Spanish village. It is useful to quote at length one of these observations because it demonstrates the depth of Smith's emotional commitment to his story and the degree to which it affected his reportage.

> Monday morning toward Barcel[ona] into wild rugged country, poor, off highway in search for village — into village hanging on side of mountains, farmed bits amid rocks, festival day, pray for rain — priests murmuring, outside church poor, civil guard, Franco flag, then altar boys, incense, priests, banners and Civil [Guardia Civil], with procession to front & in church. Suspicious Civil but we wide eyed smiling tourists — told Nina [Nina Peinado, Smith's translator] to look happier — told typical — not everyone in village, lined up behind barricade & funnelled past basket bread — donation plate, flower basket in order — we told to do same— everyone must get bread. Noticed girl about 14 one leg, crutch, intense, sensitive face trying to edge into mob to go through for bread — kept watching seemed afraid — but trying to edge closer no one was polite or paid her heed, finally just a few people, plenty of bread, she edged within close reach, stretched out hand, ignored bread passed to

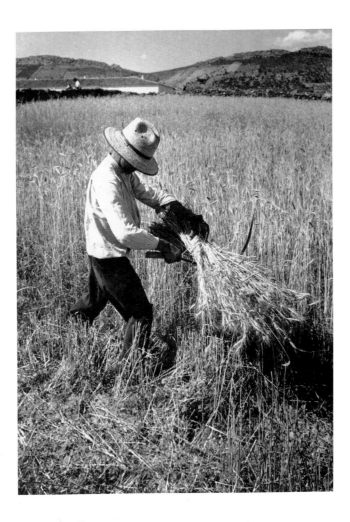

hands behind her, her hands, twitched in their pleading, and her
face furrowed in the hurt and the dark eyes darkened more in [?]
each rebuff of bread passed behind – now all were served and she
pushed squarely in front and eyes, face, hand, begged – please
now me, they shook their heads and raised their hand as if to strike
and motioned to go away, stricken she lurched away and threw her
shoulders as if to shake it off everyone in the village must receive
bread. Trying to throw a punch with camera but could not make it
strong. Civil watched and moved into conference and I decided
for now and sake of stronger more complete work of later I would
refrain.[17]

We can see from this notebook entry that Smith intended a carefully
thought-out reportage. He did not want to settle for a single incident;
he was willing to wait for "stronger more complete work."

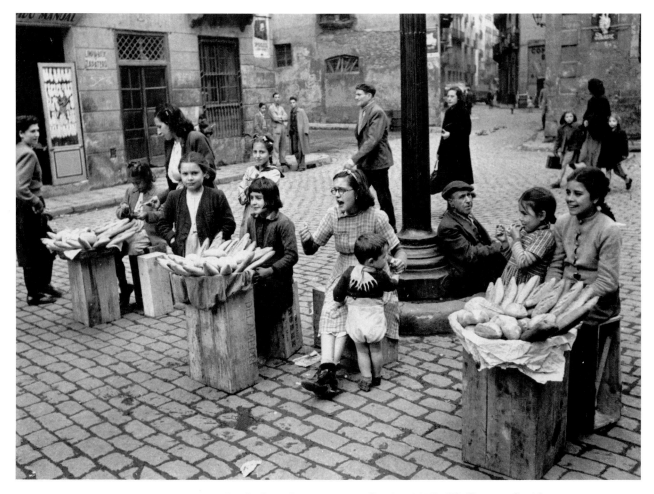

46. OPPOSITE *Photograph of wheat harvesting in Spain. 1950. W. Eugene Smith,*
*copyright the heirs of W. Eugene Smith.*

47. ABOVE *Photograph of children selling bread in Barcelona. 1950. W. Eugene Smith,*
*copyright the heirs of W. Eugene Smith.*

Smith was encyclopedic in his photographic reportage. He traveled through Spain for two months, drove over 7,000 miles, and made over 2,500 negatives, using both 2¼ and 35 mm formats. Keeping within his editorial instructions, the majority of Smith's photographs were of food and food production. He photographed the process of wheat and bread production – plowing and planting, irrigating and harvesting, grinding and baking, and finally selling the product in open-air markets (figs. 46 and 47). In large cities he concentrated on the life-style evident in the streets; in the countryside he photographed herding and harvesting. He directed his attention to religious processions; people, especially children, dominate his photographic reportage. This fact reminds us that for Smith this was not a story about the beauty of the countryside but a story about the Spanish people.

Smith's political and social concerns are also evident in these photographs. Although he seldom treated the Guardia Civil as a central subject, members of the national police force can be found throughout Smith's contact sheets (fig. 48, nos. 3–12 and 29–37). In both city and country, Smith depicted political monuments and wall slogans (figs. 49 and 50). In figure 49, for example, we see political propaganda as graffiti stenciled on a church wall. In figure 50, Smith juxtaposes a monument celebrating the victory of Franco with two veiled women, dressed in black and walking up a rocky path away from the monument. The picture suggests the social cost of the Spanish Civil War in the persons of widows who must scrape together a living from the barren earth on which they walk.

Smith photographed the extremes of Spanish society. To represent the wealthy class of Spain he selected a mother, her four children, and their three nursemaids (fig. 51). The photographer, however, remains apart from the group, content to record the scene from a distance. In contrast, to represent the poor, Smith chose a single beggar girl. For these photographs he intervened, asking his translator to talk with the little girl while he made his pictures (fig. 52). These are obviously more compassionate. In one heavily cropped photograph the girl is isolated in the lower left corner of the image; her gesture, lonely and pathetic, makes an emotional appeal directly to the viewer (fig. 53).

Despite his extensive documentation of Spain, Smith remained dissatisfied with his efforts until he discovered a small town in the eastern part of the country. Biographies of Smith say that he discovered the

48. *Contact sheet from "Spanish Village." 1950. W. Eugene Smith,
copyright the heirs of W. Eugene Smith.*

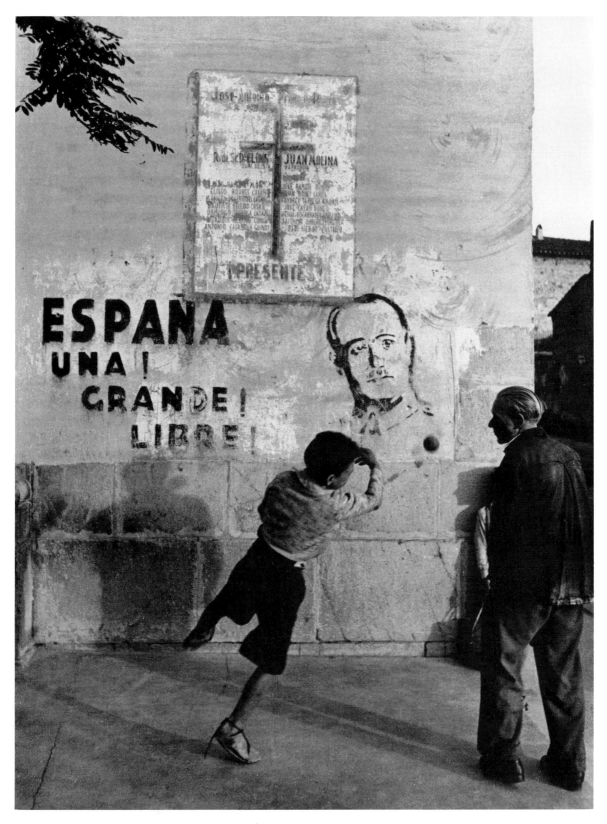

49. *Photograph of Spanish children playing handball against a wall marked
with Falangist slogans. 1950.
W. Eugene Smith, copyright the heirs of W. Eugene Smith.*

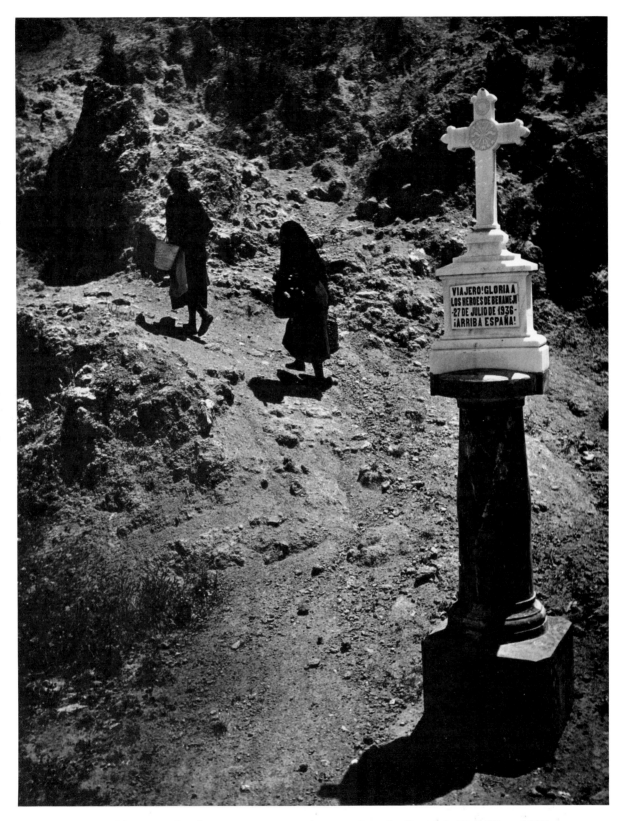

50. *Photograph of a monument commemorating the Spanish Civil War. 1950.*
*W. Eugene Smith, copyright the heirs of W. Eugene Smith.*

104

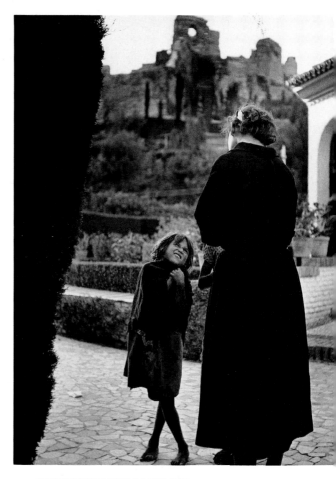

51. BELOW *Photograph of wealthy Spanish family, Malaga. 1950. W. Eugene Smith, copyright the heirs of W. Eugene Smith.*

52. RIGHT *Photograph of beggar girl and woman, Malaga. 1950. W. Eugene Smith, copyright the heirs of W. Eugene Smith.*

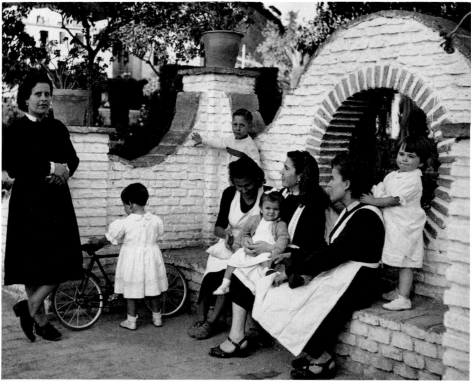

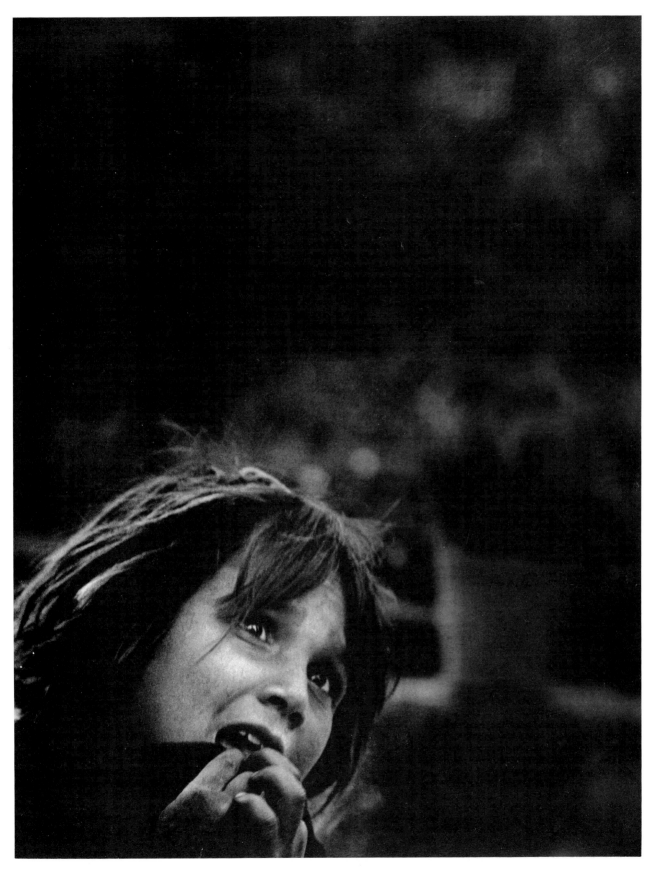

*53. Cropped photograph of beggar girl, Malaga. 1950. W. Eugene Smith,
copyright the heirs of W. Eugene Smith.*

village by accident.[18] This may be true but we know from Smith's pocket notebook that he had been looking at Spanish villages from the moment he entered the country. His discovery of the small town of Deleitosa and his commitment to document the village's life-style came in early June, a few days after the publication of an important article in a Madrid newspaper.

On May 28, 1950, while Smith was staying in Madrid, an article entitled "Meditations on a Nameless Village" was published in the Madrid newspaper *A.B.C.* Smith found the argument advanced by the article interesting enough to have it translated for his personal use.[19] The author, Gaspar Gomez de la Serna, lamented the emergence of a modern, urban Spaniard who feigned affluence and importance. He contended that the true character of the Spanish was not to be found in an urban setting but in the anonymous villages which dotted the Spanish countryside. The similarities between Gomez de la Serna's text and Smith's photographs of Deleitosa are so remarkable that it is worth quoting the text at length:

> It is not necessary to mention the name of this small village, stretched out before the eyes of the traveller in the Castille plain, because it is just an ordinary little village like many others. Its history is not such as to entitle its fame to be blazoned abroad, yet neither is it so insignificant as not to entitle it to a place in the general hurly-burly of Spanish life, despite its anonymous, quiet existence. It is here in front of us, in the Spring sunshine, with its humble silence and its longsuffering resignation, with its little low houses, the colour of the earth, engirdling the graceful form of the church like a brown skirt. . . .
>
> But precisely because of its anonymous character, the same as that of hundreds of other villages, the traveller is more impressed by this little place than by the luxurious court of the great city, lifting its rich cosmopolitan silhouette over the immense sea of Spanish towns. Actually, what *this modest hamlet, simple down to the poverty-line, is shouting from out of its unheard silence, is the modesty of Spain itself.* It is inviting us to measure with the yardstick of its dusty alleys, its familiar "adobe" walls and its poor harvests, the exact and true compass of Spanish material life.[20]

Deleitosa, the village selected by Eugene Smith, was just the type of village Gomez de la Serna had described: a picturesque adobe town that sat on a slight rise above the Estremadura plain (fig. 54).[21] Be-

cause Deleitosa had no facilities for tourists, Smith, Castle, and Pei-
nado spent nights in a hotel in Trujillo and drove to Deleitosa during
the day. After photographing for seven days in mid-June they returned
to Madrid for two days, developed negatives, then drove back to De-
leitosa.[22] This pattern of photographing the village for several days,
going back to Madrid for a day or two, and then returning to Deleitosa
was repeated four times before Smith felt his reportage was complete.

Smith's documentation of the village was not easy; he met resistance
from both the villagers and the authorities. He was able to gain the
confidence of the villagers through the mediation of a widow whose
husband had been killed by Franco's troops during the Civil War. She
personally assured her neighbors of Smith's good intentions and was
the key to his success in Deleitosa.[23] Smith never did gain the confi-
dence of the civil authorities, however. Luckily, his letter of introduc-
tion was misinterpreted by many petty officials who thought it gave
official sanction to his photo-reportage. Although the police denied
him the right to take notes,[24] Smith conducted interviews with the
village doctor, the mayor, the postman, a teacher, a hitchhiker, a vil-
lage family, the village midwife, and an unidentified woman whose
husband was jailed by the government. Topics included village sani-
tation, education, religion, and government persecution.[25]

Smith photographed all aspects of village life, including the govern-
ment-appointed mayor of the city (fig. 55). In this portrait, Smith hints
at the political corruption in Spanish regional government. He poses
the mayor in the foreground, sitting beneath a picture of Franco. Using
a low camera angle and a wide-angle lens, Smith distorts the mayor's
features; this camera viewpoint makes the man appear oafish. For the
most part, though, Smith focused his attention on one family, the Cu-
riels. He systematically documented their daily activities – washing,
planting, going to church, and preparing and eating their evening meal.

Smith's centering of his project on a single village made officials
uneasy and ultimately brought an end to his photography of Spain. He
was forced to finish abruptly when he and his interpreter were accosted
by a plainclothesman and the Guardia Civil. Smith wrote about the
incident:

> He walked straight up to us and without courtesy demanded our
> papers. He glanced through them, then held Nina's Spanish pass-
> port in one hand, kept drumming it against the other. His tone was

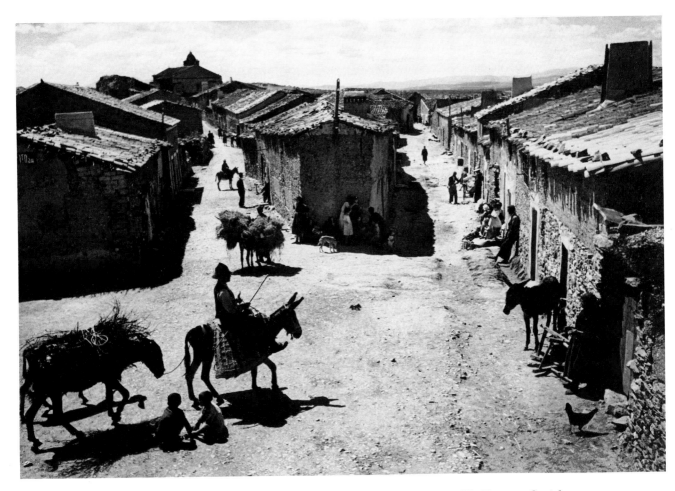

54.  ABOVE *Photograph of the town of Deleitosa. 1950. W. Eugene Smith,*
*copyright the heirs of W. Eugene Smith.*

55.  OPPOSITE *Photograph of the mayor of Deleitosa. 1950. W. Eugene Smith,*
*copyright the heirs of W. Eugene Smith.*

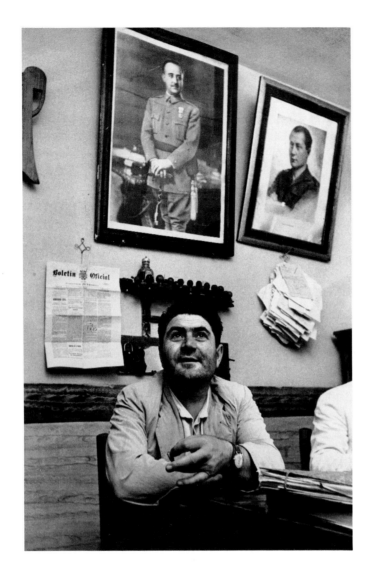

rough as he questioned her and then the both of us. He tried to
threaten. He also questioned where the films were, when they would
be developed, who would pass upon them. We parried, pacified,
threw false scents, said the film was almost all in Madrid (which
it was). Abruptly he turned and left, so did the uniformed men.

We stood staring at the emptiness. "Nina, dear child, may I
make a slight suggestion – let us pass up our remaining, rather
unimportant pictures, and get the hell out of here while you still
have your freedom, and I still have my film."[26]

Smith took the threat very seriously. They taped their film to the un-
derside of the car and left Madrid at 4:30 A.M. on July 8, 1950. By
July 13 they were in Paris, and in London two days later. Only when

they were safely in England did Ted Castle finish developing the film and begin to print the negatives.

While Castle was making the prints, Smith finished the written research, typing caption material and writing a forty-five-page typescript that clustered his photographs thematically. He suggested two possible themes for the photo-essay.[27] The first emerged from his experience of Spain: a story of life in a small Spanish village. The second idea was a variation of the story as originally assigned: a photo-essay about the shortage of food. For the latter, more complex story, Smith suggested beginning with a photograph of a black market in the city and then shifting to a consideration of an agricultural village.

In organizing the fifty-seven photographs he selected as most representative of his reportage, Smith grouped them in six categories: "a Single Family"; "Doctor and Sanitation"; "Influence of the Catholic Church – Birth, School, Death"; "Three Needs of Agriculture – Irrigation, Fertilizer, Modernization"; "Harvest of Grain"; and "Protestants – Second Class Citizens." He introduced his caption material with a lengthy description of the history of Deleitosa and concluded with commentary on its current political situation.

His selection of twelve photographs of the Curiel family represented a typical day in their lives: rising at dawn, eating, washing, farming, baking bread, and drawing water from the community well. He presented four pictures for the section on sanitation: a photograph of the town doctor, a boy defecating in the street, and two variant pictures of a woman emptying dishwater outside her front door. The next section – "Influence of the Catholic Church – Birth, School, Death" – contained twelve pictures, almost half of which were published in the *Life* photo-essay. These were followed by ten photographs of agriculture and the harvest of grain. The last titled section, "Protestants: Second Class Citizens," introduced a lengthy discussion of the Spanish Bill of Rights.

In deference to editorial choice Smith supplied an additional fifty-six pictures and brief, one-sentence captions. These photographs he characterized as "variations of preceding ones or others that cover a little more ground."[28] *Life* editors checked specific details in the typescript and asked a *Life* agent in Madrid, Piero Saporiti, for further research. Saporiti supplied the editors with twenty-four pages of statistical data concerning the agricultural productivity of Spain.

Their photo-reportage complete, Smith and Castle took time out to make a brief visit to the Leica factory in Germany, and on August 26, 1950, Smith departed for New York City. In October, he wrote to his mother complaining about the delay in publishing his photographic reportage: "LIFE has made no decisions concerning the use of the Spain stories — it is supposedly one of my better sets of pictures — it doesn't fit the present LIFE and U.S. policy of bootlicking Franco."[29] As will be discussed in the second reading of the photo-essay, this may well have been true. Nevertheless, part of the reason for the delay was Smith's inability to direct his attention to completing the photo-essay.

When Ted Castle returned from London with the finished prints on September 20, Smith was hospitalized.[30] Soon after his arrival in New York, Smith had suffered an emotional breakdown, presumably caused by his abuse of amphetamines and alcohol. He was taken to Bellevue Hospital but soon was transferred to the Payne-Whitney Clinic at the insistence of Edward K. Thompson, managing editor at *Life*. His stay was extended for several months and certainly delayed the story.[31]

Unlike his reportage of the British elections, for "Spanish Village" Smith retained his negatives. As a result, *Life* editors were forced to wait for the prints, which were not completed in their entirety until February 1951.[32] The photo-essay was delayed further by disagreements over the layout of the photographs. Assistant managing editor Maitland Edey remembered that the final form of "Spanish Village" was arrived at only after "a great deal of arguing, of preliminary sorting and discarding, after many other arrangements were tried and abandoned."[33] The final form of the photo-essay, the sequence and layout of the photographs, was completed by Bernard Quint, one of *Life*'s finest art directors.

The timing of the photo-essay's publication was the result of a variety of factors. Commercial competition was certainly one important issue. On January 30, 1951, *Look* published a photo-essay on Spanish poverty.[34] Spain also had renewed significance as a news story in late March. On February 14, the United States Export-Import Bank had granted Spain a $12.2-million loan for agricultural and industrial assistance, and on March 16, a $5-million loan for wheat purchases. This latter loan was undoubtedly in response to the March food riots in Barcelona, a fact that was brought to the attention of *Life*'s editors

by the *Life* reporter in Madrid, Piero Saporiti.[35] After repeated delays, "Spanish Village" was finally published on April 9, 1951.[36]

## Narrative and Aesthetic Reading

"Spanish Village" is the artistic touchstone by which all other photo-essays are judged. In a departure from traditional photo-essays, "Spanish Village" emphasized individual photographs. It was an ingenious presentation that united Smith's concerns with *Life*'s promise of a story on the Spanish wheat shortage. Unlike the clear narrative structure and point of view found in "Country Doctor," "Spanish Village" was loosely constructed around two general themes: poverty and religious faith. Intertwined with these themes was an iconography suggesting the life cycle of nature: from planting to harvest, birth to death.

In recognition of the high quality of Smith's photographs, layout devices were used that had not been attempted in earlier *Life* photo-essays.[37] Assistant managing editor Maitland Edey took pride in the artfulness of the photo-essay layout:

> The final organization seems simple, but it is a maze of subtlety. Of its seventeen pictures, no two are the same size, no two line up horizontally or vertically. The purpose of this – aided by a generous use of white space – is to isolate each picture slightly so that the reader is encouraged to look at it as an individual work of art before he goes on to consider it in relation to other pictures in the story. . . . Everything fits together miraculously in a bewildering but unnoticed blend of full bleeds, partial bleeds, and white surrounds. Margins grow, shrink, and disappear effortlessly.[38]

A close reading of "Spanish Village" demonstrates these aesthetic qualities of *Life* magazine's layout design.[39]

In "Spanish Village" a three-paragraph introduction describes the geography of the countryside and reinforces the themes of poverty and faith stated in the title. Captions provide simple identification of subject matter and, at the same time, a coherent narrative flow. How such an image/caption element functions to support the photograph can be seen in an examination of the introductory spread of the photo-essay (figs. 32–33).

Figure 32 introduces the themes of poverty and faith. In the photograph one sees a young girl dressed in a pure white, carefully arranged dress, veil, and shoes, standing beside a barefoot little girl and her naked sibling. The caption gives us the details: "First Communion Dress: Lorenza Curiel, 7, is a sight for her young neighbors as she waits for her mother to lock door, take her to church." This juxtaposition demonstrates the importance of the event: the spiritual initiation of this young Spanish girl.[40] The photograph indicates the photographer's and the editor's recognition of the importance of this event in these people's lives.

The first double-page spread is laid out so that the viewer's attention is led on a diagonal from the large photograph on the left, through the title, to the image of the town in the upper right. This small photograph introduces us to the geographical context of the villagers and is captioned with descriptive information about the village houses and the church belfry in the distance. It is bled off the right edge of the page, directing our attention diagonally into the main body of the photographic essay. The subsequent photographs are also organized on paired pages and develop the themes of poverty and faith stated in the introduction.

The photographs on the third and fourth page are unified by size and tonality (figs. 34–35). The two largest photographs contain single figures whose dark silhouettes face each other. These two photographs also represent two basic human needs: physical food, represented by the girl carrying the loaves of bread, and spiritual nourishment, embodied in the person of the village priest. The dominant photograph of the girl carrying unbaked bread to a community oven is striking in that it visually equates the round shapes of the loaves with the round stones that form the foundation of the village (fig. 34).

Looking for qualities shared by these images, one sees that the editors selected pictures of isolated individuals whose actions and iconography underscore the poverty of the town – a little boy collects manure from the street to be used as fertilizer for the family field, and a doctor visits his patients carrying a kerosene lantern to illuminate the dreary interiors of the peasant homes (fig. 35). On this double-page spread manipulation of scale, tonality, and placement of pictures directs the reader's attention and reinforces the themes of "Spanish Village."

The picture layout of the next spread (figs. 36–37) is less directional than the previous pages. The pull of the largest photograph, in the upper right corner, is offset by the scale of the photograph below it and the image diagonally across from it in the lower left corner. As a result the viewer's attention is constantly shifting between the pictures. They illustrate the hard work of the women and men of the town. In this context it is worth noting that more women than men are represented. This choice may have been made to underscore the villagers' plight for paternalistic American readers, but it also served Smith's political ends by suggesting the human destruction of the Spanish Civil War.

The images on these pages convey the character of the hard labor of the villagers as they struggle to eke out a meager existence from the land. Iconographically, the photographs show the process of farming and harvesting land which we see as barren, rocky, and dry. Particular attention is directed to the primitive tools and ancient farming methods of the villagers. Although these people are surviving, there is, in their gestures and facial expressions, a kind of desperation surrounding their labor. This is one of the few layouts without specific reference to the Catholic Church but, even here, the natural cycle of planting and harvesting carries biblical overtones.

The next-to-last spread of the photo-essay presents Deleitosa in its contemporary political context (figs. 38–39). Dominating, both in size and scale, is a close-up of three members of Franco's feared Guardia Civil. In this case the picture layout reinforces a sense of menace and cruelty. The photograph of the Guardia Civil looms over the other images visually just as the specter of Franco's rural police looms psychologically over all village activity. The caption makes this reading explicit: "These stern men, enforcers of national law, are Franco's rural police. They patrol the countryside, are feared by people in villages, which also have local police." The surrounding photographs are independent representations of social activities that make up the humble life of the villagers. The photograph in the upper right corner repeats the theme of spirituality by depicting a baptism. The other three photographs reinforce the simplicity and poverty of the villagers, a message that is made explicit in the captions. Juxtaposed to the photograph of the three members of the Guardia Civil, these men and women are seen as powerless victims of Franco's fascist regime.

The conclusion of the photo-essay confirms our sense of the dignity of these people and the role of religion in their lives (figs. 40–41). A single unframed photograph of a Spanish wake spans the final two-page spread. Smith's camera viewpoint places the viewer alongside the body, as if we, too, were mourning the death of the old man. The composition is extremely stable, reflecting the solitude and solemnity of the occasion. The sharp diagonal of the body leads from the fore-ground picture plane back into the shallow space of the mourners. This diagonal is anchored by the pyramidal arrangement of the central group of figures in the middle of the picture. Even the gazes of the two women in the center cross each other, giving the picture further visual weight and stability. The caption draws our attention to the generational cycle of village life, an interpretation that is underscored by the photographer's careful bleaching of the faces of the three nearest women.

This final photograph dramatically summarizes the theme stressed throughout the photo-essay: the contrast between the material poverty of the villagers and the nobility of their spiritual strength. The theme is explicitly stated in the last sentence of the opening text:

> For Deleitosa, barren of history, unfavored by nature, reduced by wars, lives in poverty – a poverty shared by nearly all and relieved only by the seasonal work of the soil, and the faith that sustains most Deleitosans from the hour of First Communion until the simple funeral that marks one's end.[41]

This sentence recapitulates the cycle of life displayed in the photographs. Looking in particular at the introductory and concluding photographs one sees that editors have stressed this timeless theme by opening the photographic essay with the birth of religious experience and closing it with prayers over an old man's corpse.

## Political and Ideological Reading

The editorial sophistication and artistic beauty of "Spanish Village" satisfied neither the Spanish government nor Smith. Franco was insulted by the characterization of his government as threatening and ruthless. Smith, on the other hand, had hoped his photo-reportage would influence public opinion in the debate over foreign aid to Spain.

After Franco's tacit support of Hitler during World War II, Spain had
been an outcast among the Allies. Nevertheless, in the early 1950s,
the country was gradually accepted by European governments and the
United States. This shift in policy was, in part, the result of pressure
from military leaders who viewed Franco not as a Fascist dictator but
as a bulwark against the spread of Communism in Europe. In the sum-
mer of 1950, as Eugene Smith crisscrossed Spain making his photo-
graphic reportage, the United States Senate debated whether to end
the U.S. boycott of Spain and give foreign aid to the Franco govern-
ment.[42] Smith vigorously opposed that aid. An analysis of the editorial
position at Time-Life suggests the opposition that Smith must have met
in arguing for his interpretation in "Spanish Village."

Eugene Smith was not the first *Life* magazine photographer to do a
photographic essay on postwar Spain. In April 1949, *Life* had pub-
lished Dmitri Kessel's reportage, "Spain: Franco's Regime, Slightly
Mellowed, Looks West for Friendship and Aid."[43] A close reading of
this photo-essay reveals that even as early as 1949, *Life* was encour-
aging a shift in foreign policy in favor of Franco. In Kessel's reportage,
Franco is depicted not as a totalitarian dictator but as a sportsman who
goes duck hunting. Echoing the conservative, military position, the
body of the photo-essay shows the Pyrenees displayed across a double-
page spread with a caption that describes them as "a formidable mili-
tary asset." Along the right side of the page are photos of the outdated
military equipment used by the Spanish army. The text accompanying
these pictures praises the army, which "lacks only modern equipment
to be a first-rate fighting force." The picture spreads illustrate the
changing Spanish society and give examples of its burgeoning capital-
ist economy. In brief, the photo-essay stresses the military importance
of Spain and depicts it as a country on the verge of change, a country
moving toward laissez-faire capitalism and worthy of U.S. support.[44]

The change in editorial slant that marks "Spanish Village" demon-
strates the power of the photographer to influence the presentation of
his photographs. Particularly instructive is the contrast between the
treatment of the Guardia Civil in "Spain" and "Spanish Village" (figs.
56 and 57). Kessel's police are posed at ease with their hands covering
their gun barrels in a disarming gesture (fig. 56). In Smith's picture,
however, the men are at attention with gleaming gun barrels promi-
nently displayed over their shoulders (fig. 57).

Smith's contact sheets show that this display of power and menace was important to the photographer. He first posed the guardsmen inside the town, mingling with townspeople (see various shots in fig. 48); but these pictures failed to capture the menacing power of Franco's rural police. Smith then managed to get the desired effect by posing the guardsmen outside the city walls. He made over seventy-two exposures, some of which showed the men relaxed and with half smiles (fig. 58). To make the photograph he wanted, he walked around the men while they faced directly into the sun. Smith convinced them that the discomfort was worth it. "It makes you look handsome," he told them.[45]

In this picture Smith photographed the men as archetypes, representations of a repressive political system. The details of the photograph – the low angle, the squinting eyes, and the sun gleaming off the gun barrels – make the power and ruthlessness of the men overwhelm any more humane characteristics. With this photograph Smith established visually his intentions for the "Spanish Village" picture sequence: to convey the repressive nature of Franco's dictatorship. This example demonstrates the ability of the photographer to use formal means to influence the presentation of his photographs.

The inclusion of the picture of the menacing guardsmen in "Spanish Village" was a significant editorial concession, running counter to Time-Life editorial policy. An examination of the *Time* news stories on Spain makes this clearer. Publisher Henry Luce was actively concerned with American foreign policy and expressed his opinions in *Time*.[46] On March 6, 1950, shortly after Smith's departure, *Time* ran a three-column story titled: "Roundup."[47] The story focused on two people, Don Bernardo Bernardez and Luisa Maria, Duchess of Valencia. Both were ranking monarchists who legally opposed the regime of Francisco Franco and who were summarily jailed without charges or explanation. *Time* presented them as political martyrs and explicitly attacked Franco's claim for legitimacy as a bastion against Communist takeover. *Time* concluded: "It looked as if Franco had finally decided that the monarchists had become more dangerous to his regime than the Communists." By the time Eugene Smith returned from Europe, however, the attitude of the *Time* editorial board had begun to shift, and by February 1951, six weeks before *Life*'s publication of "Spanish Village," *Time* embraced Franco.

56. *Photograph of the Guardia Civil from "Spain: Franco's Regime,*
*Slightly Mellowed, Looks West for Friendship and Aid,"*
Life, *XXVI/14 (April 4, 1949), pp. 114. Dmitri Kessel,* Life *magazine,*
*copyright 1949, Time Warner, Inc.*

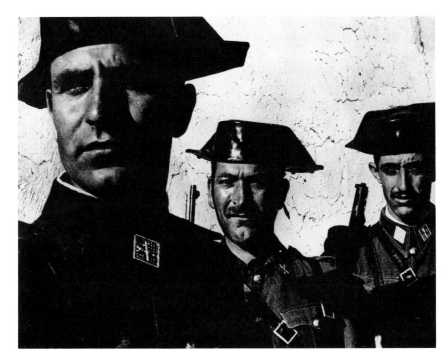

57. *Photograph of the Guardia Civil. 1950. W. Eugene Smith,*
*copyright the heirs of W. Eugene Smith.*

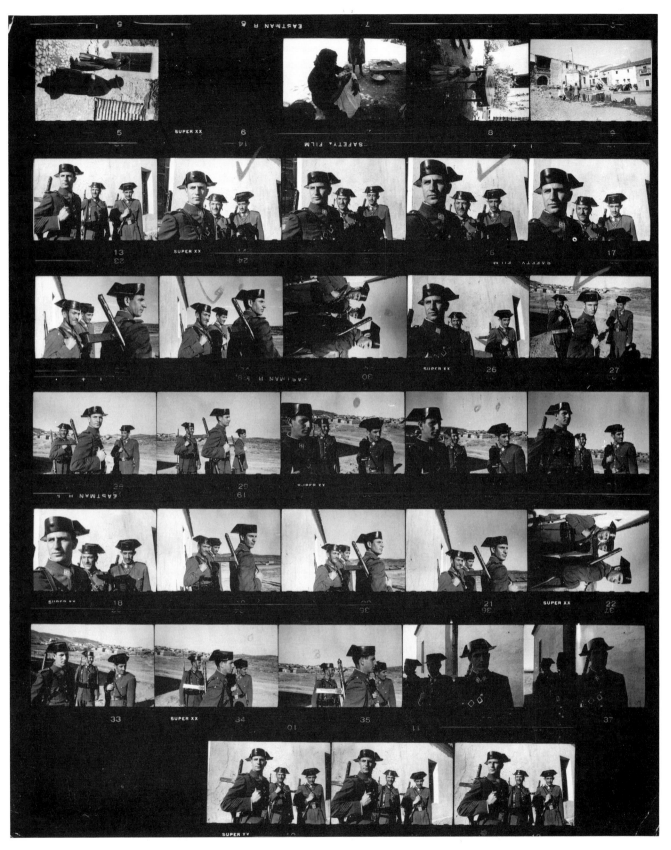

58. *Contact sheet from "Spanish Village." 1950. W. Eugene Smith,*
*copyright the heirs of W. Eugene Smith.*

*Time*'s interest in Spain was prompted by a debate in Congress on a proposed $100-million loan. In November 1950, *Time* summarized the debate:

> Most Americans don't like Francisco Franco, never have and probably never will. They didn't like the way he got to power with the help of Hitler and Mussolini, or the dictatorial way he stayed in power. In his favor it could only be said that, along with his fulminations against democracy, he had also been anti-Communist. There was one other thing to be said for Franco's Spain: its location.
>
> Many a U.S. militaryman has privately argued the case for Spain as a potential naval base and a possible beachhead for the Army in case of a Russian blitz on Western Europe.[48]

By 1951, the *Time* editorial position had become unequivocal. A February 26th article entitled "22 Divisions" stressed the military importance of Spain and minimized Franco's fascist connections.

> [L]ately Atlantic pact strategists have been thinking hard about the Spanish army. If the Communists marched across Europe, Franco's men would be needed to fight from the Pyrenees to Gibraltar for the Continent's strategic southwest corner. . . . Spain's topography is a formidable military asset. Franco has built a defense in depth in the Pyrenees. Mountain passes are studded with pill-boxes. Airfields have been built against the day when they might be used by bombers the air force does not possess.[49]

The article went on to point out that the Spanish army, so important to a NATO defense against a Communist attack, was not as effective a fighting force as it could be because of poor equipment. *Time* concluded by calling for passage of a U.S. loan to help Spain modernize its armed forces.[50]

Parenthetically, it should be pointed out that *Time*'s tilt toward Franco was also evident visually. On August 14, 1950, beneath a one-and-a-half column article titled "A Fee for Franco?," the generalissimo was posed stiffly and formally, dressed in his olive drab army uniform.[51] Approximately one year later, however, in an article applauding the U.S. policy shift allowing Spain into the Western alliance, Franco was presented as a family man – relaxed, dressed in a white navy uniform, and playing with his infant granddaughter.[52]

Smith was keenly aware of the political sensitivity of his photographs. He wrote shortly before his return to the United States:

> Spain story quite mediocre. . . . LIFE will probably like the story and depending upon their policy of the moment the story is libel *(sic)* to end up as one long plea for a loan to Spain — that would be a bit of mockery that may bring my resignation. In fact I am so afraid that will happen I am already laying the groundwork (if I can) for another project.[53]

He wanted a photo-essay that made a strong political statement. "I do not feel a story on a village in Spain is complete without this ever present political overtone," Smith wrote to his editors.[54]

The research typescript he submitted with his photographs made suggestions for a cover of the magazine that centered on the human cost of the poverty in Spain. The one Smith said he "really believed in as a cover" was a carefully posed photograph of a village mother and her small daughter (fig. 59). It was a conventional composition belonging to the iconography of the Madonna and Child, but in his picture Smith secularized the tradition. His Madonna was thin and ragged, her child dirty-faced — allegorical figures representing Spain and her cycle of poverty. In his selection of images and in his caption material Smith articulated his understanding of the linkage between his photo-reportage and the contemporary political debate. He wrote:

> In my choice of subjects within the village I also tried to reach a fair balance and to not show the very worst. In looking at my pictures now, I feel that I was too fair, and they do not properly translate the poverty that is Spain. I hope this is borne in mind at time of layout and writing.
>
> Under individual pictures I have not placed political opinions, nor have I mentioned the part and the tragedy that was theirs during the Civil War. I have done this for the safety of my subjects. But these subjects have been touched by the oppression, the imprisonment, and the murders that must be charged to the government and its supporters — the people to whom we are preparing to give a 100 million dollar helping hand.[55]

Smith followed this plea with personal recollections of political repression.[56] The conclusion of his report reiterated the relationship

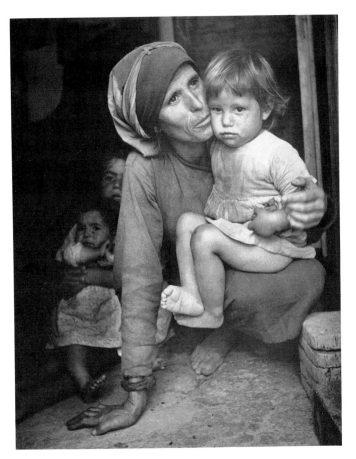

59. LEFT *Photograph of a Spanish woman and her daughter. 1950.*
*W. Eugene Smith,*
*copyright the heirs of W. Eugene Smith.*

60. BELOW *Photograph of a Spanish woman and baby begging at the back of a church. 1950.*
*W. Eugene Smith,*
*copyright the heirs of W. Eugene Smith.*

61. OPPOSITE *"Spanish Spinner." 1950.*
*W. Eugene Smith,*
*copyright the heirs of W. Eugene Smith.*

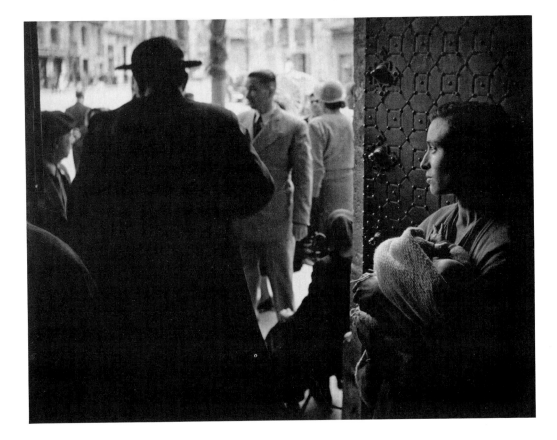

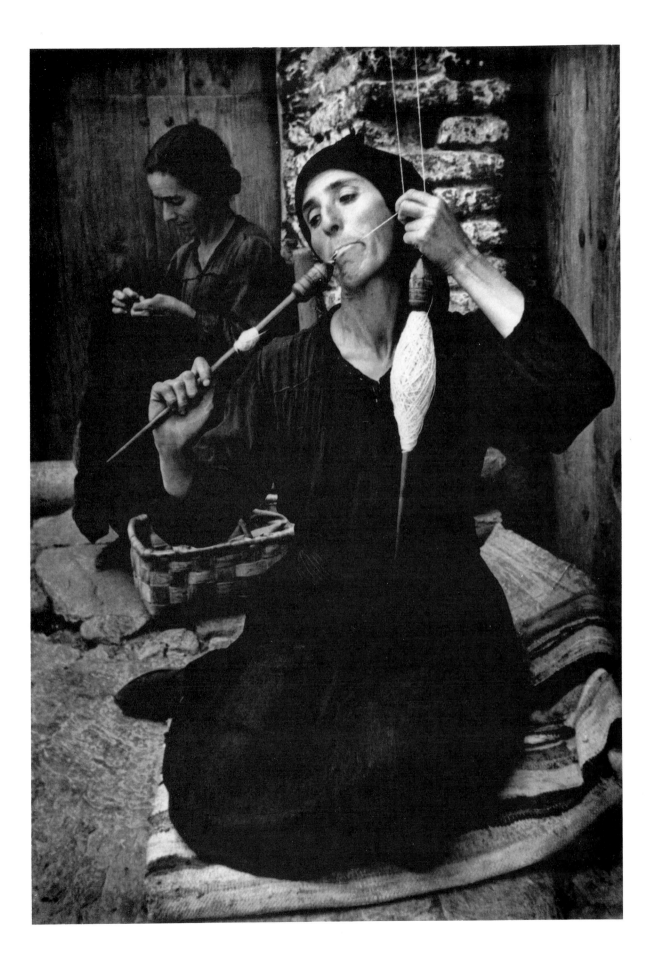

between his photographs and politics. He ended his research type-
script with what he titled "Personal Opinion Department":

> In the moral sense, many people believe it better to perish than to
> fall under the degrading yoke of communism. I agree. I also be-
> lieve it better to perish in the fight against communism than to aid,
> support, and use such as Franco. In the idealistic sense of justice
> – purported to be our belief – we cannot accept such as Franco
> under any terms. . . . I know that most of what I have written on
> the last few pages is of no value as research – my interest in the
> inclusion of it is that I can establish the mood I feel is needed in
> the handling of the story to make it the truest possible interpreta-
> tion of the actuality of Spain. I am so very much afraid that it will
> end up a favourable and not an unfavourable article – and in that,
> all I believe would be compromised.[57]

As the narrative and aesthetic reading of the photographs demon-
strates, politics was of secondary importance in the published photo-
essay. The two themes around which the photographs were organized
were the poverty of the villagers and the comforting presence of reli-
gion in the lives of the villagers. Smith felt keenly the economic pov-
erty of the majority of the Spanish people, but the idea that the Cath-
olic Church was a positive influence in Spain was diametrically opposed
to Smith's report.

Smith was shocked by what he felt was the complicity of the Church
with the Franco government. His editorial research text quoted ver-
batim the Catholic catechism's "Enumeration of Modern Errors." Some
examples of sinful behavior included "subscribing to liberal papers."
Other questions taught Spanish children the necessity of the suppres-
sion of "personal freedom, modernism, communism, and rational-
ism."[58] His photo-reportage included pictures that alluded to the alli-
ance between Church and State by juxtaposing Franco's monuments
with the crucifix (figs. 49 and 50). Other photographs that indicated
the negative role of the Catholic Church were even more explicit. One
shows a young woman begging at the back of a church (fig. 60). We
see her standing in shadow, clutching her child and looking at a priest
as he leaves the church, turning his back on her poverty. These were
not selected for publication, nor were photographs of a clandestine
Protestant religious service.

For Smith the religious aspect of his photo-reportage had complex
political and personal ramifications. Shortly before "Spanish Village"

was published Smith wrote to his mother:

> I don't see why you continue to worry about Franco and his ruth-
> less group, and as for the church, it should clean its nose, instead
> of trying to bluff and lie about its doings in Spain. I did my best
> to balance it [his Spanish reportage] out honestly, in fact if any-
> thing, I minimized the corrupt dealings and persecutions of the
> church – and I am sure that out of fear of Mrs. Luce the editors
> will further minimize it.[59]

The photographer's fears in this area were well-founded. In most
cases the editors simply did not select for publication photographs
critical of the Catholic Church. When potential criticism might be
found in a photograph, it was diffused by captions and titles. For ex-
ample, in the introductory picture the photographer captures the in-
congruity of the white, carefully arranged dress, veil, and shoes, in a
place where other children are barefoot and naked (fig. 32). Even the
girl's mother, whom we see locking the door before accompanying her
daughter to church, is barefoot. Co-opting a reading of the image as
critical of a religion that encourages people to spend their meager
earnings on an expensive communion dress, the caption is used to
demonstrate the centrality and importance of religious faith in the lives
of these people.

In summary, an analysis of "Spanish Village" shows that in some
ways Smith's editors respected his choices. They allowed him certain
editorial privileges – writing his own research text, making the initial
selection of pictures, and printing the photographs. The general out-
line of the photo-essay – "a Spanish village, its life and its influences"
– was suggested by Smith in his research statement. Eighteen of the
nineteen published photographs were from Smith's initial selection of
fifty-seven and the photo-essay presented the subjects Smith had sug-
gested: a single family, the land, harvesting, life, death, and sanita-
tion. There was even a statement about government repression in-
cluded beneath the photograph of the Guardia Civil.

Nevertheless, "Spanish Village" was not the statement Smith wanted
to make. Not only was his reportage about the Catholic Church left out
of "Spanish Village" but even his political message was subtly under-
mined. The photo-essay aestheticized the poverty of the men and women
of Deleitosa. These aesthetic qualities, which the layout accentuated
by surrounding the photos with white space, were of secondary impor-
tance to the photographer. Smith's own selection of photographs stressed

documentation over pure aesthetic considerations. For example, the photo of the wake, the strongest image in "Spanish Village," was not given special emphasis by the photographer. Even the "Spanish Spinner" (fig. 61), the most acclaimed single photograph from the essay, was not included in what Smith felt were the fifty-seven most important photographs.[60] This photograph was singled out by later critics for its aesthetic qualities but was intentionally omitted by Smith because, while the photograph is a beautiful image, it contains no overt reference to Spanish poverty or government repression.

For Smith, what was important was the potential influence his photographs would have over public attitudes toward the Franco government. As our close reading has demonstrated, however, the photo-essay, as it was published, did not impress the general reader with the horrors of dictatorship as much as with the economic plight of these strong, hard-working people. This sympathy was ambiguous with regard to its underlying politics, and ambiguity was clearly not what the photographer/author wanted.

Despite these problems, Smith did not lose his battle with the editors; he was defeated long before the photo-essay went to layout. Shortly after Smith's return to New York City, a joint session of Congress agreed upon a foreign aid appropriation that included a loan to Spain of $62,500,000.[61] Although it has not been acknowledged by scholars, Smith's recognition of this outcome as a personal defeat may have contributed to the breakdown that hospitalized him a few days later.[62] This is particularly ironic, given the overwhelming acclaim for "Spanish Village."

## Public Reception

The public acclaim for "Spanish Village" was unprecedented.[63] An internal *Life* report, forwarded to Smith by Bill Gray, summarized the reader response during the week of April 9–13:

> The April 9 issue contained no great controversies and, except for the 119 who worried about what happened to the jumping paratrooper who seemed destined to lose his right arm, LIFE readers regarded the issue with comparative calm and approval. Even the readers who disagreed did so mildly and reasonably, often with a

compliment before the slam. . . .
*General Bradley's story*, with widely varied comments, placed third
in number of responses and the sensitive artistry of Gene Smith's
photographic essay on a Spanish village received the highest praise,
even from those who called the story unfair. His pictures are com-
pared to the great works of an old master and the death scene is
called "truly a cut gem in cameo."[64]

This positive reading of the public reception of the photo-essay,
however, was a selective view of the correspondence. Smith wrote to
his mother:

> Although the Spanish story in the magazine is as neutral and non-
> political as any story could possibly be (to my regret) I find that
> many people wish to make politics out of it, and all to the point of
> how unfair I am to dear old Franco's Spain. . . .
>
> Otherwise, this printed story of mine which is a printed story of
> a simple straightforward study of a single village (and I made sure
> that it would not be presented as a typical village) and which has
> been ruled unfair by one group – has, on the artistic level received
> a reception so overwhelming that I am completely staggered. Al-
> though the praise is greater than I expected the split reaction, as
> a whole, is rather as I expected. Tourists, blind except to the
> vistas and the landmarks, I didn't expect to know and understand
> Spain. Catholics seem to be completely fanatical in screaming at
> even an imagined criticism. . . .[65]

Smith did not exaggerate the praise for the aesthetic quality of the
"Spanish Village" photographs. Lincoln Kirstein, an important con-
temporary critic of the arts, wrote to express his admiration for the
"terrible humanity" of the photographs. In July 1951, *Life* republished
"Spanish Wake" in its "What's in a Picture" section, and in December
1951, two variations of the photo-essay were published in the *U.S.
Camera Annual* and in *Modern Photography.*[66] In a public tribute to
the artistic excellence of "Spanish Village," Tom Maloney, editor and
publisher of *U.S. Camera*, and Edward Steichen, director of photogra-
phy at the Museum of Modern Art, selected W. Eugene Smith for the
first *U.S. Camera* Achievement Award in 1951. This was a prestigious
honor and carried a prize of $1000 in cash and a gold medallion.[67]

"Spanish Village" was equally acclaimed in the editorial offices of
*Life* magazine. *Life* published a special portfolio of eight new pictures

from Smith's Spanish photo-reportage (fig. 62).[68] Smith wrote to his mother about the photographs:

> It has been a rush, rush, rough time, although little seems to be accomplishment done *(sic)*. The Spanish story with rather neutralized text is due on the stands this Friday. The promotion department is doing a rather neat and unusual thing about the story. They are making up an "Art portfolio" consisting of eight full page pictures each on its own separate sheet of paper "suitable for framing." The strange part about it is that every one of the pictures was a reject and not used in the story. I will send you one of these.[69]

This special recognition undoubtedly pleased Smith. Equally important to him was the selection of the photographs used for this publication. It is not known who chose the pictures but among the reproductions were several of the politically charged images that were expressed favorites of the photographer, such as one juxtaposing a beggar, a political slogan, and a bombed-out building (fig. 63).

If Smith selected these images for their political impact, however, he soon found that the intended political message was easily appropriated by *Life*'s advertising department. The text printed on the inside cover of the portfolio explained the difficulty editors had choosing the photographs to publish. It stressed the importance of the photographer's preparation, gave examples of the difficulties Smith had to overcome, and concluded with a blatant pitch to advertisers:

> The 17 pictures *Life* prints in this story are more than an outstanding example of camera art by a *Life* photographer. They demonstrate the fine reproduction quality of *Life*. Constant research with printing inks and papers continues to increase the value of the product *Life* – a product which today reaches in 13 issues a majority of all Americans, and is the foremost advertising medium in America.[70]

This message was also stated on the outside of the portfolio envelope, the verso of which carried a picture of the *Life* cover of April 9, 1951, and the words: "First in Circulation/First in Audience/First in Advertising/First in Editorial Impact."

Not surprisingly, "Spanish Village" found little favor in Spain. The

media reaction came quickly after "Spanish Village" was published in the June 4 issue of *Life International*. In July 1951, the Spanish magazines *Semana* (Madrid) and *Mundo Hispanico* criticized "Spanish Village" as a one-dimensional, biased view of Spain. The author of the *Semana* article labeled the *Life* story "unfair sensationalism."[71] He admitted that there were villages like Deleitosa in the Spanish countryside, but claimed that these villages were only one aspect of contemporary Spain. The text noted that for Smith to get to Deleitosa he had to drive across broad stretches of land tilled by tractor. It criticized Smith and his editors for not choosing to represent these positive aspects of Spain.

To support their claim, the *Semana* editors pointedly juxtaposed photographs selected from the *Life* article with those made by a *Semana* cameraman. For example, Smith's view of the medieval houses of Deleitosa was contrasted with a newly built town in Spain; the woman spinning flax was shown opposite modern textile mills; and the girl carrying the bread into the community oven was juxtaposed with a mechanized city bakery. This publication was the official government response. While it may have persuaded uncritical readers, the argument that Smith and his editors were selective does not challenge the validity of his photo-reportage. A more thoughtful criticism was published in *Mundo Hispanico*.

*Mundo Hispanico* began its extensive rebuttal with an open letter to the editor of *Life* published in both Spanish and English. Thoughtfully argued, the letter was written by Gaspar Gomez de la Serna, the man whose "Meditations on a Nameless Village" encouraged Smith's search for a small Spanish town as an appropriate focal point for his photoreportage. Gomez de la Serna admitted that there were many villages like Deleitosa, "Black Spain" he called them, but he said they were evidence of the past rather than the present. "Spanish Village" was misleading, he argued, because it ignored the historical context of Spain's villages.

> Spain, the country of slow-ripening fruit, was slower than ever in gathering the ripe fruit of progress, and, meanwhile, especially in her spacious countryside, she perpetuated rural, pre-nineteenth-century living conditions which were economically saturated with absentee-landlordism, aristocratic neglect, and social helplessness.[72]

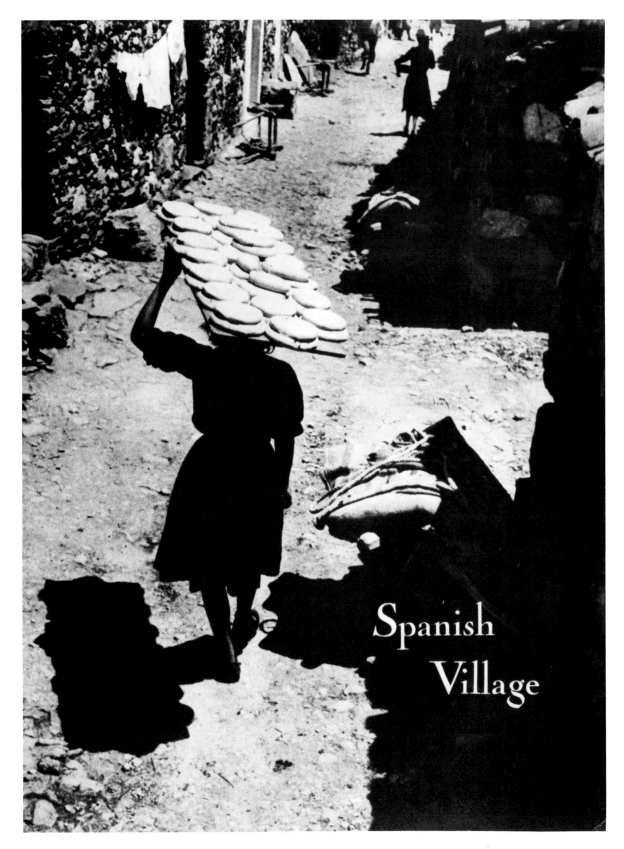

Spanish
Village

62. *Cover of* Spanish Village Portfolio, *published by* Life *in 1951.*
*W. Eugene Smith, copyright the heirs of W. Eugene Smith.*

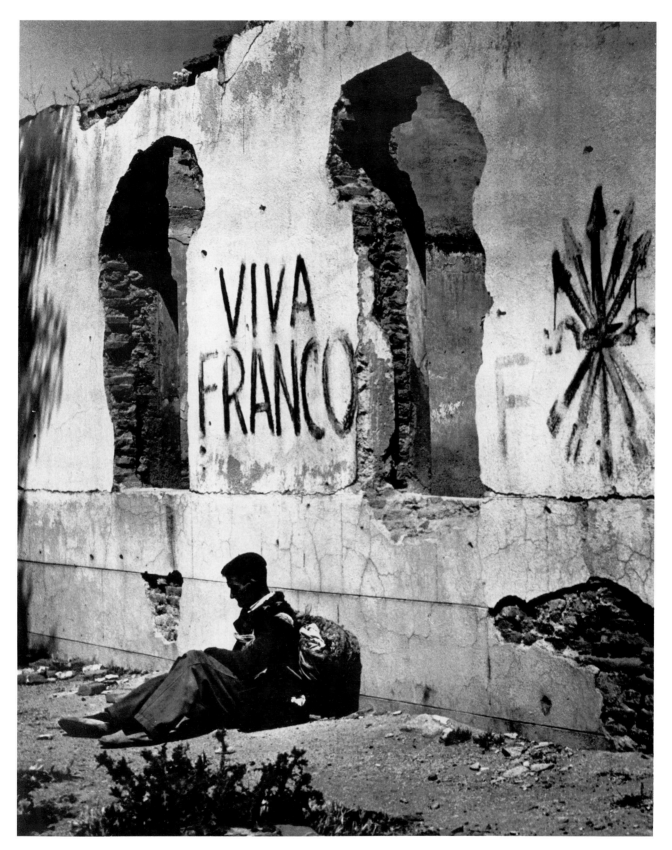

*63. Photograph of Spanish beggar and wall slogan. 1950. W. Eugene Smith, copyright the heirs of W. Eugene Smith.*

In the twentieth century, Gomez de la Serna asserted, progress had
come to Spain and villages such as Deleitosa were in decline. At best,
"Spanish Village" was a representative and accurate picture of
nineteenth-century Spain; but he criticized the photo-essay for perpet-
uating a stereotype and for failing to recognize the shift in Spanish
consciousness toward modernism. He concluded his argument:

> Deleitosa is no longer a representative village; it is a regrettable –
> though still not unique – exception in the general perspective of
> Spain. To hold up that sad picture as anything else, Sir, is a piece
> of deceitful sophistry, as hurtful a falsehood as it would be to dub
> a gangster film "Scenes of American Life" without any qualifica-
> tion.[73]

Like *Semana*'s, *Mundo Hispanico*'s editors felt the need to combat
the rhetoric of Smith's photographs with photographs of their own. Fol-
lowing Gaspar Gomez de la Serna's open letter, the magazine pub-
lished an eight-page photo-story, an illustrated rebuttal to "Spanish
Village." The first page reproduced the five two-page spreads of the
*Life* photo-essay in greatly reduced size. They did this in order to
contrast the photo-essay with "the new Deleitosa," Bernuy, a town
recently constructed by the Spanish government.[74] The editors used
fourteen large photographs, all displaying a carefully arranged view of
this new Spanish construction project.

Although he was interested enough in the Spanish reaction to have
the magazine articles translated for him, Smith dismissed most of the
criticism as heavy-handed propaganda of the Spanish government.[75]
An exception was the criticism of the *Mundo Hispanico* correspondent.
Smith responded to Gomez de la Serna's criticism:

> The other writer [Gomez de la Serna], I like, even though he doesn't
> like me – he admitted to the truth of the pictures, and I think just
> regretted their being shown to the world – the old portrait business
> of I want it to look just like me only better. . . . The amusing
> thing about the second writer is that I turned in to LIFE a long
> and needling article from a Spanish paper which in most ways was
> so perfectly a picture of my village that it could have served en-
> total as my captions and led to much of my reasoning that led to
> my picking of this village . . . it ["Meditations on a Nameless

Village"] was a sensitive and beautifully written article (the first
one I read in Spain), I think the one attacking me was also nicely
written. . . ."[76]

The government's negative response to "Spanish Village" continued
long after its publication. Writing to Smith from Valencia, Spain, over
a year after the publication of the photo-essay, Robert Frank informed
him: "In Spain, *Life* – thanks to your "Spanish Village" – is known as
a Communist paper!! By police I was more than once asked if I work
for *Life* and if I would know E. Smith."[77]

*Life* reacted to the aesthetic qualities of Smith's photographs by pub-
lishing an "Art Portfolio"; they reacted to the political reception by
publishing another photo-essay on Spain. At the insistence of Henry
Luce, *Life* sent Dmitri Kessel, author of the 1949 photo-essay, back
to Spain to make colorful, apolitical, picturesque images. "Spain:
American Tourists Rediscover Treasure of Color and History" was not
so much photo-reportage as it was promotion of Spanish tourist attrac-
tions.[78] The eleven pages of color photographs were accompanied by
a text that made a blatant appeal for American tourism.

With the passage of time the photographs included in "Spanish Vil-
lage" have lost none of their luster. The photo-essay continues to be
recognized by historians of art and the media as the finest example of
the genre, a touchstone by which other photo-essays are judged. Eu-
gene Smith's imagery is strong and powerful. It must be recognized,
however, that although he must have been heartened by the praise for
the aesthetic beauty of his photographs, Smith was frustrated by his
inability to make effective use of his images to rally popular support
against Franco. "Spanish Village" did not stop the passage of the first
U.S. aid grant to Spain in 1950, nor did it stop a second loan the
following year. This inability of the photographer to influence political
events caused Smith to view "Spanish Village" as a failure. An award
for the artistic merits of "Spanish Village," the first *U.S. Camera* award,
Smith bitterly characterized as commercialization's "thinly gilded gold
achievement medal."[79] Although he failed to effect change with "Spanish
Village," Smith realized his desire a few months later with his story
about a black nurse-midwife from South Carolina.

# CHAPTER 4

# "NURSE MIDWIFE"

OVERLEAF

*64–75. "Nurse Midwife: Maude Callen Eases Pain of Birth, Life and Death,"*
Life *XXXI/23 (December 3, 1951), pp. 134–145. W. Eugene Smith,*
Life *magazine, copyright 1951, Time Warner, Inc.*

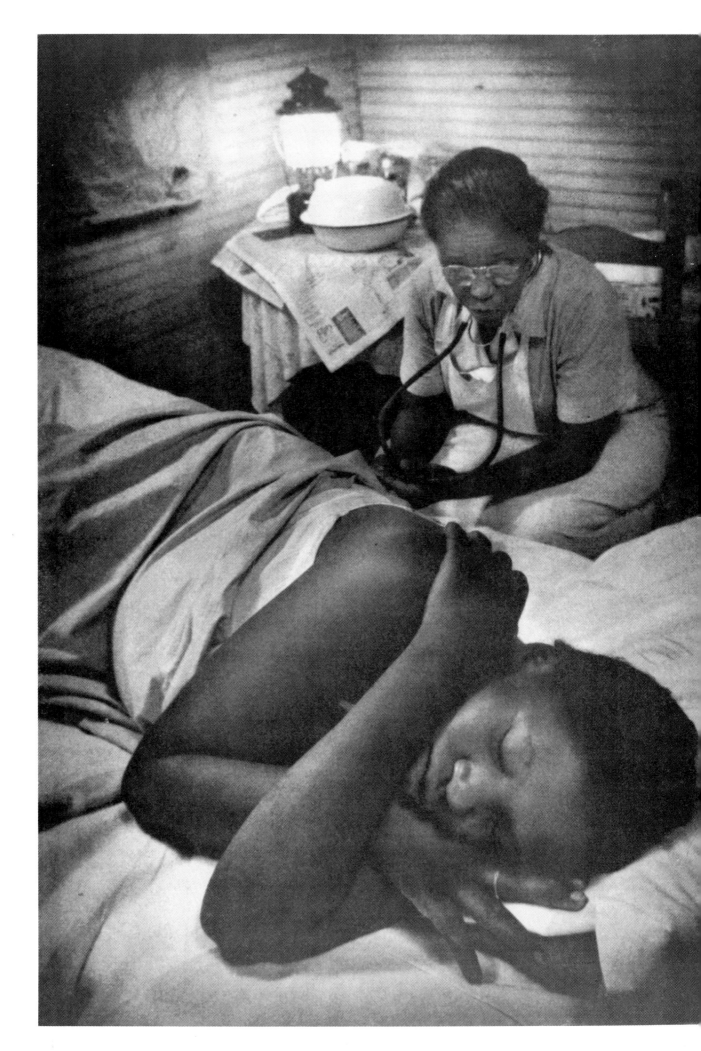

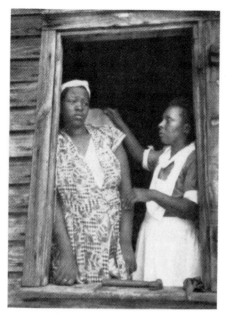

**WAITING,** the young mother leans forlornly against the window, ignoring sympathy and looking for Maude's car.

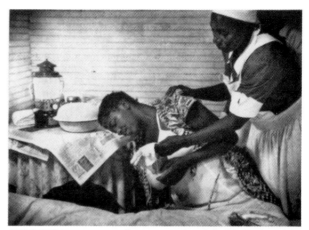

**FRIGHTENED AND SICK,** the nervous mother is helped by Phoebe Gadsden, the first midwife she called. Mrs. Gadsden, a practicing midwife who attended Maude's classes (*pp. 144, 145*), has helped at several deliveries but felt that this one needed special attention and so decided to ask Maude to come and supervise.

# Nurse Midwife

## MAUDE CALLEN EASES PAIN
## OF BIRTH, LIFE AND DEATH

### PHOTOGRAPHED FOR LIFE BY W. EUGENE SMITH

Some weeks ago in the South Carolina village of Pineville, in Berkeley County on the edge of Hell Hole Swamp, the time arrived for Alice Cooper to have a baby and she sent for the midwife. At first it seemed that everything was all right, but soon the midwife noticed signs of trouble. Hastily she sent for a woman named Maude Callen to come and take over.

After Maude Callen arrived at 6 p.m., Alice Cooper's labor grew more severe. It lasted through the night until dawn. But at the end (*next page*) she was safely delivered of a healthy son. The new midwife had succeeded in a situation where the fast-disappearing "granny" midwife of the South, armed with superstition and a pair of rusty scissors, might have killed both mother and child.

Maude Callen is a member of a unique group, the nurse midwife. Although there are perhaps 20,000 common midwives practicing, trained nurse midwives are rare. There are only nine in South Carolina, 300 in the nation. Their education includes the full course required of all registered nurses, training in public health and at least six months' classes in obstetrics. As professionals they are far ahead of the common midwife, and as far removed from the granny as aureomycin is from asafetida.

Maude Callen has delivered countless babies in her career, but obstetrics is only part of her work. To 10,000 people in a thickly populated rural area of some 400 square miles veined with muddy roads, she must try to be "doctor," dietician, psychologist, bail-goer and friend (*pp. 140, 141*). To those who think that a middle-aged Negro without a medical degree has no business meddling in affairs such as these, Dr. William Fishburne, director of the Berkeley County health department, has a ready answer. When he was asked whether he thought Maude Callen could be spared to do some teaching for the state board of health, he replied, "If you have to take her, I can only ask you to join me in prayer for the people left here."

◀—**WEARY BUT WATCHFUL, MAUDE SITS BY AS MOTHER DOZES**

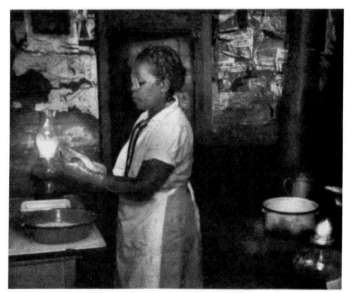

**MAUDE GETS READY** in the kitchen by lamplight. In addition to the stethoscope and gloves, her equipment consists of about $5 worth of such items as clean cloths, bits of cotton, scissors, cord ties, Lysol, surgical gown and mask and a blood-pressure gauge. Her deliveries are always made under aseptic conditions.

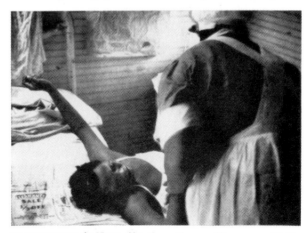

**IN DEEP PAIN,** the 17-year-old mother writhes, mumbling prayers while Mrs. Gadsden holds her hand. She could do little to relieve pain because she is not permitted to administer any drugs. The mother was worn out and weak even at the beginning of her ordeal, having previously gone through a period of false labor.

**4 A.M.** As hard labor begins, the face of Alice Cooper seems to sum up all the suffering of every woman who has ever borne a child.

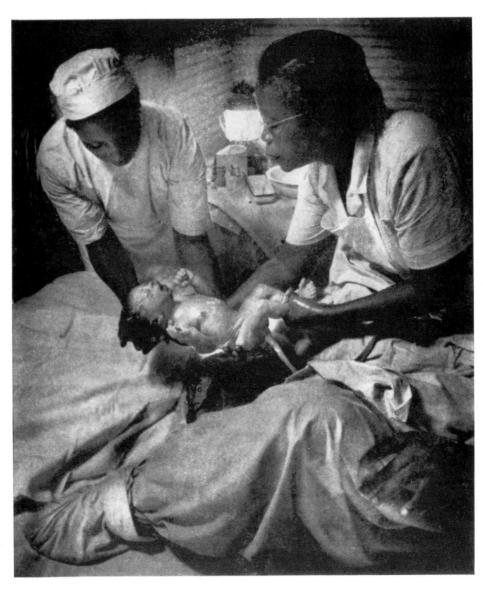

**5:30 A.M.** A few seconds after the normal delivery, Maude Callen holds the healthy child as he fills his lungs and begins to cry.

**5:45 A.M.** The mother's aunt, Catherine Prileau, tries to soothe her so that she will go to sleep and begin to forget her misery.

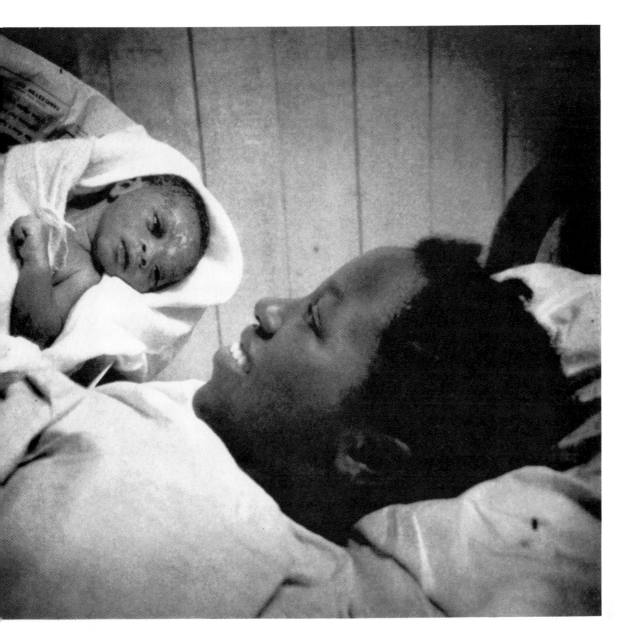

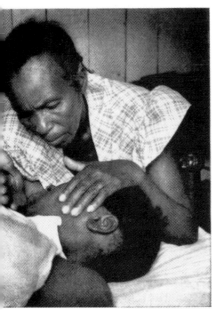

**5:40 A.M.** The long suffering over, the mother first sees her son. She had no name for him, but a week later she chose Harris Lee.

**6:20 A.M.** Her work over at last, Nurse Midwife Callen quietly takes the first nourishment that she has had for more than 27 hours.

CONTINUED ON NEXT PAGE

MAUDE AT 51 has a thoughtful, weary face that reflects the fury of her life. Orphaned at 7, she was brought up by an uncle in Florida, studied at Georgia Infirmary in Savannah, became a nurse at 21.

HEALTHY TWINS, who were delivered a day apart last year by Maude, get a quick once-over when she stops in to see them and to pump herself a drink of water. Only about 2% of her patients are white.

# MAUDE'S 16-HOUR DAY

Maude's duties as midwife are no more important than those as nurse. On her daily rounds she sees dozens of patients suffering from countless diseases and injuries. She visits the nine schools in her district to check vaccinations, eyes and teeth. She tries to keep birth records straight, patiently coping with parents who say, "We name him John Herbert but we gonna call him Louie." She tries to keep diseases isolated and when she locates a case of contagious illness like tuberculosis she must comb through her territory like a detective, tracking down all the people with whom the patient may have been in contact. She arranges for seriously ill men like Leon Snipe (*right*) to go to state hospitals, and she keeps an eye on currently healthy babies to see that they remain that way. Whenever she is home—she is childless and her husband, a retired custom-house employe, sees her only at odd hours—she throws open a clinic in her house to take care of anyone who wanders in. And sometimes patients like Annabelle McCray Fuller (*below, right*) will travel all the way from Charleston, 50 miles away.

Maude drives 36,000 miles within the county each year, is reimbursed for part of this by the state and must buy her own cars, which last her 18 months. Her work day is often as long as 16 hours, her salary $225 a month. She has taken only two vacations and has now become so vital to the people of the community that it is almost impossible for her to take another.

TUBERCULOSIS CASE, 33-year-old Leon Snipe, sits morosely on bed while Maude arranges with his sister for him to go to state sanatorium. Maude had met him on road, noticed he was thin, wan and sickly.

AFTER ANOTHER DELIVERY Maude departs at 4:30 a.m., leaving the case in charge of another midwife. Since she is already up, she is likely not to go to bed but to continue through rest of morning.

ACCIDENT CASE is brought to Maude's door one night. Annabelle Fuller was seriously cut in an auto accident and Maude had given her first aid. Now the girl returns to have her dressings changed.

**CRIPPLED GIRL** greets Maude at her door. Last summer Maude arranged for her to go to a state camp for crippled children which had strict entrance requirements —each child had to have two dresses and one pair of pajamas. The girl could not meet these, but after Maude got her one dress and one pair of pajamas, she could.

CONTINUED ON NEXT PAGE

**NEW DRESSES** for 9-year-old Carrie (*right*) and 8-year-old Mary Jane Covington were dropped off by Maude on her way to a patient. Occasionally, as in this case, she gets clothing from friends or charitable organizations and distributes it where she thinks it is most needed. But sometimes she buys the clothes herself.

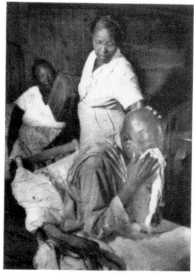

**SIMPLE KINDNESS** overwhelms an old man. Frank McCray had a headache one day in 1927, soon was paralyzed, and has been in this chair ever since. He broke down and wept when Maude stopped in.

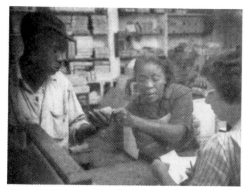

**EXTRA DUTY** assumed by Maude includes cashing of relief checks and dealing with storekeepers for several people who are mentally incompetent or, like this man, blind. She paid his bills for him and counted out change so he could buy some tobacco.

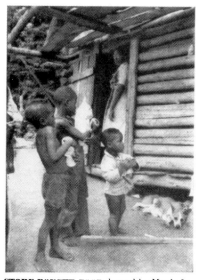

**STORE-BOUGHT FOOD** donated by Maude fascinates youngsters outside log cabin. She frequently finds families with only two or three items on their diet, recently found this one living entirely on corn.

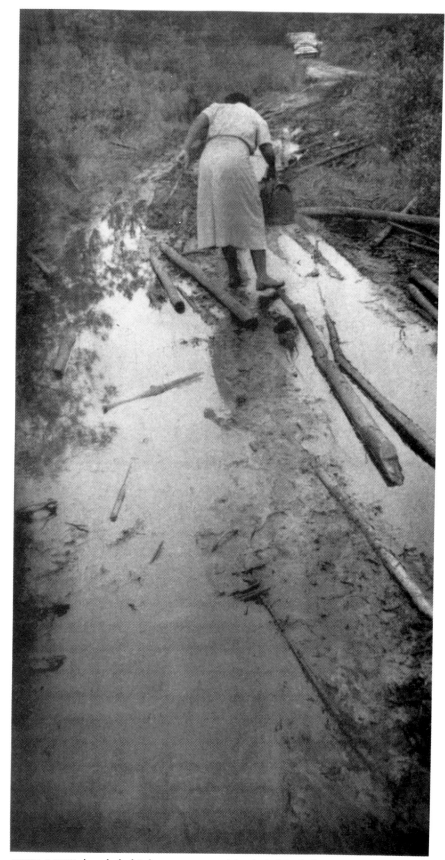

**AFTER A CALL** she wades back to her car. Roads like this are not unusual. At the end of some of them in the '20s, she "found people who did not know the use of forks and spoons."

CONTINUED ON NEXT PAGE

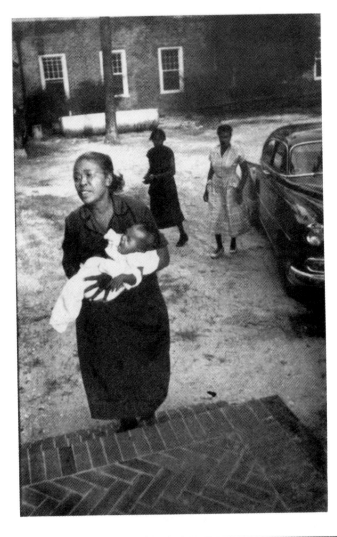

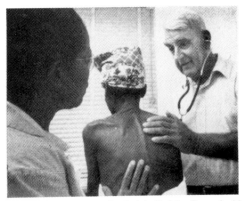

**DR. W. K. FISHBURNE,** head of the Berkeley County health department, examines a patient brought to hospital by Maude.

# MAUDE AND M.D.

When she is not visiting her patients in their homes, Maude holds clinics in churches, school buildings and backwoods shanties throughout her district. Some are for a single purpose—inoculations, classes for midwives or expectant mothers, examinations for venereal disease. Others are open to all comers with all ills. All are part of the activities of the South Carolina State Board of Health, Maude's ultimate employer, which has perhaps the best state midwife-education program in the U.S., although a recent budget cut seriously threatens it.

At her clinics Maude does not compete with doctors. There are not enough M.D.s in any case to cover the territory, and whenever her patients are in need of treatment that Maude is incompetent or unauthorized to give, she takes them to the health department clinic or the county hospital. There she works under the direction of Dr. William K. Fishburne (*above*), from whose shoulders she has taken an enormous amount of work.

**DYING BABY** who is suffering from acute enteritis is rushed to hospital. Mother brought her to Maude, who took her temperature (105°) and raced 27 miles in hope of saving her life.

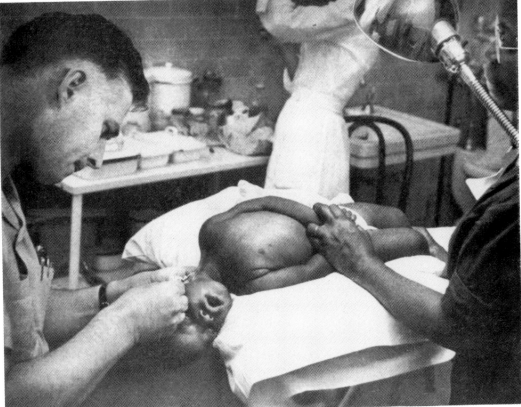

**TRANSFUSION** was almost impossible because fever's dehydration had affected arm veins and doctor had to try one in neck. Baby died before he could get blood flowing.

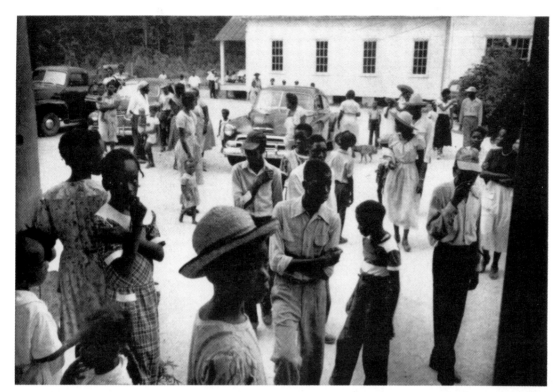

**OUTSIDE A CLINIC**
held in school, crowd waits
to see Maude. On one aft-
ernoon, with one assist-
ant, she gave 810 typhoid
shots, later went out and
delivered another baby.

**INSIDE A CHURCH,**
Maude inspects a patient
behind a bedsheet screen.
She dreams of having a
well-supplied clinic but
has small hope of getting
the $7,000 it might cost.

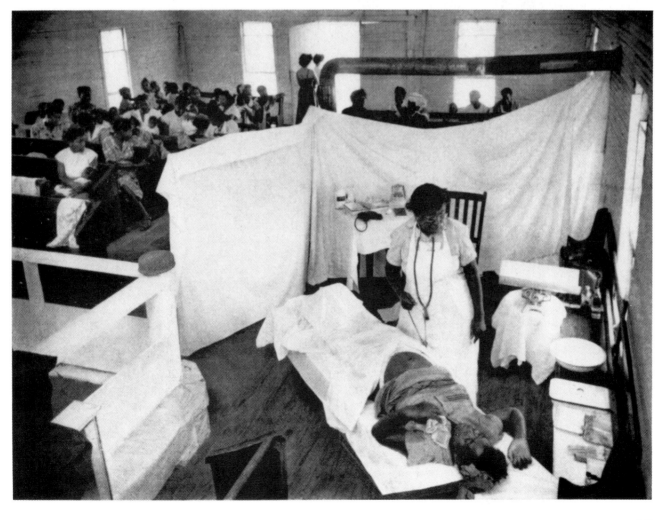

CONTINUED **ON NEXT** PAGE 143

## Nurse Midwife CONTINUED

**MAKING A DELIVERY PAD** in patient's home according to classroom method, Maude crimps together the edges of several pieces of newspaper. Her materials must be makeshift; even paper is scarce.

**INCUBATOR** is made of box and whisky bottles full of warm water. The bottles are placed at foot and sides of box, then covered with layers of cloth. This will sometimes work for as long as two or three hours.

**CRIB** is made of an old fruit crate propped near a cold stove. Maude must demonstrate even this simple idea—she has seen newborn babies thrown into bed with older children where they might suffocate.

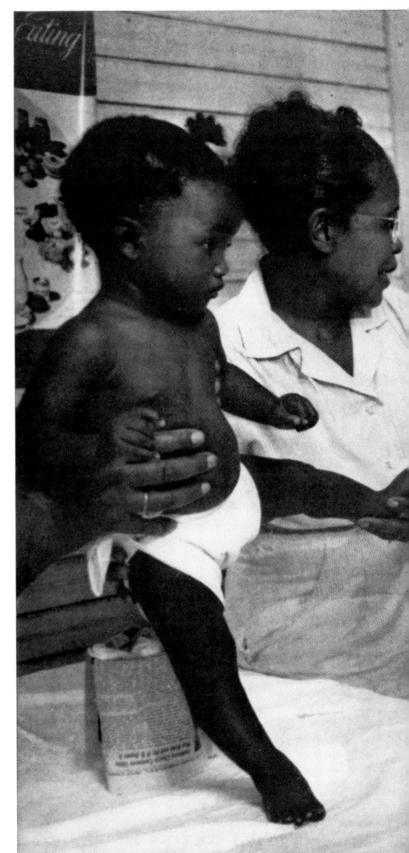

**TEACHING A MIDWIFE CLASS,** Maude shows how to examine a baby for abnormalities. She conducts some 84 classes, helps coach about 12 new wives each year. These midwives, who are alr

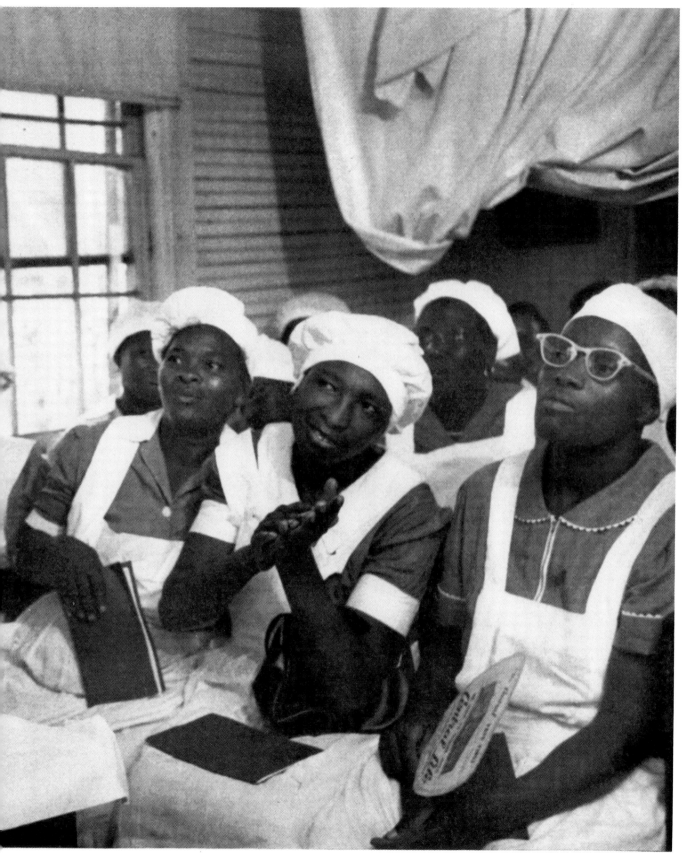

practicing, return to Maude for monthly refresher courses which open and close with a hymn. Few have more than fourth-grade education but are trained for two weeks at the state midwife institute and are very proud of their calling. Unlike Maude, they get fees for deliveries, set at $25 but often paid in produce.

## Concept and Publication

Midwifery was not a particularly topical subject in 1951, so it is likely that the idea for "Nurse Midwife" was suggested by Smith. According to him,

> As near as I can remember – the first idea came in Wales. I wanted to do a midwife essay there. Went to Spain, however, and tried to incorporate midwife as an element there. This ended when we fled the country. I left more hurriedly than I intended.
>
> One night I wakened to the fact – what better country than the U.S.? – idea of the common midwife.
>
> I approached the magazine and got an agreeable answer. Kenneth MacLeish of the Science Dept. – I have done several stories with him and it's been most rewarding. We tried to find out about midwife programs and found the best one in S. Carolina. . . .[1]

Although Smith may have suggested the original idea, it had to be approved by editors and go through official *Life* magazine procedure. It is interesting to examine the preparation for the story because it demonstrates the extensive and complex process of photo-essay production at *Life* magazine.

After the editors discussed the idea, they assigned a researcher, Nancy Genet, to investigate the subject further. It is not known exactly when the story was proposed but in mid-April 1951 Genet sent a memo to picture editor Ray Mackland in which she outlined possible approaches. In the opening sentence of her two-page typescript she stated the premise of the photo-essay:

> We have in mind a real honest-to-gosh grass roots human interest essay on midwifery – a phase of American medicine that is little known, rarely publicized, and still very important in many sections of the country.[2]

She provided a rough shooting script and suggested it revolve around two basic situations: first, "a good midwife club meeting"; and second, "the difficulty she has in traveling to her scattered cases and the assortment of problems she meets up with."[3] Genet advised choosing a midwife and a community that were photogenic and suggested several

possible locations – showing the subject visiting a variety of scenery and homes and reaching her patients by more than one means of transportation. She concluded her typescript by recommending either South Carolina or Louisiana and suggested that the photographer be assigned as soon as possible. Despite her proposals for particular pictures, her conclusion stressed the freedom of the photographer:

> We do not want point pictures, or pictures showing women in clinics etc.; emphasis will be on human interest. . . . We leave it up to the photographer to pick the community he feels offers the best pictorial possibilities, and we leave the precise pictures up to him. . . .[4]

Picture editor Ray Mackland assigned Smith to the story. Two weeks after her first letter, Genet sent additional research directly to Smith. It was a a thorough document. The three-page memo summarized the past research done by *Life* "stringers" in South Carolina, Georgia, Mississippi, and Louisiana.[5] The typescript provided names, addresses, and phone numbers of the people who had done preliminary research in each state, the public health official to be contacted, and a brief description of the advantages and disadvantages of each location.

Nancy Genet's research report made pointed reference to the fact that several state public health officers expressed an unwillingness to cooperate with the project. For example, Dr. Felix Underwood, head of the Board of Health in Jackson, Mississippi, refused to help because "he thinks we will end up making Mississippi look backward."[6] Even with South Carolina's model program, Dr. Ben Wyman, the head of the State Health Department, was skeptical of *Life*'s intentions:

> He at first was reluctant to help us because he doesn't like Luce-papers – but after Leland assured him we wanted to show that South Carolina has somewhat of a model program in midwifery and that our approach would be positive, not negative, he finally has OKd the program provided we check for accuracy with him – which we'd do anyway.[7]

She concluded her research by recommending South Carolina because, she said, its midwife program was the most professional and its varied terrain would provide picturesque locations.

South Carolina was a good choice for many reasons. In most states,

midwives were discouraged from practicing, but not in South Carolina. Responding to an abnormally high maternal death rate, the South Carolina Public Health Department had begun actively regulating midwives in the 1930s. By 1951, midwives were licensed by the state and were required to attend a two-week midwife institute (an intensive course of study) every four years. The purpose of these institutes was "to teach better care for mothers and babies and to teach a broader concept of living."[8] At the institutes midwives learned to be good birth attendants and also were instructed in broad areas of preventive health care. State midwife institutes introduced ideas about nutrition, venereal disease, tuberculosis, and children's diseases.

*Life*'s research stressed the progressive qualities of South Carolina's program of midwife training. The *Life* editors assigned Smith to document this training and to report on typical midwife activities. Over the next several weeks the *Life* research staff provided him with typescripts and tearsheets from magazines, pamphlets on midwives, a *Manual for Midwives* published by the Mississippi State Board of Health, and a teaching guide for the film *All My Babies*, an educational film about midwifery done under the auspices of the Georgia Department of Public Health.[9]

Under normal circumstances a researcher/writer either preceded or accompanied the photographer, taking down names and other pertinent information for the captions and text. For "Nurse Midwife" Smith assumed this responsibility. He gathered the background information; selected the subject; got the relevant names, release forms, and details; conducted interviews with the principals involved; and typed the final research report. For "Nurse Midwife," Smith was the primary researcher, a fact that allowed him to alter the editorial enterprise for this photo-essay.

Smith began his on-site research almost immediately. In May 1951, he drove to South Carolina with his assistant, Berni Schoenfield. The chronology of the notations in Smith's reporter's notebook shows that he met first with Dr. Wyman and Dr. Sheriff, the men in charge of the South Carolina state public health program. Smith quizzed them about the organization of the Public Health Service, its history, and the number of doctors in the state.[10] During his on-site research, Smith noted the extreme importance of the midwife in South Carolina. In the early pages of his notebook he contrasted the number of beds for obstetrical cases (1123) and the number of births per year (58,000).

At the end of the month, Smith attended a midwife institute in Beau-
forte, South Carolina, where he took photographs and spoke with Nurse
Laura Blackburn. Nurse Blackburn had been directing the midwife
training courses for over twenty years and championed midwife train-
ing both in her model public health programs and in professional jour-
nals.[11] In his interview, however, Smith noted her distinction between
the types of midwives he would find in South Carolina: "1) eager and
neat and clean, 2) not too much background, older, 3) older and won't
learn."[12]

After interviewing Laura Blackburn at the midwife institute, Smith
traveled around the state visiting midwives.[13] During these travels Smith
had an experience that set the tone for his reportage. In Leesville, a
small town outside the South Carolina capital of Columbia, Smith at-
tended a Ku Klux Klan meeting. Smith was appalled by the meeting
but he stayed, as he would later explain, "to photograph by the light
of the flaming cross." This emotional experience of racism provided a
context not available in the *Life* research but one that shaped the pho-
tographer's intentions for the photo-reportage. It was experiences like
the Leesville rally that encouraged Smith to shift the story to Maude
Callen.

It is unclear exactly when Smith met the subject of "Nurse Mid-
wife," Maude Callen. She does not seem to have been recommended
by any one of the principals *Life* sent him to see. Smith noted that
Laura Blackburn told him not to bother visiting Berkeley County (where
Maude Callen worked) because he would find nothing there.[14] It isn't
until about two-thirds of the way through his reporter's notebook, past
several other names and addresses, that Smith wrote down directions
to the Health Center at Moncks Corner in Berkeley County. There
Eugene Smith and Berni Schoenfield interviewed Maude Callen and
Eugenia Boughton, two black nurse-midwives who were also involved
in training midwives. The decision to focus his photo-reportage on
Callen was made during one of these interview sessions.

The interview began with general questions about midwives but soon
turned to the need for advanced training. Neither Callen nor Boughton
held out much hope for further training because of the high cost to the
state. It was implied that white doctors would oppose the training be-
cause of the potential economic impact on their practice if nurse-
midwives were able to supply low-cost medical care.[15] Despite the
objections that further training was impractical, Smith persisted:

> [I]f we never suggest it — if we never implant that germ in their mind it will never grow — I mean it looks like such an impossible situation, but here is one man that was able to do it. Here is one nurse-midwife that was able to do it — over here. Oh fine — maybe we can do it. . . . And if we can have more Maudes, more Eugenies, more — I don't remember the girl down there, and it will gradually — it will always take an individual. . . .[16]

This idea was taken up by Eugenia Boughton. She reminded them that Maude Callen had been recommending further training for midwives for many years. In fact, she continued, it was because of Maude's encouragement that Boughton, after receiving her certification as a midwife, went on to become a nurse. Turning to Maude (this familiar form to Maude Callen was used by Smith and contemporaries) she told the interviewers:

> [A]s a nurse-midwife, why she goes out, and if it hadn't been for her, many lives would have been lost. I mean [your reporting] something, that would show what the midwife is doing. . . .[17]

To center his photo-reportage on Maude Callen would mean changing the story as it was understood by the editors.[18] They had asked for a narrative about the life of a rural midwife and the role an enlightened white woman, Laura Blackburn, had played in the establishment of one of the finest midwife programs in the United States. Using Maude Callen as a leitmotif, however, allowed Smith to act as an advocate for the midwife's cause, as he understood it. By focusing his narrative skills on a black woman whose training exceeded that of the common midwife and by showing the critical role she played in the public health of the people she served, Smith hoped to raise public appreciation for midwives and encourage other women to follow her example.

The importance of advanced midwife training was one aspect of the revised photo-essay concept; the issue of racial prejudice was another. Although present in the conversation about the lack of trust regarding the nurse-midwife's ability to administer simple drugs to her patients, the issue of race was not brought up by either Eugenia Boughton or Maude Callen. It was first broached by Smith:

> I should say their [the doctors'] lack of concern for the negro people — I mean it is one of the things that the negro — the midwifes have taken it upon themselves to be midwifes as a way of helping their own people where the doctors just completely ignored them.[19]

At first, the two women disagreed and reminded Smith that there were white midwives as well as black, but one of the interviewers (presumably Smith's assistant, Berni Schoenfield) countered:

> 4TH VOICE: Doesn't that seem a little bit odd that there are some 1,400 midwifes in the whole state — there are only 11 white?
> CALLEN: Something to think about.
> 4TH VOICE: That definitely indicates something. To me it just adds up that doctors are not particularly concerned with negro work. The more intelligent people amongst themselves have decided that they have to look after themselves — and one way to do it was to take up midwifery.[20]

This passage reveals the second aspect of Smith's interpretation of his assignment — the midwife as a social response to racial prejudice. In this area, also, Maude Callen seemed to be the ideal model for Smith's story. She was a black woman who was trained as a nurse and administered primary health care to the black, rural populace of Berkeley County, South Carolina.

Smith began his photo-reportage a few days after the June 20 interview.[21] To document Callen's medical and social practice, Smith used the same working method that had been so successful in "Country Doctor"; he followed her everywhere during her long, exhausting day. Smith mailed the undeveloped film to the *Life* magazine office in New York, where the negatives were contact-printed and returned to him in South Carolina. This process helped him with the technical problems he encountered in the small-roomed houses that Maude Callen visited. The contact sheets also served as a reminder of what he had already photographed and showed him the development of his narrative. The pictorial control evident in the pictures of the "Country Doctor," however, was, for the most part, absent from the "Nurse Midwife" contact sheets.

The contact sheets show a rapid sequence of events occurring beyond the photographer's control. Despite his inability to manage his photo-reportage, a careful reading of Smith's negatives shows the systematic development of the photographer's conception of his story. The first set of pictures centered on the variety of Maude Callen's practice: examining patients and giving shots, visiting the sick in their homes, doing well-baby checkups, working in clinics, and teaching a midwife

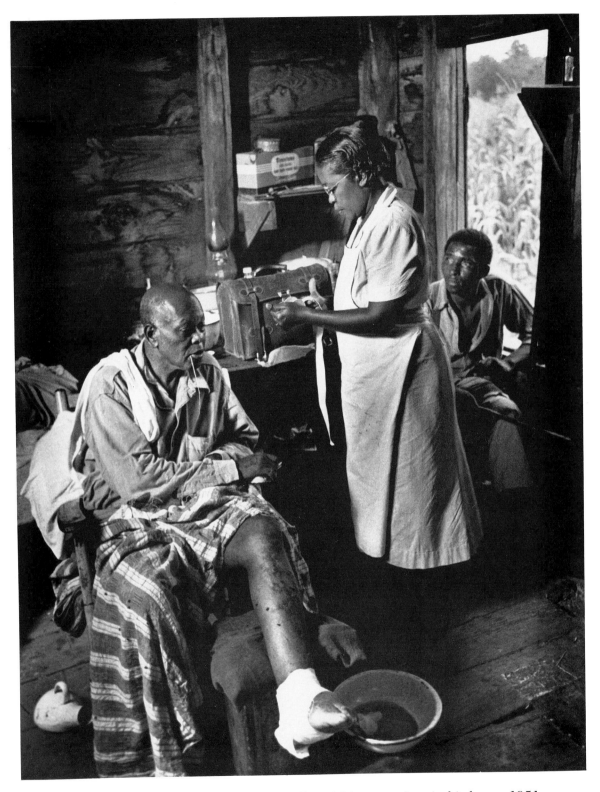

76. ABOVE *Photograph of Maude Callen visiting a patient in his home. 1951.*
*W. Eugene Smith, copyright the heirs of W. Eugene Smith.*

*77. Contact sheet from "Nurse Midwife." 1951. W. Eugene Smith,
copyright the heirs of W. Eugene Smith.*

class (fig. 76).[22] Her calls are many but routine. The exception to this generalization, however, was an emergency that, like the Ku Klux Klan rally, served as a reminder to Smith that his story was more than a simple call for midwife training.

In late June, a mother brought her seven-month-old baby to Maude Callen; the little boy's temperature was 104 degrees. Maude recognized the seriousness of the baby's condition and rushed him to the nearest hospital, twenty-seven miles away. His temperature continued to climb. The baby needed an immediate blood transfusion but the hospital had no blood bank and neither the mother nor Maude Callen was the right blood type (fig. 77). Smith volunteered his blood and related the reaction of the white medical staff in an unaddressed letter entitled "Chronicle of the South":

> They were startled, received the suggestion without warmth, but begrudgingly agreed to use it. That is, the nurses and doctor. The doctor I think was more startled than disgusted. . . .
>
> From the moment I offered my blood, the nurses refused to speak to me unless it was unavoidable, and in that moment had turned completely unfriendly. After all, the stake in the matter was merely a nigger baby's life, not to be confused with anything of value. It certainly was not (to their idea) for a white man to put himself out about it. . . .[23]

Despite their efforts the baby died. This was just one of several reminders Smith would have of racism and its place in his story.

A second set of negatives was developed by *Life* on July 13. Like the first set of pictures they show Maude on her rounds, but these focus more on her social practice: bringing food to a hungry family, helping a blind man buy groceries, and visiting young mothers and their babies for postnatal checkups (fig. 78). A comparison of these two sets of contact sheets shows the systematic nature of Smith's development of his reportage. In the July 3 set, he quickly sketched out the parameters of his story. With only two exceptions the narrative sequences on this first set of contact sheets are only six to twelve frames each. The second set of contact sheets (dated July 13) shows a more thorough reportage, often exposing an entire roll of film to present a single event.

The development of his reportage was also catalogued in his pocket notebook. Sometimes these notations were quick listings of sequences:

Brace to
straighten club feet
pouring water on
hands – cancer patient
at desk in her house
walking, wet, at nite
incubator
measuring pelvis
Maude at picnic[24]

Other notebook entries demonstrate that Smith was considering specific narratives:

Sequence
1. The man arrives to get Maude
2. Washing hands at home, two oil lamps
   (pulling on rubber gloves)
3.4.  During delivery
5.  Leaving (re-shoot)

Clinics
1. Waiting room
2. Fetal heart
3. Church clinic
4. Typhoid clinic[25]

This systematic, conceptual approach to his story allowed Smith to control and form his reportage. Conceptual control was particularly important for this photo-essay because, as we have seen, Maude Callen's hectic pace made it virtually impossible for the photographer to direct events.

Smith concluded his reportage in mid-July after he had photographed Maude Callen assisting a midwife with a woman whose labor was prolonged. As his work came to an end, Smith made sure he fulfilled the details of the shooting script outlined by Nancy Genet. He drove Maude to different locations and made photographs of her walking "in varied terrain" (figs. 79 and 80).[26] After Smith ended his photographic documentation he conducted three sets of follow-up interviews. In addition to providing background information, these interviews explore a latent theme in Smith's photo-reportage – racism. His inter-

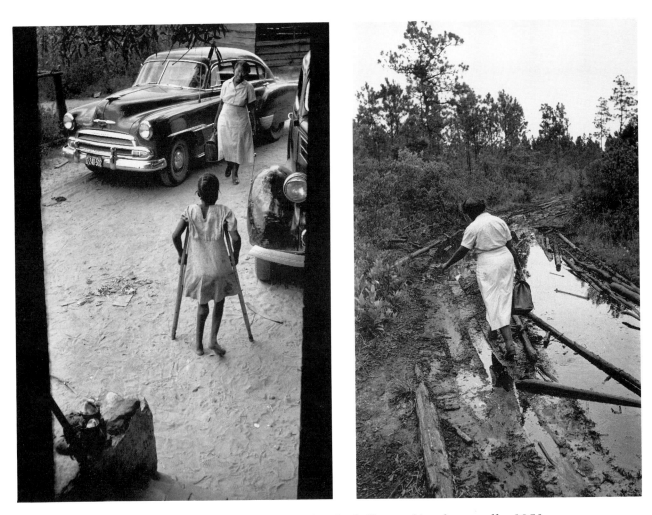

78. LEFT *Photograph of Maude Callen making housecalls. 1951.*
*W. Eugene Smith, copyright the heirs of W. Eugene Smith.*

79. RIGHT *Photograph of Maude Callen crossing muddy road. 1951.*
*W. Eugene Smith,*
*copyright the heirs of W. Eugene Smith.*

view with Maude Callen on July 25 focused on biographical information, the relationship between the Public Health Department and private hospitals, and the problem of racism. It was a long interview; there are more than a hundred pages of transcripts. Numbered drafts of the questions, although not exactly repeated in the interview, were initially jotted down in his notebook. These questions were not exploratory; they were "for the record" questions, soliciting answers that Smith could anticipate. This was true for the majority of Smith's last interviews on this assignment.

On July 27, he talked with both Dr. Fishburne, head of the Public Health Department in Berkeley County where Maude Callen worked, and Dr. Banov, head of public health in Charleston, South Carolina. The interview with Dr. Fishburne centered on the financial support of the Berkeley County Public Health Department, the importance of Maude Callen's work to the county, and the future of maternal and

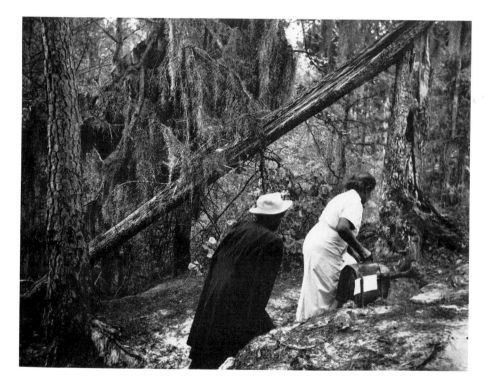

*80. Photograph of Maude Callen*
*walking through forest. 1951. W. Eugene Smith,*
*copyright the heirs of W. Eugene Smith.*

child care.[27] Toward the end of the interview Smith brought up the issue of nursing training for midwives. Dr. Fishburne admitted that there weren't going to be more doctors and that nurse-midwives might be the answer, but he qualified this endorsement by saying, "there just aren't enough sufficiently educated girls." He reminded Smith that cost was an important factor. Dr. Fishburne talked about the expense to the state of training – a prospective nurse had to be sent to Richmond, Virginia for her final training and internship and to New York City for her obstetrical specialty. What he didn't say, but what Smith knew, was that this travel was necessary only because South Carolina maintained strict segregation in its hospitals.

When Smith interviewed the director of public health in Charleston, Dr. Banov, he was introduced to a man with a different sociopolitical agenda. Dr. Banov directed the interview to a lengthy discussion of the private medical profession's perception of public health care as "socialized medicine." He stated clearly *his* intentions for Smith's picture narrative:

> BANOV: Well to tell you the truth I know that your article aims at the general masses, but I'm sure that it'll be read with interest by a great many doctors and I think it'll have an enlightening influence on them. It'll show them that we're not the red died-in-wool socialists that they speak of with so much horror. . . .[28]

Although the discussion returned to this theme over and over again, Smith also discussed his agenda – the importance of training more nurse-midwives. Significantly, in answering, Dr. Banov did not at first understand the intent of Smith's question. He responded by talking at length about the history and the value of trained midwives.[29]

Toward the end of the interview Dr. Banov agreed that nurse-midwives might be very useful, but when he realized the implications, he resisted the idea of further nursing training:

> SMITH: I mean – most of our people laugh – oh the midwife – ha, ha, ha – well we've resented that immensely.
> BANOV: Because their picture of a mid-wife is an old granny that is almost too blind to be useful in any sense. That is the old type of granny that we had in the generation or two ago, but that gen-

eration has gone as you see. These women were in earnest – in
terrible earnest in their work there.
SMITH: And many of them were saying "well, we're out of the first
grade now why don't they teach us a little bit more" – Well, maybe
that can be done and maybe not.
BANOV: Maybe they're not ready for it – maybe – that we don't
know. The chances are they may not be ready, but they have made
progress.[30]

As these passages make clear, Smith was given little hope for addi-
tional training of black midwives by these two relatively enlightened
and sympathetic white, male administrators.

Smith returned to New York in early August, having sent his final
set of negatives to *Life* approximately two weeks earlier. During the
editorial phase of his photo-reportage, Smith wrote the research text.
After the photographs were printed, 161 of them were given to Eugene
Smith to identify and caption. He was systematic in this process. He
first made a handwritten list of the photographs and summary notations
of the information he remembered. In instances where he lacked im-
portant details, Smith wrote follow-up questions and sent them to Maude
Callen. He then combined his original handwritten text with her re-
sponses and compiled an extensive typewritten text of caption infor-
mation for individual photographs and narrative sequences. In addi-
tion to captions, Smith supplied a *Life* writer with a sixteen-page
typescript summary of his research. Smith's statement concentrated on
three main areas: a description of the public health mechanism in
Berkeley County, biographical information about Maude Callen, and
a litany of Maude Callen's good works.

It should be mentioned that Eugene Smith's research was far from
an unbiased, objective statement. His text was an emotional declara-
tion of the photographer's adulation for Maude Callen. The first para-
graph of the research statement was a sentimental introduction to the
nurse-midwife:

> There beats a heart, surrounding that heart is the sturdy body
> of a woman; and in that body is a strong clear mind educated in
> nursing, in obstetrics; and in that mind is more than medical
> knowledge, for, from the woman pours forth, a quiet, eversurging,
> powerful flow of dedicated work that is more than technical com-
> petence; by reason of tremendous depth of compassionate under-

standing, a complete, unselfish love of humanity – the all that is
the stature of this person; a truly noble realization of the human
potential to good, so seldom found.[31]

Smith exercised an unusual amount of control over the structure of
the "Nurse Midwife" essay. His typescript provided the factual data
from which the accompanying text was written. He also sketched pic-
ture layouts on *Life*'s graph-lined layout sheets. These sketches recon-
firm his commitment to a single heroic individual as the focus of his
story.[32] Although his layouts were not used, Smith was pleased with
the final arrangement of "Nurse Midwife," which was published on
December 3, 1951.[33]

## Narrative and Aesthetic Reading

"Nurse Midwife" does not carry an explicit call for more training for
midwives. It does, however, fulfill Smith's overriding concern: that
Maude Callen be represented as an ideal for public emulation. Callen
is shown as a widely skilled medical practitioner who unselfishly serves
the poorest members of her community. A narrative and aesthetic reading
of the photo-essay demonstrates how the pictures and text structure
the photo-essay to convey this message to *Life*'s readers. The narrative
structure of the photo-essay is divided into three sections of four pages
each. These sections center on Callen in her roles as midwife, nurse,
and public health professional.

The introductory section consists of two double-page spreads that
chronicle a woman's labor and the birth of her baby (figs. 64–67).
Maude Callen is shown to be the critical figure in the medical care of
this young mother. The introductory photograph, filling the left-hand
page of the first spread, is large-scale and vignetted, its corners and
edges overexposed in the darkroom (fig. 64). The photographer has
cleverly disguised the vignetting by having the light seem to emanate
from the kerosene lantern. The highlights in the photograph direct our
attention to the bedridden young mother and to Maude Callen sitting
beside her. This picture and those on the right-hand page (fig. 65)
introduce us to the main focus of the photo-essay – the nurse-midwife.
The title, "Nurse Midwife: Maude Callen Eases Pain of Birth, Life and
Death," also informs the reader of the range of Callen's medical skills.

The picture layout subtly stresses her competence as a medical practitioner. In the large photograph on the far left, for example, Callen touches her stethoscope. This brings the reader's attention to the instrument which, iconographically, is associated with doctors and modern medical care. The photograph on the far right, center, serves a similar purpose. It is borrowed from a different birth sequence (see fig. 108, no. 8) but is inserted among these birth pictures because it demonstrates the professionalism with which Maude treats her patients. Despite a dingy interior whose walls are covered with torn newspaper, Maude cleans her instruments and wears surgical gloves to insure aseptic conditions. The text accompanying the photographs underscores this message:

> Maude Callen is a member of a unique group, the nurse midwife. Although there are perhaps 20,000 common midwives practicing, trained nurse midwives are rare. There are only nine in South Carolina, 300 in the nation. Their education includes the full course required of all registered nurses, training in public health and at least six months' classes in obstetrics. As professionals they are far ahead of the common midwife, and as far removed from the granny as aureomycin is from asafetida.[34]

This passage strongly endorses advanced training for midwives but does so in a backhanded way, by citing the shortage of qualified nurse-midwives. The photographic narrative that follows demonstrates to the reader the importance of the nurse-midwife's work, as seen through the efforts of Maude Callen.

The narrative sequence of birth pictures concludes on the next double-page spread (figs. 66–67). The photographs are arranged in a linear progression from the left-hand page to the right-hand page and from the top to the bottom. Picture edges are darkened, directing the viewers' experience of the photographs and pushing our gaze inward. Two photographs were particularly important to the photographer. The image in the lower left corner (fig. 66) of Callen with the newborn baby was necessary to show explicitly Callen as a midwife. The photograph in the upper right (fig. 67), the mother's first look at her baby, was a motif Smith photographed several times because of its inherent emotional appeal.

The second section of the photo-essay focuses on Callen's duties as a nurse (figs. 68–69). These pictures, reinforced by the text, develop the idea of the range of need for medical care and of the skills of the nurse-midwife. The title and text tell us of Callen's long working hours (fig. 68). She is overworked and underpaid. We see her working late at night, leaving her house carrying only a kerosene lantern to illuminate the dark interiors of her patients' homes. Pictorially her fatigue is conveyed in the picture in the upper left — the drooping flower a visual analogue to Callen's weariness. The other photographs show her as an active and busy medical practitioner and reinforce our perception of her importance to the community. We see her working with a variety of generations, some far removed from the pediatric care traditionally associated with the midwife. The photographs give evidence of her service to the poor and disenfranchised; those who cannot afford to come to her, she visits in their homes.

The next spread (figs. 70–71) continues this exploration of Maude Callen's medical practice, providing examples of the diversity of her humanitarian effort and looking at the social side of her work — feeding and clothing the poor, giving comfort to the afflicted, and assisting the blind. Her status as a healer is given particularly resonant visual form in the small photograph in the top center of the spread (fig. 71). Here we see Maude in the traditional Christian motif of the laying on of hands. She compassionately places her hand on an old man's head in a gesture that suggests healing as well as compassion. The photograph on the far right shows us the environmental difficulties that she must overcome.

The final two spreads present the institutional aspect of Maude Callen's work. In figures 72–73, her public health efforts are described in the text while pictures show her assisting public health doctors and running medical clinics. Two photographs on the left side (fig. 72) narrate the story of the little boy who was brought to Maude with a high fever and for whom Smith was a blood donor. The other three photographs in the spread are grouped around the general theme of public health care. We notice, however, that they continue to stress the diversity of Maude's medical expertise and her invaluable role within the community. The accompanying text addresses two specific social issues that Smith stressed in his research text.[35] It describes South Carolina's advanced midwife training program and notes that the program is threatened by legislative budget cuts. The writer indirectly

calls for more health care training by pointing out that the county lacks doctors and, therefore, that Maude Callen provides basic health care for the community.

The largest photograph on the spread, in the lower right (fig. 73), shows Maude performing prenatal examinations behind the bedsheet in a local church. It became a focus of the photo-essay, not because of the picture but because of the caption, which reads: "Inside a church, Maude inspects a patient behind a bedsheet screen. She dreams of having a well-supplied clinic but has small hope of getting the $7,000 it might cost."[36] This statement came directly from Smith's research typescript. In it he asked the writer to include a plea for money to build a clinic in which Maude Callen could teach her classes and tend the sick. He wrote:

> I gave her a slight hope of her dream coming true, by telling her of my deep burning desire that somehow the story I am doing, perhaps a word or two in some caption, might plant the seed in some mind, that could afford to accomplish it. Call it "The Maude Callen Clinic" and build it while she is alive to know, and let her feel that perhaps there was some gratitude for her life of complete devotion to others.[37]

In this passage Smith states the standard by which he would judge this photo-essay a success.

The conclusion of the photo-essay is a double-page spread of pictures showing Maude as a teacher (figs. 74–75). The column of small photographs on the left remind the reader of the people's poverty and demonstrate Maude's ability to use simple, everyday objects in place of more expensive medical materials. The photo-essay concludes with a large photograph showing Maude teaching postnatal care to a class of midwives; the picture emphasizes the theme of additional training for midwives called for in Smith's research. Not limited to care for laboring mothers, these women are being trained to take responsibility for pediatric care as well.

The introduction of the baby into this final spread also provides an important narrative link to the opening sequence of birth. A comparison of the introductory photographs and the concluding images suggests a chronological progression from birth to childhood – a metaphor for the progression of the midwife to the nurse-midwife. Conceptually

there has also been a progression from Callen as a birth attendant to Callen as a teacher, passing her knowledge along to others. This conclusion, as Smith had intended, encouraged black women to improve themselves by following in Callen's footsteps, taking classes, broadening their abilities, and caring for the indigent black population.

As we can see from this narrative and aesthetic reading of the photographs, the published photo-essay conveys Smith's primary intentions: the depiction of Maude Callen as a mythic heroine whose actions should be emulated by other black women and the communication of the importance of midwives as primary health care professionals. The photographs and text work in tandem: while the photographs direct attention to the works of an exemplary individual, the text supplies the narrative flow and gives details of the breadth of Maude Callen's medical practice. Pictorially, Smith added a sense of theatricality to the narrative by using high-contrast, vignetted prints. The narrative drama upon which Smith focused his camera was Maude Callen's work as a nurse and teacher of midwives, but the photo-essay also had underlying social and political implications that were equally important to the photographer.

## Political and Ideological Reading

*Life*'s original editorial intention was to publish a story about the advances in midwife training. Smith changed the narrative focus and updated it, centering his story on a single black woman who acted as nurse, doctor, and social worker. Instead of straightforward documentation, Smith wanted to use his photo-reportage as a tool for changing the conditions under which Maude Callen and her black constituents lived. Smith's understanding of these sociopolitical issues was central to his reportage. In order to understand the sociopolitical context of Smith's photo-essay one must appreciate the class, gender, and race questions inherent in any reportage on midwives in mid-century America.

For the majority of health care professionals the debate over midwife delivery had culminated in the early 1920s.[38] By the 1950s, the midwife was a relic of the past. Just how rapidly this change came about can be seen in an examination of birthing statistics between 1919 and

the early 1950s. In 1919, New York City midwives delivered 40,000 babies (30 percent of the total births). Ten years later, however, they were responsible for only 12,000 births (12 percent of the total). In the following decades this rapid decline in the use of midwives continued as more and more women elected to have their babies in the hospital. In 1935, 36.9 percent of all births in the United States took place in the hospital; by 1949, this proportion had reached 86.7 percent, and by 1959, 96 percent.[39] The role of the midwife was not of interest to the majority of Americans; it was, however, a major issue among public health officials.[40] They recognized that among the nation's poor, primarily immigrants and blacks, midwifery would remain the dominant form of birthing, in large part because of the high cost of hospitalization.

By the 1950s, the practice of midwifery had become ghettoized among poor black women, especially in the rural South.[41] Because many midwives lacked training, this meant a significant increase in the black infant and maternal mortality rates. The overall maternal death rate in the United States in 1950 was 0.6 per thousand; in dramatic contrast, it was 29.8 among Southern black women. Although this discrepancy was used by public health officials as evidence of the necessity for more midwife training, one can see historically that the lack of public health care was the result of class and racial discrimination.[42] Discrimination was routinely practiced by medical schools and it fell to two black universities, Howard in Washington, D.C., and Meharry in Nashville, Tennessee, to educate the vast majority of black doctors.[43] In 1948 the nation as a whole had a ratio of one black doctor to 3,681 patients; in the South the ratio decreased to one to 6,203, and in South Carolina to one to 12,561.[44]

It comes as little surprise, then, that two-thirds of all black births in South Carolina were attended by a midwife.[45] What is perhaps more surprising is the systematic way in which black midwives took the place of white doctors as the primary health care providers in the black community. As doctors migrated in greater numbers to urban areas, rural health departments began to take measures to mitigate what they termed the "obstetrical gap." One way to bridge this gap was to use midwives on the county health department staff to assist in deliveries.

This aspect of the situation in South Carolina was understood by Smith, as can be seen from an exchange he had with Dr. Fishburne. It began with the Doctor's testimonial to Maude Callen:

FISHBURNE: . . . She's got that much sense. — that when she gets
to where she feels like she's getting in deep water then she'll hunt
me.
SMITH: Deep water in what direction?
FISHBURNE: I mean in — to do what maybe a nurse *could* do; but
has no business to do.
SMITH: Would this be in relationship to her knowledge or in rela-
tionship to what the — might tread on the medical associations.
FISHBURNE: What the medical profession allows. We do an awful
lot of work here that the medical profession would take a fit over.
SMITH: And — here's one of the situations when necessity demands
that you do that.
FISHBURNE: That's right. I mean what . . .
SMITH: Who'll take care of them? Doctors aren't taking care of
them?[46]

Smith was not content with a simple call for further midwife train-
ing, however. He felt it was equally important to foreground issues of
race and gender. He rejected the paternalistic approach of a progres-
sive white woman, Laura Blackburn, in favor of a progressive black
woman, Maude Callen. He did this for very specific reasons. He wrote
to his mother:

> The "Nurse-Midwife" story, for many reasons has been very re-
> warding to me. First it has proven out of a long argued theory of
> how to handle certain sections of the racial theme. This seems to
> have been a good and positive way which seems to have left the
> bigots speechless. . . . As for me I feel (as do others) that the
> story struck a powerful blow (though not miracle working) against
> the stupidity of racial prejudice and the theory of inferiority.[47]

Smith chose to address racial discrimination implicitly through a
narrative that stressed the positive actions of an exemplary black woman.
Maude's humanitarian efforts proved her to be as capable as a white
doctor. It was Smith's hope that the example of Maude Callen would
undermine the concept of racial inferiority by demonstrating the ca-
pabilities of this black woman and, by extension, black people in gen-
eral. Maude Callen was not the stereotyped black of early 1950s tele-
vision and film, shiftless and slow-witted; she was authoritative and
knowledgeable. She was clearly an intelligent, capable individual who

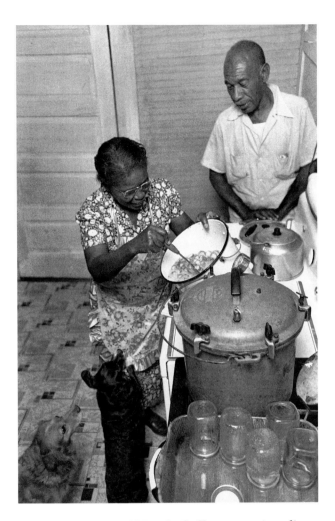

*81. Photograph of Maude Callen preparing dinner.*
*1951. W. Eugene Smith,*
*copyright the heirs of W. Eugene Smith.*

showed both compassion and self-assurance. The photo-essay por-
trayed her in such a way that one could not look down upon her as
inferior, but the opposite: one admired her humanitarian dedication, a
quality that seemed to elevate her above the white doctors with whom
she worked.

Smith also recognized the gendered aspects of his photographic
interpretation. The importance of empowering women is evident in the
raw picture material. To complete his project Eugene Smith made over
2,600 negatives, but with the exception of the two white doctors, there
are no photographs of men in positions of power. Smith's documenta-

tion depicts women helping other women. Dr. Evans, a black doctor who participated in the June 20 interview, is not shown in any photograph. Those few men that are included in the pictures are patients who were helped by Callen, or, in one particular case, assistants who carried a patient into Maude Callen's house. Callen's husband is shown in only a few frames of Smith's negatives and, when he does appear, he is passive and needy (fig. 81). Smith's pictorial record shows a powerful woman and invites others to imitate her. This important point must be understood as another aspect of Smith's intention to encourage black *women* to fill the medical gap, improve the black mortality rate, and become nurse-midwives.

To communicate these ideas, however, Smith went beyond objective reportage. For example, in the third picture spread (fig. 68), beneath a portrait of Maude Callen, the caption informs us: "Maude at 51 has a thoughtful, weary face that reflects the fury of her life. Orphaned at 7, she was brought up by an uncle in Florida, studied at Georgia Infirmary in Savannah, became a nurse at 21."[48] The accompanying biographical text implies that Maude Callen was typical of the black underclass but had improved her standing through hard work and perseverance. Such was not the case, however. Maude Callen's mother did die when she was seven years old, but Maude was raised in a middle-class home by her uncle who was a doctor in Tallahassee, Florida, and who supported her financially during her nursing training. After her marriage, she and her husband settled in Charleston, South Carolina, where her husband worked in the customs house and she became a private-duty nurse.

Her work in Berkeley County was a shift in priorities, but not one born of economic necessity. It began as part of a religious mission, a fact unacknowledged by the *Life* photo-essay. An ardent Episcopalian, Maude was sent by her church as a medical missionary into the outskirts of the Charleston diocese in 1925. She worked independently of the county public health service for over ten years, during which time her salary was paid by the Episcopal Church. Her commitment, then, was religious and it was as a nurse; only much later did she become involved with the Public Health Department as a midwife. Contrary to the implicit theme of the photo-essay, which called for midwives to be trained as nurses, Callen was a nurse who, only at the insistence of the Public Health Department, had taken midwife training.

The published photo-essay did not acknowledge these exceptional aspects of Maude Callen's life; nor did it acknowledge other ways in which Maude Callen was extraordinary. Although selfless in her practice of health care, Maude Callen was removed from the people she served. She and her husband lived in a middle-class home, one of the few in Berkeley County with electricity, and she was one of the county's highest-paid nurses, black or white. Although it is true that she drove over 3,000 miles a month doing public service, she did so in a relatively new car. She collected two salaries, one from the Public Health Department and one from the Episcopal Church, and her husband drew a monthly state pension check.[49] The three sources of income made her financially comfortable.

In addition to using the research text to de-emphasize certain aspects of Maude Callen's public service, Smith also adjusted his photo-reportage to convey the messages he felt were essential. For example, he had shot pictures of five births before he took the sequence of birth photographs ultimately published. The final sequence was strikingly similar to the earlier ones; the major difference was that in the earlier sequences it was the midwife, not Maude, who delivered the baby. In these sequences, Maude Callen supervised but did not interfere with the midwife's work; she was, after all, not a midwife but a teacher of midwives. In the case of the published sequence, however, we see Smith posing Maude immediately after the delivery as if she is delivering the child herself (figs. 82 and 83). This idea of the nurse-midwife replacing the simple midwife was so important to Smith's interpretation that he made sure that he had captured it literally. For this photo-essay, Smith felt that the ends – furthering midwife training and helping Maude Callen – justified the means. As subsequent historical events make clear, even this positive interpretation was flawed.

"Nurse Midwife" was certainly an endorsement of further education for midwives; it was not, however, a strong indictment of racism. By downplaying the racial segregation of Maude Callen's environment and by ignoring the privileged upbringing she had, Smith failed to make any comment on the economic and social institutionalization of racial discrimination in South Carolina. More importantly, by not directly addressing these issues, the photo-essay left itself susceptible to a sociopolitical reading that supported the racist status quo and tolerated the institutionalization of a segregated class system.

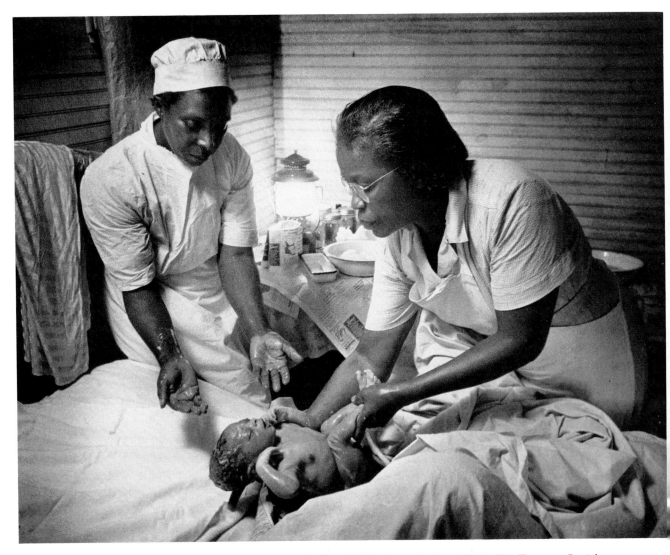

82. ABOVE *Photograph of Maude Callen delivering a baby. 1951. W. Eugene Smith, copyright the heirs of W. Eugene Smith.*

83. OPPOSITE *Contact sheet from "Nurse Midwife." 1951. W. Eugene Smith, copyright the heirs of W. Eugene Smith.*

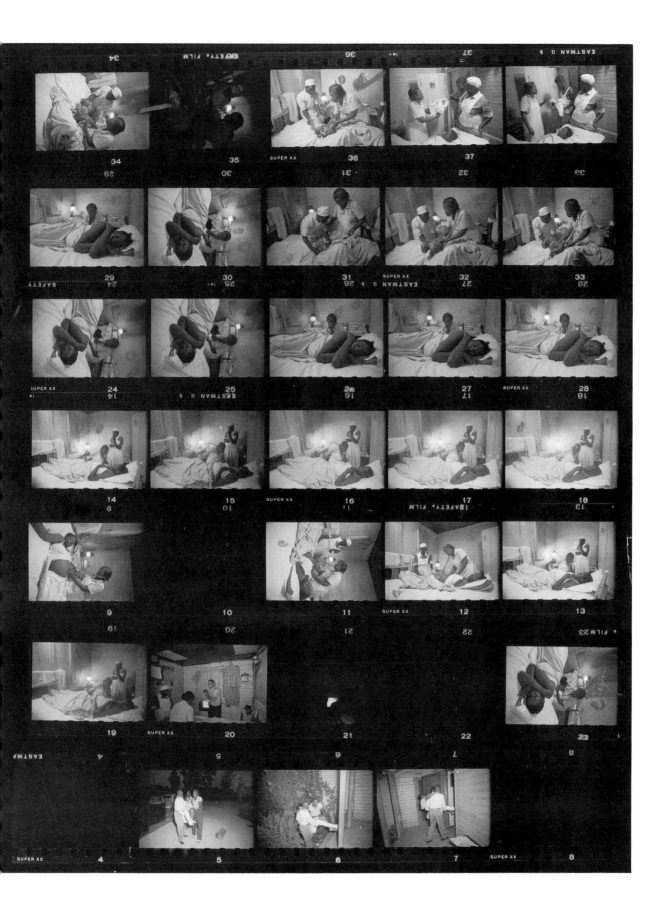

The success of an advanced training program for midwives would have had the general effect of diffusing anger about the treatment of South Carolina's black population. In addition, it would have had two specific negative effects: it would have assured the continued exclusion of black maternity cases from all-white hospitals and it would have meant that white doctors would not be called upon to serve destitute black patients. In South Carolina, midwives functioned as intermediaries between the white and black communities, insuring black segregation. Further public health training of midwives would have institutionalized these injustices. These implications went unrecognized by the photographer, who judged the photo-essay his most successful because of its direct benefit to the person he championed, Maude Callen.

## Public Reception

Smith and *Life* editors did not have to wait long for the public response to "Nurse Midwife." Maude Callen, the Berkeley County Public Health Department, and *Life* magazine were overwhelmed by an outpouring of financial support from *Life* readers. On December 4, Dr. Fishburne wrote to *Life* to thank them for the story and to tell them about a deluge of contributions. A telegram sent by the *Life* office in Charleston on December 8 stated that Maude had become a celebrity and that a steady stream of letters and contributions had begun arriving two days after *Life* went on sale. Even a month later, in its January 7, 1952, issue, *Life* reported that letters and contributions were still averaging over 150 a day. People sent money, clothing, even canned goods, and by late January more than twice the amount needed for the medical clinic had been contributed by individuals who had been affected by Smith's photographs (fig. 84).[50] Some letters addressed the social and political implications of the photo-essay. In a draft letter to his mother, Smith characterized the readers' responses:

> from dirty nigger-lovers, to communist, to "you capitalistic Republican bastard trying to butter up the Dixicrats," etc. Just shows it was a good balance between extremes of both ends. . . .[51]

One particular letter, however, is worth considering in detail because it is a rare challenge to Smith's mediation of his reportage.

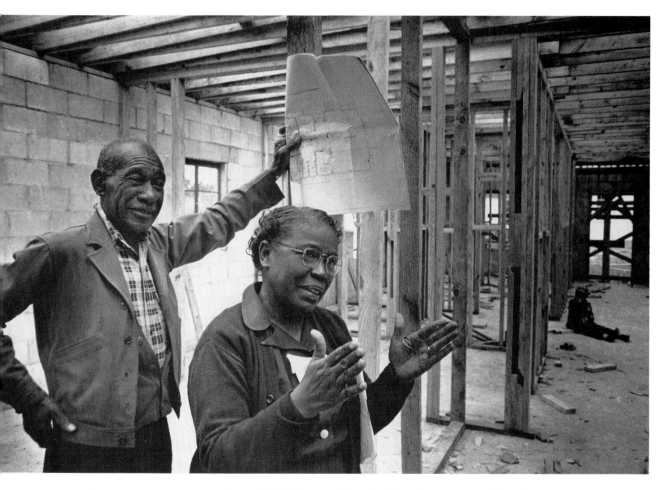

*84. Photograph of Maude Callen and her husband at construction site
of the new medical clinic. 1952. W. Eugene Smith,
copyright the heirs of W. Eugene Smith.*

In a sometimes heated exchange of letters with *Life* magazine, the Episcopal bishop of Charleston characterized "Nurse Midwife" as biased reportage. He summarized his concerns:

> I wrote to advise the editors that the article has omitted certain essential facts about Mrs. Callen: that she is an employed worker of the Episcopal Church; that she lives not near but at Redeemer Mission, Pineville; that she is a worker of the mission; that her work was initiated, is sponsored and partly financed by the Episcopal Church. It seems to me that these are facts of such importance that they should have been included in a twelve-page photographic essay. . . .
>
> Up to the present I have had no light on the real cause of the omission – whether it was simply poor reporting or whether LIFE has certain editorial biases which take precedence over complete honesty in any one article.[52]

Bishop Carruthers was correct in his criticism.

Smith's research text acknowledged Maude's connection with the Redeemer Mission only briefly and his chronological summary of Maude Callen's medical work makes no mention of her association with the Episcopal Church. He wrote, "The transition from the going it alone period, contacting the County Health Board, slowly increasing the inter-cooperation until finally officially uniting with them, covered a span of fifteen years."[53] Research shows that religious instruction was a primary reason for Maude Callen's visits to the families in Berkeley County. Yet Smith's description of her home visits de-emphasized their religious aspect. His only mention of her religious calling was to minimize it: "Sometimes she teaches a bit of the bible to someone who feels he has the call from God to preach."[54] This omission was deliberate.

In addition to his personal distrust of organized religion, Smith must have felt that calling attention to Callen's religious affiliation would limit the potential impact of his story. He wanted "Nurse Midwife" to make a broad appeal, encouraging black women to become medical professionals. Including information about the centrality of her religious affiliation would have marginalized her commitment to health care in the black community. Smith wanted Callen to serve as a model that would encourage others to enter into public health nursing, and he undoubtedly felt that the omission of her religious affiliation was a small price to pay for the positive changes brought about by "Nurse Midwife."

One such change involved state support. The public attention and the overwhelming support for Callen influenced South Carolina legislators to restore funding to public health programs. In the early 1950s, extensive new school construction had forced the South Carolina legislature to systematically cut statewide expenditures.[55] Looking specifically at public health monies, one sees a decrease in the 1949–1950, 1950–1951, and 1951–1952 budgets.[56] For the fiscal year following the publication of "Nurse Midwife," however, expenditures increased by more than $10,000.[57] This increase was a significant sum and was a further sign of the social effectiveness of the "Nurse Midwife" photo-essay.

The publication was seen as problematic at the *Life* editorial offices, however. Writing to Smith the day before the magazine hit the newsstand, managing editor Edward Thompson praised the photographs but criticized Smith's research:

> I'm glad you liked the layout. The pictures were wonderful so not too much credit attaches to the guys who made the arrangement.
>
> I might as well warn you though that I am not so happy about the experiment of letting you do your own research. I don't think the writing came up to the pictures and one reason was inadequate or over-emotional research. I think that next time we will have to work out some compromise whereby you direct the development of the story, which of course suggests the research, but have an experienced reporter either go along or follow you. This doesn't mean that you lose control of the story, the direction and much of the detail will still be yours. It does mean that we assure ourselves of substantial enough research to make possible a writing job that doesn't let the pictures down.[58]

Smith was insulted and angry. His annotations in the margins of Thompson's letter place blame on the writer. Smith claimed that the text had been rushed to print and that the writer did not take the necessary time to craft it.[59] Smith's notes, however, are self-serving. Thompson was right. Smith had failed to report accurately Maude Callen's religious commitment. Furthermore, the tone of Smith's research text was emotional and the tone of the *Life* text was also. It must be recognized, however, that the "Nurse Midwife" text was an accurate reflection of the authorial intentions and emotional advocacy of the photographer.

Despite Thompson's negative response, Smith was very pleased with
the photo-essay. The hypercritical Eugene Smith wrote to his mother:

> Then again out of it all there comes a moment relaxed by a
> reward, a feeling of warm contentment rather than happiness. This
> reward is not of pompous scrolls, nor of commercializes (*sic*) thinly
> gilded gold achievement medals [the *U.S. Camera* award for
> "Spanish Village"]. It comes mostly from within and is the under-
> standing within myself that something I have tried to create, or to
> interpret to others with my pictures has been at least fairly well
> accomplished.
>     Better yet, if my story has become a force for at least a little
> good.[60]

The outpouring of public support was large enough to build a clinic for
Maude Callen and was an affirmation of the persuasive power of Smith's
photographs.

Smith considered the public reception of his photographs as the
most critical element in his photo-reportage. Because of the extent to
which his photographs evoked a humane public response, he con-
sidered "Nurse Midwife" his most outstanding success. If, as seems
likely, Edward Thompson followed through on his insistence that Smith
allow others to supply the research for future essays, "Nurse Midwife"
represents the height of Smith's authorial power. It was short-lived,
however. These issues of authorial intention, editorial interference,
and public reception would cause Smith to resign from *Life* magazine
over the publication of his reportage about Albert Schweitzer.

# CHAPTER 5

## "A MAN OF MERCY"

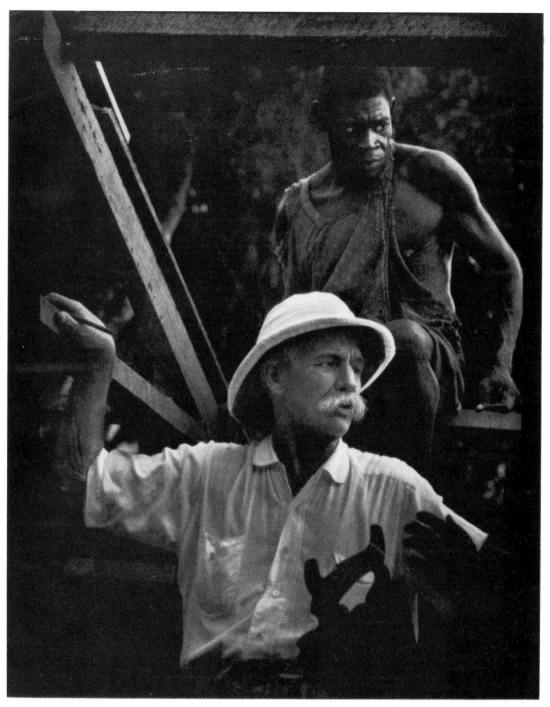

TOILERS, Schweitzer and a carpenter, watch hospital building

# A Man of Mercy

## Africa's misery turns saintly Albert Schweitzer into a driving taskmaster

"No one knows me," Albert Schweitzer has said, "who has not known me in Africa." In Norway last week, where he had come to acknowledge a Nobel Peace Prize, crowds jammed streets to cheer a great figure of our time. As they cheered they were convinced that they knew him well: he is the humanitarian, warm and saintlike. In full manhood he had turned away from brilliant success as a preacher, writer and musician to bury himself as a missionary doctor in Africa.

All this was truth—but admirers who have followed Dr. Schweitzer to French Equatorial Africa know a different man. There, amid primitive conditions, Europe's saint is forced to become a remote, driving man who rules his hospital with patriarchal authority. For those seeking the gentle philosopher of the legend, he has a brief answer: "We are too busy fighting pain." Then he turns back to the suffering and the work that make up the African world of Albert Schweitzer.

Photographed for LIFE by W. EUGENE SMITH

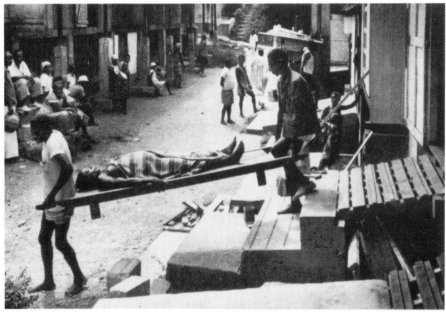

A New Mother is carried across a hospital village's main street from the delivery room to a ward. Her baby, now being washed and clothed, will be cared for at the mother's bed.

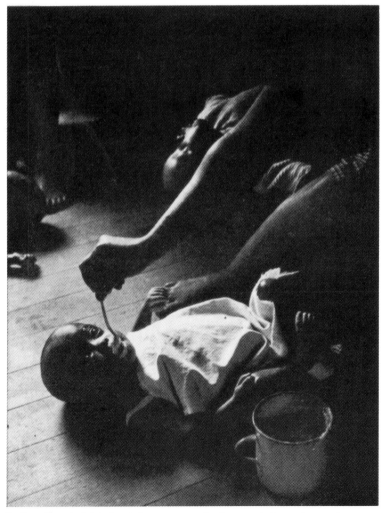

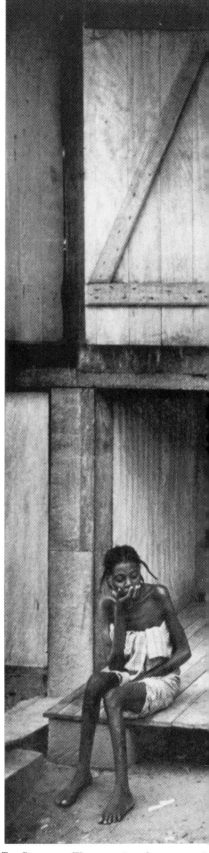

Big-Eyed Baby is fed in hospital nursery. Children whose parents are unable to care for them may be kept as long as three years before being turned over to tribal relatives.

The Doctor at Work examines the postoperati patients on the upper floor of a Schweitzer-designe

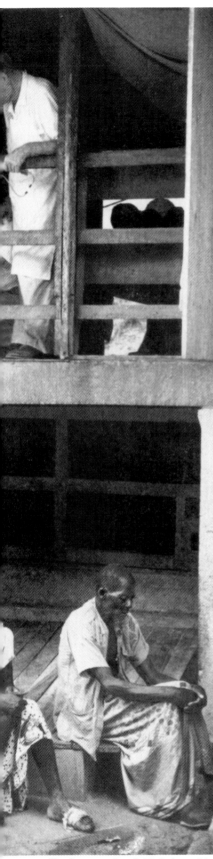

structure. The lower section, behind the waiting patients, is used for storage and emergency rooms.

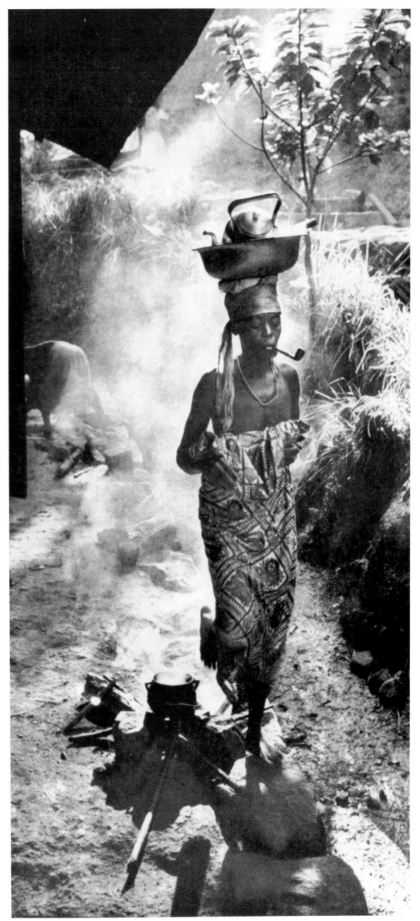

A PATIENT'S WIFE, having finished cooking husband's meal on an open fire in street, takes utensils away. Hospital issues rations to patients but families have to cook them.

CONTINUED ON NEXT PAGE 163

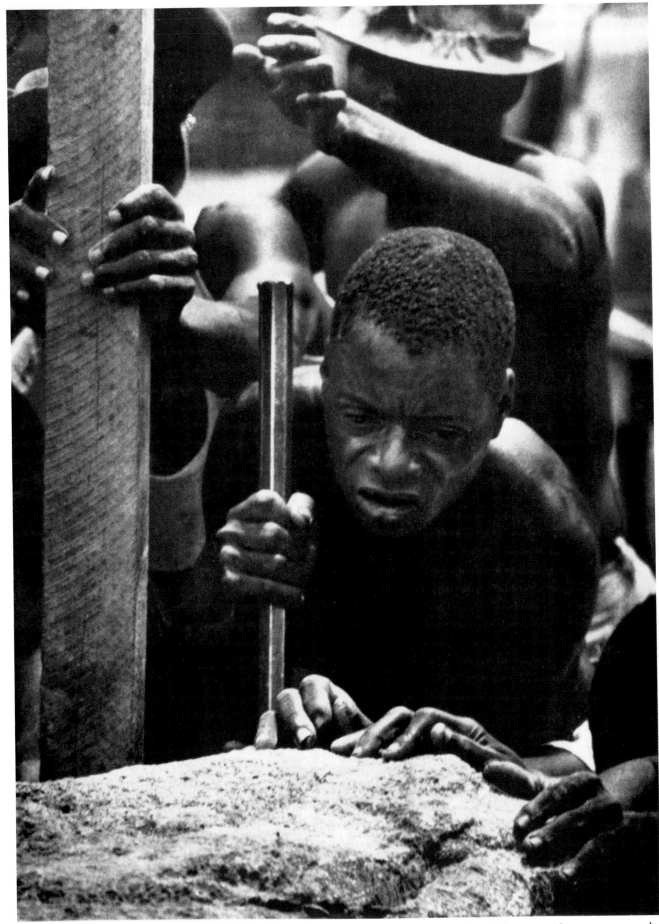

INTENT ON HIS JOB, one of Dr. Schweitzer's workers leans his weight against a crowbar as men try to roll great rock out of the main street of the new village for lepers. Although there are quicker ways to move rocks, this one was muscled out in arduous tradition of African hand labor.

HIS UMBRELLA, carried to work in wet season, is stuck in sand when Schweitzer goes to other job.

# A world of hard work

Starting with a small mission hut which he found in existence when he first came to Lambaréné nearly 42 years ago, Dr. Albert Schweitzer built his general hospital village (*previous pages*). With his $33,149 Nobel Peace Prize he has been building in the past year and a half a separate village nearby for lepers. Every morning at 8 o'clock a bell sounds in these villages and the able-bodied and the walking sick report to the doctor. He assigns them tasks for the day and then begins roaming about watching everything, supervising and pitching in here or there to help or set a faster pace. Except for the hot noontime period men are laboring everywhere, framing buildings, hauling earth and pouring concrete. Occasionally a roar of wrath can be heard as Dr. Schweitzer demonstrates his capacity for exasperation over slow or mishandled work. But soon calm returns and the work goes industriously on.

SHOES for muddy rainy season weather are nearly 30 years old. On y day Schweitzer's restless feet carry him to all parts of settlement.

PORTABLE RAILROAD, lent by a nearby plantation owner, is set down in the main street of the leper village for a major project in earth moving.

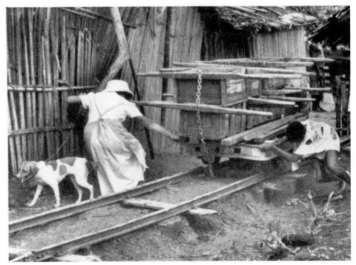

THE TWO RACES, white and black, work together pushing flatcars. The doctor's ire rises when happy-go-lucky workers use carts as roller coasters.

CONTINUED ON NEXT PAGE 165

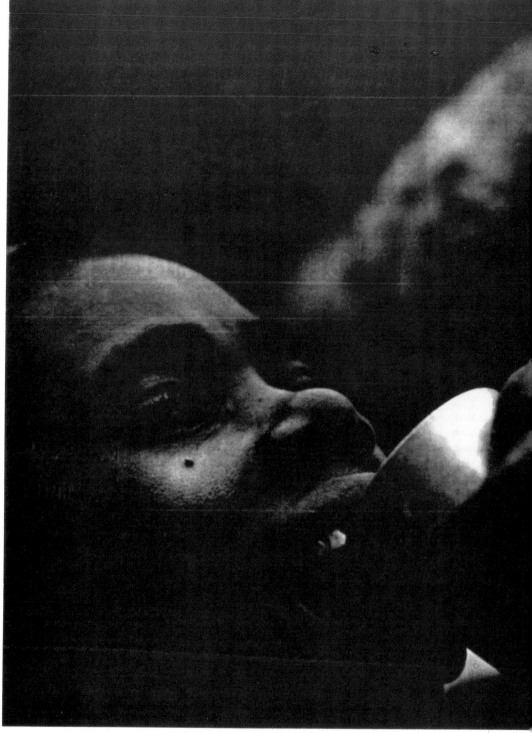

DANISH NURSE Erna Spohrhanssen (*below*) watches
an African aid give sulphone derivatives for leprosy.

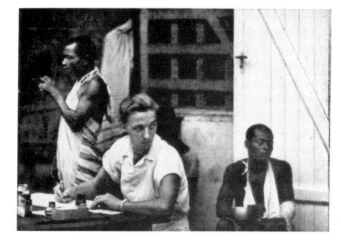

# For the despairing leper

Some visitors from abroad have been startled by the hospital Dr.
Schweitzer directs. Cleanliness is not its most notable quality.
In the open-air operating theaters the antiseptic area is not very
large. Only recently has enough gasoline-generated electricity
been mustered to operate an X-ray machine. Patients, attended
by flocks of relatives, arrive laden with bundles of dirty rags.
The relatives are there to cheer them up, to help nurse them
and on certain rare occasions to see that they are not poisoned
by tribal enemies occupying nearby beds. Sometimes one of
the relatives, intrigued by an unfamiliar piece of furniture, will

LEPERS in line open mouths for medicine (*above*).
One receives pills, another water to wash pills down.

## ...ome hope in new drugs

...ke over the patient's bed while the patient sleeps on the floor.
...But to the African the hospital is a friendly place. Shrewd Dr.
...chweitzer makes sure that it avoids the formality of the gov-
...rnment institutions. And it is kind. In his own village a leper
...ight be driven into the wilderness. Here he is given the drugs
...hich hold out the best hope for curing leprosy. When a bell
...ngs, he stands in line and has an injection of Promin or a Dia-
...one pill popped into his mouth. Then he is given a vitamin tab-
...t against possible bad reactions and a glass of milk because Dr.
...chweitzer thinks it is good for him whether he likes it or not.

NURSE Spohrhanssen treats sores on leper's feet

167

DYING OF OLD AGE, Eugenia Mwanyeno sits under heavy mosquito netting on bed in leper hospital, swaying back and forth with eyes closed, holding tight to last moments of life.

DYING OF OLD AGE, Eugenia Mwanyeno sits under heavy mosquito netting on bed in leper hospital, swaying back and forth with eyes closed, holding tight to last moments of life.

THE MOURNERS, daughter of Eugenia, Helene (*left*), and granddaughter, Hen

THE FUNERAL was attended by Dr. Schwei walking hands clasped behind back, to

A BRANCH OF PALM LEAVES to cover the coffin of Eugenia rests on the ground beside the grave-digging tools. Africans often wrap their dead in palm leaves.

# Death and its sorrowing

"Ethics are pity," Dr. Schweitzer has written. "All life is suffering." What became an almost pantheistic reverence for life drove him into the African wilds to help suffering men. At dinner table he has been known to drop bits of food on the floor for the ants to eat, and it pains him that, in fighting sleeping sickness, he must destroy bacteria. He turns away from death, ignoring it when he can. But sometimes in his hospital settlement an old friend, some familiar landmark in the doctor's long life, passes away. Then Dr. Schweitzer will follow the coffin to the grave and bow in rebellious salute to the enemy, death.

'eno, are in despair by bedside. Granddaughter broke into sobbing chant when coffin lid was closed; for the rest, mourners guarded grief in silence.

raveyard. Though he seldom goes to funerals, he made this an exception ecause Eugenia had long been familiar figure in life of the settlement.

A NURSE stands at the side of the grave, holding her floral tribute

169.

FRUGAL HABITS mark Schweitzer's life. He opens up used envelopes for manuscript paper and he punctures binding holes in them with old nails.

SALVAGED PAPER is tied together with bit of string. Schweitzer's desk always full of old string and pins hoarded to keep his papers in order

# Nights of toil and music

Amid his day-to-day problems Albert Schweitzer at 79 still enriches the reputation from which he turned away when he was 38. Having published more than 17 books ranging from works of philosophy to music lessons, he still writes on in the evenings. Having won renown as an organist, he still practices on a piano equipped with organ pedals, although his powers of concentration are so great that, away from his piano-organ, he can play Bach silently, making the motions on a table top.

SCHWEITZER'S "ORGAN" is a piano with organ pedals. He must imagine in its pianolike "pings" the sound a real organ would make.

LONG after the hospital is asleep, Schweitzer works at his desk

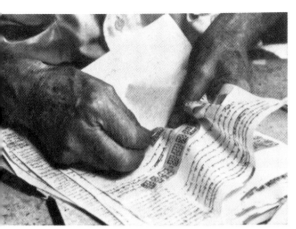

BARS OF MUSIC are carefully pinned to a manuscript to illustrate a point. Schweitzer writes rapidly, filling sheet after sheet in small, precise hand.

FRUIT OF HIS WORK hangs on nails in Schweitzer's study out of reach of any wandering animals. He once lost half a chapter to a hungry antelope.

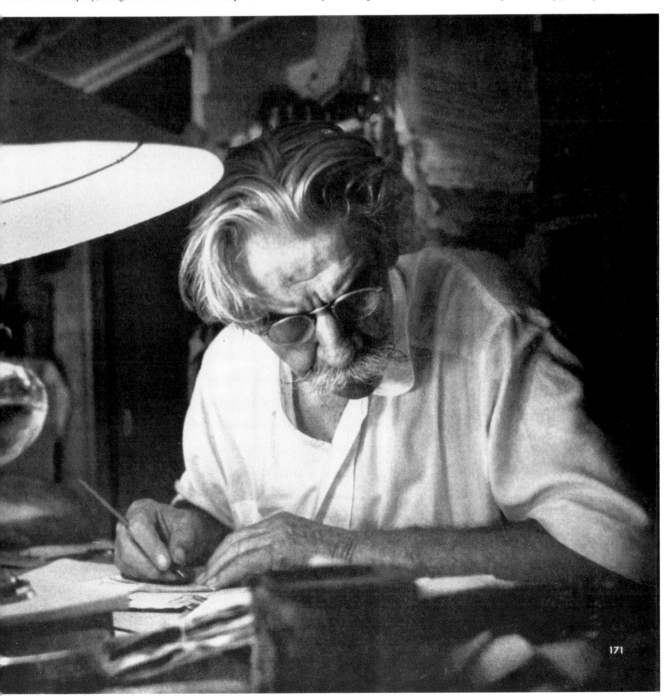

171

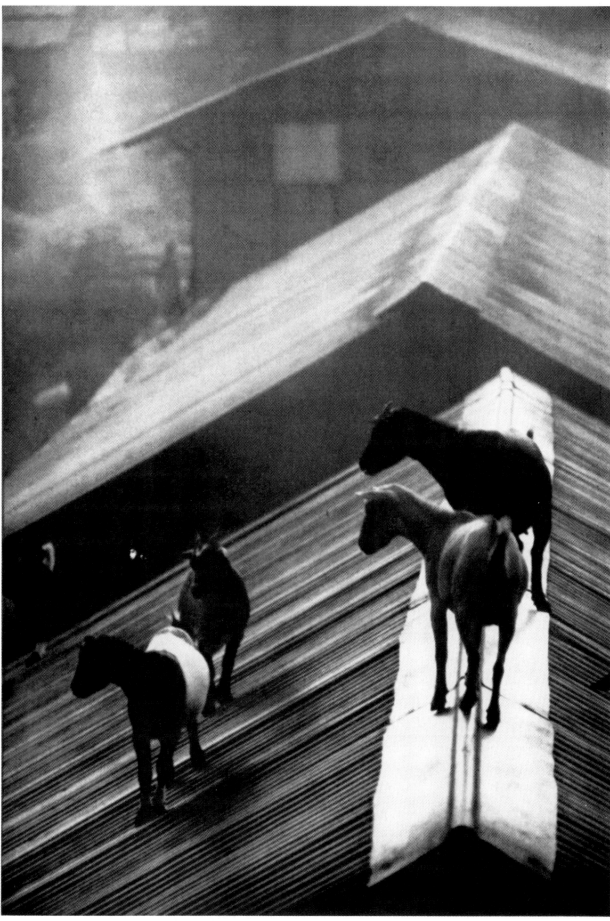

GOATS ON THE ROOFTOPS clatter about and often butt and wrestle each other for the best positions on the ridges. Schweitzer imported a basic herd from Europe some years ago. Its playful descendants still flourish and are allowed to run freely through the village streets and the orchard.

## Concept and Publication

In 1952, Eugene Smith submitted an extensive list of story ideas to managing editor Edward K. Thompson; among them was a suggestion for a story about Albert Schweitzer, the medical missionary, philosopher, and scholar who ran a remote but celebrated hospital in Lambaréné, French Equatorial Africa (in what is now Gabon). Thompson replied to thirteen of Smith's suggestions but was not enthusiastic about a Schweitzer story.[1] Smith brought the subject up again with picture editor Ray Mackland a year and a half later. His letter gives us important insight into his personal motivations and preconceptions:

Dear Ray:

During the past nine years, the story I have more wanted to do than any other has been a full, careful, and intimate story of Dr. Schweitzer. I have brought the subject up many times, as you probably know, and now I bring it up again, hoping the importance of it has been freshly marked by the news of the awarding to him of the Nobel Prize. I have long regarded Dr. Schweitzer as the one man I know of in the entire world I feel I could truthfully call a great man.

I know that from time to time stories [about Schweitzer] have appeared in the magazine, including a text piece. Yet nothing of photographic stature has been done that I know of, and I believe it would be an unfortunate lapse in the documentation of this era, if this one real apostle of good, dies before this is accomplished.[2]

As this letter makes clear, Smith's commitment to the story was deeply personal. His approach to the story was set long before the photo-essay was approved.

The idea of a photo-essay on Schweitzer was discussed by the editors and three weeks later Smith received notification of the assignment from Gene Farmer, foreign news editor.[3] On the same day, Farmer also cabled Schweitzer to ask his permission to send the photographer to Lambaréné. In his cable Farmer told Schweitzer that the purpose of the essay was to "show in pictures the work of your remarkable mission," something he felt could be accomplished in three to four weeks.[4] Acceptance of their proposal was expected; Time-Life had been instrumental in the American recognition of Schweitzer.

In 1949, when Schweitzer made his only trip to the United States, there was a plethora of media attention.[5] *Time* made him the cover story of their July 11 issue and *Life* ran a major text piece supplemented with photographs by W. Eugene Smith and by Dr. Charles Joy, a Schweitzer devotee who had photographed the doctor in Lambaréné. Schweitzer's trip became such a media event that he commented wryly, "One might think I was a movie star or a prize fighter."[6]

Recognition of Schweitzer in the United States was largely a postwar phenomenon.[7] Between 1947 and 1949 four biographies were published in America, and three books by Schweitzer and an anthology of Schweitzer's writings were translated. Among the articles that appeared during this time, *Life* magazine's piece seems to have been particularly influential in this public recognition.[8] Miriam Rogers, the president and organizer of the fund-raising group Friends of Albert Schweitzer, wrote in 1962:

> Musicians, ministers, and scholars in this country naturally were more aware of Albert Schweitzer than was the general public. This was not true, however, in Europe, where Albert Schweitzer was more generally well known. However, when *Life* magazine appeared with this fine article, it was the first time that I had ever heard of Albert Schweitzer. I am sure there were many thousands like me, even millions, but I suddenly realized that I had come "home."[9]

Eugene Smith shared this enthusiasm and attended events sponsored by organizations supporting the work of Albert Schweitzer. In early 1954, Emma Hausknecht, Schweitzer's chief nurse, toured the United States showing slides of the hospital and soliciting funds for its support.[10] This event was widely reported and it is likely that Smith took advantage of her visit to attend her slide lecture and to talk with her about his desire to photograph Schweitzer in Lambaréné.

At approximately the same time, Smith attended an exhibition of photographs sponsored by the Albert Schweitzer Fellowship. The exhibition featured pictures of Schweitzer by Erica Anderson, a movie maker who had filmed biographies of Henry Moore and Grandma Moses. The six-page exhibition catalogue featured quotations from Schweitzer juxtaposed with photographs that presented him in different roles: doctor, preacher, builder, philosopher, teacher, and musician.[11] For the most part the photographs were posed and lifeless.[12] They directed the

viewer's attention to the primitive tribespeople who were hospital pa-
tients and to Doctor Schweitzer as a benevolent man, helping all those,
animals as well as humans, who came to him for assistance. Soon after
the exhibition closed, in late January 1954, Smith received permission
to photograph at Lambaréné.

Schweitzer's January 30 reply graciously invited Smith to come
whenever he wished, stay as long as he wanted, and photograph what-
ever he liked. Schweitzer had only three conditions: if a text was to be
added it must be approved by Schweitzer "to eliminate eventual mis-
understandings or mistakes"; there must be nothing in the text about
Schweitzer as the "greatest man" (a reference to the title of *Life*'s ear-
lier story); and Smith must not shoot any movie film.[13] These condi-
tions were all acceptable to Smith and formal preparations for his de-
parture began.

Smith had already done extensive research. Since he had first cov-
ered Schweitzer for *Life* in 1949, Smith had continued to read books
by and about the doctor.[14] In addition to his personal interest, *Life*'s
research archive contained over one hundred pages of typescript infor-
mation for their 1949 story and tearsheets of more recent magazine
articles.[15] This material was turned over to Smith, who read it and
annotated pertinent information.[16] Both the interviewees and *Life*'s bi-
ographical summary were lavish in their praise of Schweitzer. This
adulation was qualified, however, by comments about the human side
of the man.

Read carefully, the interviews with people who had visited Schweitzer
in Lambaréné revealed a less publicized aspect of the man. Dr. Emory
Ross, chairman of the Albert Schweitzer Fellowship, commented to
the *Life* researcher June Herman:

> Schweitzer is a perfectionist, an individualist who must personally
> participate in any venture or that venture is not a success. He
> seems unable to delegate authority for even the most menial of
> tasks. . . . His major characteristics are tenacity and gentle-
> ness.[17]

After an interview with Melvin Arnold, a man who had visited Schweitzer
in Lambaréné and coauthored a book on this experience, the re-
searcher summarized: "Arnold, like many others, had envisioned a
saintly and somewhat stodgy man, worthy of respect but somewhat

deadly to talk to. Instead, Schweitzer is vigorous, dynamic, hard-driving, hard-shouting."[18] These aspects of Schweitzer's behavior in Africa, especially his insistence on control, would cause major obstacles for Smith.

Eugene Smith left New York City on March 14, 1954, and flew to Lisbon, Portugal. He spent four days in Lisbon, boarded a plane for Leopoldville, Belgian Congo, stayed there two days, then flew to Brazzaville. From there a boat took him to Schweitzer's hospital in Lambaréné. Despite the distance and difficulty, Smith did not travel lightly – his luggage included twenty bags of camera equipment. Upon arrival he did not immediately make photographs; he observed the day-to-day activity and tried to become part of the hospital environment.[19]

Despite Schweitzer's open invitation to come and photograph anything he wanted, once he was at the Lambaréné hospital Smith found that he was restricted in several ways. The specifics of the first conflicts are not clear, but Smith considered them serious enough to threaten to leave. After learning this, Schweitzer asked him to stay and to "forgive his personality." Schweitzer assured Smith that he would be able to photograph in any way he wanted.[20] This pattern of restriction, conflict, and reassurance would repeat itself several times during Smith's nine-week stay at the hospital.

Scarcely five days later, on April 1, Smith confronted Schweitzer again. In his pocket calendar Smith wrote: "Crucial meeting (while building village, I had wanted otherwise) with Clara + Dr. – problem of freedom, of intimacy, dining room, egg symbol – glasses, etc."[21] As this note suggests, one of his biggest frustrations was that Smith found himself excluded from certain activities that promised an "insider's" look at the Schweitzer hospital and its staff. The "egg symbol" is a reference to a birthday custom which included the presentation of an egg as a symbol of the person's value to the community.[22] The "dining room" most likely alludes to a custom performed every evening in the Schweitzer hospital. After everyone was finished eating dinner Schweitzer would read a passage from the Bible and then would quietly walk over to an old piano and lead the staff in singing hymns. The doctor had never allowed this evening prayer service to be photographed.[23] Seeking another way to convey Schweitzer's spirituality, Smith considered but rejected the overused device of photographing the brief Sunday service. This had been done earlier by both Dr. Charles Joy and Erica Anderson. Shooting a new subject such as the evening

prayer service might have been more than a simple novelty; it might have helped to convey a personal view of Schweitzer. Smith rejected the controlled, public manifestation of Schweitzer's spirituality and sought a private vision of the man.

Confounding Smith's intentions, the organization of the Schweitzer hospital made any attempt at intimate portrayal extremely difficult. Schweitzer was surrounded by a tight group of followers who, because Smith did not speak French nor Schweitzer English, were Smith's only way to communicate with the doctor. It is worth quoting at length an unsent cable because it shows the difficulties the bureaucratic organization created for Smith's photo-reportage. He complained;

> The riddles three that I must solve must be in spite of people to whom I would do heartfelt honor. Their smiling grace and hospitality are but masks in front of doors, sometimes open, but too often closed doors. Narrow narrow-mindedly, suspiciously too often pettily closed though I would give them freely of the warm ultimate of my talent. I believe they are fearful of my misunderstanding yet they persist and insist this be a shallow therefore untrue story. Untrue not by intent but untrue by the superficiality of important omissions forced upon me by a narrow-minded closed door policy.
>
> If not for my stubborn desire for depth and fairness I could walk from here today at no cost to my reputation nor to the magazines'. Yet I must try to give them justice for the good work they do or eye (sic) suffer consequence of my conscience. . . . I must attempt to do them justice in spite of themselves. Strange also that on a story open to greatness I have come so close to resigning in bitter failure.
>
> Am not sure at times whether staff is coy or overly modest or just plain terrified of camera. Anyway, Dr. Schweitzer's kind words of my freedom to photograph do not work out in actual fact though not necessarily his fault.[24]

Smith does not seem to have blamed Schweitzer for these restrictions, but it is clear that Schweitzer allowed them. He understood the rhetorical power of the photograph and attempted to control the motifs photographed by Smith, limiting his reportage to posed photographs. For example, Schweitzer made sure that he was photographed as if he still practiced medicine (fig. 97).[25] Schweitzer wanted posed pictures because he could control their content; he was worried about how he

would appear in Smith's candid snapshots.[26] In his notebook Smith expressed his frustration as if in conversation with Schweitzer:

> What I am trying to do in these photographs, is that the result will no longer be a photographer striving to achieve, and no longer will it be Dr. Schweitzer, only as a physical being, a glass such as in a museum placed between us, but through the myriad changes an artist can sometimes work, the results shall be a symbol, a series of symbols of your multi-varied life, not a record that you did sit at a paper covered desk in Lambarene, but a feeling, an emotional, spiritual, human feeling that this is Dr. Schweitzer as he actually wrote words that influenced the world – this can not be achieved by any signal, are we both ready for this photo to be made, and it must be achieved, if it is to be achieved, when such words are being written, or words in which he is giving equal concentration.[27]

Smith argued strenuously against Schweitzer's restrictions, insisting that any limitations to his camera vision would condemn the story to untruth. Evidently, Smith's persistence won concessions from Schweitzer.[28] On April 8 Smith noted: "day of work with Schweitzer, in [?] 12 hours, of sitting, kneeling, bending, 12 hours of almost constant holding up to eye of cameras, keeping my anticipation, my reflexes without a descent into lethargy."[29]

At Lambaréné Smith did not find the moral philosopher whom he had read so diligently before he left for Africa; instead, he found a labor foreman. At the time of Smith's visit Schweitzer was supervising the construction of a new leper village (figs. 98 and 99). In this capacity, he assigned work in the morning, signaled lunch break, and decided when the construction would end. He relentlessly exhorted the native laborers, the vast majority of whom were leper patients, to work harder. Smith wrote to Don Burke, head of the *Life* London office:

> I hope, and work, but do not trust that it will be a good story. The good Doctor is a strangely difficult man, and this place is a strangely complex situation that is not necessarily so, in brotherhood. He is a vain, shy man, passionate in work, and the ruler of the land – his subjects dealt with by firm justice.[30]

This realization that Schweitzer's character was flawed forced Smith to reevaluate the program for this photo-reportage.

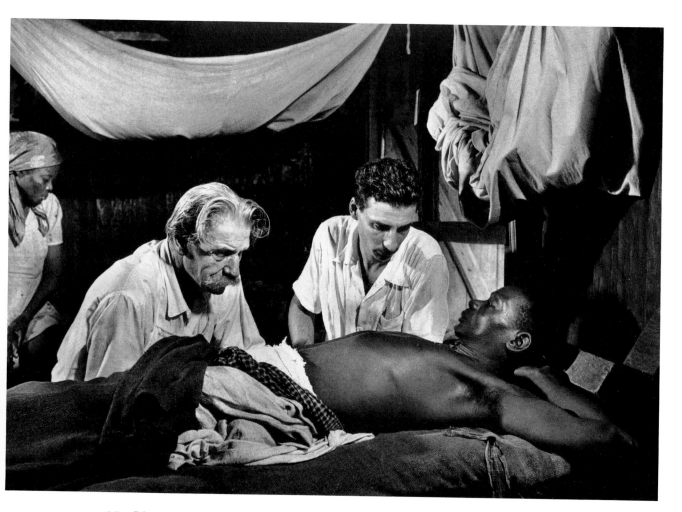

*97. Photograph of Schweitzer at patient's bedside. 1954. W. Eugene Smith,
copyright the heirs of W. Eugene Smith.*

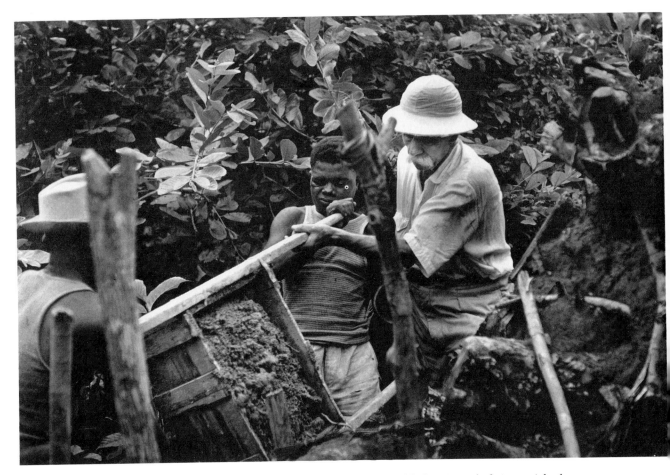

98, 99.  ABOVE AND OPPOSITE *Photographs of Schweitzer helping with the
manual labor of building the leper village. 1954. W. Eugene Smith, copyright
the heirs of W. Eugene Smith.*

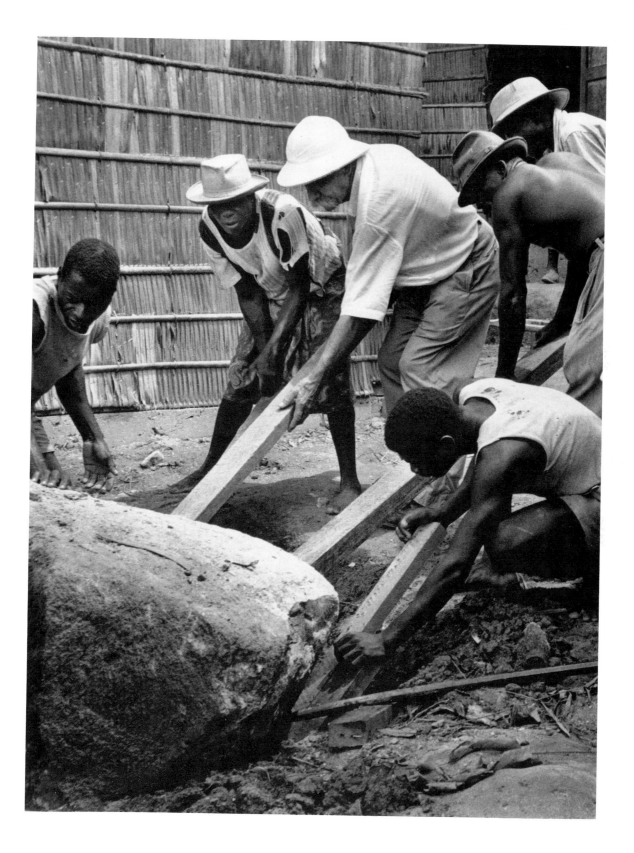

For example, Smith wrestled with the conflicts between Schweitzer's philosophy and his actions toward the black patients, at one time appalled by Schweitzer's treatment of the Africans, another time excusing him. Smith reasoned that Schweitzer's importance was not in his personal actions but in his value as a symbol and an ideal of self-sacrifice. In his notes Smith wrote:

> And once having accepted this man in his weakness, then his towering strengths begin to reassert their values of goodness and wisdom, and the fact of his greatness does return; and the viewer, once more viewing in [a] perspective that penetrates the superficial is still aware of the ragged edges but does not allow their raggedness to delude himself that this is the quality of the whole area of his thinking, of his doing . . . the ideal that has touched millions rather than the idea in execution, cruel righteousness in reverse. There is little question of it being delusion, that the effect of the ideal has been greater than the actuality. . . .[31]

A similar distinction was made by the British journalist James Cameron in a series of articles that Smith sent for in mid-April.[32]

Cameron was straightforward in both his praise and his criticism. He lauded Schweitzer's commitment and characterized the paradoxical nature of the man:

> [I]t may be hard to communicate that a man may be good and testy; of legendary resolution, but frail; capable of universal tolerance and sudden superb impatiences; full of Christ and fun.[33]

Cameron was sympathetic to Schweitzer, but, like Smith, he found two men: the man of legend and the man of fact. In concert with the Cameron articles, Smith decided the essence of Schweitzer was paradox: a man whose abstract commitment to humankind was universally admired but whose interactions with specific individuals bordered on the cruel.[34] Summarizing his thoughts Smith wrote:

> There is seldom the warmth of two hearts reaching each other — the "love" is expressed without intimacy, it appears to be, a doing of good reaching past and without access to the patient, or a care to gain him, to the obligation of the greater good, an intellectual, or religious or guilt drive that still though it is based upon helping, it is the ideal or obligation of helping rather than the emotional

need of helping that man, out of a reason of seeing a man in pain
and wishing to ease it if you can.
    And as with "Reverence for Life" which is an arrived at intellec-
tual decision, unto the snakes and spiders, a duty of respect, not
necessarily with compassion. . . .[35]

Schweitzer's unemotional, dispassionate approach to his mission left
Smith with a dilemma. His most successful essays had been of indi-
viduals to whom Smith had a strong emotional commitment, a commit-
ment he had captured on film. Yet with Schweitzer, Smith was faced
with a personality that he had not expected, a person for whom he
could not be an uncritical advocate. Schweitzer was too complex for
simple solutions, too complicated for single-minded advocacy.
    When Smith began to "make his move for photographic interpreta-
tion," he had already exposed almost 3,600 negatives.[36] The over 4,000
photographs that make up his visual archive of the Schweitzer hospital
are divided into named categories: "Dr. Schweitzer"; "Animals – In-
sects (Reverence of Life)"; "Natives: At Village and Hospital"; "Hos-
pital"; "Staff, Living + Life"; "Leper Village"; and "Miscellaneous."
This list presents us with the motifs sought by Smith, but equally in-
teresting is what he left out of this visual encyclopedia. For example,
although there are many different photographs of Schweitzer interact-
ing with animals, there are few photographs of Schweitzer communi-
cating with people. There are no photographs of pure landscape, nor
any of religious services, few photographs of any patient's physical
deformities, even fewer of people smiling and enjoying themselves –
in Smith's photographs only animals are playful (figs. 100 and 101).
    His photo-reportage, as Smith began to envision it in April, would
not center on Albert Schweitzer as a flawed human being but on
Schweitzer as a symbol of self-sacrifice. He decided he would accom-
plish this by making the hospital, as the visible sign of Schweitzer, the
center of his reportage. To do this, he documented the leper village
construction. In early April he wrote to his wife, Carmen, "the set of
photographs I have been making of the sweat and strain of building a
leper village (by the lepers) is almost brutal in its intensity. . . ."[37] As
time passed, Smith became more enthusiastic about the images, noting
later in the month, "The leper village pictures are strong enough to be
their own separate story – perhaps too earthlike for saints and leg-
ends."[38]

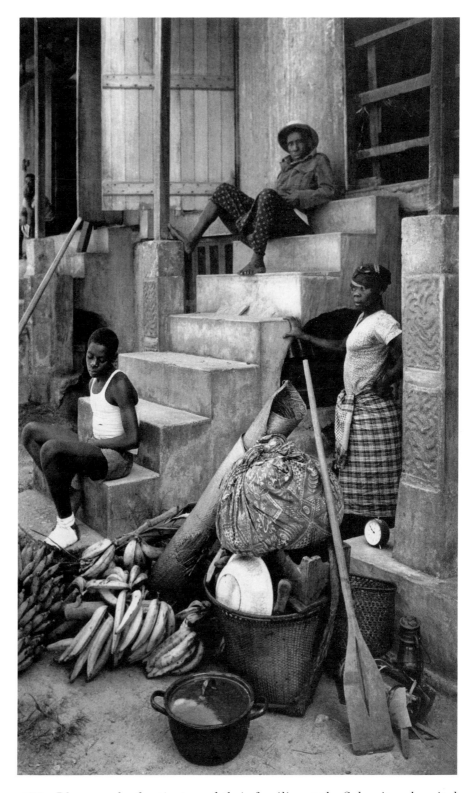

*100. Photograph of patients and their families at the Schweitzer hospital. 1954. W. Eugene Smith, copyright the heirs of W. Eugene Smith.*

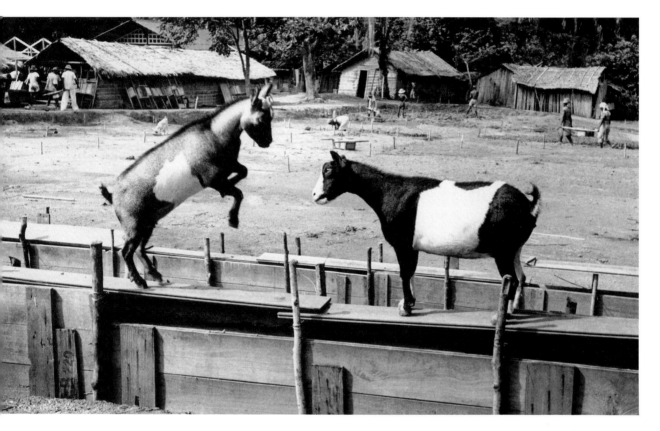

*101. Photograph of two goats playing on top of construction forms. 1954.*
*W. Eugene Smith, copyright the heirs of W. Eugene Smith.*

By late April his ideas had taken more definite shape. He wrote to
an acquaintance at the UNICEF office in Brazzaville:

> [S]trangely enough, I feel that I am still almost at the beginning of
> photographing this strange, paradoxical place and the man who
> built it to his domain. The photographs must almost be split into
> two articles, one of them being on the building of the Leper vil-
> lage, the other a more general story of the rest of the hospital, the
> zoo, the plantation, the temple of philosophy.[39]

This separation of the essay into two parts gives the historian insight
into Smith's thinking about the public presentation of his reportage
about Albert Schweitzer. The first part, the construction of the leper
village, would allow him to present the doctor's current activities. Having
presented the reality of the man, in the second photo-essay he pro-
posed to show Schweitzer's value as a symbolic figure. In this way,
Smith hoped to transfer the influence and the power of Schweitzer from
the individual to the institution.

In mid-May, shortly before Schweitzer was to leave to accept the
Nobel Peace Prize, Smith completed a forty-six-hour examination of
the story, laying it out as two separate photo-essays.[40] Finishing up
his work in Africa, he sent a cable to *Life* that asked for significant
editorial consideration and expressed uncharacteristic optimism:

> Departing Hospital Schweitzer exhausted as usual clutching rough
> giant of imperfectly hewn endeavor major to photographic journal-
> ism. Whether its live power or certain flaws still unavoided shall
> determine final value could perhaps be a question. Upon closer
> examination how could eye miss for eye photographed primitive
> village being built by country doctor and with midwife on hospital
> staff. Story renderable upon presentation of twenty-two available
> pages two equal parts with first good though not classic with sec-
> ond part probably more remarkable and this dangerously affirma-
> tive attitude eye undoubtedly shall regret so eye underline there
> are certain flaws.[41]

Despite his optimism Smith was concerned about the difficulty of
his interpretation of Schweitzer. On the day before he departed from
the hospital Smith recorded a prophetic discussion with a member of
Schweitzer's staff:

I hope you do a good story, it will be though I would not be certain
whether you would like it — portraits seldom liked — believe your
true friends will
I know you fellows don't have much control over how or what used
— I tell you right now that whatever pictures go into that magazine,
and the words underneath, I take full responsibility, blame me
and no one else[42]

As this passage indicates, Smith felt acutely the responsibility inher-
ent in the publication of his photographs. He arrived at his photo-
graphic interpretation in Lambaréné; he continued to refine it after he
returned to New York.

Soon after he returned, he gave his negatives to the lab for contact
printing but retrieved them to select and make the final prints him-
self.[43] This work caused a lengthy delay in their publication. In late
July, Smith wrote to Frank Campion, assistant picture editor, apolo-
gizing for the length of time he was taking to make the prints and
promising to finish them within the next month.[44] He explained his
reasons for making them himself:

It was a temptation to succumb to lab printing, but the temptation
was eradicated by visualization of the result of such, for the way
that I photograph is not for inarticulate printing, and I would have
been more intensely ill if this story were unveiled less than ful-
filled — like Shakespere slurred.[45]

Smith was obsessed with the Schweitzer prints, spending days ma-
nipulating their pictorial content. During June and July, while printing
his negatives, Smith worked on layouts and made typescript notes of
important observations from his stay in Africa. He wrote miscellaneous
thoughts and ideas on index cards and filed them under section titles
such as: "Relationship to Blacks — Blacks Attitude," "Music," "Intro-
ductory Thoughts," "Captions of Spreads — Specific Thoughts."[46] He
made huge stacks of 5 × 7 work prints that he used to work on layouts
of the story. This long process of gestation frustrated his editors, who

*102, 103.* OVERLEAF *Photographs of Schweitzer from "Albert Schweitzer:*
*A Picture Story of the 20th Century's Greatest Man,"*
Look, *XVIII (June 15, 1954), pp. 34–35. Erica Anderson.*

# *Albert Schweitzer*

## *A PICTURE STORY OF THE*

## *20TH CENTURY'S GREATEST MAN*

**Two worlds:** Schweitzer (left) with friends Emmy Martin, Edouard Nies-Berger in Alsace; at his piano in the jungle.

DR. ALBERT SCHWEITZER will return soon from the African jungles to Europe. After a summer of rest, he goes on to Oslo in the fall, there to accept the Nobel Peace Prize voted him last year. It is a just tribute to a matchless human being. For the good life of Dr. Schweitzer—medical missionary, musician, biographer, Biblical scholar, philosopher, preacher and prophet—has no equal in modern times. If greatness is measured in sacrifice, courage and service, then he is the greatest man of the century. At the age of 30, he astonished Europe by renouncing brilliant careers in music and theology to study medicine. At 38, he went to French Equatorial Africa to build a hospital in the jungle at Lambaréné. For most of the past 41 years, he has worked there, healing the sick and making Lambaréné a universal symbol of reverence for life. To Albert Schweitzer, the meaning of his life is that the jungle is not unlike the rest of the world—that wherever sacrifice, courage and service are needed, there is your Lambaréné. These superb photographs by Erica Anderson faithfully record the strength and the beauty of this man's ideal.

*hs by ERICA ANDERSON*

watched as one competing magazine after another published stories on Schweitzer.

*Life's* main competition, *Look* magazine, published a photo-essay that was typical of mass culture's understanding of Dr. Albert Schweitzer (figs. 102–103). The *Look* picture story was an uncritical representation of the mythic Schweitzer. The title characterized him as "the 20th Century's Greatest Man" and the pictures, at least some of which were exhibited at the American Museum of Natural History in January 1954, were all carefully posed. The text made no reference to Schweitzer's authoritarian nature, commenting instead: "Combining friendship with authority, Dr. Schweitzer is universally revered by the natives."[47] Other treatments of Schweitzer were only nominally more critical.[48]

Smith's photo-essay would break new ground in examining not only Schweitzer, but his legacy. When the finished prints were finally delivered, layout possibilities were considered. A preliminary layout of the photographs was made in summer 1954 but was abandoned because of editorial disagreement.[49] The prints were arranged once again in October under the direction of Robert Elson, who was acting as managing editor in Edward Thompson's and Maitland Edey's absence.[50]

The issues Elson confronted were different from those faced by Smith. For Elson, the important considerations were competition and magazine balance. Elson decided to use Smith's photo-essay because of the expected competition from other magazines and because he needed to balance the November 15 issue.[51] Elson lacked a strong lead news story, and he needed a photo-essay strong enough to carry that week's issue.[52] Smith's Schweitzer story was the logical choice. Schweitzer was topical, having given his Nobel acceptance speech the week before; the photo-essay had been worked on and a sample layout had been made. Elson gave it twelve pages of space and asked Berni Quint to complete the layout. Quint had worked successfully with Smith before and was one of *Life's* finest designers. This time, however, Quint and Smith could not agree, in part because Smith felt that the allotted space diluted the complexity of Schweitzer and of Smith's photo-reportage. Smith threatened to resign if the photographs were published in this abbreviated form. With a deadline approaching, Elson turned to art director Charles Tudor for a final decision. Tudor personally redesigned the essay for publication and sent it to press. It appeared on November 15, 1954.[53]

## Narrative and Aesthetic Reading

The published photo-essay did convey many of Smith's ideas and interpretations. He was involved with all phases of "A Man of Mercy" and a close reading shows that his concerns were addressed, albeit briefly. Pictorially, the photo-narrative concerned the hospital as an institution. Schweitzer was not even present in the majority of the pictures selected. When pictures of Schweitzer are used they show him as generous and self-sacrificing but not as "the greatest man in the world." An aesthetic and narrative reading of the photo-essay finds Schweitzer represented as a mythic presence, removed from the organization he had founded.

Although Smith spent days making a special composite print intended for the cover of the magazine, it was not used.[54] The editor did, however, feature the photo-essay above the issue's table of contents. The text that accompanies this introduction accurately describes the difficulties Smith confronted in completing his photo-reportage. The photo-essay itself "broke badly," with the large-scale picture of Schweitzer on the right-hand page and an equally large-scale advertisement for Lord Calvert blended whiskey on the left. The picture that opens the photo-essay is one of Smith's most carefully planned images, a picture of a saintly but stern Albert Schweitzer supervising construction work (fig. 85).

The strong diagonal of the highlighted wooden beam points to Schweitzer in the center of both the two- and three-dimensional composition. In the middle ground, Schweitzer, in the only highlighted area, supports himself with his hand resting against a crossbeam. In the background a native sits on the wood, seeming to rest on Schweitzer's shoulders. To create dramatic tension the picture is vignetted and, with the exception of Schweitzer's pith helmet, the highlights are deeply printed. If we look only at literal subject matter, we see that this photograph shows Schweitzer as labor foreman, but, through careful manipulation of the print, Smith conveys the mythological presence of the man as well.

He accomplishes this by deeply printing the negative, then carefully bleaching highlights on the face and the rim of the pith helmet. The whiteness surrounds Schweitzer's head and resembles a halo.[55] In the lower right corner, we notice a silhouette of a hand reaching for a saw. This element of the picture was added by Smith in the darkroom to

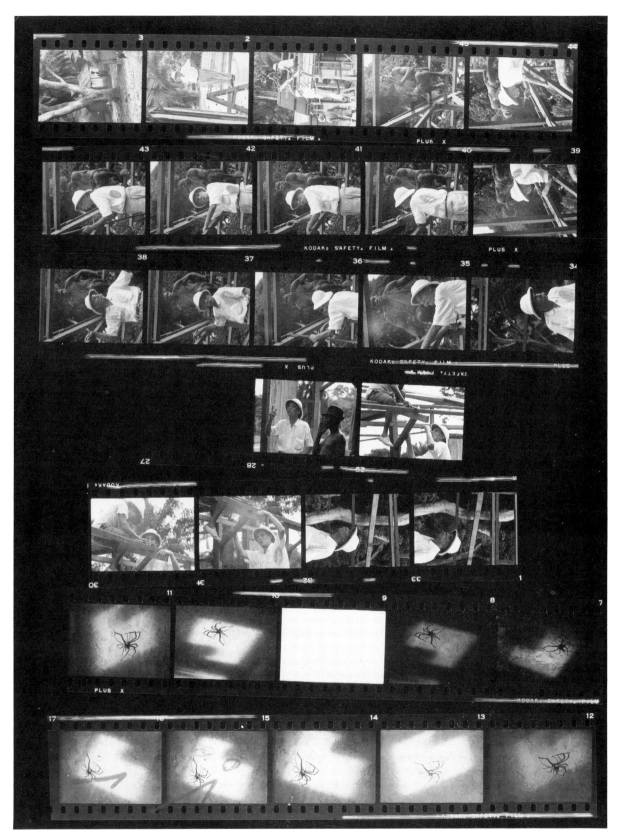

104. *Contact sheet from "A Man of Mercy." 1954. W. Eugene Smith,*
*copyright the heirs of W. Eugene Smith.*

reinforce the sense of Schweitzer as a carpenter, and perhaps, in a form of Christian iconography, to associate Schweitzer with Christ (fig. 104, no. 38).[56] Further pictorial referents to Schweitzer as Christlike are found in the way in which the diagonal beam seems to rest, like a cross, on his shoulders and the way in which the area around the pencil in Schweitzer's right hand was bleached and seems to impale his hand on the crossbeam. Like the hand and saw, this suggests Christ and his crucifixion and reminds the reader of Schweitzer's own dramatic self-sacrifice.

These Christian references are reinforced by the title – "A Man of Mercy: Africa's misery turns saintly Albert Schweitzer into a driving taskmaster." The first paragraph describes Schweitzer as "humanitarian, warm and saintlike," but the second paragraph calls him "a remote, driving man who rules his hospital with patriarchal authority."[57] These qualities are conveyed pictorially by the expression on Schweitzer's face – his brow knit with fierce determination. This introduction presents a combination of photograph and text that introduces the reader to the complex personality of Albert Schweitzer. The qualities of saintliness and stern authority, evident in this introductory page, are two conflicting aspects that Smith sought to reconcile.

The photographs on the first double-page spread of the photo-essay convey the sense of the hospital as an African town (figs. 86–87). They are arranged within a strict grid of horizontals and verticals and display the primitive aspects of the Schweitzer hospital – open-air postoperative rooms and natives cooking food outside the hospital rooms. This first spread introduces the reader to the geographical environment of Schweitzer's work. The doctor's presence is minimal – he appears in only one photograph – but he is centrally located in the picture arrangement. He is shown standing on the second story of the hospital building; his sloping shoulders and bent head suggest the burden he carries (fig. 87). Beneath him, three African patients sit long-faced, with battered clothes and bandaged feet. In the opening picture, Schweitzer is presented as a carpenter; now he is a doctor. This is not, however, the posed likeness that Schweitzer had wanted. Although he wears the instruments of medical practice, the doctor is seen alone and withdrawn, separated from his native patients.

The other pictures add detail to this characterization of Schweitzer by showing the locale of the hospital. On the extreme right is an attention-

getting, exotic image – a woman carrying a large bowl and teapot on her head and smoking a pipe. The text informs us that this woman is cooking for her husband and that families take personal care of the patients in the Schweitzer hospital. An examination of the photograph shows us the care with which Smith printed even the most informational pictures in this photo-essay. We see from the shadows that the sunlight is shining behind the woman. Nonetheless highlighted areas on the bowl and on the woman's nose and lips demonstrate Smith's careful bleaching of the print.

The only diagonal in this spread is in the lower left-hand corner (fig. 86). This picture shows a wide-eyed native baby being fed, and it makes the kind of strong emotional statement for which Eugene Smith's photographs are most noted. It is dramatically lit and is hand-crafted in the darkroom. The leg of a child in the upper left and the leg of the bed in the lower right are darkened in the print so as not to distract the reader's attention. The outline of the helping hand, the baby's face, and another child's silhouette are carefully highlighted to give the reader examples of the suffering with which the hospital staff must deal.

This picture received special attention because it was a personal favorite of the photographer. It depicts a child who was brought to the hospital when its mother was dying of leprosy. Because of the mother's disease, the baby was given only a month to live, but a white nurse at the hospital adopted it and cared for it for eight months before the baby died in mid-April. Like the death of the young black boy during his work on "Nurse Midwife," this baby's death deeply affected Smith. He wrote pages of typescripts about this tragedy and referred to it in several of his letters. While the photograph conveys a sense of this drama, the *Life* layout forsakes this emotional narrative, using the photograph for informational purposes.

The next double-page spread (figs. 88–89) centers on the hard manual labor at the hospital. A full-page photograph of a team of black laborers trying to move a boulder (fig. 88) dominates the layout. This is a very strong composition of hands and arms with a single face. The body beneath is darkened and the contours of the face are softened so that it seems to float, masklike, in the center of the picture. The man's expression powerfully conveys a sense of agony beyond physical strain. Just as the first photograph was Smith's pictorial interpretation of Albert Schweitzer, this picture is his interpretation of black Africa.

The four photographs in figure 89 reinforce the centrality of manual labor at the hospital. We see railroad track being assembled and a white nurse helping to pull a loaded flatcar along a finished track. The racial and political implications of this latter picture, white and black working together, are underscored by the caption. This particular photograph also emphasizes the unsparing physical labor of the hospital – for white as well as black, women as well as men.[58] It is important to note that Schweitzer is not included in this spread. His presence is depicted symbolically in the pictures of his umbrella and of his worn shoes. In the latter picture, Schweitzer's threadbare shoes also bespeak his personal labor and give the reader a temporal sense of Schweitzer's longstanding commitment to the hospital.

The next double-page spread (figs. 90–91) concerns leprosy, a topic with which the Schweitzer hospital was popularly associated. The pictures and layout, however, do not capitalize on the sensational deformities that can result from the disease. Instead, a single, large photograph of lepers receiving medicine stretches across the upper two-thirds of the spread, dominating the layout. This photograph is a powerful humanitarian statement, cropped and printed significantly darker than the density of the negative required. To dramatize the image, Smith carefully bleached the outlines of the facial silhouettes on the darkened print.

Anchoring this large photograph in the lower left and right are two informational pictures: one showing a nurse, an African aide, and a patient; and the other showing a leprous foot, the only graphic example of physical deformity in the photo-essay. If we look closely at the lower left-hand photograph we see another aspect of the Schweitzer hospital that Smith wanted to show in his photo-reportage. Smith's observation was that Schweitzer had resigned himself to his fate in Africa. His was an intellectual rather than emotional commitment. The facial expression of Nurse Erna Spohrhanssen is, at best, resigned, and reflects the bureaucratic attitude Smith found at Lambaréné.

Moving further into the body of the photo-essay one sees that the next spread (figs. 92–93) is a more emotional one. The pictures, organized in a chronological sequence from left to right, top to bottom, portray the death of one of the hospital patients. Beginning at the left, we see an old woman shortly before her death, the mourners at the wake, the funeral procession, the gravesite, and a final offering. Here, after an absence of four pages, Schweitzer appears; but once again he

plays only a minor role in the picture layout. We do not see his face; we see only his back as he walks to the gravesite. Reading the picture sequence elicits the pity that the text informs us is central to Schweitzer's philosophical thinking. Coequal in that philosophy, and also evident in the picture-text arrangement, is the resigned acceptance with which Schweitzer and his followers faced death.

The theme of the accompanying text – Schweitzer's reverence for life – seems appropriate to the pictures, but a close reading shows the contradiction inherent in this treatment. Schweitzer's ethics are undermined by the picture of flowers held by a graveside mourner (fig. 93). Smith understood this contradiction; one of the thirty-four typed questions he sent Schweitzer asked about his attitude toward the picking of flowers – "as decorations, or for graves."[59] Schweitzer's reply left little doubt about the incompatibility of the practice with his ethical beliefs. "Picking flowers means killing them, that's why I let them alone whenever I can. Lovingly I look at them in nature. Flowers in a vase are a sign of death."[60] We must recognize, then, that there are a number of deaths implied by this funeral sequence: those of the old woman, the cut flowers, and, ultimately, Schweitzer.

The last double-page spread (figs. 94–95) is a narrative portrait of Albert Schweitzer and the first extensive photographic treatment of the man since the opening photograph. It features Schweitzer as a musician and as a writer. Across the top are three small pictures of Schweitzer's hands as they manipulate old envelopes, papers, and manuscripts. By using pictures of Schweitzer's hands performing a precise series of actions, the photo-essay alludes to his former skills as a surgeon and his current role as a writer and a musician. Secondarily, the photographs of Schweitzer's hands show him as energetic, precise, systematic, and organized.

The largest picture, in the lower right (fig. 95), shows Schweitzer intently reading as he prepares a report. This candid portrait has caught the doctor in an unguarded moment of intense concentration (see contact sheet, fig. 105).[61] It conveys the power of his thought. His expression, the brow knit with determination, is similar to his countenance in the opening photograph. Combined with the surprising absence of Schweitzer from the body of the photo-essay, these photographs convey the idea that Schweitzer's intellectual and spiritual contributions are more important than his physical presence.

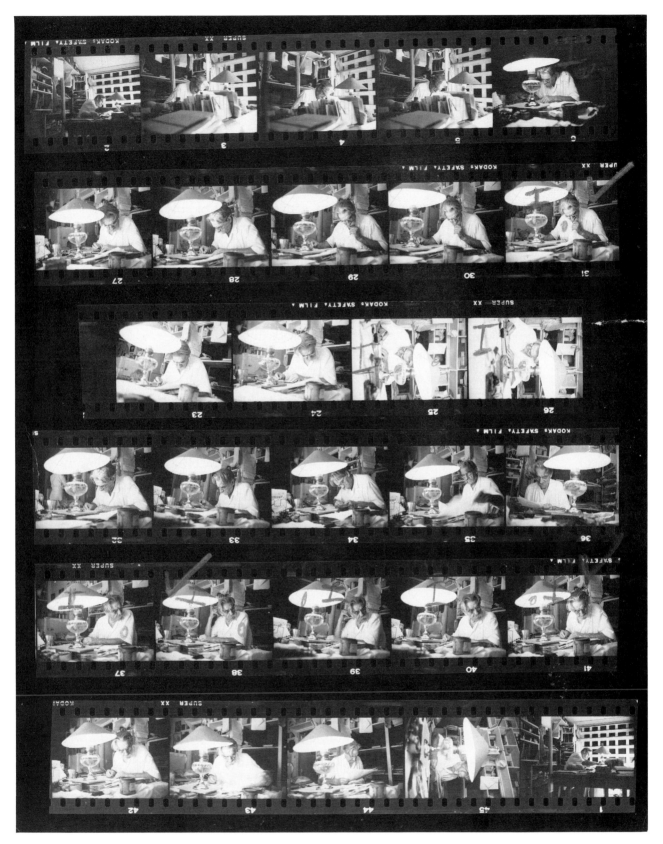

*105. Contact sheet from "A Man of Mercy." 1954. W. Eugene Smith,
copyright the heirs of W. Eugene Smith.*

The concluding photograph was one of the last aspects of the photo-essay to be completed. The piece was originally to close with a double-page photograph of the stockade for the insane at the Lambaréné hospital. Smith disliked the selection because he felt that the photograph was too easy to misinterpret. He stated his objection:

> Although this is at Schweitzer's place I believe strongly it is an unfair photograph to present out of context. I believe it should be presented as "a stockade for the insane, photographed in Africa." . . .[62]

As the concluding photograph of "A Man of Mercy," the photo of the stockade would have been placed in the context of the Lambaréné hospital and might have been misunderstood as an indictment of Schweitzer's care for the Africans. The fact that this conclusion was abandoned demonstrates the editorial influence Eugene Smith continued to have over the final stages of the photo-essay production.

To replace the stockade picture, the editors chose a single-page photograph of goats on the hospital roof (fig. 96). Given its placement, the final image should make reference to the opening photograph and should summarize the complex themes of the photo-essay. Coming after the Schweitzer spread, it should refer to his legacy – the Lambaréné hospital. This particular selection, however, fails. The picture and accompanying text make reference to Schweitzer's legacy obliquely, reminding the reader of Schweitzer's philosophy of "reverence for life" by showing the free rein that animals are given on the hospital grounds, but it is not the strong statement of Schweitzer's importance as a symbol that Smith had wanted.

Smith seems to have been involved in all stages of the photo-essay's production and was allowed a great deal of editorial influence. The photo-essay reflected his insight and interpretation, both in the individual prints and the picture sequences. But the published product is not the extended pictorial consideration that Smith felt was necessary for this complex subject. As far as he was concerned the photo-essay was being rushed into print at the expense of the subtle nuances of his journalistic treatment. He wrote to Edward Thompson:

> I do not intend to convey that I was thinking the definitive book could be accomplished within the limitations of a magazine. . . .

> [A]ll that I believed we could accomplish was a study of "the man,"
> allowing the world to know him thoroughly as a person, for the first
> time; and a thorough presentation of his hospital, of his work there,
> also for the first time. . . . The story should have accomplished
> the reopening of the minds closed by the legend, inciting those
> minds into a re-examination of their previous thinking – although
> allowing the thinker to come to his own conclusions. I think a story
> of this importance should not have been less.[63]

Smith was acutely aware of the public presentation of his photographs
and the broader political issues that Schweitzer represented.

## Political and Ideological Reading

The political and ideological context of "A Man of Mercy" must be
considered first in terms of the Nobel Peace Prize, the honor that caused
*Life* magazine editors to accept Smith's suggestion of a Schweitzer photo-
essay. In October 1953, George C. Marshall, former U.S. Secretary of
State, was awarded the Nobel Peace Prize for the success of his eco-
nomic aid plan for postwar Europe. At the same meeting, the Nobel
committee decided to award the 1952 Peace Prize, not awarded the
previous year, to Dr. Albert Schweitzer. This action was taken in rec-
ognition of Schweitzer's lifetime of service in Africa.

The year of the announcement was a significant one for Schweitzer.
It marked the fortieth anniversary of his journey to Africa and the
establishment of his missionary hospital.[64] His commitment was unique
in several ways. During a period in which European governments were
exploiting native resources and native labor, Schweitzer left Germany
for the jungles of French Equatorial Africa to reclaim land, build a
hospital, and actively seek out and treat the native population. Before
leaving Europe, Schweitzer had earned three doctoral degrees and had
abandoned promising careers in philosophy, theology, and music to
pursue a medical degree in order to serve humankind.

He had left Germany, he said, to fulfill Christ's teachings and to
atone for the wrongs that the Christian white men had done to the
underdeveloped black men of Africa.[65] A lifelong philosopher, Albert
Schweitzer formulated his most widely known principle, "Reverence
for Life," while in Africa in 1915. This ethical doctrine was governed
by pity for the suffering of all living things and was based on the

principle that all life was equally valuable and equally worthy of reverence.[66] At Schweitzer's hospital this principle applied to animal, insect, and plant life as well as human life. For the Nobel Prize Committee, Schweitzer's commitment to live out his ethical stance was particularly striking in a world still reeling from the atrocities of World War II and the horrific responsibility of the atomic bomb. Although Schweitzer's personal dedication made him a worthy recipient of the Nobel Prize, when considered in light of the contemporary political situation in Africa, the political and ideological implications of the award become evident.

In the early 1950s, Africa was in the midst of profound political change as indigenous populations demanded independence from the European colonial powers. British disengagement from India in 1947 established the principle of decolonialization and, following India's example, black African nations demanded their independence.[67] By 1953, the struggle for self-determination was hotly debated. The issues were outlined in a special edition of *The Saturday Review* that headlined essays about the Mau-Mau uprising in Kenya and the racial unrest in South Africa.[68] Conversely, in the same issue the reader also found an article describing the Schweitzer hospital. It held Schweitzer up as a model for the white man's commitment to Africa:

> No picture of the relationship between white man and black in Africa would be complete without reference to Dr. Albert Schweitzer, that great humanitarian who has labored for forty years to practice the Christian ideal in Africa as well as preach it.[69]

Amidst the racial tension in Kenya and South Africa Schweitzer was viewed as an oasis: a positive aspect of Western colonialization.

The idea of Schweitzer as a positive symbol of colonialism was fostered by Schweitzer's followers. In "A Visit to the Africa of Albert Schweitzer," Clara Urquhart described Schweitzer's coming to Africa, the building of the hospital, and the difficulties he faced with the native population.

> It is a great and humbling experience to visit the hospital in the jungle. To see what can be achieved when the will to achieve does not falter. . . .
>
> I found it difficult to believe that in 1953 there still existed such

primitive forms of life as those we saw around Lambaréné. The *indigènes* have only a sort of rhythmic shout. There are no handicrafts. They do not work except to pick berries or catch the odd fish to eat.[70]

Her article went on to describe contemporary political tensions in Africa and to defend French colonialism. She characterized Schweitzer as the light in an otherwise dark colonial past. A *Time* magazine article used a similar metaphor, characterizing Schweitzer as a "bright highlight in the relations between the white race and the black."[71] Black African leaders were not so enthusiastic. For them, Albert Schweitzer was a symbol of paternalistic colonialism.

Schweitzer's attitudes were known to Smith, both from personal experience and from the James Cameron articles sent to Smith by the London Time-Life office. Cameron's reports considered the political context of Schweitzer at length. He characterized Schweitzer as "militantly conservative."[72] Discussing the impending independence of African nations, Schweitzer had told Cameron:

> You ask whether the *indigène* can ever develop to responsibility without us, and the answer is No, they cannot. Others disagree. The United Nations Trusteeship Commissions and so on — they think in terms of *politics*. Do they ask who plants the trees that the African can eat, who bores the wells that he can drink? No, they say "How are they progressing to self-government?" Self-government without resource, without thrift? Democracy is meaningless to children.[73]

Cameron wrote at some length about Schweitzer's antiquated views of the black African, views that demonstrably linked Schweitzer with European imperialism.[74]

Smith thought about his reportage in this context. Several of his follow-up research questions addressed these broad political issues. For example, he asked Dr. Schweitzer: "Does the Doctor believe it is mental capacity, or environment, that makes the colored peoples of Gabon so primitive in their approach to living, and in their lack of acceptance of agricultural stabilization and the becoming of skilled workmen?"[75] Schweitzer responded that the reason for the primitive state of the people of Gabon was that they did not fully appreciate work. He was trying to train and educate them in this regard.[76]

Smith also tried to draw out Schweitzer's opinions about the political changes in Africa by asking the doctor to comment on the statement: "Two political ideas and their gigantic forces are snorting and sniffing and stalking – measuring each the other, with a result that may be the most disastrous conflagration that has yet been conjured by the diabolical in man."[77] This was not a trap into which Schweitzer was easily drawn. He apologized for not answering, saying he "was too tired for political questions." These political and ideological issues were an important part of the thinking behind "A Man of Mercy," as can be demonstrated by a second reading of the photo-essay.

If we reread "A Man of Mercy" in terms of this political context we see that Smith indirectly addressed the two major political issues: the tremendous natural and physical resources of Africa and the transfer of political sovereignty. "A Man of Mercy" alludes to the physical resources of the continent by accentuating the physical power of the African workers. A reconsideration of the introductory photograph shows that just as Smith worked on the print to bring out certain qualities in Schweitzer, he also carefully bleached the figure of the African behind him (fig. 85). In particular, Smith highlights the man's shoulder and arm to make his veins stand out and to call attention to his physical strength. This motif is repeated three pages later when Smith shows the workmen moving a huge granite boulder (fig. 106). This sense of physical power was a pictorial construction of Smith's. Most of the workers at the Lambaréné hospital were patients, often the lepers themselves (fig. 107). They were not, on the whole, powerful men, but Smith made them appear powerful in order that they might represent the latent power of the emerging African nations.[78] There is, in Smith's depiction, an interesting qualification, however.

Reading the photo-essay as a statement about the potential power of black Africa, we notice that Africans are presented as a physical force only. They are dependent on their white counterparts. For example, in the opening photograph the African carpenter seems literally to be carried on Schweitzer's shoulders, and later in the essay the reader sees African faces lined up, open-mouthed and needy (figs. 90–91). Smith's own beliefs were confused. Deliberating over his photographic interpretation, he wrote:

And if it is puzzling (sometimes quite irritating) to see Schweitzer's relationship to the Blacks, especially to an observer who has

worked + lived among Negroes each intellectually equal to the other, it must also be remembered the intellectual opportunities and strides made in the United States, in the last few years, and that Schweitzer's practical experience has almost all been among the least advanced (his cajoling, admonishing, sternly demanding, threatening the ration, promising extra sweets, etc.)

And almost with the same impersonal attitude that is part of a work bossing, he will walk forward, inquire about a worker ill or one who has worked with a will, and say this man has worked enough, may be excused for the day.[79]

Smith excuses Schweitzer, presenting the tribesmen as endowed with an elemental force but not capable of independent action. In the published photo-essay it is whites who control black laborers and, by extension, black destiny.

Considered within the volatile political context of the decolonialization of Africa, the awarding of the Nobel Peace Prize to Albert Schweitzer must be seen as an apology for a failed colonialism. To many people, Schweitzer symbolized the positive aspects of colonial rule. Smith's photo-essay was not so simpleminded. Rereading "A Man of Mercy" one recognizes that Smith is also suggesting the end of Western colonialism in Africa. Schweitzer, the symbol of Western colonialism, is shown as aged and removed from power. In the introductory picture (fig. 85), we see this in the wrinkled skin of his arm, a stark contrast to the heavily muscled African. The spread devoted to the death and funeral of the old woman alludes to Schweitzer's own advanced age and his impending death. Even before his physical passing, we are shown the erosion of Schweitzer's power. His removal from the daily functions of the Lambaréné hospital, then, becomes an analogue for the inevitable transfer of power to black Africa.

In the body of the photo-essay we see that Schweitzer is out of touch with the medical aspects of his hospital. In the only picture in which he is shown as a doctor we see that he holds the symbol of his medical practice, the stethoscope, but does not use it (fig. 87). He looks on as another doctor examines the patient. This demonstrates the replacement of Schweitzer's medical skills with those of a younger generation. An even more obvious statement of Schweitzer's displacement can be found in the next spread (fig. 89). Here Schweitzer is not even recognizably present, but presides symbolically in the attributes of the umbrella and the ancient rain shoes. The umbrella and shoes, however,

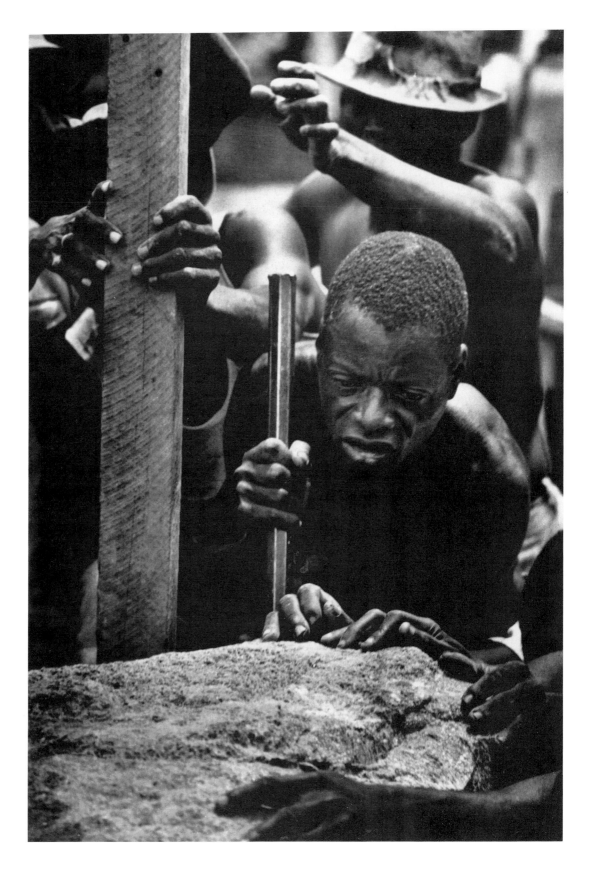

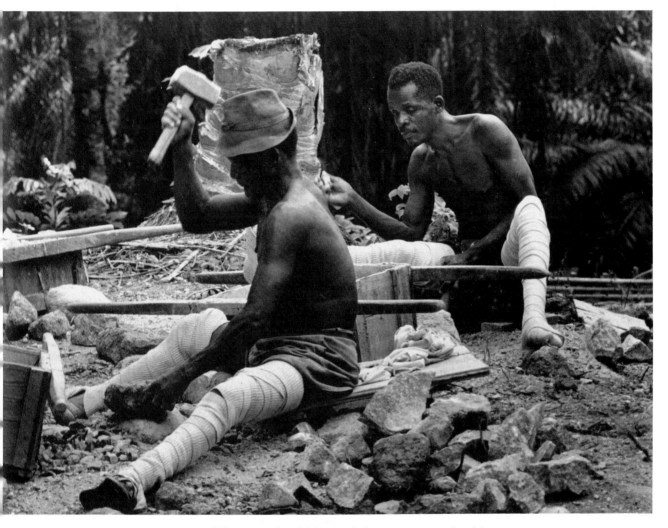

*106.* OPPOSITE *Photograph of African laborers moving boulder. 1954.*
*W. Eugene Smith, copyright the heirs of W. Eugene Smith.*

*107.* ABOVE *Photograph of African leper patients breaking rock for roadway.*
*1954. W. Eugene Smith,*
*copyright the heirs of W. Eugene Smith.*

can be felt as symbols of weakness as much as presence; the Africans do not seem to need umbrellas or shoes. As we can see from this second reading, Smith recognized the tremendous potential in Africa and, through the personage of Schweitzer, showed the inevitability of the transfer of power.

## Public Reception and Resignation

Understanding the personal, political, and ideological complications of the Schweitzer story, Smith was convinced that the abbreviated version published by *Life* was doomed to inaccurate superficiality. He resigned orally on November 2, hoping this action would stop the publication of his photographs. When it became clear that his threat would not deter the editors, Smith wrote a formal letter of resignation and mailed it to managing editor Robert Elson. Despite Smith's misgivings, the photo-essay enjoyed an overwhelmingly positive response.

For the most part, the "Letters to the Editors" published on December 6 were gushing in their praise for the doctor. "The essay is a truly great documentary of a great man and a beleaguered race" was typical of the majority of the responses.[80] Among the correspondence addressed directly to Smith were letters of praise from the Biblical Seminary in New York City: "[P]hotography in *Life* of Mr. A. Schweitzer has caused quite a wonderful impression on everyone in the country. Many thanks for your hard and beautiful work."[81] There was also a letter from Miriam Rogers, chairman of the Friends of Albert Schweitzer. She began by saying that she had been to the Lambaréné hospital and had photographed Schweitzer there.

> I must say, I found your pictures the finest I have seen yet! They are impersonal, artistic, truthful, and the composition so elegant that many of them look like paintings. I congratulate you.[82]

Despite the universal praise for "A Man of Mercy," Smith felt the photo-essay was shallow, "like Shakespeare slurred."[83] He wrote to Schweitzer:

> I shall be very brief, for silence must guard the bitterness of my mind, the hurt of my heart which comes from the intensity of my

dislike for the way that the photographs of you and your hospital were used by Life Magazine. . . .

My name appears with the story in LIFE, it is a usage of my work, and no matter how unfortunately it was done, I must accept the responsibility for it. I can but say, that I fought as hard, as completely as I could; and when I lost, which I did, I resigned from the magazine. . . . Let me in fairness add that it was a difference of viewpoints, and through reasons of circumstance that the harm came about, and not through any deliberate attempt by the editors. And so it ends, that phase, and I place my sincere regrets before you.[84]

A close reading of Smith's Schweitzer reportage shows that the questions of the responsibility of the photographer and of authorial control confronted Smith in a dramatic and personal way during this assignment. From his study of Albert Schweitzer, Smith knew that the doctor's life was based on a belief in the significance of individual actions. The 1949 *Life* article, illustrated with Smith's photographs, had summarized Schweitzer's beliefs:

The modern man, even the so-called leader, has abdicated his freedom of will in deference to "public opinion" and to mass illusions of false progress. Even, or especially, among scientists it has become almost a matter of good manners to declare oneself incompetent on ultimate questions of good and evil. . . . Thus, to a dangerous degree, mankind has lost sight of the right and duty of the individual to choose between good and evil in working out his own salvation. . . .

Modern man, Schweitzer believes, has surrendered his personal opinion, and with it his moral judgment. He thinks of progress only in terms of reformed institutions. He has an obsession that if he could only get his institutions perfected, civilization would take care of itself. But in this, Schweitzer affirms, he is tragically mistaken.[85]

*Life*'s refusal to honor Smith's request to delay publication, and Schweitzer's example of moral practice in a world of immoral institutions, left Smith with a clear choice. The publication of Smith's photographs in spite of his strenuous objections demonstrated that the institutionalized process of photo-essay production at *Life* could not be reformed. For Smith, the principle of authorial control was paramount. The editorial treatment of his Schweitzer reportage meant that Smith

could never author the public presentation of his photographs. A discussion of this point was the central topic of an exchange of letters between Smith and managing editor Edward Thompson.

When he returned from vacation Thompson wrote to Smith and asked him to reconsider his resignation and "leave the door open between you and LIFE."[86] He acknowledged Smith's objections but reminded him that

> as a creative journalist, you have an obligation to bring your work to the attention of the largest and most receptive audience possible. I don't say that LIFE is the perfect medium but it is by any figuring the best one (maybe the only one). LIFE needs your work and I think you need LIFE. . . .[87]

Ten days later Smith wrote to Thompson and admitted that the journalistic power of the magazine was an important consideration. He agreed to reconsider his resignation. At the same time he reemphasized his concerns: "Whatever the work of the future, the fuel of renewal must be from that work. I must believe in it fully, mind and heart, and that it will and must retain in its presentation the essence of the artist, and of the responsible citizen. . . ."[88] After thinking about it for two and a half weeks Smith reverted to his decision to resign.

In a single-spaced, eight-page resignation letter Smith explained the reasoning behind his departure from *Life*. He enumerated the details surrounding his Schweitzer assignment and described the battles he fought in Africa against Schweitzer's restrictions and the difficulties he had in creating an honest, penetrating narrative. He expressed his frustrations over the layout. Smith wrote:

> The story as it finally ran had a certain confusing accuracy to it. However, it was like an unsatisfactory, oddly balanced adaption of a great play, with one or two potent phrases retained – I would have preferred silence.[89]

He concluded, however, by acknowledging the honest efforts of the editors of "A Man of Mercy."[90] His disagreements were not with the individuals who handled the photo-essay but with the *Life* magazine editorial organization.

Smith's resignation letter demanded a change in *Life*'s hierarchy of photo-essay production. He insisted on the right to veto publication of his photographs. He asked Thompson:

> Is it possible to assure that major stories will, other than in an exceptional emergency, be carefully examined, and in sufficient time to permit a thoughtful, intelligent re-adjustment of any vital problems – whether they be of layout, or of outlook, or of mechanical problems presented by advertising?[91]

As the price of his continuing under contract with *Life*, Smith insisted on an alteration of the editorial balance of power, a change that would have given him exclusive authorial control.

Displaying a subtle understanding of the audience of the photojournalist, Smith expressed the opinion that competition, especially from television, would force the magazine to consider alternatives such as this one. He wanted to be at the forefront of this move, "to break new paths beyond now rutted horizons."[92] He made specific suggestions regarding the growth of the photographic essay, suggestions that are worth quoting in their entirety:

> I believe that the structure of the pictorial-prose essay must gain a far freer flexibility of form, both as to length and in treatment, for handling the exceptional when the exceptional is possible. The essay form must become sufficiently free to unchain words and pictures from nullifying habits; it must – for instance – allow captions to more often seek to give additive merit and not so continually to be a subordinate echo, merely a device for a repetitive cataloging of picture contents; and more often there should be no necessity of mentioning the accompanying photograph, depending upon the informative adequacy of the photograph, and even of its purpose in the layout. The photograph itself should be of a greater stature and of more importance than the limited, the merest making of an editorial point, although an ideally strong pictorial presence should be indicative also of an editorial point. Other text as well should more often be less bound to the narrow fact in order to intensify the depth of its ability to give understanding to the story subject – and this can be done, I believe, without any increased measure of editorializing.
>
> Whether the ultimate presentation arises from a few photographs utilized to give a severe, sudden, dynamic thrust with an

economy of words, no matter the length in pages; or whether it be
lyrical; or whether it is laid out and written to emphasize a detailed
insight penetration through a complex thematic handling; the ex-
ploitation of the variations possible through a really freeform in-
tegration of space and balance must be derived to give the strong-
est possible accuracy and dramatic validity to each subject. The
medium should be flexible enough to step into each immediate
challenge, regardless of the past.[93]

Toward the end of his letter Smith stated that he would return to *Life*
"if." He was not hopeful and concluded with a restatement of his res-
ignation.

Thompson's reply of January 14 was lengthy and showed that he had
considered carefully the points Smith had raised. Not surprisingly, he
disagreed with most of them. Regarding the specifics of the Schweitzer
essay Thompson reasserted the importance of the editor, suggesting
that Smith was too emotionally involved to make an objective appraisal
of his photographs. Thompson admitted that he might have laid
the story out differently but, unlike Smith, he thought the story did
"reopen minds closed by the legend, inciting those minds to a re-
examination of their previous thinking."[94]

With regard to Smith's criticisms of the organization, Thompson was
equally straightforward. He reminded Smith

> that in making any decision re LIFE you should think of it as a
> magazine, not any one individual. As a reader, I got out of the
> story what you intended. Elson, Mackland, Tudor and I — whoever
> is responsible for a layout — is simply the midwife who delivers
> the idea to the readers as best he can.

Thompson stressed the great freedom that *Life* gave to Smith, and re-
minded him again of the magazine's large audience. He asked him
rhetorically, "Is it better to reach a lot of people with something good
than a very few with something you may think is completely good?"[95]

Thompson, in view of Smith's demands, was skeptical about the
photographer's future with *Life*. He wrote:

> We certainly are not going to agree, sight unseen, to provide space
> for extended essays. We will keep an open mind about them. There
> are some production limitations as of now. In a year or two, with

new presses, these will not be so onerous. But each case must be decided on its merits and we may disagree. We do disagree on Schweitzer.

What about your future if you stay in journalism? Well, I think that your work should be split into two parts. One should be relatively simple stories, arising, in your words, from "a few photographs utilized to give a severe, sudden, dynamic thrust with an economy of words." The other would be the more ambitious projects. But even in these I think you should get your own thinking clear so that we'll have no more Schweitzer hassles, hassles in which I think you fight more with yourself than with us.[96]

As time would prove, Thompson was correct in his insight that Smith's battles were as fierce with himself as they were with his editors.

Despite Thompson's reluctance to make a contract, in early February Smith wrote again and enclosed "a sprawling – think over – preliminary draft intended only for myself. . . . My return [to *Life*] depends on your reaction to this letter and to the enclosure."[97] Although there is no record of the contents of Smith's contract notes, his letter ignored the concerns Thompson had raised and left little room for discussion. Smith concluded: "One of these additional decisions is that there shall be no continuance of relationship with LIFE, unless it is by guarantee – if agreement is at all possible."[98]

At the end of February Thompson replied:

It took me a little while to get at the full text of your submission and, after that, to talk them over with the people who would have to administer any agreement we worked out. I realized immediately that, because of our relations with other members of the staff, it would be impossible to accept your proposals as made. I did think we might come up with a counter-proposal which might be used as a basis for discussion.

I'm afraid, however, that we are too far apart even for that.[99]

Despite the absolute nature of this rejection, Thompson left the door open for future cooperation between the magazine and Smith.

Perhaps we could leave it this way. If you have an idea which you think could be best presented in LIFE, tell us about it. If we have an idea which we think would interest you, we'll tell you. We can work out terms, I'm sure, on a per story basis. Perhaps some-

thing more permanent could come out of a trial period such as I
have described earlier in this paragraph.[100]

Between 1948 and 1954, Smith had gradually assumed editorial
prerogatives over the presentation of his photographic reportage. De-
spite a series of editorial concessions, however, he never did wrest
final control from the managing editor. Any illusions he might have
fostered concerning the degree of his authority were shattered by the
publication of "A Man of Mercy." He decided that severing all con-
nections with *Life* was the only way he could be assured of authorial
control over his photographs. This act of resignation was the resolution
of a conflict that had begun six years earlier and that had assumed
moral dimensions for Smith, as can be seen from an examination of
his practice of photojournalism.

# CHAPTER 6

# PHOTOJOURNALISTIC PRACTICE

## Conceptual Framework

Fine-art aesthetics did not motivate Eugene Smith's photographic practice; it was the possibility of charging his photographs with persuasive power. Smith understood the photographic essay as a rhetorically constructed, pictorial language that could be used to express a personal point of view. The photo-essay carried moral and humanitarian implications because of the sociopolitical impact of its mass readership. *Life* magazine had an influence on popular thought that outdistanced even its circulation of 7,000,000 readers. Smith felt keenly the responsibility of these implications. In his efforts to influence the public interpretation of his photographs, he actively participated in the lives of the individuals he photographed and became an advocate of their cause – Dr. Ceriani in Kremmling, Colorado; the Curiel family in Deleitosa, Spain; Maude Callen in Berkeley County, South Carolina; Dr. Albert Schweitzer in Lambaréné, West Africa. Because of the responsibility he felt toward the people and causes he photographed, Smith struggled to author his reportage, to make the photo-essay his direct, personal statement, and to sway public opinion.

In June 1948, Smith published a manifesto for correct photojournalistic practice.[1] Not only was it a call for specific actions, but its publication by the Photo League, an organization that had been blacklisted by the House Un-American Activities Committee, marked it as a political gesture.[2] In his statement, Smith insisted that photographers recognize the gravity of photojournalistic practice:

> Those who believe that photographic reportage is "selective and objective, but cannot interpret the photographed subject matter" show a complete lack of understanding of the problems and the proper workings of this profession. The journalistic photographer can have no other than a personal approach, and it is impossible for him to be completely objective. Honest – yes! Objective no![3]

Smith's understanding of the implications of photojournalistic practice was certainly aroused by his reportage of World War II. It would be a mistake, however, to attribute these ideas entirely to his war experience. Ironically, *Life* magazine editors also played a role. Al-

though unacknowledged in the literature on Smith, the year before Smith's essay in *Photo Notes*, *Life* picture editor Wilson Hicks published his own ideas about photojournalism, ideas that Smith would echo a year later. Hicks stated:

> One of the most effective methods of arousing public opinion today is that of socially significant photography properly planned and edited. In this field lie the greatest opportunities for the most talented and ambitious cameraman; here is the highest challenge for the thoughtful and *honest* journalist.[4]

While Hicks called vaguely for "socially significant photography," Smith went further and defined a humanistic practice of photo-reportage. He called attention to the fact that photographs, especially when published in the mass media, were used to sway public opinion. Smith left no question about the position of the photographer in this mass media practice. He wrote:

> Photographic journalism, because of the tremendous audience reached by publications using it, has more influence than any other branch of photography. For these reasons it is important that the photographer journalist have (beside the essential mastery of his tools) a strong sense of integrity and the intelligence to understand and present his subject matter. . . .
>
> The photographer must bear the responsibility for his work and its effect. By so much as his work is a distortion (this is sometimes intangible; at other times damnably obvious) in such proportion is it a crime against humanity. Even in rather "unimportant" stories this attitude must be taken — for photographs (and the words underneath) are molders of opinion and a little misinformation, plus a little more misinformation, is the kindling from which destructive misunderstandings flare.[5]

Traditionally, the sociopolitical implications of the picture story and of the photo-essay were the responsibility of the editor. Smith challenged this tradition and insisted that the responsibility for the impact of photographs was the photographer's. Smith developed a practice that was consistent with these lofty goals.

He demanded that photo-reportage not be something that was "snapped" during a two- or three-day stay; it must be the result of deep understanding based on significant research and on-site exami-

nation. For Smith, photo-reportage was a political action that articu-
lated the photographer's interpretation of the people and events he was
photographing. To do this properly involved intensive study, as Smith
stressed in his essay:

> It is the responsibility of the photographer journalist to take his
> assignment and examine it — to search with intelligence for the
> frequently intangible truth, and then very carefully (and some-
> times very rapidly) work to bring his insight as well as the physical
> characteristics of the subject, to his finished pictures.[6]

Smith's own practice began with extensive research.[7] At *Life* maga-
zine, background information was gathered by the staff and given to
the photographer. Smith carefully read these materials, annotated the
typescripts and tearsheets, and supplemented them with his own in-
dependent research. With this background, he often arrived at an
interpretation even before he left on assignment.[8] Once in the field,
he spent weeks on a single reportage, continually refining his photo-
graphic narrative. One criterion he used to gauge his success in arriv-
ing at an honest interpretation was his ability to gain the acceptance
of the people he was photographing. Smith alluded to the importance
of personal approval in a letter in which he described his coverage of
the British elections:

> Since my arrival here edged between overwork and depression
> until began to function with some good photographs, in fact (mostly
> for myself) have been making some of my best. Then I became
> involved in an election, photographically, intellectually, and emo-
> tionally. . . .
>   Prime Minister Atlee (*sic*) and our little group became rather
> good friends, would startle the rest of the press by coming over to
> us, to joke, talk, or just to point out something having nothing to
> do with the campaign or story.[9]

For Smith the establishment of personal relationships was critical to
successful reportage. As this passage shows us, Smith sought a privi-
leged position from which to report as an insider, a participant in the
events he photographed, rather than an outside observer.

Smith's own emotional involvement was inextricably entwined with
his photographic practice. He romanticized photo-reportage as a chiv-

alrous practice in which the camera was a weapon wielded against injustice. This understanding was made explicit when, while photographing in Spain, he saw a beggar who was denied bread by Spanish officials of the Catholic Church. He wrote heatedly about the incident, concluding, "edged closer trying to throw a punch with camera. . . ."[10] This crusading spirit characterized his photo-reportage; at times he even intervened directly in the lives of the people he was photographing, as when he gave a black baby in South Carolina a transfusion of his blood despite the disapproval of the white hospital staff.[11] This interpersonal, emotional commitment demanded a photo-journalistic practice that included authorial control.

His insistence on personal responsibility challenged traditional photojournalistic practice, which privileged editorial prerogative over photographic authorship. Historically, photographers did not attempt to influence the publication or reception of their work. The client/ editor owned the negatives and controlled their publication. Smith's call for photographers to recognize the public impact of their work and to assert their authorial rights to control the meaning of their pictures was a direct challenge to this hierarchical structure.

This was a radical position and was not universally supported by his contemporaries. Writing to war correspondent Red Valens, Smith related:

> [O]ne of the old Life "Professionals," visited me yesterday, there was a mention of the story I am going to attempt soon, he asked me how I was going to do it – I started to tell him of my feelings for that story and how those feelings throbbed in my mind in my heart, in my every inch of guts – in the giving of myself completely to it. The words started, dried as saliva on my lips. This man was and still is a good photographer – he and I have one incompatible difference – he will judge his success at the end of each year by the number of pages he gets in the magazine. I will judge by the quality of my page, or pages, and whether I have said what I feel needs to be said in that page, or pages.[12]

By 1954, Smith was the acknowledged spokesman for an ethical photojournalistic practice.[13] In 1952, Smith's pictures from the "Spanish Village" and "Nurse Midwife" photo-essays were included in the Museum of Modern Art exhibition *Diogenes with a Camera*. In its re-

view of the exhibition, *The New York Times* commented specifically about Smith's approach to photography:

> In these [photographs] the photographer appears to be as much a part of the experience he photographed as if he himself were concerned. The truth unfolds, therefore, in some measure autobiographical and self-regulatory. His approach is unique to American journalistic photography.[14]

Smith's fame as a humanistic photographer extended beyond the United States. Writing for the Swiss periodical *Camera*, Dr. Fritz Neugass wrote:

> Eugene Smith does not believe in "objectivity" of photography. Each photographer will see the same subject with different eyes and will thus attain a very personal interpretation. As straightforward and truthful it may be, it will never be "objective." In the case of Eugene Smith it is the social consciousness, the wish to help and to improve humanity, which is the strongest drive in his creativity. . . .
>  But more than his technique it is always his human approach which brings his photographs so close to us. His pictures penetrate us and captivate us just as very great works of art.[15]

What made Smith unique among his contemporaries was his appreciation of the moral implications of mass media photographic production, his public declarations of his values, and his idealistic and vocal battles with his editors for authorial control. In his attempts to assume this power, Smith developed a practice of photo-reportage that maximized his authority and influence over the publication of his photographs.

## The Negative

The aspect of photojournalism that was traditionally controlled by the photographer was the creation of the negative. Smith made thousands of negatives while on assignment. For "Country Doctor," "Spanish Village," and "Nurse Midwife" he made over 2,500 negatives each; for "A Man of Mercy" he made over 4,000. These large numbers seem excessive until one remembers the length of time Smith spent on as-

signment. He took twenty-three days for "Country Doctor," six weeks
for "Spanish Village," two and a half months for "Nurse Midwife," and
almost three months for "A Man of Mercy." During the shortest of
these four assignments, "Country Doctor," the production of 2,500
negatives meant that Smith used an average of only three rolls of film
a day.

Smith's contact sheets disclose his working method. He began his
reportage by shooting a wide variety of locations and situations. Then
as his work progressed, he refined his approach. Ted Castle, Smith's
assistant from 1949 to 1951, characterized his practice: "Smith's pho-
tographs were not something he grabbed, like a snapshot. They were
developed from his ideas."[16] Castle's comments are confirmed by a
careful examination of Smith's contact sheets. In looking through thou-
sands of contact prints one is struck by the paucity of different motifs.
One sees that he worked and reworked a single motif until he was
satisfied. This practice Smith accurately compared to that of a writer:

> If a writer says that he wrote twenty six versions of his last
> chapter, it is interpreted as showing what a diligent, careful, hard-
> working perfectionist he is. With a photographer it merely is in-
> terpreted as showing that if you take enough, some are bound to
> be good. When I am charged with doing a story, I must produce
> certain situations I know are necessary for the story. In the begin-
> ning I may photograph these even though I am not happy (even
> before taking) with the situation as it may stand, but I do this to
> get them under my belt, then I keep on searching for a better way
> to make the same point. Perhaps I will make another variation,
> will keep on searching, photographing the same point many times,
> discarding the thought of having to use the poorer interpretation
> each time I am able to lock up a better version. . . . I even chart
> the days shooting, marking after each subject, impossible, poor,
> fair, passable. . . .[17]

Analysis of Smith's contact sheets shows this constant reevaluation
and reshooting as he perfected the pictorial expression of single ideas
and motifs.[18]

An informative example of this refinement of pictorial presentation,
and of the photographer's ability to affect directly the editorial aspects
of the photo-essay, can be seen in pictures of the birth selected for
"Nurse Midwife" (figs. 64–67). Smith photographed over five births in
South Carolina before he made the photographs that were selected by

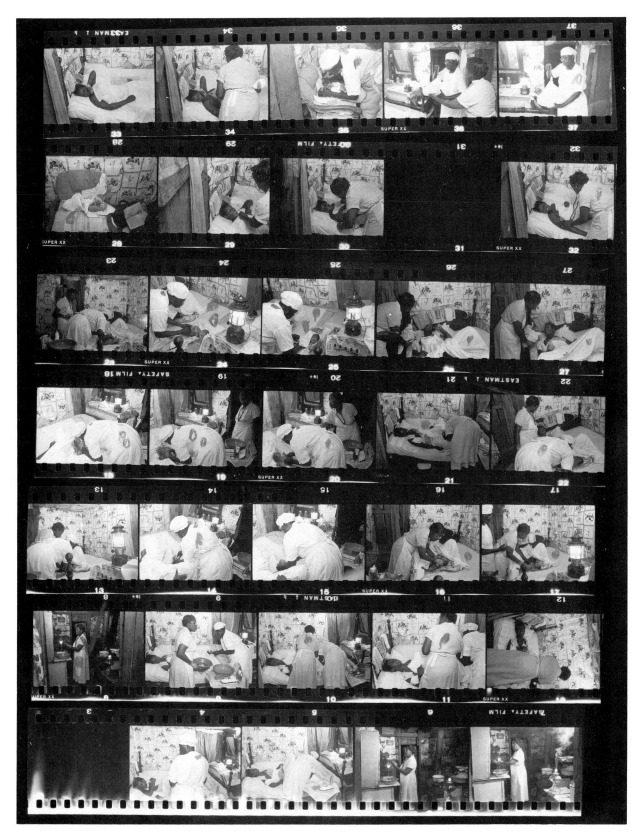

*108. Contact sheet from "Nurse Midwife." 1951. W. Eugene Smith,
copyright the heirs of W. Eugene Smith.*

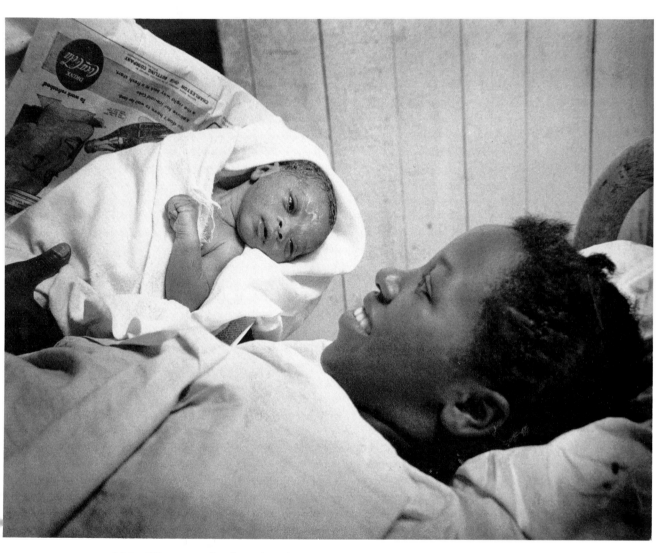

*109. Photograph of mother first seeing baby. 1951. W. Eugene Smith,
copyright the heirs of W. Eugene Smith.*

the editors. He photographed the first birth sparingly, using less than a roll of film. He shot increasingly more negatives with each subsequent birth and ended by documenting the entire birthing process — from the initial labor to the weighing of the newborn child — on over three rolls of film (figs. 108 and 83).

Each time he photographed a birth, Smith repeated specific motifs that he had chosen for their emblematic value. In each of the birth sequences, for example, he photographed the presentation of the baby to the mother (fig. 108, nos. 26 and 27; and fig. 109). His early attempts at capturing that emotional moment are unremarkable. In his final version, however, he arrived at a unique solution by moving behind the mother and photographing both her and the baby's first recognition of each other. This was a motif he selected for its emotional appeal to readers, but it also served his interpretive ends by acting as an implicit reminder of the need for continued medical care for both mother and child.

In his effort to author the meaning of his photo-reportage, Smith was willing to move beyond literal reportage. He told a camera club audience in 1954:

> [A]ll is not of a moment, all is not necessarily and absolutely as one finds it. I do not believe and I do not rearrange to suit my dramatic tastes, but I do try to search in the actuality to find what I consider the strongest way of saying what I arrive at as a way of interpreting what I am trying to do; that this took many exposures was because if I photographed at the moment that the flame was there and the smoke was not, then that was not the feel of this place.
>
> So, I feel free, and use it as sparingly as possible, to have a certain amount of readjustment direction in a photograph if, by doing this, I'm gaining an optical cohesiveness and a stronger editorial statement, if — and this is that great hinge word, which goes back to objective honesty — if the rearranging that I have done is of the spirit and the truth of the actuality.[19]

In some cases, this meant a subtle change in technique, in others a direct intervention.

If Smith could not establish a sufficiently strong picture he was not averse to posing the people he was photographing. In attempting to communicate, for example, the burden and responsibility of a country

doctor, Smith wanted a photograph of an exhausted Dr. Ceriani. Working on this idea, he posed the doctor in several different locations over the three-week period, making over 100 exposures using both $2\frac{1}{4}$ and 35 mm formats. He photographed Dr. Ceriani staring blurry-eyed at a patient's X-ray, pretending to be asleep on the examining table (fig. 110), and slumped in a chair. For the picture selected for publication, Smith posed the doctor in the kitchen area of the hospital. His picture of Dr. Ceriani clad in his surgical gown, slumped against the counter and balancing a cup of coffee and a cigarette, is one of his most successful (fig. 111).[20] Looking at the contact sheets, one sees how Smith achieved this effect. He had the doctor spread his feet until his arm was level with the kitchen counter. Smith moved around the doctor, shooting first from the left and then from the right side. The awkward position of the doctor's legs can be seen in nos. 11 and 12 (fig. 112). Smith, and *Life* editors, were careful to hide the photographer's intervention in the composition, selecting exposure no. 9, a negative that conceals the awkward spread of the doctor's legs.

Smith did not pose tableaux for the majority of his pictures; the technique he favored was directorial.[21] Using this approach, he would ask the subject to perform a certain action important to his interpretation of the photo-essay. He would then photograph the subject acting as requested. This approach had a double advantage. It allowed the photographer to exercise control over the actions of the people he was photographing and, at the same time, make negatives that appeared spontaneous. One example of a picture made in this way is the introductory photograph for "Country Doctor." Looking at the contact sheet (fig. 113), one sees that this is not a picture quickly snapped by the photographer. It is a photograph in which the cameraman carefully considered his vantage point, set his camera, and asked the doctor to walk across the field carrying his bag. This allowed Smith to make a picture that would introduce Dr. Ceriani surrounded by the signifiers of country life – a vacant lot, picket fence, and dark, brooding sky.

Exercising this control was a complex and a controversial practice. Wilson Hicks commented on this technique with regard to the "Spanish Village" pictures:

> By explaining to the villagers that he wished to tell who they were and what they did in the most interesting possible manner, and to draw the full import and most suggestive meanings from their ac-

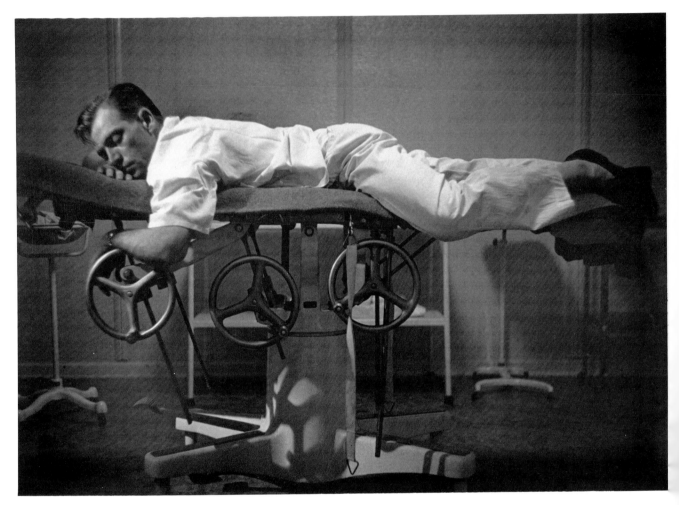

*110. Photograph of Dr. Ceriani*
*pretending to sleep on a hospital examination table. 1948. W. Eugene Smith,*
*copyright the heirs of W. Eugene Smith.*

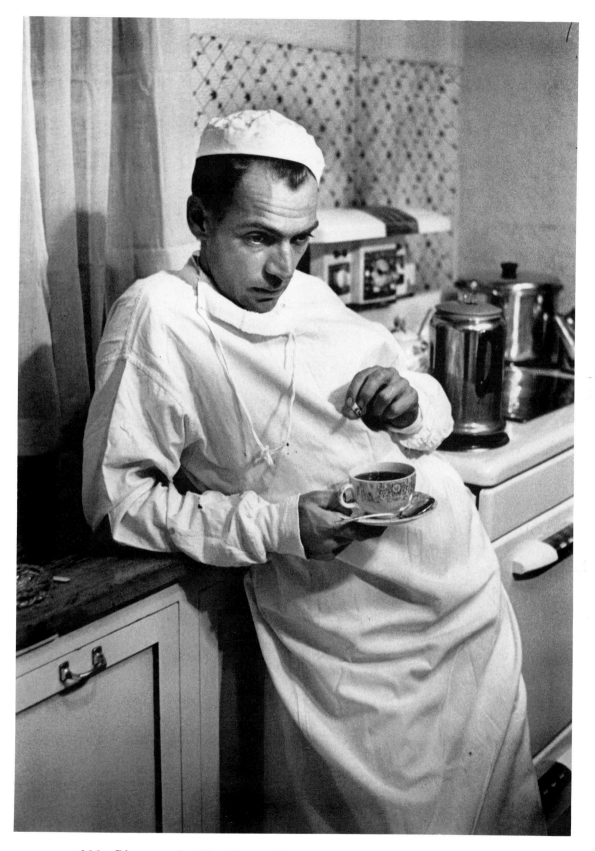

*111. Photograph of Dr. Ceriani leaning against a kitchen counter. 1948.*
*W. Eugene Smith, copyright the heirs of W. Eugene Smith.*

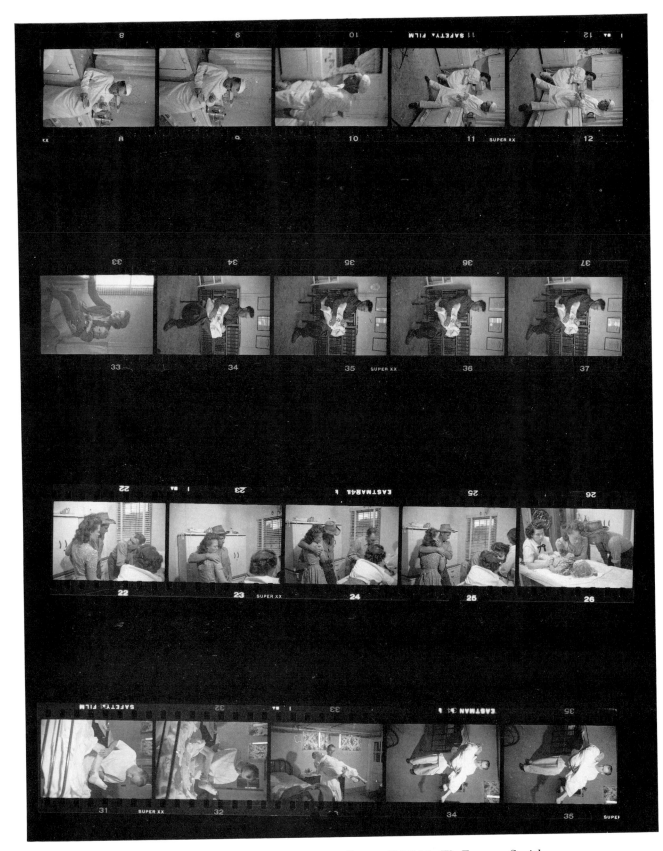

*112. Contact sheet from "Country Doctor." 1948. W. Eugene Smith,
copyright the heirs of W. Eugene Smith.*

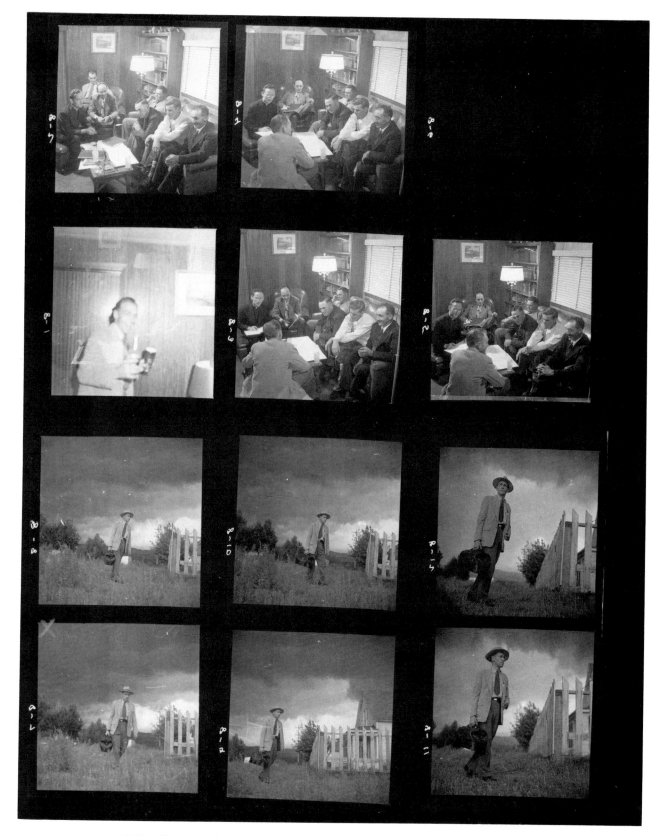

113. *Contact sheet from "Country Doctor." 1948. W. Eugene Smith,*
*copyright the heirs of W. Eugene Smith.*

> tions and appearances, *Smith made actors of them, but actors in a drama held strictly to the facts. For the camera they enacted consciously what they theretofore had done unconsciously; they did what they were used to doing better than they were used to doing it. In re-creating an actuality, Smith gave to it more power and beauty than it had originally.*[22]

Smith objected to this characterization of his method. He preferred to think of his technique as less contrived: "A 'happened' situation held briefly with an increased awareness of the camera."[23] Both descriptions of his practice, however, acknowledge that Smith initiated the person's action.[24] He favored this technique because it gave him control and, at the same time, masked the influence of the photographer.

The authorship of the photographic essay, then, was hidden in two layers of disguise: first, by the photographer who concealed his participation in the original event, and second, by the editors who gave a byline to the photographer in order to disguise the editorial superstructure on which the photographic narrative was built. These layers of masking – the photographer from the subject of his reportage and the editor from the ideological content of the publication – demanded a naive audience for whom the photograph represented unmediated reality. In his photographic practice, Smith propagated this myth by actively disguising his presence in the space and time of the picture; in his editorial practice, however, he tried to peel back the mask of the editor, insisting that the photographer-reporter shape the selection, sequence, and layout of the pictures as an author would a text. He applied this authorial imperative to his printmaking.

## The Print

For most photojournalists the creation of the negative was sufficient. *Life* photographers, for example, routinely sent their negatives to the photo lab while on assignment. Here the negatives were contact-printed and sent to the editor. Having photo labs print negatives was common practice for other photographers as well. For example, two well-known photographic contemporaries, Henri Cartier-Bresson and Bill Brandt, allowed their negatives to be printed by a photography lab.[25] Smith, however, fought for the right to make his own prints.

At the beginning of his career, his negatives, like those of his colleagues, were printed by the *Life* photo lab. The reproductions for "Country Doctor," for example, were not derived from prints made by the photographer. When they were published, however, the defects in the printing were obvious: the pictures were washed out with little light-and-shadow contrast. Smith was so disappointed in the quality of the reproductions that he reprinted the negatives and took them into the *Life* editorial offices. Smith demonstrated the difference between his prints and the *Life* photo-lab prints. At Smith's insistence, the editors agreed to allow him to make his own prints for his stories in the future.[26]

The editor's willingness to allow Smith to make his own prints was an important concession that carried with it authorial prerogatives. Doing his own printing enabled Smith to retain control over his negatives and to influence a second phase of photo-essay production: initial picture selection. At *Life*, when photographers turned their undeveloped negatives over to the *Life* photo lab, the rough selection of prints was made by *Life* staff members and the final selection by department editors. By developing and printing his own negatives, Smith assumed this control and made the first selection of his raw picture material.

Once he selected the negative, Smith printed it by building tonality and contrast. His film exposures were calculated for shadow areas; he adjusted his underexposed negatives in the darkroom. He printed the negatives by exposing them with short bursts of light, shadowing certain areas and at the same time burning light into other areas.[27] This process gradually built up tonal qualities as exposure was added incrementally. While maintaining the detail in the shadow areas, Smith darkened the majority of the print, subduing the photograph's incidental detail. The dark prints were then touched up with a bleaching agent, potassium ferrocyanide.[28] Carefully applying bleach onto specific areas of the surface, Smith brought the muted print to life by selecting highlight details. This process was an intricate one that often required meticulous hand painting of bleach onto the most minute details of the print.[29] When he was finished working on the print's surface he processed it in selenium toner, giving his black and white tones a cool intensity.[30]

Smith's technique of printing to darkness and bringing up the white tones created extreme contrasts in which brilliant highlights and deep shadows predominate.[31] Certainly this printing style was a response to

the requirements of photoreproduction, a process that favored high-contrast photographs, but it was also consistent with Smith's concept of photojournalism as emotional advocacy.[32] Looking at his contact sheets and his selected negatives, one sees that he favored melodramatic scenes. His darkroom practice increased this drama by stretching the contrast range to extremes, creating dramatic, theatrical photographs.

One example of the meticulous care with which Smith created the drama of a single print can be seen in his 1951 critique of a lab print of the introductory photograph for "Country Doctor" (fig. 114).[33] In red grease pencil, he wrote extensive directions, telling the *Life* printer to "keep darkest near the top gradually shading lighter going down — darken fence posts . . . white sky above posts." He included specific instructions for handwork — telling the printer specific sections to burn and dodge and instructing him on how to bleach the doctor's face and bush on the left.

Smith's printing practice was extremely unusual for a photojournalist and was, in large part, the consequence of his belief that through print quality the photographer could influence the reading of the photographs.[34] He told the Village Camera Club:

> The photographer here has little chance afterward to change, at least in unadulterated photography, in the printing. It is true that in that printing he may make further adjustments, balances; and I firmly believe that the making of a print is a completion of a photograph and irretrievably is the necessity of the photographer. I don't think that any really great writer would make his rough draft and then toss it to a secretary to put into final form; and I always find suspect composers who have to search and do search elsewhere for those who would orchestrate, because the subtle orchestral printing tones are extremely important. . . . [I]f I am trying to reach people, if I am trying to say something and if I am trying to say this as strongly as I can, why go to all of the other effort and then neglect one other way of reaching the reason that it all began; that a photographer also can take only what is there, has many variations. . . .[35]

The print, for Smith, was an aspect of the photograph's rhetorical structure and, therefore, could be manipulated to convey authorial intention.

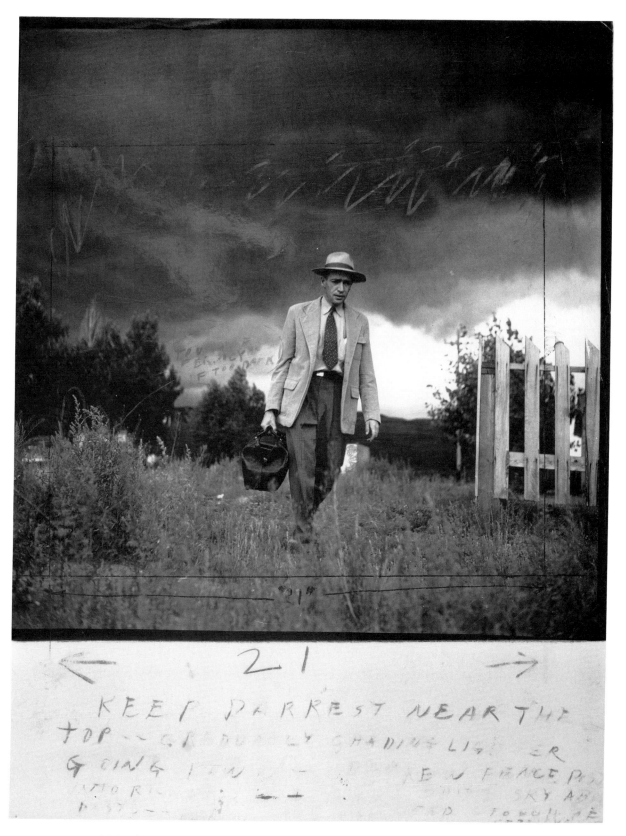

114. *Annotated print from "Country Doctor." 1951. W. Eugene Smith,*
*copyright the heirs of W. Eugene Smith.*

Smith's practice of printing to limit, or author, the reading of his photographs is demonstrated by two prints (figs. 115 and 116) made from the same negative. When he made the print shown in figure 115 in 1948, Smith darkened three of the edges in order to force the the viewer's attention inward toward the old man's gaunt face. When he reprinted the photograph in the late 1960s, however, he cropped the negative, vignetted the corners, darkened all four edges, and subdued the detail in the shadow areas (fig. 116). He bleached out selected highlights on the man's cheekbones, forehead, and eye, and cropped the figure of Dr. Ceriani. We see in this comparison one difference between a fine-art and a photojournalistic print. The first print, contemporaneous with the publication of "Country Doctor," includes the presence of the doctor and implies the context of the man's death. The later print cropped out this contextual information, drained it of its narrative potential, and placed it in the tradition of the fine-art death portrait.

Most *Life* prints display Smith's manipulation of print tonality as he continued his struggle to author his photo-reportage. As time went on, he grew bolder in his willingness to radically transform the negative. His darkroom practice became increasingly complex between 1948 and 1954. In its most simple form, his tendency to centralize his subject matter allowed him to crop his prints in the enlarger. He indicated cropping marks directly on the contact sheets. This technique usually served for only a minor tightening of the composition, but at times Smith's cropping was so radical as to create a new picture. One well-known image from "Spanish Village" (fig. 117) was constructed by extensive cropping in the darkroom. To make his picture Smith selected one woman's face from a crowd (fig. 118, no. 28), enlarged it, and by burning in certain areas created a moving and strongly graphic image.

Three years later, the Schweitzer reportage afforded an opportunity for an even more pronounced manipulation of the print. The picture of Albert Schweitzer that Smith intended for the *Life* cover (fig. 119) was not made in Africa but was constructed in the darkroom. To create the photograph, Smith used a portrait he had taken of Schweitzer with four native women in the background (fig. 120). He reprinted the picture, being careful to print deeply the areas around the left of the face (fig. 121). This dark print allowed him to disguise unneeded details; it also

gave him a clear line to cut out the figure. He then superimposed Schweitzer's portrait on a picture showing two small reed huts against a jungle background (fig. 122). The final print was very deeply printed with a strong graphic quality and highlights carefully bleached onto Schweitzer's face and helmet. This was a vision of the saintly Dr. Schweitzer set against a jungle backdrop.

While these are extreme examples of print manipulation, they demonstrate the extent to which Smith was willing to go to author an image. He routinely manipulated the formal elements of the photograph to author his photo-reportage. Research, intensive and exhaustive picture-taking, and carefully handworked prints were all used by Smith to communicate a personal interpretation to his readers. His posing and his directorial practice were in blatant contrast to the practice of many of his contemporaries and to the traditional view of candid, straightforward photojournalism. They were necessary because Smith understood the photo-essay as communication to a wide audience, a conception that demanded a self-conscious use of photographs to persuade. Smith pushed the motif and the print to its limits in order to convey his authorial interpretation. When "A Man of Mercy" was published against his express wishes, he was forced to choose between his work for *Life* magazine and the ideals he had publicly championed for over seven years. His choice was a predictable one.

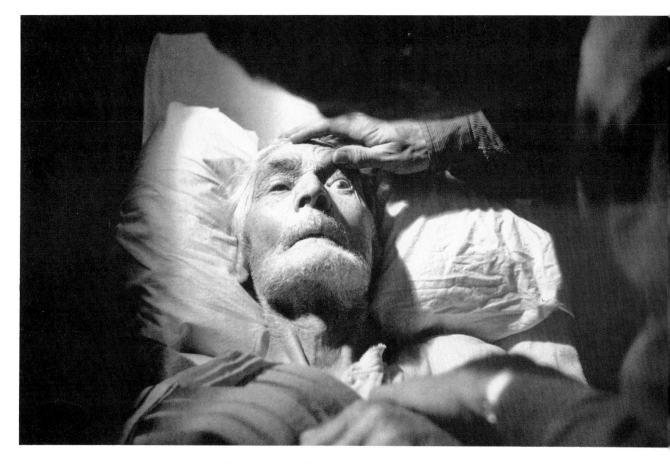

*115. Photograph of dead man from "Country Doctor."*
*1948. W. Eugene Smith,*
*copyright the heirs of W. Eugene Smith.*

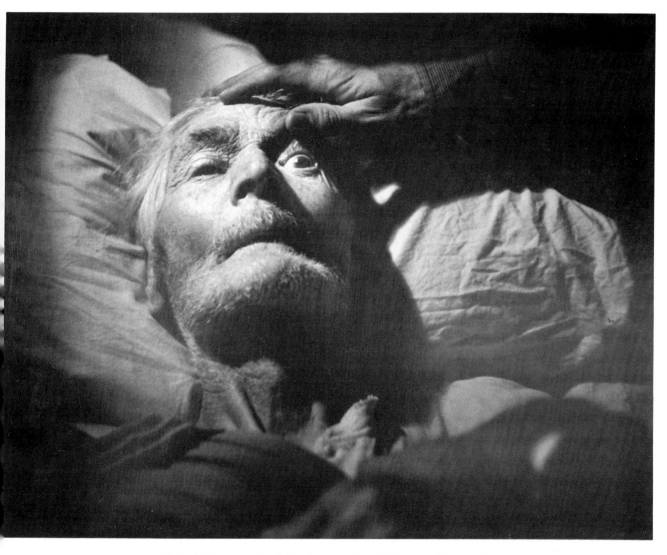

*116. Photograph of dead man from "Country Doctor."
ca. 1965. W. Eugene Smith,
copyright the heirs of W. Eugene Smith.*

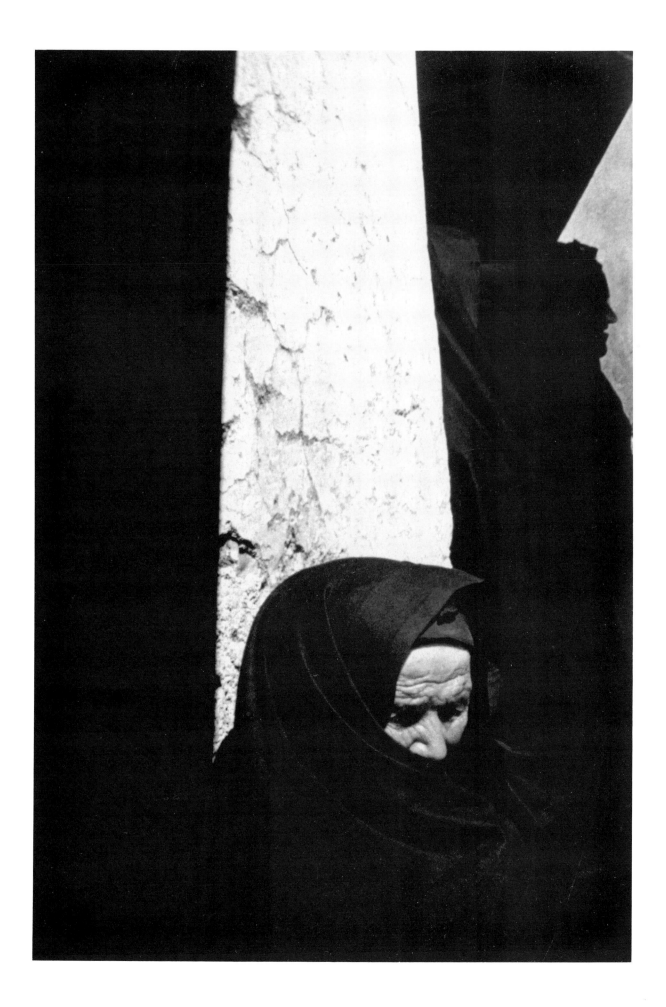

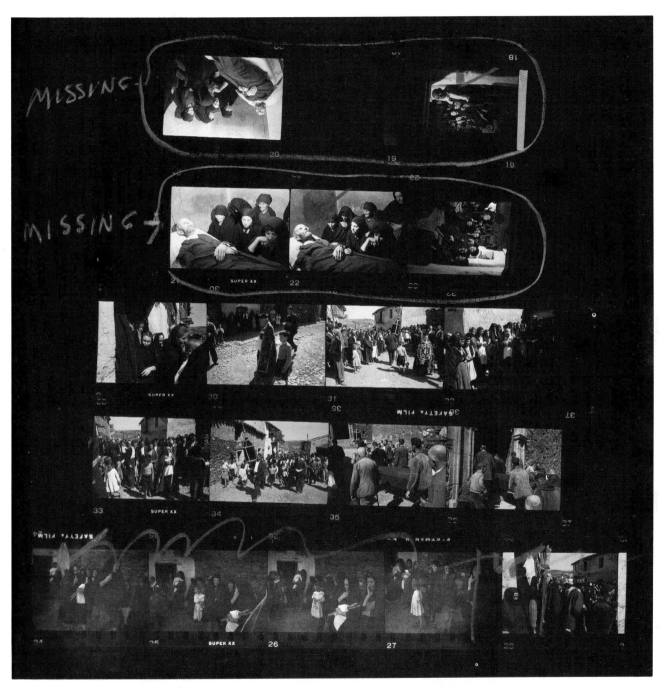

*117.* OPPOSITE *Photograph of mourning woman from "Spanish Village." 1951.*
*W. Eugene Smith, copyright the heirs of W. Eugene Smith.*

*118.* ABOVE *Contact sheet from "Spanish Village." 1950.*
*W. Eugene Smith, copyright the heirs of W. Eugene Smith.*

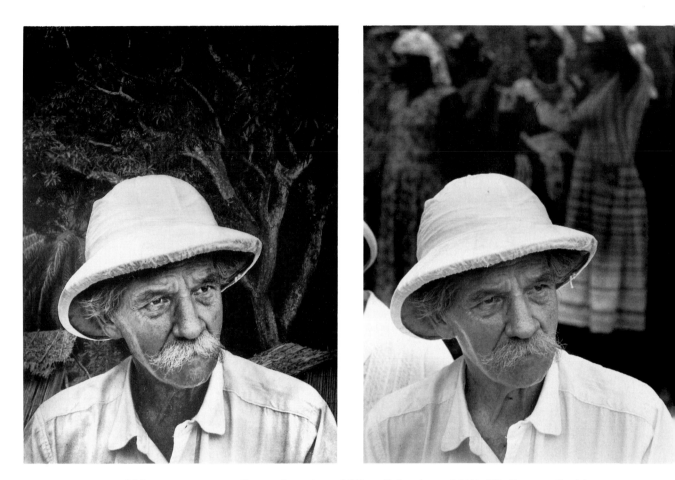

119.  ABOVE LEFT *Composite print of Albert Schweitzer. 1954. W. Eugene Smith,*
*copyright the heirs of W. Eugene Smith.*

120.  ABOVE RIGHT *Unmanipulated print of Albert Schweitzer. 1954.*
*W. Eugene Smith, copyright the heirs of W. Eugene Smith.*

121.  OPPOSITE ABOVE *Portrait of Schweitzer cut from print. 1954.*
*W. Eugene Smith, copyright the heirs of W. Eugene Smith.*

*122.* RIGHT *Landscape photograph from*
*"A Man of Mercy." 1954. W. Eugene Smith,*
*copyright the heirs of W. Eugene Smith.*

123. *"The Walk to Paradise Garden." 1946. W. Eugene Smith,*
*copyright the heirs of W. Eugene Smith.*

# CONCLUSION

In the years immediately following Smith's resignation, *Life* continued to dominate the field of the picture news magazine. But just as Smith had predicted in his letter to Thompson, toward the end of the 1950s *Life*'s position changed. Mass magazines had always relied on advertising as their main source of revenue, but with the increasing popularity of television, profit margins dropped and long-running magazines like *Collier's*, *Picture Post*, and *Coronet* were forced into bankruptcy. Why these failures occurred is dramatically demonstrated by comparing *Life*'s circulation to the growing number of television viewers. In 1945, when *Life* offered advertisers access to approximately 5,000,000 homes, there were six television stations serving only 10,000 customers. Less than a decade later *Life* readership had increased to 7,000,000, but over 200 stations brought television into 29,000,000 American homes daily.[1] Not even *Life*'s publishers could deny the huge market television provided its advertisers.

As revenues steadily declined, *Life* replaced managing editor Edward Thompson in 1962. His successor, Robert Hunt, responded to the competition from television by accentuating those aspects of the magazine that distinguished it from the new rival medium. For example, Hunt selected fewer photographs for publication and printed them in color, in large format, and on full-page or double-page spreads. This was designed to make the pictures more dramatic than the images on the small-screened, black-and-white TV sets of the time.[2] In a further recognition of the need to sell advertising space in a market dominated by television, *Life* editors used increasingly unusual pictorial designs.[3] To potential advertising customers *Life* salesmen argued that the innovations in design slowed the reading of the magazine and,

therefore, offered advertisers a more sustained consideration of their products than did a thirty-second television commercial.[4]

Hunt also responded to the superficiality of television reportage by accompanying photo-essays with extensive, in-depth articles. These written essays provided an elaborate context for the published photographs, at times relegating the pictures to the role of simple illustration.[5] Furthermore, photo-essays under Hunt carried the byline of the writer, a recognition that elevated the writer's status as "author" and diminished the role of the photographer. None of these changes, however, stemmed the loss of advertising revenue to television. Facing continued deficits, *Life* published its last issue on December 29, 1972.[6]

*Life*'s editorial attempts at challenging television left little room for the extended photographic essays at which Eugene Smith excelled. After resigning from the magazine staff, Smith worked as a free-lance photographer. He soon found out, however, that Thompson's warning had been accurate. There was no other commercial outlet for his in-depth, politically committed photo-reportage. No other mass magazine would give him authorial control; advertising, the main employer of commercial photographers, demanded single, eye-catching pictures. This was not Smith's forte; his great pictures came from his narrative reportage. More importantly, blatantly commercial photography was precisely what had driven Smith away from magazine work.

Despite these bleak prospects, in 1955 Smith received a commission that seemed ideal. Through the widely known Magnum photo-agency, he was offered an assignment to make photographs for a picture book about the city of Pittsburgh. He would be working with the pioneer European picture editor, Stefan Lorant. A former editor of the *Münchner Illustrierte Presse* and *Picture Post*, Lorant had retired from magazine editing in 1940 to begin publishing photographically illustrated books. For a volume about Pittsburgh, Lorant commissioned Smith to supply about 100 photographs. He gave Smith a brief, twelve-item list of motifs and a $500 advance for what he estimated would be a six-week assignment.[7] It was agreed that Smith would receive a final $700 payment upon delivery of the prints.

Smith dedicated himself to the project, investing it with immense personal significance. He saw it as an opportunity to demonstrate to magazine editors and colleagues that he was capable of working successfully outside the *Life* magazine system. His new authorial control and his intense self-criticism, however, stretched the six-week assign-

ment into months and, finally, into years. He shot thousands of negatives and made small work prints which he edited and reedited in endless layouts. Smith completely took over Lorant's project, refusing to make the 11 × 14 prints Lorant needed to publish his book. Even after he was forced to deliver the prints, Smith continued to photograph Pittsburgh.

After working for three years on the project, Smith talked to *Life* magazine about publishing an extended photo-essay using his pictures. Surprisingly perhaps, Bernard Quint and Edward Thompson responded positively. They worked with him for over a year and proposed several layouts, but Smith rejected all of them, forfeiting a $10,000 fee that would have prevented the eviction of his family from their home.[8] He did not give up the Pittsburgh project until late 1958, when Bruce Downes turned over an entire issue of *Popular Photography Annual* to him.[9] By that time, Smith had been working on the same assignment for over four years.

The Pittsburgh project demonstrated what many had feared when Smith resigned — that his problems as a photojournalist were more basic than his conflicts with *Life* magazine. The difficulties surrounding the completion of the Pittsburgh photographs are indicative of the problems Smith had with the editorial aspects of photo-essay production. He wanted to author his photo-reportage and foreground his personal and ideological reading of his photographs, but he could never arrive at the perfect picture sequence or at a definitive reading of his photo-text combinations. Smith was a perfectionist who tried to manipulate the subtlest nuances of photographic communication and to arrest the endless possibilities of pictorial signification. While courageously fighting editorial control from the outside, he never managed to live up to the challenge of becoming his own editor. His psychological problems — evidenced also by his heavy drinking — stood in the way of imposing a clear editorial perspective of his own.

The Pittsburgh project exhausted Smith's financial resources and his emotional health, but he continued to photograph. He undertook assignments for a wide variety of clients including Columbia Records, General Dynamics, and the Hitachi Corporation. He received three Guggenheim grants, was honored with an *Aperture* monograph in 1969, and had a large retrospective exhibition in 1971. These successes, however, were scattered and not significant enough to support Smith either financially or emotionally. He seems to have been constantly in

debt and subject to deteriorating emotional and physical health. Nonetheless, in 1975, he undertook a project that came closest to being the personal statement of committed, in-depth, moral reportage that he had been seeking since he left *Life* magazine.

Smith was in Japan with his Japanese wife Aileen when he first heard about Minimata. It was a small village whose fishing waters had been polluted by thirty-five years of chemical waste. The villagers were unaware of the danger until mercury poisoning had worked its way through the food chain and had begun to kill and maim the inhabitants of the city. The Chisso Company acknowledged responsibility for the chemical pollution and negotiated cash payments with most of the victims in the early 1960s. As more effects of the disease manifested themselves over the next decade, however, twenty-nine families sued the company for further compensation. Smith saw it as a moral crusade involving a handful of impoverished, injured men, women, and children against the corporate resources of the Chisso Company and against the Japanese government, which had approved the settlement. This imbalance was ripe for the dramatic, emotional advocacy at which Smith excelled. Eugene and Aileen Smith spent three years documenting the court trial, the demonstrations, and the human victims of the Chisso mercury poisoning.

Extensive research, exhaustive photo-documentation, and compassion for the victims notwithstanding, Smith had difficulty completing the book-length project. It would have failed entirely had it not been for the extraordinary attention of publisher Larry Schiller. In late November 1974, Eugene and Aileen Smith returned to the United States to prepare the Minimata reportage for publication. One hundred and eighty images had been selected and formats had been chosen, but the layout had not been decided, nor had any text been written. Schiller rented an apartment for the Smiths and arranged for John Poppy, a professional writer and editor, to assist them in completing the book. The work was divided but it wasn't long before the project deteriorated into a series of heated arguments that centered on Eugene Smith's unwillingness to share control over the publication.[10] In spite of conflicts so emotional that Smith threatened, on more than one occasion, to walk away from the book, it was completed within six weeks. Once more, and ironically perhaps, Smith's own inability to impose a clear editorial structure would have led to failure had it not been for his grudging acceptance of outside editorial assistance. *Minimata* re-

ceived widespread critical acclaim and brought public attention to the
dangers of chemical waste.[11] But it came too late in Smith's career to
influence photographic practice significantly.

Far more influential was Smith's photojournalistic contemporary,
Robert Frank.[12] Like several other successful photographers of the
1960s, Frank published his work in mass magazines before turning to
the book format.[13] Unlike Smith, however, Frank did not call for com-
mitted photographers to use their photographs for moral good or social
change. His book *The Americans*, published in the United States in
1959, used photographs to offer an outsider's critique.[14] Frank's photo-
reportage deconstructed photojournalism's romantic, utopian fantasy
of an affluent, homogeneous American society by depicting the vac-
uous and corrupt aspects of American consumer culture.[15] Further-
more, Frank's "snapshot aesthetic" and grainy printing style were di-
ametrically opposed to Smith's carefully composed, hand-manipulated
images.

Not only the photographers, but the critical community of the 1960s
and 1970s turned away from Smith's advocacy in favor of Frank's de-
tached, impersonal critique.[16] This shift was evident institutionally as
well. Edward Steichen, director of the Museum of Modern Art Depart-
ment of Photography from 1947 to 1962, was a champion of Smith's
photographic work. He understood photography in the same way Smith
did, as a form of communication rather than as an art existing for its
own sake, and had included photojournalism in many of his exhibi-
tions. Consonant with this understanding, during his tenure at the Mu-
seum of Modern Art, Steichen's curatorial procedure shared similari-
ties with editorial practice at the large picture magazines. Like a picture
editor, Steichen presented large, thematic exhibitions that were se-
lected and arranged by the curator and aimed at an intended audience,
without regard for the original intentions of the photographer.

For example, his tremendously successful *The Family of Man* was
an exhibition that transformed the museum space into a three-dimen-
sional photographic essay.[17] Photographs were thematically arranged
to convey a spirit of brotherhood among all nations of the earth. For
the exhibition, Steichen used several Smith photographs to communi-
cate this point and gave particular prominence to Smith's "The Walk
to Paradise Garden" (fig. 123). This photograph was Smith's most widely
recognized and one of his most sentimental.[18] He uses a low camera
angle to monumentalize two young children who walk out of a dark

foreground toward a brightly lit background. Steichen selected this photograph as the embodiment of *The Family of Man*'s theme of universal peace and hope. He had a three-feet-by-four-feet print made and placed at the conclusion of the exhibition.

This critical support changed when John Szarkowski became director of the MOMA Department of Photography in 1962.[19] Szarkowski de-emphasized thematic exhibitions and promoted, instead, a formalist aesthetic of photography that favored surprise, the unexpected, and the self-referential while shunning social context.[20] Monographic exhibitions concerned with the formal issues of the medium began to predominate at the Museum of Modern Art. As Szarkowski articulated a set of formal characteristics that removed the photograph from the specificity of its time and place, photojournalism began to fall by the wayside as a valid form of photographic expression.[21] Smith's concept of morally committed photojournalistic practice addressed to society at large (rather than to a sophisticated metropolitan audience) had little place in this canon.

Smith's last years were especially difficult. He had enjoyed his greatest personal success with *Minimata*. With the book he had broken the tight mold of the *Life* magazine format and had expanded the possibilities of the photo-essay form. The making of *Minimata* had exacted a terrible price, however. While researching the story, Smith was beaten by Chisso Company guards so severely that he was unable to undertake any more photographic assignments. Under tremendous financial strain and rapidly declining health, Smith was offered a position on the faculty of the University of Arizona in 1977. He accepted and moved to Tucson, but during the following year and a half he suffered a series of strokes. He died on October 15, 1978.

The historical evidence regarding the impact of Eugene Smith's resignation from *Life* is inconclusive. At the magazine's offices there was little change in the hierarchical relationship between photographer and editor.[22] In general, among his contemporaries, Smith's resignation was perceived as a gesture of an idiosyncratic frustration. Both editors and photographers understood that Smith was an emotionally difficult man who tended to endow his clashes with editors with the aura of a personal crusade. His commitment to the people he photographed and to the "authorship" of his photographic essays was seen by many as a matter of arrogance rather than principle.

It is equally difficult to point to specific examples of Smith's influence on photographers. His dark, brooding printing style did not find many ready followers. Nor did his insistence on emotional commitment to the people being photographed. His belief in photography as a committed "inside" practice was shared with the "New Journalism" of Danny Lyon, Bruce Davidson, and Larry Clarke, but their photographs, particularly those of Lyon and Clarke, convey a cool detachment that has more in common with Robert Frank than with Eugene Smith.

Nevertheless, references to Smith by photojournalists are abundant.[23] He was influential for later generations because of the perception of his idealistic rejection of the demands of crass commercialism. To cite a recent example, the 1990 Droit de Regard Manifesto demands the recognition of photographers as authors. Smith's symbolic presence in this movement, twelve years after his death, is made explicit through references to his writings.[24] But perhaps the most obvious example of the force of the mythology surrounding Smith is the annual W. Eugene Smith Grant. A fund was established at Smith's memorial service in 1978, intended to "further the lifetime goals of W. Eugene Smith."[25] Begun with small contributions, it has gained corporate sponsorship and now awards a grant of $20,000 annually to a selected photographer. The brochure that advertises the grant carries a brief biographical statement which is typical of the way in which portions of Smith's life are conflated with his photographic work:

> Gene Smith was a loner, a driving and driven man, who bucked the system he was a part of. Some say he sacrificed his career, and himself, on an altar of self-destructive idealism. When he died at the age of 59 in 1978, he had $18 in the bank. But his name had become synonymous with integrity. His work was his memorial.[26]

The endurance of Smith as a symbol was further memorialized by the International Center for Photography exhibition *The Human Spirit: The Legacy of W. Eugene Smith*.[27] Smith was certainly idealistic, yet one may wonder whether his mythic persona is not beginning to lose touch with the reality of his photographic practice at *Life* magazine.[28]

Before he was forty, Smith was acknowledged as a master of the photo-essay. His willingness to dedicate himself completely to his photo-

reportage and his insistence on an emotionally committed, humanistic interpretation of each assignment made him unique among his contemporaries. Through his photo-essays for *Life* magazine, he came to see that subtle textures of sociopolitical meaning were woven as much by editorial decisions as by those of the photographer. He fought continually for an "authorial" photojournalistic practice that privileged the photographer's interpretation over that of the editor. America was enriched by Smith's courageous struggle. It is a sad irony that his departure from *Life* magazine opened a Pandora's box of personal evils, intense self-criticism, and agonizingly inconclusive attempts at self-editing that silenced Smith's voice in a far more effective way than any magazine editor could have.

# Appendix A

## Chronology for "Spanish Village"

This chronology is based on notes from the pocket calendars of W. Eugene Smith and his assistant, Ted Castle. All entries within quotation marks are direct quotations from Smith's calendar; Castle's notes appear without quotation marks; my own words are bracketed. I am extremely grateful to Mr. Castle for reconfirming the chronology and sharing his information with me.

### 1949

| | |
|---|---|
| December | [Smith leaves United States to cover British parliamentary elections.] |

### 1950

| | |
|---|---|
| January 3 | [Smith arrives in England.] |
| January 4 | [Ted Castle, Smith's assistant, arrives in England and is met by Smith.] |
| January 17 | "Lost gloves in mine" |
| January 19 | "Hire of lorry, driver and herd of cattle £8" |
| January 27 | "5 miners wage – 10 shillings each" |
| January 28 | "Return" |
| February 7 | "Packing for Atlee" |
| February 8–9 | [Birmingham.] |
| February 13 | [Glasgow.] |
| February 14 | [Edinburgh.] |
| February 15 | [London.] |
| February 20 | [*Life* publishes two Smith photographs in story on British campaign.] |
| February 22 | "Election" |
| | "Cables concerning prints, past, story" |
| February 23 | [British Labour Party declared a winner by small margin.] |
| March 5 | [Smith arrives in Paris.] |
| March 6 | [*Life* publishes two Smith photographs in story on outcome of British elections. *Time* publishes story about Franco's summary jailing of political opponents.] |
| March 11 | "Left for Toulouse" |
| March 18 | "Returned to England" |
| March 22 | "Left for Paris" |
| March 23 | "Gave Nina 20,000 Francs" |
| March 24–26 | "Ill" |
| April 1 | [Smith pays hospital lab fee.] |
| April 14 | "Left hospital bill approximately 80,000 Fr. Life also advanced 50,000 Fr. from [undecipherable name]" |
| April 27 | [Smith returns to London, rejoining Castle.] |
| April 28 | [Smith flies to Paris.] |
| April 29 | [Smith again returns to London, rejoining Castle.] |

|            |                                                                                 |
|-----------:|---------------------------------------------------------------------------------|
| May 1      | [Smith and Castle leave for Paris.]                                              |
|            | "Used $100 Travel Check"                                                         |
| May 2      | [Smith receives letter of introduction from Spanish consulate.]                 |
| May 3      | "Left for Paris . . . stayed Tours"                                             |
| May 4      | [Bordeaux.]                                                                      |
| May 5      | [Smith, Castle, and translater Nina Peinado cross border into Spain.]           |
| May 6      | [They drive through Guernica, stop in Pamplona.]                                 |
|            | [San Sebastian.]                                                                |
| May 7      | [Cervesa.]                                                                       |
| May 8      | [Barcelona.]                                                                     |
| May 9      | [Valencia.]                                                                      |
| May 10     | [Taracon.]                                                                       |
| May 11–12  | [Toledo.]                                                                        |
|            | Saw El Greco.                                                                    |
| May 13–17  | [Madrid.]                                                                        |
| May 17     | Bullfight                                                                        |
|            | "Gasoline burner to heat water for chemicals"                                    |
| May 18     | [Valverde.]                                                                      |
|            | "Two cartons cigs for favors"                                                    |
| May 19–21  | [Madrid.]                                                                        |
| May 22     | "Left Madrid"                                                                    |
|            | [Toledo and Cuidad Real.]                                                        |
| May 23     | "Left Cuidad Real"                                                               |
|            | Granada (expensive hotel. Carlos V)                                             |
| May 24     | Malaga: horrible slums, beautiful parks, expensive homes on edge                |
| May 25–27  | "Anteguern [?]; arrive Seville"                                                  |
|            | Car problems: fan doesn't work                                                   |
| May 27     | "Left Seville; Fuente de Cantos"                                                |
| May 28–June 7 | "Left Fuente de Cantos; Madrid"                                               |
| May 28     | [*ABC* of Madrid publishes article "Meditations on a Nameless Village."]         |
| May 30     | Madrid: developed negatives in bathtub                                          |
| June 2     | Went to ballet in Madrid                                                         |
| June 7     | Headed out to look for village. 109 kilometers battery gave out. Also a blowout. Return to Madrid |
|            | "Had to return to Madrid"                                                        |
| June 8–15  | "Left Madrid arrived Trujillo"                                                   |
|            | Found the village! Stayed in Trujillo                                            |
| June 9 or 10 | [They meet women ("lady friend") critical to their success in Deleitosa.]     |

June 12    Back to Deleitosa; saw mayor and padre again — possible family found

June 13    Procession . . . ran with ladder
           [Castle remembers this as day of Lorenza Curiel's First Communion.]

June 14    Long walk with lady friend, much information

June 15    Village laid out plots of land; headed back to Madrid
           "Left Trujillo . . . Madrid"

June 16    [Smith bought Spanish catechism.]

June 16–17 [Madrid.]

June 18    [Smith, Castle, and Peinado go back to Trujillo and Deleitosa.]

June 19    Gene had bad day again

June 20    [Deleitosa.]

June 21    Burial in Deleitosa

June 22    4 miles out of Trujillo, shimmy in front so bad we could not go over 20 mph

June 23    [Return to Madrid.]

June 24    Madrid: stayed in the Hotel Lee
           "Madrid — doctor for Ted"

June 28    [Smith buys manila folders, paper clips, and carbon paper for research work. Smith and Peinado then leave for Trujillo and Deleitosa; Castle remains in Madrid with fever and sore throat.]

June 30    "Donation to Church for procession, Mass"

July 1     "Trujillo hotel"

July 2     "Arrived Madrid — Churchill"
           Maybe this week will end story; car has broken springs

July 5     "Car stalled 47 miles from garage — had to hire taxi to bring mechanic & equipment (round trip) 1000 pts. — repair 175 pts."
           "Having trouble with Guardia Civil at that moment — did not get receipts"
           "plus 50 pts for car taking us to telephone"

July 7     "Trujillo hotel"
           [Smith and Peinado are accosted by Guardia Civil; they leave soon afterward.]

July 8     Left Madrid 4:35 A.M.; San Sebastian 11:00 A.M.; crossed border 1:00 P.M.
           [Castle enters hospital with tonsillitis.]

July 9     "Arrive Tours"

July 13    "Left Paris"

July 15    London; developed 45 rolls of Spain this night

| | |
|---|---|
| August 9 | Left London for Paris |
| August 11 | Return to England |
| August 13 | [Smith and Castle leave London for Frankfurt, West Germany.] |
| August 14 | Arrival in Germany to go to Leica factory; bought 85 mm lens [*Time* article acknowledges U.S. dislike of Franco, but argues for Spain's strategic importance in fight against Communism.] |
| August 19 | [Smith and Castle leave Germany for London.] |
| August 21 | [Date stamped by *Life* on the verso of several "Spanish Village" contact sheets ($2\frac{1}{4}$ negatives).] |
| August 25 | [Smith leaves Europe for New York.] |
| September 5 | "Jo Havey 8:30 20th St. 251 4th Ave. *Modern Photog.*" |
| September 6 | "Call about prints for U.S. Camera" |
| September 9 | [Castle leaves England for the United States.] |
| September 20 | [Castle arrives in United States; Smith in hospital.] |

**1951**

| | |
|---|---|
| February 26 | [*Time* publishes editorial stressing military importance of Spain and value of Spanish Army in fight against Communism in Europe.] |
| March 18 | [Barcelona uprising.] |
| April 9 | [*Life* publishes "Spanish Village."] |
| December | [*Modern Photography* and *U.S. Camera Annual* publish variations of *Life*'s "Spanish Village."] |
| December 24 | [*Time* runs photograph of Franco with his wife and baby granddaughter; article applauds inclusion of Spain as U.S. ally.] |

## Appendix B

### Primary Documents for "Nurse Midwife"

These primary documents from the making of "Nurse Midwife" are typical of the preparation and completion of a W. Eugene Smith, *Life* photo-essay. Presented, in chronological order, are a memo outlining the initial editorial concept of the photo-essay; the shooting script; the typescript and tearsheet information gathered as background research for the photographer; Smith's notes while on assignment; the caption and research text Smith wrote after he returned from South Carolina; a letter from *Life* managing editor Edward Thompson to Smith after publication of "Nurse Midwife" (including Smith's annotations); and a letter critical of the photo-essay.

TO: RAY MACKLAND                                     April 13, 1951

FROM: NANCY GENET

OUTLINE FOR ESSAY ON "MIDWIVES"

Purpose: We have in mind a real honest-to-gosh grass roots human interest essay on

midwifery - a phase of American medicine that is little known, rarely publicized,

and still very important in many sections of the country. Two types of midwivery is

practiced in the U.S. today: first, there is the modern, progressive type of midwivery

found in such states as South Carolina, where the state health officers conduct

demonstration classes at which young and middle-aged women are shown what to do and

what not to do in pre- and post-natal care, in deliveries, and in hygiene and nutrition

of mothers. These trained-midwives are licensed, carry special midwife bags equipped

with all necessary equipment, and go out in all kinds of weather and to all types of

communities near their home towns. They really do a wonderful job, and the difficulties

they cope with in modes of travel to distant homes and in types of cases they have to

handle are really tough. They are a great help to doctors and the state health department

in states where hospital facilities for deliveries are insufficient; they become VIPs

in their home villages, are ~~considered important~~ respected as much as the local mayor or minister. Secondly,

there is the old-fashioned type of midwifery, a hang-over from pre-Civil War days that

nevertheless survives in such states as Louisiana, where midwives are untrained, unlicen-

sed old "granny women" who generally belong to some plantation and carry on their

practice from there, trekking to other distant communities, and delivering numerous

mothers who otherwise would get no care at all.

There are three basic situations around which the photographer should weave his

story: 1) a good midwife club meeting. These are the meetings held a few times every year

in a midwife home or in the local church, at which a visiting nurse-midwife from the health

bureau comes to show with most realistic demonstrations the do's and dont's of midwifery

and to inspect the midwives' bags, give them new supplies, and give new midwives their

licenses. Generally at the end of these meetings the midwives (who mostly are Negroes),

sing midwife songs with much clapping of hands and "Yeah, man" rhythm.  2) a sequence on

one particular midwife. The photographer should stay with her over a couple of weeks
anyway, following her on her rounds, showing the difficulty she has in travelling to
her scattered cases, the assortment of problems she meets up with (mothers ask her
about diet for their kids, or she tries to show them how to keep a bit more sanitary,
or she discovers one mother has complications and must be gotten to a clinic etc.).

3) This point is corallary to the second — we want to pick a midwife, and a community,
where there will be the maximum variety of background, both in the types of homes
visited by the midwife and in the types of territory, of scenery, she has to traverse
on her rounds; and we'll try to pick a midwife who travels by more than one means — maybe
one who gets to some communities by boat, to others by wagon, to others by foot etc.
We do not want point pictures, or pictures showing women in clinics etc.; emphasis will
be on human interest.

**When:** As soon as photographer can get off - this week (April 16-23) if possible.

**Where:** Two states: Louisiana and South Carolina. Stringers in both these states have
sent me data on the best communities and will have final wires Monday. Photographer
should see me about the people to contact, communities to visit. We leave it up to the
photographer to pick the community he feels offers the best pictorial possibilities, and
we leave the precise pictures up to him - the three bases mentioned above should be
guidance enough.

RE: MIDWIVES

TO: GENE SMITH
FROM: NANCY GENET

May 1, 1951

South Carolina

1. Who has done preliminary legwork there: Jack Leland, 2 Trumbo St., Charleston. He'll

be attending Time Inc. conference this week.

2. Contacts: you should immediately call on Dr. Ben F. Wyman, head of the state Health

Department, Wade Hampton State Office Building, Columbia, S. Carolina. Tel: 2 - 6321

(his home is 1012 Laurens St., Columbia, Tel: 6606). He at first was reluctant to help us

because he doesn't like Lucepapers - but after Leland assured him we wanted to show that

South Carolina has somewhat of a model program in midwifery and that our approach would

be positive, not negative, he finally has OKd the program provided we check for accuracy

with him - which we'd do anyway.

If he should be away when you arrive, he suggests you contact Dr. Hiller Sheriff, his

assistant, who also knows our plans.

If you should need a reporter and Leland is away, contact Tom Peck of the News and

Courier (Leland has briefed him); tel. 5522.

The woman who knows most about the midwife situation, and to whom Dr. Wyman probably

will end by referring you is Miss Laura Blackburn, nurse-midwife consultant for the state,

at State Department of Health in Columbia. She knows about our plans but won't move

without Dr. Wyman's approval. She'll be able to tell you everything you want to know about

midwifery, is considered a wonderful person of great experience.

3. The layout: this state is considered to have the best midwife-training program in the

country. There is a large number of Negro and white midwives, and in many areas doctors

are practically non-existent so the midwives are a boon. In order to get variety of

modes of travel, etc. you may find that you will have to follow a couple of midwives

rather than just one, for there is great variety of locale: in the mountains the midwives

generally go on foot into the hollows and up the trails; to get to the sea islands south of

Beaufort they go by boat; and there are stretches of low country swamps and pine barrens

without any roads at all. There are periodic midwife meetings held by nurse-consultants.

The patients are very superstitious, so sometimes the midwives have to cater to their

superstitions provided the latter don't interfere with proper hygiene.

more

## Georgia

1. Person who has done legwork: Coles Phinizy, Atlanta Bureau. He'll probably be back from the Time conference by the time you get to Georgia. Office is in Rhodes Haverty Bldg.

2. Person you should consult first is Miss Marion Cadwallader, consultant-nurse, State Office Building, Atlanta; tel: Main 4033. Better phone her couple days before arrival because she's a mighty busy person and is always off on tours or meetings. But if you give her warning, she can devote a couple days to traveling with you to likely spots. There seems to be no suspicion of Life's motives re midwives in this state.

3. The layout: for midwife meetings the south central counties of Crisp, Tift and Bleckley are the likeliest, and Blackburn says she can postpone or re-arrange a meeting to suit your convenience. As to following one midwife, these counties would be dull pictorially as far as local setting, so Blackburn is scouting for likelier spots in the mountain section of the state and also along the Okeefenokee river. Modes of travel generally are car or truck, the husband coming to fetch the midwife with whatever conveyance he can muster. The midwife program also is good in this state.

## Mississippi

1. Person who did legwork: Kenneth Toler, Commercial Appeal Bureau in Jackson (home: 917 Fairview St.). Also Dave Dreiman talked with Dr. Underwood by phone and at one point had him convinced.

2. Person to see if you bother with this state: Dr. Felix Underwood, head of the board of health, Jackson. He finally decided he would not cooperate with us because, despite a letter from me outlining our idea for the essay, he thinks we will end by making Mississippi look backward! He also would insist that someone in his bureau accompany you at all times.

3. The layout: the midwife program is good, probably second only to South Carolina. There are midwife meetings. The scenery is rather monotonous. 75% of all Negro births in the state are handled by midwives, according to Underwood admission.

## Louisiana

1. Person who has done legwork: John Wilds, New Orleans States.

2. Contacts: Dr. S.J. Phillips, State Health Officer, dept. of health in New Orleans, is top contact; he is most cooperative. Then comes Dr. C.L. Mengis, health officer in charge

of the likeliest community (St. Landry Parish), at Opelousas; he also is most helpful. Finally there are the nurses - Lilian Jeffers, chief registered nurse, and a Negro nurse-consultant, Deola Lange, who probably would be the one to accompany you to St. Landry parish and introduce you to midwives. There is also a Dr. James Ferguson at Tulane University who is a sociological historian and has written about midwivery; we've consulted him from time to time.

3. The layout: this state is swell as far as appearance of locale is concerned; but if we did the story there the whole approach would be negative, for there is really no midwife-training program, none of the younger women are learning to be midwives, the health department looks on midwivery as an unfortunate custom which is practically dead and claims that any woman can get free ambulance service and care in a hospital and that therefore there is no need for midwives, and the few remaining midwives are old, superstitious, and pretty unsanitary "granny women" towards whose elimination such good programs as that in South Carolina are aimed. The/grannies, often in their eighties, still deliver some 15% of the state's births, mostly Negro but some poor whites; the midwives go out to isolated homes within about 15 miles of their home plantations. The patients are highly superstitious, and supposedly, you are likely to see an ax under the bed "to cut the pain," or the husband's hat upon the woman's head "so the father can share the burden." There are only a very few licensed midwives in Louisiana and they are all in the cities. St. Landry parish is about 120 miles from New Orleans, has about 80 old granny women, includes sweet potato farms, bayous and some of the Atchafalaya River swampland.

Edey says he doesn't think we could include both the old granny type of midwifery and the progressive South Carolina type in the same essay; so I hope South Carolina works out (or Georgia, or perhaps Mississippi) because otherwise it means doing it in Louisiana and showing the old backward custom that is dying out.

History of Midwife Program in South Carolina.

In 1915 the Birth Registration Law was passed requiring all persons in attendance at births to register these births, especially midwives.

Prior to 1923 when the Federal Funds, (Sheppard-Towner) 7 year demonstration im maternal and child care) were released. Seven public health nurses were put out to locate and group midwives in an 8 mile radius for instruction in each county. Ten lessons were taught from an outline. Laws were adopted (1922) and certificates granted at the completion of the course. These certificates to be renewed each year. A bag was adopted. This was a blue cloth circular bag with pockets and a draw string. 2 basins were placed in the bottom, then the items as outlined were in the pockets. This was changed to a leather bag with a snapped in lining about 1926. The laws have been changed from time to time to meet a need.

The midwives were located through the birth certificates. The salary of a clerk was paid to list the names of midwives from these certificates and pass on to the nurse in the area. The doctors and Registrars helped some.

After being rouped and taught the midwives were turned over to the county health departments for further instruction and supervision.

Up to 1936 there were only 20 such health units. Where there were no health departments, the consultant nurse went into the counties twice a year. Checked bags and reports, dispensed supplies at cost and renewed the certificates. After 1936 each county had a health dept. and monthly classes were routine.

Up until 1929 there was only one prenatal clinic in S. C. This was at Charleston for the benefit of the medical students.

In 1929 the first public health prenatal clinic was established by the Consultant Nurse, Laura Blackburn, from the STate Board of Health at Florence.

-2-

This was originally at Saunders Memorial Hospital and was there until 193?
when it was moved to the county health department. When established there
was no county unit.

The Institute was started by Miss Malone, State Nurse at Denmark about
1926. This was a State Institute and was discontinued when the Sheppard-
Towner money failed. A State Institute was begun again at Denmark in 1932
and continued until 1936 whentthe institutes were reorganized on a District
basis. In the beginning there were over 4,000 midwives. We now have 1,355
certified midwives.

In 1937 it was made mandatory that midwives attend the Institute every
four years. Prior to that time, it was voluntary.

Since S. C. had the highest maternal death rate in the U. S. and was
a rural state, the teaching and supervision of midwives who delivered 50%
of all births in the State, was the first step in securing better care for
mothers and babies. The death rate is now 5th. from the highest, and midwives
deliver 28% of the births.

As late as 1932 the maternal death rate was 9.2 per 1,000 live births.
It is now 2.3.

There was no noticeable decrease in the maternal death rate until
prenatal clinics were established over the State. Since the greatest number
of deaths occur from toxemia of pregnancy, these prenatal clinics serve
a great need.

THE MIDWIFE AS AN ALLY

By Laura Blackburn, R.N.
State Board of Health, Columbia, South Carolina

"Midwives attend more than two-thirds of the Negro births in Mississippi, South Carolina, Arkansas, Goergia, Florida, Alabama, and Louisiana. They attend from one-third to two-thirds of Negro births in North Carolina, Virginia, Delaware, Texas, and Oklahoma. In Tennessee and Maryland they attend slightly more than one-fourth and in Kentucky and Missouri, 11 and 8 per cent, respectively. In the remainder of the twenty-nine states, 2 per cent or less of the Negro live births are attended by midwives." [1]

In South Carolina we have felt that we should make the midwife our ally rather than our alibi. We believe it pays to educate for leadership within the group itself. In this way the whole structure is changed and the level raised in a more permanent way than could be done from without. Our midwives forced 11,000 patients into our prenatal clinics last year. The patients do not wish to come and use every device in their power to outwit the midwife and to get out of coming. But the midwives have been standing firm and refusing to take any case in which the expectant mother did not go to the doctor or to the clinic. When the county nurse went into one county, the only organizations which she found to start working with were the class groups of midwives. These women helped her find prenatal cases, tuberculosis cases, and sick babies, helped her work up prenatal clinics, well baby clinics, and find crippled children.

Here is a letter recently received from one of the midwives and expressing so clearly their interest and co-operation:

my Deare teacher it afford me a deal of pleasure to write you and let you here from me as I was. So sorry that I did not meet you all at the one day institute which was October 14. Just as I got dress the county nurse came for me to go and help the D.R. deliver her sister. We delivered a fine boy baby at 11 o'clock, but I was still talking about being there with you all. I am hoping to see you all in January 1942. The nurse told me a meeting would be organize. I am still holding my missionary meeting raising money to send midwives to the summer institute. I am glad to say we have some getting ready. I am so glad it my time to attend the institute in 1942. I send my best wishes and many thanks to you for my training. It has cause me to help save the lives of many mothers and babbies and all so other people two and my chest has never swell so big. I still feel as humble as a child and are now trying to teach every boddie some of your good teaching. As you had fill my cup until it run over I am pouring it into other cups. We had our annual session in this month. Did injoy a health sermont by the Rev. J. H. Small. The preachers all just takes a part with us in our midwives meeting on Sundays and help us to put our programe over. We did not send you any program because we use a written program. It cost so much to have them printed we decide to save that money to help some one in the summer school. If we did not hold our little mission treasure with some money in it some of our midwives woulder had to stope practising untill next summer. It help

us so much untill our county nurse say we must work hard to raise more
money for next.

[1] Tandy, Elizabeth C., ScD. :"The Health Situation of Negro Mothers and
Babies in the United States", Washington, D. C., Children's Bureau, 1940.

From The American Journal of Nursing -- January 1942

282                              APPENDIX B

## MIDWIFE INSTITUTES

In this midwife institute class, midwives, together with teaching nurses, observing nurses, district supervisors and a county health officer, show keen interest in slides on Birth Registration shown by Rodney S. Gary of the State Board of Health's Bureau of Vital Statistics.

### Purpose

The Midwife Institute is a vital part of the Maternal and Child Health Program. It is like a patch work quilt--made up of bright ideas of nurses and midwives, but with a definite pattern.

The purpose of the Institute is to teach better care for mothers and babies and to teach a broader concept of living. To this end much is done to enlarge the midwives experience, as well as for their enjoyment. In the Coastal District, for example, a trip to see the ocean, the eating together in the dining room, travel movies, etc., are all used toward this end.

The Institute is not only a school for midwives, it is also a laboratory for teaching nurses to teach. The methods of teaching are in line with the standards used by the State Department of Education and follow somewhat the methods of the Red Cross Instructors'

Course. Lesson plans have been prepared and are used, not only in the Institutes but also in the monthly midwife classes taught in the counties. Nutrition, venereal disease, tuberculosis, crippling conditions of children and other allied subjects are taught by experienced instructors.

### Organization

The Maternal and Child Health Division maintains an overall supervision and plan for the Institutes but the district supervisory nurse is responsible for the definite plans as to place, time, amount of board to be paid, teachers, group leaders, speakers and the direct mechanics and supervision of each institute. The equipment is provided by the Maternal and Child Health Division.

As a rule there are four groups to each institute. Each group, consisting of fifteen or

Page 4

## MIDWIFE INSTITUTES (Continued)

more midwives, has its own nurse teacher, group leader, home room and equipment. The equipment has been built up during the years and is excellent, though an effort is made to approximate conditions in a home. The same lesson demonstration and practice work is given simultaneously to each of the four groups.

At times there is a fifth group whose members are taught to improve their reading and writing. The State Department of Education provides an experienced teacher. The reading is largely from primers on prenatal and baby care and similar material. Thus they gain helpful knowledge while learning to read and write.

### Group Leaders

The group leader is the unique contribution of the institute. She is chosen for her ability to lead a group and help supervise the practice work. Each group leader is made to feel that responsibility for the group is hers. She carries this responsibility well. The group leader is a source of help and pride to the supervisors and teachers at the institute. This office carries great prestige and is much coveted by the midwives. Sadie Nickpeay has for many years been the head group leader. She has filled this office with honor. The function of this office is to be assistant to the district supervisor and in charge of the group leaders. Edith Baylor of Berkeley County has this position in the Coastal District. This year Sadie was unable to attend the institute. There were great lamentations from all concerned, including Sadie. However, through good and long preparation and using Sadie as a pattern, Bertha Hill, who had returned from a good job in the North, and Sophie Turner were made co-head group leaders.

This education for leadership within the group, and thus to educate the whole strata, is an important part of the institute. Serving as group leaders were: Coastal District, Mary Parker, Louise White, Anna Hicks, Annie Smith; Richland County Institute at Benedict, Florence Cornish, Irene Loyd, Janie Poindexter, Sallie Belle Johnson; Piedmont District at Benedict, Cora Wyatt, Josie McDowell, Emargie Garrett, Nancy Washington. Pee Dee District at Morris College, Sophie Turner, Bertha Hill, Daisy Johnson, Janie Crim and Sally Marion.

### Finances

The institute is financed by the annual re-newal fee of twenty-five cents for each midwife certificate. This amount is supplemented by the Maternal and Child Health Division. Each midwife pays her own board for the two weeks at the institute. As of this year that has not exceeded $15.00. Many of the midwives pay their own transportation to the institute, many nurses provide transportation for their midwives. The board of the group leaders is paid by institute funds and this is their only remuneration.

### Awards

Every four years, each midwife is required by law to return for a refresher course. She is given a blue certificate for her first attendance, a gold seal for the second, a gold star for the third and a badge for the fourth. These honors are much coveted and failure to achieve them causes so much distress, that one wonders if we haven't overreached ourselves. Since this system is so stimulating and since an effort has been made to associate learning with pleasure, as a rule the midwife is glad to return.

### Results

The nurse here learns to regard the midwife as an important person in her total public health program and how to use her. The nurse also learns to interpret the midwife to the midwife herself, to the physician and to the community.

The improvement in the midwife, her gain in knowledge and her great contribution to the functioning of the institute as well as the lowered maternal death rate make the effort, time and money put into the institute seem well worthwhile.

During the summer of 1950 there were 355 midwives (122 new and 233 returns) under instruction at the four district midwife institutes held in the State.

It was necessary to have a fourth institute this year to care for the extra numbers needing to attend. It was held at Benedict College in Columbia for Richland and its surrounding counties.

The Piedmont Institute was also held at Benedict College. In past years it was held at St. Albans School in Simpsonville, Clinton College in Rock Hill, Bettis Academy in Edgefield County and Owings School in Owings.

The Pee Dee Institute is held annually at Morris College in Sumter.

The Coastal Institute, which has been held in various places such as Voorhees School in Denmark, State College in Orangeburg and

MIDWIFE INSTITUTES

Midwives attending the institute are divided into four groups, each with its own nurse together, group leader, home room and equipment.

Sometimes it is necessary to organize a fifth group, for reading and writing lessons. Every midwife in South Carolina must be able to read and write.

Mather School in Beaufort, is now held annually at Penn School on St. Helena's Island.

The district supervisors in charge of the institutes this year were Mrs. Amelia Tanksley, Coastal District; Mrs. Minnie Blease and Mrs. Evelyn Martin, Piedmont District; Mrs. Blanche Speed and Miss May Reed, Pee Dee District. Teachers at the various institutes this year were nurse midwives Laura Blackburn, Maude Callen, Eula Harris, Ann Stanley Chamblee, Minnie Lee Hobbs and Myra Driver; and public health nurses Agnes Cannon, Stella Barnes, Helen Dove, May Reed, Florence Miles, Anna Robinson, Delma Randolph,, Marguerite McCaskill and Betty Cain. Each of these nurses had previously observed and helped at an institute.

The nurses observing this year were Edith Black of Spartanburg, Mozelle Anderson of Pickens, Meredith Kearney of Union, Virginia Green of Newberry, Faye Pitts of Saluda, Mary B. Rossiter of Laurens, Mary Moore of Anderson, Leetta Duke of Saluda, Margaret Coleman of Fairfield, Marie Wright of Chester, Bettye Williams of York, Frostie Humphries of Lancaster, Olga Atkinson, Lila Bonner, Grace Barden, all of Richland; Edith Young of Florence, Kathleen Snowden of Williamsburg, Jettie Keisler of Lexington, and Ruth Alexander of the State Board of Health. --Laura Blackburn, R.N., Nurse Consultant, Division of Maternal and Child Health.

Recreation in the form of sightseeing trips, movies, games, or, as shown above, dancing on the lawn, is a vital part of the institute program.

STATE NUTRITION COMMITTEE MEETS

All public health personnel over the State are invited to attend a nutrition program which is being sponsored by the S. C. State Nutrition Committee in cooperation with the S. C. Dietetics Association and the S. C. Home Economics Association. This meeting will be held in Columbia on November 3 from 10 until 12:30 o'clock at the Wade Hampton Hotel. South Carolina's nutritional problems and recommendations for making improvements will be discussed. Dr. D. W. Watkins, director of the Agricultural Extension Service, is chairman of the S. C. State Nutrition Committee and will preside. Following this session the State Nutrition Committee will have a luncheon meeting.

"The greatest remedy for anger, is delay."

SALTZMAN
PL 38824

DO MIDWIFE
SCHWARTZ
MU 7-0268
Pineville
Maude Callen
Berkley County
Monks Corner
See dr. Fishern

Jennette White M.W.
in Columbia

Salley Belle Johnson

26. WHAT IS YOUR
PAY, IN LENGTH
OF SERVICE AND
EXPERIENCE, HOW
DOES THIS COMPARE
WITH WHITE NURSE-
MIDWIFE, OR NURSE

27. GENERALLY HOW
DOES PAY OF NEGRO
NURSE COMPARE.

LONGEST NUMBER
OF
MILES.

28. THE OUTSIDE
THINGS THAT YOU
DO, JAIL AT ST. STEPHENS

NAMES
CALLED

29. WHEN DID YOU
GET ELECTRICITY

30. ROAD PAVED

41. TELEPHONES

CAPTAINS
ALICE COOPER (2D
WILLIAM (SNOOK)
LABOR I AM
16½ HOURS
CHILD 7½ LBS
130 Y
2ND MIDWIFE
HENRIETTA GADAT...
A COUSIN
CARRIED FROM
MOTHER IN LAW
MARY ROGERS

2 BOYS — MAUDES CLINIC
JAMES WHITE 8
FELL OFF PORCH
HURT RIB
ERNEST WHITE
CROSS-EYED

6. YOUR HISTORY OF
WORK IN BERKELY
(DID YOU PRACTICE
BEFORE)

7. YEAR, 1923
YOUR STATUS THEN,
WITH WHAT ORGANIZAT...
AMOUNT OF PAY.

8. WHEN DID YOU
JOIN HEALTH DEPARTME...
+ DO YOU STILL
MAINTAIN STATUS
WITH THE MISSION

9. YOUR FIRST
CONNECTION WITH
MIDWIVES

10. THE FIRST
CLASS YOU HELD
FOR MIDWIVES,
WHAT PROMPTED IT
OR WHO SUGGESTED
IT.

11. WAS THIS BEFORE
OR AFTER THE
BEGINNINGS OF
STATE PROGRAM
AND OF MIDWIFE
INSTITUTE

12. THE NEW ECONOMY
SLASH BY STATE — I KNOW
THIS WILL NOT MEAN
MUCH TO YOU BUT
HOW DO YOU THINK IT STATE
WILL EFFECT T HEALTH OF STATE

## CAPTIONS

1-4  Registered Nurse Certified Midwife Maude Callen of Berkeley County Health Dept.
Moncks Corner, South Carolina -- on rounds as county nurse.

5:  Maude putting on gloves for an examination of woman in labor. In home deliveries
she strives for septic, and not sterile, conditions. Solution is Lysol. A non-
nurse midwife is not allowed to make vaginal or rectal examinations.

6-7  Woman is Affie King, the child is Lavinia Ann King (Eadytown, S.C.). The child was
born to an unwed mother and Nurse Callen arranged that the childless Affie King
would adopt the baby.

8-10  Mary Lou Broughton (age 9) was hit with infantile paralysis in 1945, was brought to
Maude's clinic by the grandmother. Maude carries her to Crippled Children's Clinic
in Charleston for treatment. She has had operation to lengthen and release heel
strap -- eventually will probably walk without crutches. Here, Maude has come to
give her a typhoid shot and to arrange for her to spend a week at the Orthopedic
Camp sponsored by South Carolina Orthopedic Clinic.

11:  Nurse Callen leaving home of Kathleen Jenkins, for whom she has delivered a 7 lb.
boy. Elize Gourdin is Midwife in doorway. Nurse Callen has supervision of Midwives
in her area. They handle most of the deliveries, call on Nurse-Midwife Callen if
any difficulties arise, or if they get a little nervous about the delivery. Time
was 4 A.M. Lantern is one Nurse Callen carries, as there is little electricity in
the area.

12:  Mary Low Broughton, age nine. (See caption 8-10)

13-14  Leon Snipe, age ___, advanced stage of contagious TB. Nurse Callen at window talk-
ing to Ethel Dawson, his sister, arranging that Leon be sent to State Park TB hos-
pital, Columbia State Park, S.C. He had no money and no way to get there, so
Nurse Callen finally arranged transportation. She frequently carries the patients
herself. Nurse Callen discovered he had TB originally in 1937 when she was doing
special follow-up work after mass x-rays. He was in TB wing of Berkeley County
Hospital (since closed) in 1937, 1938 and was released as an arrested case in 1939.
Recently, she had seen him on the highway or so a few times and noticed that he
was getting thinner again and tried to break him down for tests, but he avoided
her after making promises to meet her for x-rays and tests. Finally, she tracked
him down and made sputum tests and found that he was now far advanced. His prog-
nosis was poor. If he should be returned from State Park, he will be rehabilitated
and followed closely, although he will probably try to avoid her again. The various
contacts of family and intimate friends will be checked and watched indefinitely.
If one moves to another state or section, the local health department of that sec-
tion will be notified. Immediate contacts were his girl friend, one sister, one
brother, four nephews, mother, and three nieces. He was unmarried, worked as a
laborer farmhand.

15-16
& 17:  Nurse Callen walking to a patient in the backwoods, past were cars can go and some-
times where it is impassable just because of rain or mud. Woman has come to Nurse
Callen's home to fetch her. The nearest telephone is in a Forest Ranger Tower and
therefore they must journey to her.

18: Nurse Callen driving car through muddy backwoods path. She frequently has to go by wagon or walk. Car lasts about hear to 1½ years. She drives and average of 3000 miles a month. Health Department pays her for only approximately 1000 miles, the rest she must make up. She does this partly by leaning on pension check of husband Dick.

19: (Stella) Lottie Jackson and her year-old twins, Frankie and Frances. Maude delivered them last year. One came on one day, the second came the following day.

20-24: (Names are as they are in picture 24): A woman came to a clinic, told of a family back from the highway, destitute and hungry. They had nothing to eat but green corn. There was the 36-year-old mother and her eight children. The father has been in State insane hospital since June. The family has been living in a small storage shed since their home burned two years ago. Youngest child six months, oldest 14 years. The little boy with bandaged head and distended stomach, fell and cut head; stomach distended from worms and nutritional disturbances, 3 years of age. Maude took off the bandage and, before leaving, changed it. She came to examine and to report the situation to the welfare department so the family would receive relief. But relief takes time to go through and hunger is immediate, so Maude returned with some grits and sardines and fruit. Names: Alphonso Brooks, age 10; Vera Mae, 6 months; Genevieve, 8; Bennett, 7; Dallas, 1½. Mother's name is Annie Ruth Brooks, age 36.

25: Hester Blanding, 53, a midwife, since dead from cancer of the uterus.

26: With Mr. Cain, VD investigator from County Health Department.

27: James White, 8, fell off porch and hurt ribs. Cross-eyed boy in background, Ernest White. Taken in clinic in Maude's home.

28-29: Dorothy Mae Grant, 6 years. Infected tonsils and abscessed tooth.

30: Woman had not walked in seven years. About three years ago Maude discovered her in the backwoods, far from civilization, treated her. Now the woman can get around.

31-33: Nurse Callen, Dr. William K. Fishburne, Head of Berkeley County Health Dept. and Ida Watson -- VD and perhaps cancer -- patient came to Maude's clinic and was brought to Moncks Corner for further examination. She is now being treated at Cancer Clinic, Medical College, Charleston, S. C.

34-35 Nurse Callen working on records at 4:45 a.m. in the little study in her clinic at home. Dummy is "Mrs. Chase" used for teaching midwives. Food on table is dummy food used in nutritional teaching. She must keep records on prenatal, postnatal, VD, Morbidity, TB, Cancer, orthopedic cases.

36: Maude's clinic. Mother, Inetha White and Rebecca White, getting penicillin shot. Has pneumonia.

37-41: Teaching midwife class at St. Stephens Clinic. Clinic loaned by Baptist Missionary group. Baby was brought in to teach how to note abnormalities -- she was born with a closed vagina. Maude held first midwife instruction classes in county (see story) and midwives are now instructed, supervised, registered. There is a state program and regulations and although Maude's first classes had nothing to do with this, she now does it officially. She has also taught at state institutes in the past but this year, with Dr. Carroll dead, she could not be spared. State and County furnish supplies to midwives at cost. Here, Midwife

Research by W. Eugene Smith

## "NURSE MIDWIFE"

There beats a heart, surrounding that heart is the sturdy body
of a woman; and in that body is a strong clear mind educated in nursing,
in obstretrics; and in that mind is more than medical knowledge, for, from
thewoman pours forth, a quiet, eversurging, powerful flow of dedicated work
that is more than technical competence;by reason of tremenduos depth  of
compassionate understanding, a complete,unselfish love of humanity-the all
that is the stature of this person; a truly noble realization of the human
potential to good, so seldom found.

It began, who knows whereor how it began, or the reasons it developed
as it did. Perhaps it began with childish good intentions. For, during the
illness preceeding her mother's death, this child MAUDE CALLEN, beingsensitive
and aware,was sorrowed by the suffering her mother was forced to endure.There
There was much medicine for the mother to take, nasty tasting stuff the
mother hated, and she was not silent about her dislike of it. To thechild
the nasty medicine was part of the suffering, and with childish reasoning,
she would watch her time, running to the sickroom when no one else was there
to bear witness, would pour the dose of medicine out of the window.She was a
happier soul as she ran back to make people think the medicine had been taken,
laughing with the pleasure of the help she thought she had been.

The mother, perhaps influenced/Maude's devotion to alleviating  suffer-
ing of the sick, felt that some day she would be a nurse, told Maude's uncle
(who was a doctor) that if she were to die, she wished him to take  Maude.
The mother did die, so at the age of seven, Maude left Quincy,Florida, and
traveled in her uncle's buggy, to her new home in Talahassee. Dr. Gunn her
uncle, had no children and she was welcomed.

As she grew foom childhood, towards maturity, she completed a course
in nursing, training at Georgia Infirmary, in Savannah,Georgia. The completion
of this course in 1921, the uncle having died, Maude newly married,so the
young couple settled in Charleston, South Carolina. Nurse Maude Callen (her

Nurse Midwife
                                    -2-

married name being Callen) began her life's work by doing private duty in
Charleston. Dick,the husband,settled to his work in the custom house, a job in
which he continued until illness forced his retirement.

In 1925, Archdeacon J.Henry Brown of the Episcopal church, an old
friend from Georgia, was having a mission in Charleston. He visited the young
coupleand told nurse Callen that the Charleston branch of the Episcopal church
was trying to find a nurse to send out into the country as a missionary worker.
Agreement was reached, so Nurse Maude, who was an Episcopalian, left the city
for the backwoods  of Berkeley County, to begin the task that was ever to grow
in breadth, as her perception gave her the vision to understand and to challeng
the problems. The enormity of these problems, the unchecked disease, unhealthy
diets, the polluted water, the ignorance, the superstitions, the apathy,even
the resentment of those she was trying to help. Traveling conditions were
little less than impossible--and of course there was little money. She arriv-
ed October 1st, the last eleven miles requiring five hours of travel.A young
girl pitted against the wilderness, a wilderness not confined to the terrain.
The gap that existed between the means of progress and the the need of prog-
ress could be narrowed only by a maximum of extra effort, out of the brains
ofd the guts of Nurse Maude. Sheer burden, under which she did not bent, temper
-ed with ever increasing insight, forged maturity into the charatter of the
young nurse.

Not that she destined herself to be the maiden savior, shining armor
on fiery steed. With the freshness of youth, she could not see the solution
coming in her time. Frequently her"prancing steed" was a sorry old mule pull-
ing a wagon whose wheels formed spine jarring eccentric circles. Her "Shining a
armor" in winter might necessarily be a couple of old quilts tucked around
her while she tried to hug a bit of warmth out of a lantern tuckede between
her feet. Or during summer rains, the miles of walking and wading water and
mud, or perhaps just the saddening, energy removing heat. She also was not
the only representative of medicine in the county, or even in her section
of it, but the weight of the handful of scattered doctors, couldscarcely

Nurse Midwife

-3-

be felt by the population.(There was even a semblance of a health department
in the county seat of Moncks Corner, some 27 miles away from her base,
although she did not know it then.) But the doctors had all they could
handle with ease, so were for the most part content with the status quo.

Nurse Maude, with her idealism discreetly showing, although she
would not care to have it called that, was dissatisfied with the "status
quo" so she quietly faced the issues, always taking on a little more than
she could handle- "Well, it has to be done!- and then somehow would man-
age to handle it, naturally not to her satisfaction. However,she real-
ized then, and more so now, that orchards must be planted, nursed, and
carefully coddled if there ever is to be full fruition.

(This knowledge is apparently not a part of the intelligence of
the state legislature, which this year confused discreet pruning with
careless chopping, thereby endangering the considerable headway made in
the last 20 years or so by the State Board of Health, in their efforts to
build one of the better health programs in the Southern States. Berkeley
County, for instance, under the rather ableileadership of Dr. William L.
Fishburne, is budgeting his year's allottment of money to a period of eight
months, hoping the next legislature convening in January will make up the
deficit. Otherwise he will have to curtail severely what is already a
minimum program. However, this side note is premature, for embryo state
programs and Nurse Maude were rather unaware of each other at this time.)

Nurse Maude's area fringed and extended into an area called
Hell Hole Swamp, with her headquarters in Pineville, a short distance
from the mission church and the little mission school.  The mission was
called "The Church of the Redeemer", and both school and church have now
been replaced with the slightly better structures. Her present home (and
the clinic she installed within it) are between the two structures. it
was a very backward area, with very few paths deserving the dignification
of the term "road."  Many of the people were so isolated, so out of touch,

Nurse Midwife
                                    -4-
that they did not know the usage of knives and forks. Their food supply
was seasonal, poor in balance, and with little provisions for variety
and for conservation against the lean months.

Nurse Maude started what she termed a community project. "People
were so far behind." "I mean they knew nothing of proper diet. Peas and
rice, meat and rice, potatoes and rice, then going arount to their homes
seeing the horrible things they ate, I felt I had to get something over
to them, the value of having foods properly cooked and how to use their
food crops to better advantage."

I showed them different ways of preparing the same food, then I
tried to get them to plant a greater variety of foodstuffs. Introduced
them to salads-- they didnt even know what mayonaise was. I taught them
to can food when they had an extra supply of it. And they really accepted
it, in fact were very anxious to do it!"

Nurse Maude was also doubling as a teacher. "Well, I was working
here. I mean I was right here as a missionary nurse, but then the mission
teachers-- sometimes they wouldnt have them, or they would be out and
I taught off and on for about two years. I taught along with my other
work, but too often I would have to be out on calls."

Nurse Maude had not yet become Registered Certified Nurse Midwife
Maude Callen, however she was delivering cases, or would be called in to
assist or to take over from the untrained, unsupervised midwives. "At
that time there was no supervision,-- just superstition. Miss. Blackburn's
program may have reached Berkeley County (State Program) but you see I
had'nt associated myself with them very much. I know the program hadn't
reached me."

"Well the midwives would come here and call me out-- maybe a patient
would be sick, or they would be having some other difficulty, so I would
go and I saw the terrible time they were having in delivering patients-
just ignorant. They would carry old baskets and rusty scissors, and just

Nurse Midwife

-5-

anybody would tie the cord with any old piece of string. Washing of
hands or anything else was unheard of-- and the superstitions, oh my!
the most terrible superstitions. So I just thought something had to be
done, and could be done by supervision of them, and teaching them
something beforehand."

Pamphlets with simple basic instructions for midwives wore sent
for, this in 1927. Nurse Maude gathered together seventeen women in the
community who feht they wished to become midwives. (none of this group
were)  Then she held a class each week for ten weeks, so these were
the first classes in midwifery to be held in Berkeley County. Of this
group eleven became practising midwives and some of these remain among
the best in the county. Later, after finally joining the staff of the
County Health Department, which she did in 1938, she went to Tuskagee
Institute where the (New York) Maternity Center had a branch. The
coursewas an intensive six months course in Obstetrics comparable to the
course given doctors. This added knowledge added nothing to her pay- just
added to her work. The state did finance her training however. She was
the first negro and the second person in South Carolina to take the
midwifery course. The first was Miss. Laura Blackburn, consultant nurse
with the State Board of Health, also overall supervisor of the midwives.

It must be made clear that Nurse Midwives are those only, who
are already Registered Nurses and who have taken the additional obstret-
ical course. The other,the common midwives, have seperate research-- however ta
take the regulations, the teaching courseand the statements as to pro-
gress with that little old grain of salt. Miss. Blackburn is mainly
responsible for all statewide progress which has been made against heavy
odds, yet it is basically Miss. Blackburn's fault that the program is
in a dead end, so far a a further rise in standards is in sight. She is not
however to blame for the troubles arising from the budget confusion.

Nurse Midwife
                                    -6-

Maude Callen has handles  the delicate matter of racial relation-
ships with magnificent intelligence and grace. Her relationship with
the various white doctors faces not only the racial, but the equally
delicate tendency for there to be strain between the private pactice of
medicine and the government health sponsored programs, especially at
tangent points where there is swaying balance between conflict and coop-
eration. The fact that Nurse Callen is educated in obstetrics and has
otherwise borne such a complex load of medical problems and solutions,
so is therefore qualified to make certain types of diagnostic suggestions
concerning patients she brings to the doctors, is resented by certain of
the doctors in an arrogant effort to wear a halo of non-yielding aloof
supremacy. These doctors claim to be stepping beyond the bounds, by
showing too much authority. Towards Nurse Callen, this halo is apt to
be doubleplated.

The only time Maude became reticent in her usually clear, direct
conversations with us, was when we touched upon these points. "Oh well,-
they were just personal things, just little things I guess you can see
through now--- that were brewed up to that kind of a mess."

She works, she doesn't complain, is hesitant to accuse, she never
carries a soapbox with her, for tirades against incompetance or injust-
ice. Perhaps it could be called a quiet, passive aggressiveness in which
the propaganda of her work is her basic weapon. When she decides a situa-
tion does call for words they are never word of heated exclamation or
sharp retort. They, instead, are diplomatic, calm, yet firmly pressed to
the point. In certain circumstances, for the allover sake of her work,
she swallows it with quiet dignity, so is not intimidated. At other times,
especially in dealing with certain doctors, she has the wisdom which allows
her to lead them while making them think they are commanding the situation.
She say, "Knowing each doctor as an individual, I treat them as individuals
--- we have been made to feel very bad in some instances."

Nurse Midwife

-7-

Dr. Fishburne, head of the County Health Department, has complete faith in Nurse Callen and usually stands firmly behind her, "Maude Callen is the best dam nurse in this county. There's no nurse in the whole state health program who's done nearly the job she does. I have absolute and implicit faith in her. She has one of the best hearts in the world; -- a wonderful insight into human nature. Now she has been closely associated with you, she is able to and will tell me when you leave, if I want to know, just what kind of fellows you are. She'll tell me, and it will come closer to being what you are, than almost anyone else in the world could know-- absolutely!"

Dr. Fishburne was the man who hired Nurse Maude for the county. He had done some work with her previously so when she established the first VD clinic in the county on her own, he helped her with the treatments. If patients need special care, or hospitalization, or if is too complex a problem for Maude, or if she wants a confirmation of her ow n diagnosis, or a more thorough checkup and more tests than she is able to give in the field, she will bring her patients to thefine new clinics held in the Public Health Center in the County seat at Moncks Corner. Here she works very closely with Dr. Fishburne. It is evident that he respects her opinions, diagnosis and suggestions.  Dr. Fishburne treats both black and white, with the same impartial gruff care and generosity. It was through his drive and efforts that Berkeley county has a small but decently equipped hospital,also the comparatively new (ten years) previously mentioned Health Center.

However, he has helped Maude very little in gaining adequate places for her out-clinics, nor the materials and instruments needed for properly equipping them. There is little money allotted in the budget for the out-clinics, little- perhaps even a reduced hope that the near future will bring any upward change. Maude has had to do all the leg and spade work all alone, working for the cooperation of the church groups and schools

Nurse Midwife

-8-

for use of their buildings to work out makeshift clinics. She has had to scrounge, beg and pay for (out of her own pocket) most of the scales, tables, instruments, etc., needed for the minimum carrying out of her work. The Health Department has furnished a few things, such as her blood pressure apparatus, one scale, a sterilizer. Until the present budget trouble the county paid certain of the "private practice doctors" a fee to attend clinics such as the pre-natal out-clinics. Now these were cut from the budget. Without the doctor(for several weeks after the cut the doctor had volunteered to continue, however no one expected this to last) the pre-natal and other clinics under Maude would be called Nurses conferences.

When possible, Nurse-Midwife Eugenia Broughton, the other nurse midwife in the county (Negro, brought to the work through influence of Maude) will assist Maude with her clinics, mainly handling of records. Maude will help Eugenia when necessary. The clinics of the other two Registered Nurses working for the Health Department (both white) are sorry minimum effort affairs. Also working as Supervisor is Nurse Baskin.

Nurse Maude deeply hopes that somehow , she will be able to use a real clinic before she dies. A permanent brick or stone building built for the purpose, modestly but adequately equipped. A rough estimate of such would be at least $7000.00. I gave her a slight hope of her dream coming true, by telling her of my deep burning desire that somehow the story I am doing, perhaps a word or two in some caption, mightplant the seed in some mind, that could afford to accomplish it. Call it "The Maude Callen Clinic" and build it while she is alive to know, and let her feel that perhaps there was some gratitude for her life of complete devotion to others.

Besides Dr. Fishburne, there was another white doctor. He lived up in her area, was a close friend of Maude an ally--he was Dr. Carroll, and it was difficult to say which helped the other the most. In the last

Nurse Midwife

- 9 -

few years, Maude helped most for Dr. Carroll was old, hampered by heart
condition. His efforts were sincere, but he could not carry much of the
load, even hin own practice, so leaned more and more on her. He died
in 1950. He. too trusted Maude implicitly, never any strain of and kind
between them. When Maude established the first  Pre-Natal Clinic in
Berkely County (1933) it became a joint project. He helped her out
with drugs she needed, told her just to pick them out. When she would
be giving mass innoculations for typhoid outside his small office, he
frequently would take care of the sterilizing, preparing the needles
for her as she needed them.

He must have been a wonderful man, not similar to the "GREENBACK"
doctor who is the only one in that area now and who has only a few simple
requirements of his patients--do not try to call me out, come only to
my officeduring strict office hours and be sure to have the money to
pay me.  He, when the money would run out, and only then, might consider
sending them to Maude,or else call her in on the case.  After all, if the
patient still seriously needed treatment, you could'nt just throw him
down or out,-- not always at least. (Honor, codeof ethics, you know).
However, I dont intend to extend myself away from the office or past
office hours, my time is worth payment, but:-by God, that socialized
medicine of the Health Department had better watch its step, and keep
within bounds , or by God, I'll-- etc. . . .

Maude,to the like of this man, does not suggest the diagnosis if
she does send him a patient.    No Doctor Carroll wasn't like that. That's
probably why he and Maude got on the way they did. "His only thoughtwas
doing good for others. He had the heart of the people in mind; never
refused anybody anything in the way of medical care, as far as he was
capable of doing." Yes, Maude, that quote from you sounds as if it c
could be about yourself!

Nurse Midwife

<div align="center">- 10 -</div>

"  . . ., and I remember when they had on his door NO VISITORS
allowed," and Mrs Carroll was in there too- they were really a loving
couple--she'd hear my voice, I'd be there perhaps to admit a patient or
to find out something-- Mrs. Carroll would say "Who is that?--Maude?
I'd say, "Yes". "Dr.Carroll wants to see you!"Mrs Carroll would say.
"Sign says NO VISITORS"**"You're no visitor, you come on in here,- you're
one of us."  Doctor would look up and smile, then say"Well how's every-
thing?" I'd say,"Fine". Then he'd say,"Now Maude you know you're lying
about everything being fine up there, I 'll bet you're working your  head
off." "No, I'm not either." "How's old so and so and so? " "Oh,they are
fine Dr. Carroll." " Maude, you are still lying to me, things are not
going as well as you say--um-mmm, I can look in your eyes and tell."
I'D say, "Not lyingdoctor, everything is fine, I must go now." "No
you're not going, sit right down there." "Then I would have to tell
him about each patient he asked about. "He certainly was a swell person
to work with-- they'll never again find anyone so wonderful as he was."

During his illness, Maude tried to spend as much time as possible
helping his patiets. Changing bandages watching their progress, helping
in every way she could. Then Dr. Carroll died,leaving her virtually
alone. Her territory touched into neary half the county,(which is the
largest in South Carolina) so she was the medical touchstone for about
10,000 people.

The transition from the going it alone period, contacting the
County Health Board, slowly increasing the inter-cooperation until finally
officially uniting with them, covered a span of fifteen years, included
Maude's establishing the first Midwife class, first Pre-natal clinic and
first VD clinic. At this time she averages about 25 set classes and clinics
per month. These include both in and out*clinics or areas.  The two weekly
main clinics at the Center in Moncks Corner, also a few where she assists

Nurse Midwife

- 11 -

Nurse Broughton. The month we were working with her she had an additional
eight typhoid clinics during which she gave 1778 injections.  Does not
include the hundreds of people she saw proffessionally during the month,
does not include work done in the clinic built into the front of her
home (built 12 years ago and open at any time Maude is home) where
she sees patients at all hours, withevery degree and variety of trouble.

She serves also as district nurse for the schools, of which there
are nine in her district. Checking vaccinations, teeth, their eyes. She
doesn't do too much aboutunderweight, for she has found that usually
nothing will be or can be done because she cannot take time to follow
it up, so why waste needed time. She knows nearly every child, his history,
so the school work serves only to catch up with a few she might have
missed.  In her rounds she does as always stress , plead and suggest
that the people have greater variety and balance in the diet. Until in late
thirties, no one else had been making an attempt to check the children
in the schools.  In her effort to do this, she made her first contact xhx
with Dr. Fishburne, and the Health Department, hoping to receive vaccine,
reporting contagious cases, or those needing more adequate care than
she could give. In 1936 a public health educator was in Maude's district,
doing Tuberculin testing, she assisted and did the follow up case filing
for 1936 and 1937.

Maude's cars last from a year to eighteen months of the horrible
back roads. She averages driving between three and four thousand miles
per month.  The county allows her payment for only a thousand.  She must
fill in from her husband's pension. She knows every road, person,their
names , their birthplaces,their troubles, every involvement of their
lives. She knows who is moving where and why, which helps in contacting
patients after knowing they have TB or VD, or when they are financially
involved, are poor and need help, and believe me they are nearly all poor.

This reminds us of two other facets of Maude's value tothe

Nurse Midwife

community. Although it became compulsory to file birth registrations prior
to her arrival, this did not catch all the births by any means. The sit-
uation is getting better. Then too the people have a habit of not using
the names they were born with and registered under. "We name him John
Herbert, but we gonna call him Louie." For no other reason than that
they think another name is "More sportin' " sometimes. Then an unmarried
girl will call each child (tho all same family except father) by the name
of its father. If the mother dies, or the child is raised by another family,
the child is perhaps called by the new family. The situation is impossibly
confusing, yet time after time Maude, by her memory and association of all
people in her district, XXX is able to straighten out situations occuring
twenty or more years ago.

Then, again she is more than a nurse, for they have her hold their
relief checks, (for instance the blind or feeble of mind or crippled) and
she will keep them, work hard to prevent financial involvements, settle
their bills, make sure no one takes advantage of them, etc., She helps
with their marital problems, sometimes to put a husband in jail, other
times to get him out. She has gone ob their bonds, or just paid the fine
of someone in a scrap whom she thought she could vouch for, or someone she
felt had suffered enough. Frequently it came out of her own pocket.

At times the sheriff has released a prisoner, on the strength of her
word, even giving her the keys to let the offender out! She'll bridge
a gap between finding a family close to starving-relief, by buying food
out of her own pocket, or passing on food to them that was not needed
by other patients and had been donated to her out of gratitude. She finds
or buys clothing, or passes donations of it to those in need. She will
carry a crippled child down to the crippled children's clinic, in Charleston
hoping it can be helped to walk again. Or make a hundred fifty mile drive
to tell a son that his mother is dying and wishes to see him. She has a
long list of extra-curricular patients, bed-ridden, or wheel chair, that

Nurse Midwife
                        --13--

slips into her rounds, just to give them a little comfort by her interest.

Sometimes she teaches a bit of the bible to someone eho feels he has the

call from God to preach. On this endless go-around, until she is weary, almost

unto death, before she can rest, she has begun allover again.

     Maude never had any children of her own, has gathered several

to raise at various times, although she never makes a fuss over them, they

adore her, and never seem to want to leave her. Her husband realizes

that he must forever remain secondary to her work, has for the most part

long since sady resigned himself to the idea. Now that he is ill, and

unable to move about very much, he just sits and waits for her, (though

he would deny this display of emotion) and when she is later than he thinks

she should be-(he has never grown used to the irregularity of her hours)

he will watch and listen for her car down the road, then catching sight

of it, will withdraw into the house and into his chair to sit there as

casually as if it meant nothing to him.

     (from a letter of mine home during a hectic week following Maude
     around)     "
               "Maude, dear Maude, its legal to admit being tired!

A scant forty-five minutes or so after we flopped into bed, the beloved

wonderful, indefatigable voice chipped through our sleep,"Let's go!

get up, let's go!  We staggered out of bed, jerked to alertness and

eight minutes later backed into the road. It was another delivery, and

irrationally we were wide awake and driving tensely. Our quick arrival

and Maude's examination showed that it would be many hours before the

accomplishment of birth. Maude kept on quietly working, readying

things and watching. As Dawn broks shehad the time to visit another

patient. Back, then more watching and waiting, then another quick

trip, and finally the baby arrived. Maude stood at the window with a

coke,so very weary, but her only food since the night before---?

     Next to her home and clinic, there were 377 people in front

awaiting their yearly typhoid shots. Covering her exhaustion with her

usual normal patience, and efficiency, she heeded the 377 screaming,

Nurse Midwife

--14-- crying

crying, jabbering, laughing people through the typhoid clinic set up i n
the school next door. With the help of the minister, who volunteered
to try to keep the names straight for the record, and whom Maude had to
keep straight in the mixup of names, she carefully rushed through the
group in one and one half hours.. then she must again chek on the  patient
and baby delivered just before, and then on and on and . . .

.... more hours have passed, it is late of early night, Maude in wobbl
bly unsteadiness, exhausted, still carries on with routine patients with
unimportant problems. She never slights them into unimportance as so me
of them deserve.  MAUDE, for GOD'S sake, will you rest?-- her answer" I'm
not tired, really I'm not.

Tears cut deeply and hot through me. No story could translate
justly the life depth of this wonderful, patient, directional woman who
is my subject-- and I love her, do love her with a respect I hold for
almost no one. Humble , I am in the presence og this simple, complex, pos-
itive greatness; on and on in her self appointed rounds beyond paid-for
duty. People are important, even when they are foolish in their demands.
Understanding this makes foolishness less foolish and more understandable.

This story will be a good story, and it will be a failure. Enough?
It is impossible to say enough. I wish I could write it, I wish I could
say it photographically. The uninteresting routine is vast in its drama,
when placed in relationship to the undramatic giving of this grand person.
"She's only a nigger," why ask for more money for her, to an equal pay of the
unequal white nurses in the county?"Dr, Fishburne answered that, and  they
learned to know the why-- within certain bounds, that is.

Note: not appearing on the records:$13.50 for food for a destitute fam-
ily, until she can fight through a little county aid.  Exhaustion: she
cannot take a trip or vacation until there is someone to take her place
and she has no money. Spendthrift:food for this family or that one, "pay"
a fine for a hard-luck man.

Nurse Midwife

- -15 - -

Travel-: 13 miles to a permanently wheel chair patient off the aid lists.
He cries in gratitude as she dresses his festered legs. Another man is
blind, he recieves $26.50 relief, she councils, juggles his bills to an
adjustment to live. Trouble solved by trouble- a negro in jail-- morre
helpful were he free, maybe Maude will put up the bond herself, but she
doesnt tell the circumstances. WHITE men say to me "Nurse Maude is the
best of the colored people. I,with controlled civility, say she is the
best of people.    And so is the actuality of my story. What can I trans-
late? The shallow insignificance of the fact that she has slightly
prominent teeth when she smiles, is not too graceful in movement?  Perhaps m
more, damn- it must be more, but it can never be enough.

The music I would saturate my exhausted self with, has never been
written- Bartok, Barberm Bloch, Beethoven, it has never been written.
It is in the souls of the people I love beyond the scope of composition,
or of photographs--codeine is for headache, benzedrene a stimulant to
urge a dragging body on. But Maude,is not tired,- she says she isn't
But what holds her up at a time like this when it seems that all 10,000
need her in the space of four days? No, Maude is not tired.   Admit it
cant you Maude, admit you are dead tired.   Perhaps she can't admit  it
especially to herself, for that would bring defeat, and this one repeated
lie fools her into victory. . . I'm not tired-- Jennie is expecting  me--
isnt she wicked, four children by four different men, but the girl is
pregnant, so two lives are at stake. . .lives are at stake, lives, lives.
The car wobbles close to the ditch, but no, Maude is'nt sleepy,silly-
idea. She has had one hours sleep back thru days. Oh, a little headache
maybe, really its nothing,- no reason -- granit,blood shot eyes staring ahead
-- now I'll cook a little something for you to eat, I'" sorry it's so
little-- please sit down while I do the dishes before I work for an
infinity more. I'm not sleepy, cant understand why my eyes are bloodshot--
better catch up on my records a little- wracking exhaustion, nonsense-- so

--16--

you're going to take pictures of a midwife and put them in L$^I$FE-- ha! ha!

a big laugh, sure that is funny, good for the magazine.   The man who

laughed at that story idea would never be missed.

Dr Fishburne, answering a request from the State Board of Health for

for a loan of Maude for two weeks of teaching said :

". . .if you must have Maude, I ask you to join me in prayer

for the poor people left here!

the end

Statistics; They have annual Midwife Picnic- good food- Ice cream donated.

A Clinic at Russellville.

Nine nurse midwives in the state- three are colored.

2 in Berkeley County, both negro. Maude Callen was the first negro midwife

in the state and the second person in the state to become a nurse midwife.

Miss Blackburn, head of the program was first.

Although state figures are lower, midwives deliver 75% of the women in

Berkeley County. They are supposed to receive a fee of $25 per delivery.

Six doctors practicing in Berkeley for a population of 30,251  (1950)

in an area of 1,238 square miles.  State figures generally do not apply

to Berkeley, with its immense rural area.

Clinics are sometimes held in Churches. one a Baptist church in Ridge-

ville So.Caro, One at Russelvile outside of old office of Dr.J.W.Carroll

(dead now. 1950)

Bedpans made of 16 to 20 thicknesses of newspapers.

Incubator for a preemie, made from old whiskey and medicine bottles

filled with hot water and wrapped with clothes then with the well wrapped

baby into carton or box for a bed.  Seldom a crib so boxes are used. The

parents are to have makings of a box by the 7th month.

THIS LED TO LONG DISCUSSIONS— THE SCIENCE DEPARTMENT VOLUNTARILY BACKED ME SAYING TO ED. THAT RESEARCH WAS ABOVE AVERAGE.

FINALLY, I ASKED THOMPSON IF HE WOULD READ RESEARCH. HE SAID "NO, I MUST STAND BY MY WRITERS." I ANSWERED "IF THAT IS THE BLANKNESS OF YOUR ATTITUDE—THERE IS NOTHING MORE I CAN SAY, SIRE."

**LIFE**
TIME & LIFE BUILDING
ROCKEFELLER CENTER
NEW YORK 20

NANCY/GENE
KEN MACLEISH
November 28, 1951

Dear Gene:

I'm glad you liked the layout. The pictures were wonderful so not too much credit attaches to the guys who made the arrangement.

I might as well warn you though that I am not so happy about the experiment of letting you do your own research. I don't think the writing came up to the pictures and one reason was inadequate or overemotional research. I think that next time we will have to work out some compromise whereby you direct the development of the story, which of course suggests the research, but have an experienced reporter either go along or follow you. This doesn't mean that you lose control of the story, the direction and much of the detail will still be yours. It does mean that we assure ourselves of substantial enough research to make possible a writing job that doesn't let the pictures down.

Cordially,

EDWARD K. THOMPSON
Managing Editor

I NEVER DID KNOW AND WHETHER I DID, OR WHETHER HE FELT HE WAS ASHAMED IN DEFENDING MYSELF ESPECIALLY AS (CHECK OF COPY) WAS HAD WRONGED HIM.

THE WRITER, WARM & FRIENDLY BEFORE, NEVER MORE THAN NODDED TO ME AND QUICKLY TURNED AWAY, FROM THAT DAY UNTIL THE XMAS PARTY AFTER MY RESIGNATION

Mr. Gene Smith
126 West 104th Street
New York, New York

PIECE ABOUT MAUDE, SUCH, TO ESTABLISH IN WORDS CERTAINLY WAS EMOTIONAL WOVEN OVER & FROM HIGHLY CHECKED FACTS, PLUS PICTURE BY PICTURE CAPTIONS. THE CHRONOLOGY WAS NOT DONE & WHEN I BROUGHT MATERIAL IN SAID IT WAS NOT DONE, BUT THIS PROBLEM COULD EASILY BE TACKLED BY SOMEONE THERE. THIS FACT IS VOUCHED FOR AS AN OMMISSION OF THE DEPT.

THE WRITER; I HAD ASKED HIM EACH DAY, IF RESEARCH WAS ALL RIGHT, IF HE NEEDED MORE, SAID EACH DAY— THAT EVERYTHING WAS FINE. I HAVE HEARD HE HAD WANTED TO READ IT, PLANNING TO ON THANKSGIVING DAY— BUT THAT COMPANY CAME. HE THEN HAD TO WRITE AS HE SCRATCHED. ONE PROBLEM HE DID HAVE, ED HAD ASKED FOR A PHILOSOPHIC,

BISHOP'S OFFICE,
DIOCESE OF SOUTH CAROLINA,
CHARLESTON, S. C.

January 16, 1952

Miss Nancy J. Robb
9 Rockefeller Plaza
New York City

Dear Miss Robb:

Your letter of January 10 is hardly a compliment to my intelligence. I am wondering whether you read my letter to the editors. I certainly did not write to call their attention to the fact that Mrs. Callen is of the Episcopal faith, that she is active in church affairs, and that she happens to live in Pineville not too far distant from the Redeemer Mission. This would have been stupid in the extreme. I wrote to advise the editors that the article had omitted certain essential facts about Mrs. Callen: That she is an employed worker of the Episcopal Church; that she lives not near but at Redeemer Mission, Pineville; that she is a worker of the mission; that her work was initiated, is sponsored and partly financed by the Episcopal Church. It seems to me that these are facts of such importance that they should have been included in a twelve-page photographic essay, even though one more sentence had to be added. It seems to me that these facts were essential to identifying the subject of the article. For example, would LIFE publish a twelve-page article about Harold W. Dodds without mentioning the fact that he is the President of Princeton University, or an article of similar length about Francis Joseph Spellman without so much as hinting that he is a cardinal or even that he is connected with the Roman Catholic Church?

Your statement about the response of LIFE readers to the article is, of course, entirely irrelevant to the question. If it is true, as you suggest, that more facts would have been welcome had there been "space," I cannot but wonder why my letter which did include additional facts was not published. There is apparently no lack of "space" in the letter section. Up to the present I have had no light on the real cause of the omission--whether it was simply poor reporting or whether LIFE has certain editorial biases which take precedence over complete honesty in any one article.

The subject, however, is definitely closed so far as I am concerned. In the future I shall read LIFE wondering whether the article before me is any more accurate than was "Nurse Midwife."

With kindest regards and all best wishes, I am,

Very sincerely yours,

Thomas N. Carruthers

TNC:id

Copy to Mr. Henry R. Luce
        Mr. W. Eugene Smith

# Appendix C

## Chronology for "A Man of Mercy"

Dates in this chronology are from documents in the W. Eugene Smith Archive. Direct quotations are from the pocket calendar Smith used while on assignment; punctuation and spelling are true to the original. Unrecognizable words are indicated by a bracketed question mark. Smith sometimes drew a line to separate ideas or information; these breaks are indicated by a close-quotation mark and the beginning of a new line.

### 1953

| | |
|---|---|
| October 30 | 1952 Nobel Peace Prize awarded to Albert Schweitzer. |
| November 3 | Letter from Smith to Ray Mackland (*Life* picture editor) requesting Schweitzer assignment. |
| November 28 | Letter from Gene Farmer (*Life* foreign news editor) to Smith assigning him to Schweitzer story. |
| | Cable from Gene Farmer to Schweitzer asking for permission to do a photo-essay. |

### 1954

| | |
|---|---|
| January 6–24 | Erica Anderson's photographs of Schweitzer exhibited at the American Museum of Natural History in New York City. |
| January 25 | *Time* published article about Schweitzer's nurse Emma Haussknecht and her fund-raising efforts in New York. |
| January 30 | Letter from Schweitzer to Smith inviting him to come whenever he wants, stay as long as he likes, and photograph whatever he wants. |
| March 14 | "Depart Idlewild" |
| March 15 | "Portugal" |
| March 19 | "Left for Leopoldville" |
| March 22 | "Left Leopoldville for Brazzaville" |
| March 23 | "Schweitzer comes by door takes me through forest to Leper village . . ." |
| March 24 | "I develop film . . ." |
| March 25 | "I develop film deeply peptured by language difficulty" |
| March 26 | "Restrictions decision to leave, and resign from *Life*" |
| | "Absolutely suicidal despair" |
| March 27 | "Schweitzer asks to forgive his personality, hopes will be happy" |
| March 28 | "Released monkeys across river 'He is more pleased with me today' " |
| April 1 | "McCarthy, heated discussion, flaw in Constitution, [?], like man with belly ache evil and hurting Amer" |
| | "Crucial meeting (while building village, I had wanted other- |

wise) with Clara + Dr. − problem of freedom, of intimacy, dining room, egg symbol − glasses, etc"

"Developed film for lady from Denmark, she is nice and probably a good and good intentioned reporter. Yet, taking time, while in ignorance of camera, I am surly with thought"

April 4     "I do not like to photograph famous men, problems & ease of riding on their name, making judgement of pictures difficult"

April 5     "He was desperate, with so many important letters to write + having to overlord village − but this he must bear + world should not know"

April 6     "Cable from Carmen about filters"
            "Question the balance of honesty, place in history, weaknesses of man, contrary my own conceptions"

April 7     "The overpowering strength of village pictures"
            "Photograph − walk to paradise garden"

April 8     "Nail + strings"
            "Yellowness of floods"
            "Aching of left arm + fingers, straps hurt back + headache"
            "Day of work with Schweitzer, (in [?] 12 hours, of sitting, kneeling, bending, 12 hours of almost constant holding up to eye of cameras, keeping my anticipation, my reflexes without a descent into lethargy"
            "The mixture of light, development, trying not to copy from myself ([?]), the long exposures/ 1/10 − 1/4 − 1/2, but immediacy of reaction"
            "My critical judgement, for once (my strongest point) seems impaired, I don't like this, and assume it is because in fighting off depression I am so pleased with a measure of satisfaction"

April 9     "Compared chimp to gor − gor to man, sch. to gor"

April 10    "Presents, new achievements, yet knew problems, new picture to watch for in layout"
            "Impossibility of working with others here − if concessions and trust gained. Perhaps because understanding + sincerety have reached to him, then the other can say, he did why not me, causing pain of embarrassment three ways, probably preventing other gains − the drawing closer like being naked before a doctor so why not the plummer"

April 11    Letter from Smith to Don Burke (Time-Life, London) requesting London *News Chronicle* articles on Schweitzer by James Cameron.
            "Erna's child died"
            "Broke into write 6,000 words fiction, without a stop, not a story yet may help to clarify"

April 13    "Passport photo of Dr. + Mathilde . . ."

April 17    ". . . only passport stormy session about prints—kind behavior"

"Disappearing before glitter fire of artistic integrity – censorship of long cable – exploding – Dr. won't understand, this time I will be listened to – blood + [?] etc, etc"

April 19–22    Tour of "waterways, lakes, and forests"

April 22    "Setting to work, concentrating to solve this unsolvable riddle, and think my way through to, if not profound story at least not one offensive to truth + insight – an aware visit perhaps, rather than a searching analysis – I do not like this yet I will not allow myself to blunder to decisions, for the sake of making decisions"

April 23–24    "Ill"

April 25    "The leper village pictures are strong enough to be their own separate story – perhaps to earthlike for saints and legends"

April 26    "When leaving donate $200 or $250 to hospital in lieu of payment, also film timing clock nikkor tanks plastic bottles"

April 27    Letter from Smith to Mr. J. L. Vinck (UNICEF official Smith had met on the plane from Europe to Africa) requesting more film and asking about possibilities of finding an interpreter.

"First evening talk with Emma, she preserves the enigma, they do not like 'the search for truth,' when it searches their paradox"

"Drs. orders he eat meat"

April 28    "I must have an interpreter, I must begin my move, my [?] for photographic interpretation, I understand it as well as I will – perhaps the enigma is that I do not wish to admit that I do understand"

April 29    "The story must be presented as a paradox, to leave the viewer with definite but puzzling views, without his knowing quite why, for that is what – + including the staff – one apparently concludes even after years of being here"

April 30    "Perhaps I am being almost too powerful a photographer – especially for European and American conditioning of minds – it will be strange, an opposite struggle to reduce the emotional power of my photographs"

May 1    "Made passport pictures, electricity unsteady, prints still bad"

"Why is it that a mediocre picture, done competently, than a good picture, with a slight flaw is more horrifying"

May 5    "Still ill, I made one of the good pictures today, the high good excitement of jelling a dozen incoherent forms into one unified, even symbolic picture"

"Dull situation, yet the serenity, power, emotional moving qualities, in relationship to tugging chain, spraying rocks, and makeshift organ – elaborate lights"

May 8    "Cable to *Life* etc about it potentially one of my best stories"

May 9    "Doctor is finishing a manuscript, I will not intrude"

May 10   "And now he is packing, preparing to depart, I wish I were more rude (I do not) – UN woman here since Saturday, Emma upset because we fall in with gripeers"

May 12   "I lost a picture at funeral because of tourists three"

May 13   "The day I lost the battle of the red warrior ants"
         "Panic that doctor is about to depart"

May 14   "Wool flannel suit ruined by mold + chewing bugs"
         "Trying to stay up nites and days to out guess emergencies because they neglect, ever to let me know"
         "White woman on stretcher, day after"

May 15   "Doctor ordered 12 more a 'passport photograph I shall use to the ends of my life"

May 16   "He also asks if he can have many of the print to send out"

May 17   "A 46 hour examination of story, laying it out, trying only for two essays – the leprosy village will take care of itself – but the first one, again enough for two, but no relationship between doctor, and other people, which is as it has been"

May 18   "Since Dr. is leaving I shall work on through Sunday nite, thinking"
         Schweitzer leaves Lambaréné for Europe.

May 19   Letter from Smith to Schweitzer asking follow-up questions.
         "Cables to Schweitzer, Ali – Oberman, Mathilde – canoe, etc . . ."

May 20   "I have gone about as far as I can go with this story"

May 21   "Miss Rysell departs"

May 22   "Cables, film, reservations, (etc) customs on films"

May 24   Letter from Schweitzer to Smith answering Smith's follow-up questions.

May 27   Second letter from Schweitzer to Smith.

May 28   "Capa is dead I think on the anniversary of my being hit – insert teleg"

May 29   "Werner Bishoff is dead"

May 31   "I hope you do good story, it will be though I would not be certain whether you would like it – portraits seldom liked – believe your true friends will"
         "I know you fellows don't have much control over how or what used – I tell you right now that whatever pictures go into that magazine, and the words underneath, I take full responsibility, blame me and no one else"

| | |
|---|---|
| June 1 | "Departed . . . arrived Brazza" |
| June 5 | "Left Brazza" |
| June 6 | "Arrived Rome" |
| June 16 | "Left Rome" |
| June 18 | "Boubat, Martinez" |
| June 19 | "Left Paris" |
| July 5 | *Look* magazine publishes photo-essay on Schweitzer using photographs by Erica Anderson. |
| July 27 | Smith asks for another month to finish prints. |
| November 4 | Dr. Schweitzer delivers Nobel Prize address in Oslo. |
| November 15 | *Life* publishes "A Man of Mercy." |
| November 16 | Letter from Smith to Dr. Schweitzer, Dr. Grant, Dr. Percy, and Emma Haussknecht apologizing for published story and telling them he has resigned from *Life*. |

# Notes

## Introduction

1. This concept of mastery is the basis for several recent biographies. Three of the most informative are Jim Hughes, *W. Eugene Smith: Shadow and Substance* (New York: McGraw-Hill, 1989); Ben Maddow, *Let Truth Be the Prejudice: W. Eugene Smith, His Life and Photographs* (Millerton, NY: Aperture, 1985); and William Johnson, *W. Eugene Smith: Master of the Photographic Essay* (Millerton, NY: Aperture, 1981).

2. Beaumont Newhall, *History of Photography* (New York: Museum of Modern Art, 1983), pp. 248 and 263.

3. Naomi Rosenblum, *A World History of Photography* (New York: Abbeville Press, 1984), pp. 508–512.

4. John Szarkowski, *Photography Until Now* (New York: Museum of Modern Art, 1989), pp. 224–227.

5. *Life*'s official circulation during the period was approximately 5,000,000; market studies indicated that the magazine's readership was about 20,000,000.

6. Standard references for the theoretical issues surrounding the concept of the author are: Roland Barthes, "The Death of the Author," in *Image, Music, Text*, edited and translated by Stephen Heath (New York: Hill & Wang, 1977), pp. 142–148; and Michel Foucault, "What is an Author?," edited by Donald Bouchard and translated by Donald Bouchard and Sherry Simon (Ithaca: Cornell University Press, 1977), pp. 113–138. A recent article by Molly Nesbit has raised interesting issues regarding the implications of "authorship" for the photographer in France. Molly Nesbit, "What Was an Author?" *Yale French Studies*, no. 73 (1987), pp. 229–257.

For a recent challenge of the poststructuralist concept of author see David Saunders and Ian Hunter, "Lessons from the 'Literary': How to Historicise Authorship," *Critical Inquiry*, XVII (Spring 1991), pp. 479–509.

7. For a discussion of the implied reader and of readers' response criticism see Wolfgang Iser, *Prospecting: From Reader Response to Literary Anthropology* (Baltimore: Johns Hopkins University Press, 1989); *The Act of Reading: A Theory of Aesthetic Response* (Baltimore: Johns Hopkins University Press, 1978); and *The Implied Reader: Patterns of Communication in Prose Fiction from Bunyan to Beckett* (Baltimore: Johns Hopkins University Press, 1974). For a discussion of the limits of Iser's theory of aesthetic response see Robert Scholes, "Cognition and the Implied Reader," *Diacritics*, V/3 (Fall 1975), pp. 13–15; and Stanley Fish, "Why No One's Afraid of Wolfgang Iser," *Diacritics*, XI/1 (1981), pp. 2–13. Iser's reply to Fish can be found in "Talk like Whales," *Diacritics*, XI/3 (1981), pp. 82–87. For a different interpretation of readers' response criticism see Stanley Fish, *Is There a Text in this Class?: The Authority of Interpretive Communities* (Cambridge: Harvard University Press, 1980).

## Chapter 1. *Life* Magazine and the Photographic Essay

1. For a contemporary discussion of the program of the illustrated newspaper see "Pictorial Newspapers in America," *Frank Leslie's Illustrated Newspaper*, I/1 (December 15, 1855), p. 6.

2. This traditional approach to photojournalism was established by Beaumont Newhall in his *History of Photography* (Boston: Little, Brown and Company, 1982), fifth edition (first edition, 1938). It has continued to the present. The same methodology is used, for example, in Marianne Fulton (editor), *Eyes of Time: Photojournalism in America* (Boston: Little, Brown and Company), 1988.

This approach seems unnecessarily restrictive, as William Johnson argues in "Back to the Future: Some Notes on Photojournalism before the 1870s," *Views*, IX/2 (Winter 1988), pp. 8–12. One example of an alternative history is Rune Hassner, *Bilder för Miljoner* (Stockholm: Sveriges Radio, Rabén & Sjögren, 1977).

3. Among the best-known are *Illustrated London News* (May 14, 1842), *L'Illustration* (March 4, 1843), and *Die Illustrierte Zeitung* (July 1, 1843).

4. For a description of this process see Mason Jackson, *The Pictorial Press: Its Origins and Progress* (London: Hurst & Blackett, 1885), pp. 315–354; and Ernest Clair-Guyot, "Un Demisiècle à *L'Illustration*," *L'Illustration* (1933), unpaginated.

5. Lena Johannesson discusses the complexity of pictorial understanding in the nineteenth century in *Visual Paraphrases: Studies in Mass Media Imagery* (Stockholm: Uppsala, 1984), pp. 9–68, see especially p. 64.

6. For an example of a simple chronological contrast see "The Siege of Charleston," *Harper's Weekly*, VIII (October 31, 1863), pp. 693, 695.

A rare exception that uses four images in temporal and geographical sequence is "The Approach to San Francisco," *Harper's Weekly*, I/23 (June 6, 1857), pp. 360–361.

7. "En Route for China: Sketches from our own Artist and Correspondent," *Illustrated London News*, XXX/855 (April 25, 1857), pp. 377–379.

8. The imaginative depiction of the news in pictures is also mentioned in an untitled article concerning the death of Valerian Gribayedoff, *The Nation*, LXXXVI/2225 (February 20, 1908), p. 162.

For examples of the editorial manipulation of the photographic image see Frederic Ray, *Alfred R. Waud: Civil War Artist* (New York: Viking Press, 1974), p. 35; and "Un Demi-siècle à *L'Illustration*" (note 4), unpaginated.

For a scholarly discussion of the sociopolitical context of the early years of *L'Illustration*, see David Kunzle, "*L'Illustration*, 1843–1853: le premier magazine illustré en France," *Nouvelles de l'estampe*, 43 (1979), p. 8–19.

9. Quoted in "Frank Leslie's Artists in the War," *Frank Leslie's Illustrated Newspaper*, XVIII/451 (May 21, 1864), p. 289.

10. Obituary article on the death of Valerian Gribayedoff in *The Nation* (note 8).

The process of altering photographs is described in "Photographing on Wood," *Philadelphia Photographer*, III/31 (July 1866), pp. 215–216. For an example of photographic manipulation see William Stapp, " 'Subjects of strange and fearful interest': Photojournalism from Its Beginnings in 1839," an essay in *Eyes of Time: Photojournalism in America* (note 2), pp. 17–28.

11. For a discussion of the implications of this shift to the new technology see Mark Roskill, "New Horizons: The Early Life and Times of Photojournalism," *Views* (Winter 1987), pp. 6–11. A more lengthy consideration of the illustrated magazine in America can be found in Robert Kahn, *The Antecedents of Photojournalism* (Ann Arbor: University Microfilms, 1969). For a scholarly treatment of the impact of technological progress on German illustrated magazines see Bernd Weise, "Pressefotografie II. Fortschritte der Fotografie – un Drucktechnik und Veränderungen des Pressemarktes im Deutschen Kaiserreich," *Fotogeschichte*, IX/33 (1989), pp. 27–62; particularly interesting is his discussion of the shift in audience for photographically illustrated magazines and newspapers, pp. 44–52.

Recently, the privileging of technological innovation over social factors has been criticized: *Visual Paraphrases* (note 5); Ulrich Keller, "Photojournalism Around 1900: The Institutionalization of a Mass Medium," an essay in *Shadow and Substance: Essays on the History of Photography in Honor of Heinz K. Henisch* (Bloomfield Hills, MI: Amorphous Institute Press, 1990), pp. 283–304.

12. An examination in March 1899 of nine of the leading European and American illustrated journals showed that halftone photographs outnumbered engraved drawings in all but one case. Clement K. Shorter, "Illustrated Journalism: Its Past and Its Future," *The Contemporary Review*, LXXV (1899), pp. 481–494.

13. Ibid., p. 489.

14. The promotion of this celebrity status was particularly pronounced in the early years of the century. See, for example, "The Perils of Photography," *The Nation*, LXXXV/2193 (July 11, 1907), pp. 28–29, and Will Irwin, "The Swashbucklers of the Camera," *Collier's*, XLVIII/20 (February 3, 1912), pp. 11–13.

Although few cameramen's fame outlasted their photo-reportage, one exception was the late-nineteenth-century photojournalist Jimmy Hare. For his biography see Lewis Gould and Richard Greffe, *Photojournalist: The Career of Jimmy Hare* (Austin: University of Texas, 1977).

15. Although he was allowed to file his own reports, even a famous photojournalist like Jimmy Hare traveled with a reporter; ibid., see especially pp. 11–15 and pp. 33–52. In contrast, Alfred Waud traveled alone and *Harper's Weekly* published his written articles as well as his sketches. *Alfred R. Waud: Civil War Artist* (note 8), p. 26.

16. The social practice of the photo-agency was presaged by the arrangements between publications for sharing sketches. Compare, for example, the coverage of the trial of President Garfield's assassin in *Harper's Weekly* and the *Illustrated London News*: "The Trial of Guiteau," *Harper's Weekly*, XXV/1301 (November 26, 1881), pp. 788–790; "The Trial of Guiteau at Washington for the Murder of President Garfield," *Illustrated London News*, LXXIX/2220 (December 3, 1881), pp. 533ff. See also the advertisements for "free-lance" sketches quoted in *Alfred R. Waud: Civil War Artist* (note 8), p. 28, note 5.

According to Helmut Gernsheim, the Illustrated Journals Photographic Supply Company (1894) was the first photo-agency supplying the

mass media. Before the end of the century, however, it was joined by Underwood & Underwood (1896), Bain's News Picture Service (1898), Illustrated Press Bureau (1899), and World's Graphic Press Agency (1899). Helmut Gernsheim, *The History of Photography* (Oxford: Oxford University Press, 1969), pp. 454–455.

For an excellent discussion of the rise of the German picture agency in the late nineteenth century see Diethart Kerbs, *Die Gleichschaltung der Bilder Pressefotografie 1930–1936* (Berlin: Frölich & Kaufmann, 1983).

17. Edward Earle has discussed the sociopolitical contexts of turn-of-the-century illustrated magazines in "Halftone Effects: A Cultural Study of Photographs in Reproduction, 1895–1905," *California Museum of Photography Bulletin*, VIII/ 1 (1989), pp. 1–24.

18. Lewis Hine (photographer), "Snapshots of a Race," *Collier's*, XLIII/7 (May 8, 1909), p. 8.

19. For a discussion of the development of the European illustrated magazines between 1925 and 1933 see Tim M. Gidal, *Modern Photojournalism: Origin and Evolution, 1910–1933* (New York: Macmillan, 1973). This has aspects of a memoir, as Gidal was a photographer and a participant in the events he describes.

Scholarly treatments of the development of the European illustrated magazine can be found in *Picture Magazines Before Life* (New York: Catskill Center for Photography, 1982), and Sandra Phillips, "The *Berliner Illustrirte, Vogue*, and *Vu:* Pictorial Magazines in Europe before World War II," an essay in *Visual Explorations of the World*, Martin Taureg and Jay Ruby, editors (London: Herod, 1985), pp. 140–166.

20. In the case of the German magazines the trend began when the Münchner Illustrierte Presse and the *Berliner Illustrirte Zeitung* engaged in a competitive battle to increase their circulations. The *Berliner Illustrirte Zeitung* was an established success with over 1,600,000 subscribers. Its rival in Munich tried to boost sales with an innovative use of photographs urged by its editor, Stefan Lorant.

21. For an informed and insightful discussion of photojournalistic practice in Germany, see Karen Becker, "Forming a Profession: Ethical Implications of Photojournalistic Practice on German Picture Magazines, 1926–1933," *Studies in Visual Communication*, XI/2 (1985), pp. 44–60.

22. For a discussion of this new generation of photographers see *Modern Photojournalism* (note 19), pp. 19–27, and Felix Man, *Man with a Camera* (New York: Schocken Books, 1983).

23. Quoted in John R. Whiting, *Photography is a Language* (New York: Ziff-Davis Publishing Company, 1946), p. 22.

24. John Font, "The Berliner Illustrirte and Photojournalism in Germany, 1929–1935," an essay in *Picture Magazines Before Life* (note 19), pp. 1–5.

Notable exceptions to the generally apolitical point of view of the German illustrated weeklies can be found in the *Münchner Illustrierte Presse* edition of October 11, 1931, and February 19, 1933.

25. Sandra Phillips, "The French Picture Magazine *Vu*," an essay in *Picture Magazines Before Life* (note 19), pp. 6–9.

26. For a discussion of the rotogravure see Laura Vitray, John Mills, and Roscoe Ellard, *Pictorial Journalism* (New York: McGraw-Hill, 1939), pp. 353–371.

27. Several illustrated magazines were begun during the late 1920s and early 1930s, although none survived for more than a few years. Some of those titles were *Pic, Click, Picture*, and *Peek*.

28. For a description of the events leading up to the founding of *Life* magazine see Loudon Wainwright, *The Great American Magazine: An Inside History of "Life"* (New York: Alfred A. Knopf, 1986), pp. 3–79, and C. Zoe Smith, "Emigré Photography in America: Contributions of German Photojournalism from Black Star Picture Agency to *Life* Magazine, 1933–1938," unpublished doctoral dissertation, University of Iowa, 1983.

29. *Four Hours a Year* (New York: Time Inc., 1936).

30. In addition to "Emigré Photography in America" (note 28), for a discussion of the important role Korff played in the formation of *Life* magazine see C. Zoe Smith, "Germany's Kurt Korff: An Emigré's Influence on Early *Life*," *Journalism Quarterly*, pp. 412–419ff.

31. "Emigré Photography in America" (note 28), Appendix C: "Memorandum from Kurt Korff to Ralph Ingersoll, April 13, 1936," pp. 248–251.

32. Ibid., "Appendix B: Kurt Korff's Essential Outline for a New Illustrated Magazine," pp. 245–247.

33. Sandra Phillips made the distinction between the personal editorial structure of *Vu, Münchner Illustrierte Presse*, and *Vogue*, and the corporate structure of *Berliner Illustrirte Zeitung*. Sandra Phillips, *Visual Explorations of the World* (note 19), p. 149.

For a more detailed discussion of the editorial practice in Germany between the wars see Becker, "Forming a Profession" (note 21).

34. Advertising continued to be a critical element in the economic success of *Life*. The ability of the magazine to make a profit was not based on public purchase or subscription but on the sale of advertising space. As an example of their power, the advertising executives of *Life* selected the cover of the magazine, the only part of the process of producing *Life* not controlled by the managing editor. For a discussion of the production of *Life* covers see Ray Mackland, "How *Life* Picks a Cover," *Popular Photography*, XXXI/3 (September 1952), pp. 62–65ff.

In marketing their product to advertisers Time, Inc., commissioned elaborate studies of their audience. See, for example, Alfred Politz Research, Inc., *A Study of the Accumulative Audience of Life* (New York: Time, Inc., 1950).

35. Tim Gidal in *Modern Photojournalism* (note 19), p. 18, indicates that Lorant's layouts were limited to two pages, but an examination of the *Münchner Illustrierte Presse* indicates that three and on rare occasions four pages were devoted to photostories.

36. *The Great American Magazine* (note 28), pp. 94–95.

37. J. L. Brown, "Picture Magazines and Morons," *American Quarterly* (December 1938), p. 407.

38. *The Great American Magazine* (note 28), pp. 99–100.

39. "The Camera as Essayist," *Life*, II/17 (April 26, 1937), pp. 60–61.

40. Luce's selection of Joseph Addison as a model for the photo-essay is informative. In his *Spectator* essay No. 96 Addison announced that his intention was to do more than "amuse and entertain"; he wanted his essays to "convince and instruct." A. R. Humphrey, *Steele, Addison, and their Periodical Essays* (London: Unwin Brothers, 1959), pp. 17–24.

41. *The Great American Magazine* (note 28), pp. 99–103.

42. Ibid., p. 102.

43. Maitland Edey, *Great Photographic Essays from Life* (Boston: New York Graphic Society, 1978), pp. 7–11.

44. "Vassar: A Bright Jewel in U.S. Educational Diadem," *Life*, II/5 (February 1, 1938), pp. 25–31.

45. The large image on the left was a photograph from the Fairfield Aerial Survey; the small picture in the lower right, a portrait by Edward Steichen; only the photograph of the Vassar entrance gate was made by Alfred Eisenstaedt. The use of multiple picture sources makes clear that these early photo-essays were considered editorial expressions.

Before World War II, it was not unusual for *Life* editors to make extensive use of photoagencies. For a discussion of the importance of the Black Star agency to *Life* magazine in the 1930s see C. Zoe Smith, "Black Star Picture Agency: *Life*'s European Connection," *Journalism History*, XIII/1 (Spring 1986), pp. 19–25.

46. "Vassar: A Bright Jewel in U.S. Educational Diadem" (note 44), p. 25.

47. Although they do not make the important distinction between the editorial practices of different managing editors, other discussions of the political subtext of *Life*'s photo-essays can be found in Ulrich Keller, "The Twilight of the Masterpiece," *California Museum of Photography Bulletin*, VI/1 (1987), pp. 6–10; and Carol Squires, "Looking at *Life*," *Artforum*, XX/4 (December 1981), pp. 59–66.

48. *Great Photographic Essays from Life* (note 43), p. 10.

49. Ibid., p. 12.

50. "The Clothing Workers' Union: It has Changed a Whole Industry and the Lives of 375,000 Members," *Life*, XXIV/26 (June 28, 1948), pp. 79–87.

51. For a more detailed accounting of the events leading to Thorndike's resignation see *The Great American Magazine* (note 28), pp. 169–176.

52. Ibid., p. 181.

53. *Great Photographic Essays from Life* (note 43), p. 16.

54. According to Karin Becker the situation was very different in Germany. She argues that German photojournalists identified themselves with an elite profession. "Forming a Profession" (note 21), see especially pp. 58–60.

55. Quoted in *The Great American Magazine* (note 28), p. 110. This issue is also addressed in Wilson Hicks, *Words and Pictures* (New York: Harper Bros., 1952), p. 100.

56. *The Great American Magazine* (note 28), pp. 110–111.

57. For a more detailed discussion of the process of constructing an issue of *Life*, see *Words and Pictures* (note 55), pp. 47–79.

58. *Great Photographic Essays from Life* (note 43), p. 10.

59. Hicks was a former picture editor for the Associated Press who came to *Life* in 1937 and became the most powerful picture editor in *Life*'s early history. For a description of Hicks's importance and function on the *Life* staff see *The Great American Magazine* (note 28), pp. 109–110.

60. Shooting scripts continued to be used after Wilson Hicks's resignation (1950), but his successor, Ray Mackland, did not have the same prerogatives. If an idea was suggested by the editors, it was understood to have been approved by managing editor Edward K. Thompson and it was assigned.

61. Interview with Peggy Sargent, August 25, 1986. She states that she selected the size of the prints largely on the basis of the quality of the photograph.

62. Telephone interview with Earl Kersh, *Life* art director's staff, 1945–1975. Mr. Kersh estimates that on average there would be three or four photostated revisions of a photo-essay.

63. *Great Photographic Essays from Life* (note 43), p. 9.

64. An example of building a particular issue (November 12, 1956) is given in *The Great American Magazine* (note 28), pp. 191–250.

65. This last step was especially important during Edward K. Thompson's term as managing editor. He enjoyed the "scoop" and it was not unheard of for him to fly a crew of writers and layout specialists to the Chicago printing plant to work on a late-breaking story through Saturday night.

66. The most comprehensive biographies of Smith's early life are: Jim Hughes, *W. Eugene Smith: Shadow and Substance* (New York: McGraw-Hill, 1989); Benjamin Maddow, *Let Truth Be the Prejudice* (Millerton, NY: Aperture, 1985); William Johnson, *W. Eugene Smith: Middle Years* (Tucson: Center for Creative Photography, 1984); and William Johnson, *W. Eugene Smith: Early Work* (Tucson: Center for Creative Photography, 1980).

67. *Let Truth Be the Prejudice* (note 66), p. 12.

68. It should be pointed out, however, that this arrangement was not unusual. Several Black Star photographers also worked for *Life* and later were added to the *Life* photography staff. See "Black Star Picture Agency" (note 45), p. 22.

69. William Johnson (editor), *W. Eugene Smith: Master of the Photographic Essay* (Millerton, NY: Aperture, 1981), p. 7.

70. Ibid., pp. 7–8.

71. "Union Station," *Parade*, II (December 13, 1942); "They Look for Trouble," *Parade*, II (July 25, 1942); "13-Year-Old Veteran," *Parade*, III (September 26, 1943). All tearsheets are in the W. Eugene Smith Archive, Center for Creative Photography, University of Arizona.

72. Quoted in *Let Truth Be the Prejudice* (note 66), p. 18.

73. Quoted in *W. Eugene Smith: Master of the Photographic Essay* (note 69), p. 21.

74. *Let Truth Be the Prejudice* (note 66), p. 87.

75. Ibid., p. 23.

76. Ibid., p. 92.

77. "Japanese Civilians on Saipan," *Life* XVII/19 (November 6, 1944), pp. 45–48ff.

78. *W. Eugene Smith: Master of the Photographic Essay* (note 69), p. 14.

79. *Let Truth Be the Prejudice* (note 66), p. 28.

80. Quoted in ibid., p. 29.

81. "Americans Battle for Okinawa: 24 Hours with Infantryman Terry Moore. 'Wonderful' Smith tells about advancing through the mud and getting hit by a mortar fragment," *Life*, XVIII/25 (June 18, 1945), pp. 19–25.

82. P. I. Prentice, "A Letter from the Publisher," *Time*, XLVI/1 (July 2, 1945), p. 11. The publication includes a portrait of Smith.

83. *W. Eugene Smith: Master of the Photographic Essay* (note 69), p. 8.

84. "Folk Singers: Mountain People Remember the Old American Music," *Life* XXIII/16 (October 20, 1947), pp. 63–66.

85. Selma Robinson, "He Photographed the Real War," *PM's Sunday Picture News* (May 26, 1946), pp. 1, 7–15.

86. This commitment to advocacy radically challenged the tradition of photojournalism. Karin Becker argues that objectivity and loyalty were expected of photojournalists and that distinguishing and distancing themselves from the individuals and groups they photographed was critical to the profession. Although her study focuses on Germany in the 1930s, this attitude must have been prevalent at *Life* magazine through the German émigré photographers on the staff. "Forming a Profession" (note 12), p. 60.

## Chapter 2. "Country Doctor"

1. Maitland Edey, *Great Photographic Essays from Life* (Boston: Little, Brown, 1978), p. 11.

2. Albert Q. Maisel, "So You Can't Get a Doctor," *Collier's*, CIX (May 17, 1947), pp. 16–17ff; and "Doctors Increase Faster Than U.S. Population," *Science Newsletter*, LIV/9 (August 28, 1948), p. 136.

3. Smith's assistant, Robert Harrah, recalls that Dr. Ceriani was selected after a researcher determined him to be particularly photogenic. Interview with Robert Harrah, March 29, 1987.

4. Telephone interview with Barron Beshoar, July 27, 1987.

5. I am extremely grateful to Robert Harrah for supplying details regarding the events leading up to the "Country Doctor" essay in a letter of April 11, 1986, and an interview with the author, September 12, 1987.

6. This information courtesy of Barron Beshoar (note 4).

7. Ibid. Beshoar says that most of his suggestions were followed but not all of them. He adds that these reports had no length limitation.

8. Robert Harrah remembers the script being from one and a half to two pages long and containing about forty-five suggested motifs. Smith's reporter's pocket notebook lists numbered motifs that suggest the contents of the shooting script. W. Eugene Smith Archive, Center for Creative Photography, University of Arizona, uncatalogued brown notebook.

9. It must be acknowledged that there was pictorial precedent in Smith's earlier work. See James Rorty (text) and W. Eugene Smith (photographs), "A Doctor for All of Us," *Collier's*, CXII (August 21, 1943), pp. 29ff, and W. Eugene Smith (photographs), "The Small Town Doctor at War," *Parade*, XI/52 (July 4, 1943), pp. 2–7.

10. This photo-reportage was published shortly after "Country Doctor." "Lung is Collapsed by Plastic Balls: New and Controversial Technique is Designed to Immobilize Tuberculous Organ without Disfiguring the Chest," *Life*, XXV/18 (November 18, 1948), pp. 127–128.

11. In addition to his photographic documentation Smith kept a small reporter's notebook in which he recorded those aspects of the doctor's life that he had photographed, listed ideas from the shooting script he wanted to be sure to illustrate (e.g., "medically most diversified"), and wrote down editorial comments from the doctor that might add life to the researcher's factual presentation. W. Eugene Smith Archive, Photo-Essay Project Files – Country Doctor, Center for Creative Photography, University of Arizona.

12. While shooting the story Smith commented that the doctor "takes care of anyone who comes along. They sure love him around here – he's a legend already." Ben Maddow, *Let Truth Be the Prejudice* (Millerton, NY: Aperture, 1985), p. 17.

13. This information comes from Robert Harrah. Very few of the contact sheets in the Smith Archive have *Life* stamps on the verso. The one or two that are stamped are dated July 13, 1948.

14. Interview with Peggy Sargent, August 25, 1986.

15. "Country Doctor: His Endless Work Has Its Own Rewards," *Life*, XXV/12 (September 20, 1948), pp. 115–126.

16. Wall label from exhibition *The Photo-Essay*, Museum of Modern Art, New York, March 16–May 16, 1965.

17. "The Private Life of Gwyned Filling," *Life*, XXIV/18 (May 3, 1948), pp. 103–114.

18. "A Practical Man of God: Here Is the Life of a Typical U.S. Parson," Life, X/5 (February 3, 1941), pp. 55–63.
My thanks to Joseph Thorndike for suggesting this comparison.

19. *Great Photographic Essays from Life* (note 1), p. 50.

20. "Me and Gene . . . and Photojournalism," an unpublished memoir by Robert Harrah, typescript, W. Eugene Smith Archive, Center for Creative Photography, University of Arizona.

21. *Let Truth Be the Prejudice* (note 12), p. 37. The ten pages to which Smith refers are those given to his photo-essay "Trial by Jury," published one week after McCombe's on May 10, 1948.

22. "Country Doctor" (note 15), p. 126.

23. Joseph Thorndike confirms that it was uncommon to run such a lengthy text after the pictures. He suggests it may have been done because the writer was asked to add specific information not covered by the photographs and captions. Interview with Joseph Thorndike, August 27, 1986.

24. The importance of news to *Life* magazine editors was stressed by Edward K. Thompson during an interview, August 22, 1986.

25. "The Battle of Britain," *American Journal of Public Health*, XXXIII/5 (May 1948), pp. 735–736.

26. "Shortages of Medical Men: Dispute Whether Lack is Fundamental or Due to Uneven Distribution," *U.S. News*, XXIII/9 (September 5, 1947), pp. 20–21.

27. For a historical discussion of this debate see Odin W. Anderson, *Health Services in the United States* (Ann Arbor: Health Administration Press, 1985), pp. 135–139.

28. Ibid., pp. 115–117.

29. This support for the American Medical Association was widespread in postwar journalism and is documented in Verne E. Edwards, Jr., "The American Medical Association As Reported in Six U.S. Dailies," *Journalism Quarterly*, XXVI (1949), pp. 417–423.

30. "The Public's Health: Britain Is about to Care for It in a New Way – Not Necessarily the Best for Us," *Life*, XXIII/9 (September 1, 1947), p. 28.

31. *Medicine and the Changing Order: Report of the New York Academy of Medicine* (New York: Commonwealth Fund, 1947).

32. "The Public's Health" (note 30).

33. Paul Starr, *The Social Transformation of Medicine* (New York: Basic Books, 1982), pp. 286–288.

34. Interview with Robert Harrah, September 12, 1987.

35. Karl Detzer, " 'Doc' Wins a Medal," *Hygeia: The Health Magazine*, XXVI/10 (October 1948), pp. 720–721ff.

36. Ibid., p. 736.

37. Charles M. Swart, "Revolutionary Doctors," *Survey Midmonthly*, LXXXIII/12 (December 1947), p. 331.

38. In 1949 the A.M.A. assessed its members special dues and hired the public relations firm of Baxter & Whitaker. As part of its campaign the public relations firm made posters of Sir Luke Fildes's *The Doctor* with the caption: "Keep Politics Out of This Picture." The posters were sent to doctors throughout the United States and hung in office waiting rooms. For a discussion of this public relations effort see "Expensive Operation," *Time*, LIV/25 (December 19, 1949), pp. 77–78.

39. "So You Can't Get a Doctor" (note 2) and "Doctor Shortage – and Why," *Collier's*, CIX (June 28, 1947), p. 90; "What it Takes to Make a Doctor," *Look*, XII (August 31, 1948), pp. 63–67.

40. "Norman Rockwell Visits a Family Doctor," *Saturday Evening Post*, CCXIX/41 (April 12, 1947), pp. 30–33.

41. "Country Doctor" (note 15), p. 117.

42. Ibid., p. 126.

43. "Middle Park Hospital To Be Featured in *Life* Magazine," *The Middle Park Times and Kremmling Record*, LXVIII/7 (July 22, 1948), pp. 1ff. Photocopy of tearsheet included in "Me and Gene . . . And Photojournalism" (note 20).

44. This editorial position was made explicit in later news articles published by the parent news magazine of the Time-Life Corporation, *Time*. In particular see "Battle Ahead," *Time*, LIII/1 (January 3, 1949), p. 40; "Country Doctor, 1950," *Time*, LV/2 (January 9, 1950), pp. 29–30; "The Price of Health: Two Ways to Pay It," *Time*, LV/8 (February 20, 1950), pp. 19–21; and "Doctors at War," *Time*, LVI/1 (July 3, 1950), pp. 30–31.

45. Correspondence files, 1948, W. Eugene Smith Archive, Center for Creative Photography, University of Arizona.

46. Ibid., letter from Wayne Miller dated September 17, 1948; cable from Leonard McCombe dated November 21, 1948.

47. Ibid., memorandum dated September 21, 1948.

48. Ibid. Kurt Szafranski began his journalistic career as the publishing director of the *Berliner Illustrirte Zeitung* in the early 1920s (Tim N. Gidal, *Modern Photojournalism: Origin and Evolution, 1910–1933* [New York: Macmillan, 1973], pp. 13, 15, 24). In 1948, he was editor of Black Star picture agency. For information about his role with Black Star see C. Zoe Smith, "Black Star Picture Agency: *Life*'s European Connection," *Journalism History*, XIII/1 (Spring 1986), pp. 19–25.

49. *Memorable Life Photographs*, exhibition at the Museum of Modern Art, New York, November 1951.

50. The fame of "Country Doctor" continues. On the anniversary of the publication of the photo-essay, September 20, 1983, Dr. Ceriani was a featured guest on public television's MacNeil/Lehrer News Hour; and Ceriani's successor in Kremmling was featured in a photo-story, "New Doc in Town," in *Hippocrates* (September/October 1988), pp. 50–57.

51. Correspondence files (note 45), letter dated September 19, 1948.

52. Ibid., letter dated September 21, 1948.

53. *"Derevenskij Vrac. Prijnatel 'nost' bolnyx – nagrada za bolshoj trud"* ("Country Doctor. The gratitude of patients – the reward for his hard work"), *Amerika Illjustrirovannyi svurnal* (America Illustrated), no. 54 (no date, ca. 1951), pp. 3–9.

54. *The Department of State Bulletin*, XXVII/683 (June 28, 1952), p. 127.

55. Ibid., p. 128.

## Chapter 3. "Spanish Village"

1. Ted Castle, Smith's assistant for "Spanish Village," interview with the author, May 2, 1986.

2. Letter from W. Eugene Smith to Nettie Smith, undated, pp. 2–3, Correspondence files, W. Eugene Smith Archive, Center for Creative Photography, University of Arizona.

3. "Hard Times on Broadway: Too Many Actors with Too Few Jobs Dream and Scramble to Keep Sock and Buskin Together," *Life*, XXVI/7 (February 14, 1949), pp. 87–95.

4. Ted Castle interview (note 1).

5. Maitland Edey, *Great Photographic Essays from Life* (Boston: New York Graphic Society, 1978), p. 14.

6. This incident was related by Ted Castle during an interview with the author (note 1).

7. "Britain's Future is up to the Voters," *Life*, XXVIII/8 (February 20, 1950), pp. 29–35. Pictures by other photographers are included in the article. Smith's photographs appear on pages 31 and 34. Contact sheets in the Center for Creative Photography are dated February 9 and February 23.

8. "Attlee Surveys the Ruins of Victory," *Life* XXVIII/10 (March 6, 1950), pp. 21–23. Pictures by other photographers are included in the article. Smith's photographs appear on pages 21 and 22. Smith's reputation was such that he was the only photographer to receive credit.

9. Letter from Edward K. Thompson to the author, April 2, 1987.

10. Letter from Edward K. Thompson to the author, September 24, 1986.

11. These articles are dated February 21–24, 1949. Photo-Essay Project Files – Spanish Village, folder 3, W. Eugene Smith Archive, Center for Creative Photography, University of Arizona.

12. Ibid., folder 1.

13. Letter from W. Eugene Smith to Nettie Smith, undated, Correspondence files (note 2).

14. Ted Castle, Smith's assistant, commented that after the success of "Country Doctor," Smith could do what he wanted without interference from *Life* editors. Ted Castle interview (note 1).

15. Letter from W. Eugene Smith to Nettie Smith, undated [May 1950], Correspondence files (note 2).

16. Small spiral reporter's notebook, Photo-Essay Project Files – Spanish Village, folder 2 (note 11).

17. Ibid.

18. For example, Ben Maddow, *Let Truth Be the Prejudice* (Millerton, NY: Aperture, 1985), p. 40, and Jim Hughes, *W. Eugene Smith, Shadow and Substance* (New York: McGraw-Hill, 1989), p. 252.

19. Gaspar Gomez de la Serna, "Meditacion Ante un Pueblo sin Nombre," *A.B.C.* of Madrid, May 25, 1950. Typescript dated May 28. Original and typescript translation in Photo-Essay Project Files – Spanish Village, folder 4 (note 11).

20. Ibid., typescript, p. 1. The original typescript has underlining for italics.

21. Smith wrote about the importance of this article as a justification of his "Spanish Village" reportage in a letter to his mother dated April 15, 1951, Correspondence files (note 2).

22. Ted Castle developed the negatives in their hotel room. The film containers were rinsed in the toilet and washed in the bathtub. Interview with Ted Castle (note 1).

23. Ibid.

24. W. Eugene Smith, "A Spanish Village," *U.S. Camera Annual 1952* (New York: 1951), p. 153.

25. Photo-Essay Project Files – Spanish Village, folder 2 (note 11).

26. *Let Truth Be the Prejudice* (note 18), pp. 41.

27. As further background, Smith suggested the editors read two articles by a former *Time* magazine correspondent, Charles Wertenbaker. These articles were critical of the Franco regime. For example, Wertenbaker placed the blame for the food crisis squarely on Franco, who appointed cabinet ministers on the basis of personal loyalty rather than expertise. Charles Wertenbaker, "Franco: Fascism and Futility," *The Reporter*, II/13 (June 20, 1950), and "The Men Who Run Spain," *The Reporter*, III/1 (July 4, 1950).

28. "Captions – Spanish Village – Bread," typescript, Photo-Essay Project Files – Spanish Village, folder 2 (note 11), unpaginated (p. 3).

29. Letter from W. Eugene Smith to Nettie Smith, dated October 12, Correspondence files (note 2).

30. Interview with Ted Castle (note 1).

31. For a discussion of Smith's breakdown and hospitalization see *Shadow and Substance* (note 18), pp. 266–268.

32. A letter from W. Eugene Smith to Edward Thompson indicates that Smith did not submit the finished prints until February 27, 1951. Correspondence files (note 2).

33. *Great Photographic Essays from Life* (note 5), p. 105.

34. "Franco's Spain: Poorhouse of the West," *Look*, XV/3 (January 30, 1951), pp. 21–26.

35. In the Smith Archive there is a six-page cable to *Life* editors from Piero Saporiti giving specific information about the riots. Photo-Essay Project Files – Spanish Village (note 11).

36. "Spanish Village: It Lives in Ancient Poverty and Faith," *Life*, XXX/15 (April 9, 1951), pp. 120–129.

37. *Great Photographic Essays from Life* (note 5), p. 12.

38. Ibid., p. 10.

39. For a perceptive analysis of the aesthetic complexity of the editorial aspects of the photo-essay see Keith Hardiman, "Spanish Village,"

*Creative Camera*, CXLVI (August 1976), pp. 262–265.

40. The importance of the event was recognized by Smith, himself a former Roman Catholic. Looking at his contact sheets we see that Smith systematically documented all aspects of Lorenza's preparation – dressing, arranging her hair, and leaving for the church.

41. "Spanish Village: It Lives in Ancient Poverty and Faith" (note 36), p. 120.

42. "A Fee for Franco?," *Time*, LVI/7 (August 14, 1950), p. 9.

43. "Spain: Franco's Regime, Slightly Mellowed, Looks West for Friendship and Aid," *Life*, XXVI/14 (April 4, 1949), pp. 111–123.

44. This stance was clearly ideological. For a contemporary, contrasting viewpoint in the popular press see Irving Wallace, "Will the Spanish Town Live Again?" *Saturday Evening Post*, CCXX/1 (July 5, 1947), pp. 15–17ff.

45. Quoted in *Let Truth Be the Prejudice* (note 18), p. 41.

46. For a discussion of Luce's control over *Time* magazine see the official history of Time, Inc.: Robert T. Elson, *The World of Time, Inc: An Intimate History of a Publishing Empire, Volume 2: 1941–1960* (New York: Atheneum, 1973).

47. "Spain," *Time*, LV/10 (March 6, 1950), p. 32.

48. "A Fee for Franco?" (note 42).

49. "Spain: 22 Divisions," *Time*, LVII/9 (February 26, 1951), p. 35.

50. It is informative to contrast this reading of the facts about Spain with Charles Wertenbaker's reports mentioned in Smith's research as important background reading. Wertenbaker's observations were similar to those of *Time* – the Spanish army was poorly equipped and what little equipment it had was outdated – but he concluded his report by questioning whether the Spaniards would be willing to fight to preserve their "present way of life." See "Fascism and Futility" (note 27), p. 12.

51. "A Fee for Franco?" (note 42).

52. "Making Sense of Spain," *Time*, LVIII/4 (July 30, 1951), p. 21.

53. Letter from W. Eugene Smith to Nettie Smith, undated [August 17, 1950], Correspondence files (note 2).

54. "Captions – Spanish Village – Bread" (note 28) (p. 3).

55. Ibid. (p. 1).

56. Ibid. (pp. 33–38).

57. Ibid. (pp. 39–40).

58. Ibid. (pp. 19–20).

59. Letter from W. Eugene Smith to Nettie Smith, dated January 28, 1951, Correspondence files (note 2). The role of the Catholic Church in Spain was the major topic in a continuing exchange of letters between Smith and his mother during 1950 and 1951. Nettie Smith, a Roman Catholic convert, defended Franco and tried to persuade her son to temper his critical reportage. See, in particular, the correspondence between W. Eugene Smith and Nettie Smith, undated [June 1950]; January 28, 1951; and June 26, 1951.

60. This photograph was singled out for praise by Edward Steichen, the Director of Photography at the Museum of Modern Art, was reproduced by Beaumont Newhall in his *History of Photography*, and has remained one of Smith's best-known works.

61. The bill was passed on September 6, 1950. *U.S. Statutes at Large*, 81st Congress, 2nd Session, 1950–1951, vol. 64, part 1, p. 758.

62. The exact nature of and reason for Smith's breakdown are not known. It is reported that he was found half-clothed and screaming in the middle of a street when he was picked up by police and taken to Bellevue Hospital. Because his medical records remain sealed the exact date of his emotional breakdown is unknown, but we know from a letter he wrote to his mother that he entered the hospital in early September. Letter from W. Eugene Smith to Nettie Smith, dated October 12, Correspondence files (note 2). The coincidence between the date of the passage of the foreign aid bill (September 6, 1950) and Smith's hospitalization suggest that his depression over the bill's passage was an important factor in his breakdown.

63. "Letters to the Editor," *Life*, XXX/18 (April 30, 1951), p. 4, and the Correspondence files (note 2).

64. "Life Letters Report Summary: April 9, 1951 Issue," dated April 27, 1951, Correspondence files (note 2).

65. Letter from W. Eugene Smith to Nettie Smith, dated April 15, 1951, Correspondence files (note 2).

66. *U.S. Camera Annual 1952*, (note 25), pp. 149–159; Jacquelyn Judge, "Eugene Smith's Spain," *Modern Photography*, XV/12 (December 1951), pp. 79–87ff.

67. Letter from Edward Hannigan, former assistant editor of *U.S. Camera*, to the author, dated March 19, 1986.

68. *Spanish Village Portfolio*, published by *Life* magazine in 1951; a copy of the portfolio is in

the W. Eugene Smith Archive, Center for Creative Photography, University of Arizona. The portfolio, packaged in a folded envelope, contains eight individual 8 × 10 pictures printed on heavy cream-colored paper with a matte finish.

69. Letter from W. Eugene Smith to Nettie Smith, undated, Correspondence files (note 2).

70. *Spanish Village Portfolio* (note 68).

71. W. Fernandez Florez, "De la Leyenda Negra a la Foto Negra Sobre España," *Semana* (July 24, 1951), unpaginated. A typescript, literal translation of the article can be found in Photo-Essay Project Files – Spanish Village (note 11).

72. Gaspar Gomez de la Serna, "Letter to the Editor of 'Life'," *Mundo Hispanico*, IV/40 (July 1950), p. 18.

73. Ibid.

74. "Deleitosa de 'Life' La España contra la que España lucha: y los Deleitosa de la nueva España," *Mundo Hispanico*, IV/40 (July 1951), pp. 21–29.

75. Correspondence files (note 2).

76. Ibid.

77. Letter from Robert Frank to W. Eugene Smith dated June 3, 1952, Correspondence files (note 2). Even thirty years later the effect of Smith's photo-reportage remained. Kathryn Livingston, "Short Takes: A Classic Reprise," *American Photographer*, VI/4 (April 1981), pp. 50–51.

78. Dmitri Kessel, "Spain: American Tourists Rediscover Treasure of Color and History," *Life*, XXXIII/7 (August 18, 1952), pp. 50–61.

79. W. Eugene Smith to Nettie Smith, undated, Photo-Essay Project Files – Nurse-Midwife, folder 16, W. Eugene Smith Archive, Center for Creative Photography, University of Arizona.

## Chapter 4. "Nurse Midwife"

1. Ben Maddow, *Let Truth Be the Prejudice* (Millerton, NY: Aperture, 1985), pp. 43–44. That Smith originated the idea was substantiated by Berni Schoenfield, Smith's assistant for "Nurse Midwife," in a conversation with the author on January 9, 1991.

2. Two-page typescript memo entitled "Outline for Essay on Midwifes," dated April 13, 1951, Photo-Essay Project Files – Nurse Midwife, folder 25, W. Eugene Smith Archive, Center for Creative Photography, University of Arizona.

3. Ibid., p. 1.

4. Ibid., p. 2.

5. Three-page typescript memo dated May 1, 1951, Photo-Essay Project Files – Nurse Midwife, folder 25 (note 2).

6. Ibid., p. 2.

7. Ibid.

8. "Midwife Institutes," *State Board of Health of South Carolina*, VII/10 (October 1950), p. 3. Typescript copies in Photo-Essay Project Files – Nurse Midwife, folder 19 (note 2).

9. Photo-Essay Project Files – Nurse Midwife, folders 19, 20, 22, and 23 (note 2).

10. Small, brown, spiral notebook, unpaginated, Photo-Essay Project Files – Nurse Midwife, folder 24 (note 2).

11. The importance of Laura Blackburn to the editors' idea of the story can be seen in the bibliography they gave to Smith before he went to South Carolina. He was given at least five typed transcriptions of articles by Laura Blackburn: "The Midwife: As Recorded by a Sincere Observer," *The Trained Nurse and Hospital Review* (September 1935); "The Midwife Problem in Rural Areas of the South," *The Trained Nurse and Hospital Review* (August 1939); "A Suitable Substitute for Midwives," *The Trained Nurse and Hospital Review* (June 1941); "The Midwife as Ally," *The American Journal of Nursing* (January 1942); "Midwife Institutes," *State Board of Health of South Carolina* (October 1950). Typescript copies in Photo-Essay Project Files – Nurse Midwife, folder 19 (note 2).

12. Laura Blackburn published this distinction in "The Midwife Problem in Rural Areas of the South," ibid., p. 4.

13. In his reporter's notebook one finds phone numbers, names, and directions to several different midwives. Photo-Essay Project Files – Nurse Midwife (note 10).

14. Transcript entitled "Callen tape 4," p. 15, Photo-Essay Project Files – Nurse Midwife, folder 28 (note 2).

15. During the interview Maude Callen and Eugenia Boughton gave examples of their inability to practice the skills for which they had been trained. For example, despite being registered nurses licensed to administer drugs, neither woman was allowed to carry simple drugs such as sedatives. According to public health policy these could only be given to laboring mothers by a doctor.

16. Transcript entitled "Callen tape 4" (note 14) p. 28.

17. Ibid., p. 29.

18. A further reason for selecting Maude Callen was that although she was older and less de-

monstrative, she was more photogenic than Eugenia Boughton. Conversation with Berni Schoenfield, January 9, 1991.

19. Transcript entitled "Boughton & Callen tape 1, side 2," p. 35, Photo-Essay Project Files – Nurse Midwife, folder 31 (note 2).

20. Ibid., p. 36. There is no indication to whom the "4th voice" belonged. According to Berni Schoenfield it was either Smith's or his.

21. A letter from Eugene Smith to his mother, dated June 26, 1951, indicates that he had already begun his story on Maude Callen. Correspondence files, W. Eugene Smith Archive, Center for Creative Photography, University of Arizona.

22. The first set of fourteen contact sheets is stamped July 3, 1951 on the verso. The back of the set is also marked #580 in pencil, and each sheet is given a sequential number, beginning with C1 and ending with C14. It must be pointed out, however, that the *Life* darkroom did not chronologically sequence the exposed negatives when they received them; therefore one cannot assume that the contacts are organized in a temporal sequence.

23. "Chronicle of the South," unaddressed and undated letter, Photo-Essay Project Files – Nurse Midwife, folder 25 (note 2).

24. Reporter's notebook, Photo-Essay Project Files – Nurse Midwife (note 2).

25. Ibid.

26. These motifs were suggested in a memo from Nancy Genet, May 1, 1951 (note 5).

27. In particular, Dr. Fishburne expressed his frustration over the State Medical Society's inability to consider local needs when allocating funding and described the "old boy" political network he used to get critical funding for Berkeley County. Typescript entitled "Fishburne," p. 17, Photo-Essay Project Files – Nurse Midwife, folder 29 (note 2).

28. Typescript entitled "Dr. Banov, side 2," p. 26, Photo-Essay Project Files – Nurse Midwife, folder 30 (note 2).

29. Ibid., pp. 19–21.

30. Ibid., p. 21.

31. Undated typescript entitled " 'Nurse Midwife' Research by W. Eugene Smith," p. 1, folder 25, Photo-Essay Project Files – Nurse Midwife (note 2).

32. For example, one of Smith's layouts, intended as the opening page, was entitled: "Soc?o?y of Ann Amer/Larger than Life Heroes." It was undoubtedly meant to read: "Society of Anonymous Americans." Photo-Essay Project Files – Nurse Midwife, folder 26 (note 2).

33. "Nurse Midwife: Maude Callen Eases Pain of Birth, Life and Death," *Life*, XXXI/23 (December 3, 1951), pp. 134–145.

34. Ibid., p. 135.

35. " 'Nurse Midwife' Research by W. Eugene Smith" (note 31), p. 3.

36. "Nurse Midwife" (note 33), p. 143.

37. " 'Nurse Midwife' Research by W. Eugene Smith" (note 31), p. 8.

38. For a history of the midwife debate see Frances E. Kobrin, "The American Midwife Controversy: A Crisis of Professionalization," an essay in *Sickness and Health in America: Readings in the History of Medicine and Public Health*, edited by Judith W. Leavitt and Ronald L. Numbers (Madison: University of Wisconsin Press, 1978), pp. 217–225; and Judy B. Litoff, *American Midwives: 1860 to the Present* (Westport, CT: Greenwood Press, 1978).

39. These statistics are compiled from three sources: Litoff, *American Midwives* (note 38), p. 12; President's Commission on the Health Needs of the Nation, *Building America's Health* (Washington, DC: U.S. Government Printing Office, 1952–1953), vol. 2, p. 68; and Paul Starr, *The Social Transformation of American Medicine* (New York: Basic Books, 1982), p. 359.

40. For a contemporary discussion of the concern of the Public Health Service with maternal and child care see John Whitridge and Edward Davens, "Are Public Health Maternity Programs Effective and Necessary?," *American Journal of Public Health*, XLII/5 (May 1952), pp. 508–515; "The Local Health Department – Services and Responsibilities," an official statement of the American Public Health Association adopted November 1, 1950, published in Peter Van Avery, *Public Health* (New York: H. W. Wilson Co., 1959), pp. 302–307; and John Whitridge, "Practical Aspects of Coordinating Maternity Care: The Role of Health Departments," *American Journal of Public Health*, XLI/11, part 2 (November 1951), pp. 5–9.

41. *Building America's Health* (note 39), p. 81. In Maryland, for example, 80 percent of black mothers were assisted by a midwife, but less than half of these were trained by the Public Health Department. "Are Public Health Maternity Programs Effective and Necessary?" (note 40).

42. Idus A. Newby, *Black Carolinians: A History of Blacks in South Carolina from 1895 to 1968* (Columbia: University of South Carolina Press, 1973), p. 299. This legacy of racism continues today; see "Special Report: Forgotten Americans," *American Health Magazine*, IX/9 (November 1990), pp. 41–56.

43. It is estimated that these two medical schools supplied 83 percent of the 6,000 black physicians practicing in the United States in 1970. James L. Curtis, *Blacks, Medical Schools, and Society* (Ann Arbor: University of Michigan Press, 1971). For a detailed discussion of the obstacles confronting the black physician see W. Montague Cobb, *Medical Care and the Plight of the Negro* (New York: National Association for the Advancement of Colored People, 1947).

44. This disparity is not surprising given the South Carolina State Medical Society's exclusion of black doctors. What was especially frustrating about this practice was that black doctors were caught in a system of exclusion: exclusion from the local medical society meant exclusion from the American Medical Association, and exclusion from the A.M.A. meant exclusion from hospital practice. It is little wonder that so few black doctors stayed in the South to practice medicine under such oppressive conditions. For a discussion of this problem see Herbert M. Morais, *The History of the Negro in Medicine* (New York: Publishers Company, 1968), p. 155.

45. "The Midwife as an Ally," p. 1, Photo-Essay Project Files – Nurse Midwife (note 2).

46. Typescript entitled "Fishburne" (note 27), p. 18.

47. Undated letter addressed "Dear Mother," Photo-Essay Project Files – Nurse Midwife, folder 16 (note 2).

48. "Nurse Midwife" (note 33), p. 138.

49. The Episcopal Church continued to pay her as did the county Public Health Department. According to Dr. Fishburne, he insisted on this when he hired Maude Callen. He said when the Episcopal bishop found out that she was being hired by the county he decided to drop her from his payroll. When Dr. Fishburne heard this he phoned the bishop and threatened to drop her from the county payroll, arguing "she does too much for what we are able to pay her." Typescript entitled "Fishburne" (note 27), p. 22.

50. There was more than enough money raised to build the clinic. In fact, public interest was so high that *Life* sent Smith to do a follow-up story about the construction of the new clinic. "Sequel: Maude Gets Her Clinic; *Life* readers donate $18,500 to nurse midwife of Pineville, S.C.," *Life*, XXXIV/14 (April 6, 1953), pp. 139–140ff.

51. Undated letter begun "Dear Mother," Photo-Essay Project Files – Nurse Midwife (note 2).

52. Letter dated January 16, 1952, from Thomas N. Carruthers to Miss Nancy Robb, Correspondence files (note 21).

53. " 'Nurse Midwife' Research by W. Eugene Smith" (note 31), p. 10.

54. Ibid., p. 13.

55. Under the pressure of the U.S. Supreme Court's "separate but equal" doctrine, the governor decided that the only way that South Carolina could avoid desegregating its school system was by undertaking a massive campaign to build new schools for black students. For further discussion see *Black Carolinians* (note 42); and Numan V. Bartley, *The Rise of Massive Resistance: Race and Politics in the South During the 1950s* (Baton Rouge: Louisiana State University, 1969).

56. Prior to the publication of "Nurse Midwife," expenditures for health services had dropped from $130,442 in 1949–1950 to $89,019 in 1951–1952. E. C. Rhodes, comptroller general, *Report of the Comptroller General of South Carolina to the General Assembly for the Fiscal Year* (Columbia, SC: State Budget and Control Board, 1950, 1951, 1952, and 1953).

57. Ibid., 1953.

58. Letter from Edward K. Thompson to W. Eugene Smith, dated November 28, 1951, Photo-Essay Project Files (note 2).

59. Annotations in margins of Thompson's letter. Ibid. Smith's annotations imply that the writer did not read the research until shortly before the deadline; as a result, he had no time to craft the text. This may or may not be accurate. Such marginal notations are clearly self-serving and are problematic for the historian. There are indications that they were written much later, after Smith's resignation from *Life* in 1954.

60. Undated letter entitled "Dear Mother," Photo-Essay Project Files – Nurse Midwife, folder 16 (note 2).

### Chapter 5. "A Man of Mercy"

1. Letter from W. Eugene Smith to Edward K. Thompson dated July, 5, 1952, Correspondence files, 1952, W. Eugene Smith Archive, Center for Creative Photography, University of Arizona.

2. Letter from W. Eugene Smith to Ray Mackland dated November 3, 1953; Photo-Essay Project Files – Man of Mercy, folder 12, W. Eugene Smith Archive, Center for Creative Photography, University of Arizona.

3. Letter from Gene Farmer to W. Eugene Smith dated November 28, 1953; ibid., folder 13.

4. Cable from Gene Farmer to Albert Schweitzer dated November 28, 1953; ibid.

5. Schweitzer came to the United States at the invitation of the organizers of a Goethe Festival honoring the German poet's 200th birthday. He did not want to make the long trip, preferring to stay in Africa, but the large honorarium offered by the organizers persuaded him. The entire Goethe celebration was tainted by economic considerations; it was organized by Walter Paepcke to publicize his attempt to turn Aspen, Colorado, into a resort. See "Reverence for Life," *Time*, LIV/2 (July 11, 1949), p. 74; and Winthrop Sargeant, "Albert Schweitzer," *Life*, XXVII/ 4 (July 25, 1949), pp. 74–80ff.

6. "Albert Schweitzer's Impact on America," in *In Albert Schweitzer's Realms*, edited by A. A. Roback (Cambridge, MA: Sci-Art Publishers, 1962), p. 420.

7. Its earliest public manifestations were the 1939 formation of the Schweitzer Fellowship and the 1945 publication of commissioned tributes edited by A. A. Roback entitled *The Albert Schweitzer Jubilee Book* (Cambridge, MA: Sci-Art Publishers, 1945).

8. " 'The Greatest Man in the World,' " *Life*, XXIII/14 (October 6, 1947), pp. 95–96ff.

9. Miram Rogers, "How the 'Friends of Albert Schweitzer' Came into Being," in *In Albert Schweitzer's Realms* (note 6), p. 410.

10. Reported in "Missionary from Lambaréné," *Time*, LXIII/4 (January 25, 1954), pp. 82ff.

11. Pamphlet entitled *Albert Schweitzer*; Photo-Essay Project Files – Man of Mercy, folder 26 (note 2).

12. There is no checklist of the particular prints in the exhibition but it is likely that they were the same photographs later published in *The World of Albert Schweitzer*. Of the six photographs reproduced in the exhibition pamphlet five were reprinted a year later in *The World of Albert Schweitzer*, photographs by Erica Anderson, text by Eugene Exman, picture editing and book design by Barbara Morgan (New York: Harper Brothers, 1955).

13. Letter from Albert Schweitzer to W. Eugene Smith dated January 30, 1954; Photo-Essay Project Files – Man of Mercy, unnumbered folder titled by Smith "Resignation, letters, etc." (note 2).

14. This was far more than a casual interest. In 1954 Smith's library contained at least sixteen books by or about Albert Schweitzer. (This estimate is based on Smith's library preserved at the Center for Creative Photography).

15. Two articles that remained in Smith's possession were: Albert Schweitzer, "The Problem of Ethics for Twentieth Century Man," *The Saturday Review*, XXXVI/24 (June 13, 1953), pp. 9–11ff; and Anthony Lewis, "Man of Our Century," *Cosmopolitan*, CXXXIV (February 1953), pp. 64–71.

16. The W. Eugene Smith Archive contains two sets of these typescripts. The first is an original, unmarked typescript, Photo-Essay Project Files – Man of Mercy, folder 25; the second is a carbon copy that has been underlined and annotated by Smith, folder 27 (note 2).

17. Ibid., from typescript entitled "Interview with Dr. Emory Ross," p. 5 and p. 11. Both passages were highlighted by Smith.

18. Ibid., from typescript entitled "Interview with Melvin Arnold," p. 1.

19. Letter from Dr. Neville Grant to the author dated June 30, 1987.

20. Notes from W. Eugene Smith's pocket calendar, March 26, 1954, Photo-Essay Project Files – Man of Mercy (note 2).

21. Ibid., April 1, 1954.

22. The person having the birthday was awakened by singing colleagues and, after a short testimonial by Dr. Schweitzer, was presented with an egg as a symbol of his or her value to the community. This tradition began early in the history of the Schweitzer hospital when eggs were a rarity and having an egg for a birthday meal was a special treat.

23. From typescript entitled "Interview with Emma," Photo-Essay Project Files – Man of Mercy, folder 22 (note 2).

24. Handwritten text, three pages, last page entitled "Unsent telegram to N.Y. about story," Photo-Essay Project Files – Man of Mercy, folder 21 (note 2). It is not completely clear why this cable was never sent but Smith noted in his pocket calendar after April 17 his anger at the "censorship of long cable" by Schweitzer's staff.

25. By 1954, Schweitzer had stopped practicing medicine and had become the hospital building foreman.

26. Letter from Dr. Neville Grant to the author (note 19).

27. Undated loose-leaf pocket notebook pages, Photo-Essay Project Files – Man of Mercy, folder 19 (note 2).

28. In general Smith seems to have gotten the freedom he wanted. He photographed at least two events that were originally denied to him: a birthday celebration inside the dining room and Schweitzer wearing glasses. There were undoubtedly other desired motifs that he was never allowed to document; he never photographed the after-dinner prayer service, for example.

29. Smith's pocket calendar, April 8, 1954 (note 20).

30. Letter from W. Eugene Smith to Don Burke dated April 11, 1954, Photo-Essay Project Files – Man of Mercy, folder 12 (note 2).

31. Annotated typescript with hand-printed title: "Acceptance of Schweitzer," Photo-Essay Project Files – Man of Mercy, folder 22 (note 2).

32. James Cameron, "Schweitzer: Genius in the Jungle," *London News Chronicle*, December 7, 8, and 9, 1953. All articles were annotated by Smith.

33. James Cameron, "Over the Tomtom Comes the Ripple of the Fugue," *London News Chronicle*, December 7, 1953.

34. Previously, there had been no serious criticism of Schweitzer in the United States. Just as he had used Charles Wertenbaker's report on Spain as reinforcement for his own interpretation, so Smith must have welcomed Cameron's reportorial interpretation.

35. Handwritten notes on undated index card, Photo-Essay Project Files – Man of Mercy, folder 19 (note 2).

36. Smith's pocket calendar, April 28, 1954 (note 20).

37. Letter from W. Eugene Smith to Carmen Smith dated April 7, 1954, Photo-Essay Project Files – Man of Mercy, folder 14 (note 2).

38. Smith's pocket calendar, April 27, 1954 (note 20).

39. Letter from W. Eugene Smith to J. L. Vinck, dated April 27, p. 1, Photo-Essay Project Files – Man of Mercy, folder 13 (note 2).

40. Smith's pocket calendar, May 17, 1954 (note 20).

41. Undated copy of cable from W. Eugene Smith to Mackland Caturani/TimeInc/New York City, Photo-Essay Project Files – Man of Mercy, folder 18 (note 2).

42. Smith's pocket calendar, May 31, 1954 (note 20).

43. Versos of contact sheets are dated with *Life* stamp June 25, 1954. W. Eugene Smith Archive, Center for Creative Photography, University of Arizona, Contact Sheets – Man of Mercy.

44. The editor's frustration was understandable: most *Life* photographers turned their negatives over to the *Life* photo lab to be printed. Edward K. Thompson, managing editor, blamed the difficulty in getting the prints from Smith for the hasty manner in which the final essay was laid out. In an exchange of letters with Smith, Thompson argued that because the prints arrived so late in the process the editors did not have time to try different layouts.

45. Letter from W. Eugene Smith to Frank Campion dated July 27, 1954, Photo-Essay Project Files – Man of Mercy, folder 18 (note 2).

46. Handwritten notes on undated index cards (note 35).

47. Erica Anderson, "Albert Schweitzer: A Picture Story of the 20th Century's Greatest Man," *Look*, XVIII (June 15, 1954), p. 41.

48. Two contemporary examples are John Gunther, "A Visit to Albert Schweitzer," *Reader's Digest*, LXV/388 (August 1954), pp. 43–49; and Norman Cousins, "The Point about Schweitzer," *The Saturday Review*, XXXVII/40 (October 2, 1954), pp. 22–23. The latter was a particularly important article. An annotated copy was kept by Smith and it is mentioned on one of the index cards that Smith used to organize his information on the essay. Handwritten notes on undated index cards (note 36).

49. Talk given by Edward K. Thompson at the W. Eugene Smith Symposium, Amon Carter Museum, January 10, 1987.

50. At that time both managing editor Edward K. Thompson and assistant managing editor Maitland Edey were on vacation.

51. Letter from W. Eugene Smith to Edward K. Thompson dated December 30, 1954, p. 6 (note 13).

52. This was cited as the most important consideration by Robert Elson in a conversation with the author, August 5, 1986.

53. "A Man of Mercy: Africa's Misery Turns Saintly Albert Schweitzer into a Driving Taskmaster," *Life*, XXXVII/20 (November 15, 1954), pp. 161–172.

54. The advertising division of the magazine selected *Life* covers, while the managing editor was responsible for all other aspects of the issue. The cover of the November 15 issue bears a half-length portrait of Gina Lollobrigida in a low-cut evening dress.

55. In a note he wrote while in Africa, Smith mentioned that Schweitzer's white pith helmet had replaced his halo. Photo-Essay Project Files – Man of Mercy, folder 26 (note 2).

56. This interpretation was suggested by Ted Castle, Smith's darkroom assistant between 1949 and 1952. My reading of the photograph, while admittedly extreme, is consistent with Smith's tendency to pursue metaphoric means, as is evident from the considerable amount of handwork he used on this print. This kind of darkroom manipulation of the print was not allowed at *Life*

magazine. In a recent talk managing editor Edward K. Thompson said if he had known about the manipulation of this print he would not have run the photograph. W. Eugene Smith Symposium, Amon Carter Museum (note 49).

57. "A Man of Mercy" (note 53), p. 161.

58. An earlier layout used a picture of Schweitzer's white carpenter, shown in close-up, hammering a beam in place while two black men held up the wooden frame. By selecting the published image, however, the editors reinforced the strenuous physical labor by showing women working alongside men. Photo-Essay Project Files – Man of Mercy (note 2).

59. Typescript entitled "Research: Appendage # Seven (7)," Photo-Essay Project Files – Man of Mercy, folder 20 (note 2), p. 3.

60. Letter from Albert Schweitzer to W. Eugene Smith dated May 22, 1954, Photo-Essay Project Files – Man of Mercy (note 2).

61. In a concession to Smith, Schweitzer allowed himself to be photographed wearing glasses. He resisted at first because he felt it made him look too old. The prohibition, however, was restored with later photographers. It was mentioned by Yousuf Karsh when describing a photo session with Schweitzer in the summer of 1954. "The Camera's Eye," *Atlantic*, CC/6 (December 1957), pp. 94–95.

62. Quoted in Benjamin Maddow, *Let Truth Be the Prejudice* (Millerton, NY: Aperture, 1985), p. 170.

63. Letter from W. Eugene Smith to Edward K. Thompson, December 30, 1954 (note 28), pp. 4–5.

64. His early life and the beginnings of his work in Africa are recounted in Albert Schweitzer, *On the Edge of the Primeval Forest* and *More from the Primeval Forest* (New York: Macmillan Company, 1948).

65. For three versions of the reasoning behind Schweitzer's commitment see ibid., especially pp. 1 and 114–118; George Seaver, *Albert Schweitzer: The Man and His Mind* (New York: Harper Brothers, 1947), pp. 47–50; and George Marshall and David Poling, *Schweitzer: A Biography* (Garden City, NY: Doubleday & Company, 1971), pp. 57–58.

66. *Albert Schweitzer: The Man and His Mind* (note 65), especially pp. 278–298. Smith took a copy of this book with him to Lambaréné in 1954.

67. For a general discussion of the process of African decolonialization see Henry S. Wilson, *The Imperial Experience in Sub-Saharan Africa Since 1870* (Minneapolis: University of Minnesota Press, 1977), pp. 290–308.

68. *The Saturday Review*, XXXVI/18 (May 2, 1953).

69. Homer Jack, "With Schweitzer in Lambaréné," *The Saturday Review*, XXXVI/18 (May 2, 1953), pp. 16–17.

70. Clara Urquhart, "A Visit to the Africa of Dr. Albert Schweitzer," *Phylon* (September 1953), pp. 295–300.

71. "Reverence for Life" (note 5), p. 68.

72. James Cameron, "Over the Tomtom Comes the Ripple of the Fugue," *London News Chronicle*, December 7, 1953.

73. James Cameron, "Here is Not One Man – But Two," *London News Chronicle*, December 9, 1953.

74. In 1953, Albert Schweitzer was seventy-nine years old. We must recognize that his ideas were those of his generation – the generation of the turn of the century. His concept of the European relationship to Africa was not dissimilar to that of the Permanent Mandates Commission established by the League of Nations. The commission understood its primary responsibility not as educational but as bureaucratic: the assurance of professional standards for colonial administration. For a discussion of the Permanent Mandates Commission see *The Imperial Experience in Sub-Saharan Africa Since 1870* (note 67).

75. Typescript entitled "Research: Appendage # Seven (7)" (note 59), p. 8.

76. Letter from Dr. Albert Schweitzer to W. Eugene Smith dated May 22, 1954 (note 60).

77. Typescript entitled "Research: Appendage # Seven (7)" (note 59), question no. 29, p. 10.

78. Africa as an untamed yet powerful continent was the theme of most reports in the early 1950s. In addition to articles previously cited, see John Gunther, *Inside Africa* (New York: Harper Brothers, 1955).

79. Handwritten notes on undated index card (note 35).

80. "Letters to the Editors," *Life*, XXXVII/23 (December 6, 1954), p. 16.

81. Letter from the Biblical Seminary in New York to W. Eugene Smith dated November 14, 1954, Photo-Essay Project Files – Man of Mercy, folder 13 (note 2).

82. Letter from Miram Rogers to W. Eugene Smith dated November 24, 1954, Photo-Essay Project Files – Man of Mercy, folder 13 (note 2).

83. Letter from W. Eugene Smith to Edward K. Thompson dated December 12, 1954 (note 13).

84. Letter from W. Eugene Smith to Dr. Schweitzer dated November 16, 1954, Photo-

Essay Project Files – Man of Mercy, folder 18 (note 2).

85. Winthrop Sargeant (note 5), p. 79. For Schweitzer's comments on the subject, see Albert Schweitzer, "The Problem of Ethics for Twentieth Century Man" (note 15), especially p. 47.

86. Letter from Edward K. Thompson to W. Eugene Smith dated December 2, 1954 (note 13).

87. Ibid. It is interesting to note that this same sentiment was expressed to Smith by Robert Frank two years earlier. See letter from Robert Frank to W. Eugene Smith dated June 3, 1952, Correspondence files (note 1).

88. Letter from W. Eugene Smith to Edward K. Thompson dated December 12, 1954 (note 13).

89. Letter from W. Eugene Smith to Edward K. Thompson dated December 30, 1954 (note 13), p. 5.

90. Smith praised the editors' efforts in a letter to Edward K. Thompson, ibid., p. 6. This sentiment was repeated several times by Smith in letters to friends. A letter to Ansel Adams is typical: "I cannot, in the particular instance, accuse the Life people involved of a lack of integrity. This I wish understood, and I am pleased that I can say it." Letter from W. Eugene Smith to Ansel Adams, undated, Correspondence files, 1954 (note 1).

91. Letter from W. Eugene Smith to Edward K. Thompson dated December 30, 1954 (note 89), p. 7.

92. Ibid.

93. Ibid.

94. Letter from Edward K. Thompson to W. Eugene Smith dated January 14, 1955 (note 13), p. 1. Thompson is quoting here from Smith's letter of December 30, 1954, p. 5.

95. Ibid., p. 2.

96. Ibid.

97. Letter from W. Eugene Smith to Edward K. Thompson dated February 1, 1955 (note 13), p. 2.

98. Ibid.

99. Letter from Edward K. Thompson to W. Eugene Smith dated February 23, 1955 (note 13).

100. Ibid.

## Chapter 6. Photojournalistic Practice

1. W. Eugene Smith, "Photographic Journalism," Photo Notes (June 1948), pp. 4–5. Several drafts of the article can be found in the Smith Archive at the Center for Creative Photography, University of Arizona, Tucson.

2. For a discussion of the cold war politics that enveloped the Photo League see the special issue of Creative Camera, nos. 223/224 (July/August 1983), especially Anne Tucker's essay, pp. 1013–1015.

3. "Photographic Journalism" (note 1), p. 4.

4. Wilson Hicks, "The Camera in Journalism," University of Missouri Bulletin, Fourth Annual (1947), p. 59.

5. "Photographic Journalism" (note 1), p. 4.

6. Ibid.

7. For an informative comparison see Margaret Bourke-White's description of her photojournalistic practice for Life magazine. Margaret Bourke-White, "Assignments for Publication," The Encyclopedia of Photography, vol. I (New York: National Educational Alliance, 1942), pp. 312–318.

8. Although usually in agreement, at times Smith challenged the Life research. For example, when he submitted his research text for "Nurse Midwife" he contradicted Life's research department, informing the editors: "The other, the common midwives, have separate (sic) research [by the Life staff] – however take the regulation, the teaching course and the statements as to progress with that little old grain of salt. . . . [I]t is basically Miss Blackburn's fault that the program is in a dead end, so far no further rise in standards is in sight." " 'Nurse Midwife' Research by W. Eugene Smith, " p. 5, folder 25, Photo-Essay Project Files – Nurse Midwife, W. Eugene Smith Archive, Center for Creative Photography, University of Arizona.

9. Letter from W. Eugene Smith to Nettie Smith, undated [early March 1950], Correspondence files, W. Eugene Smith Archive, Center for Creative Photography, University of Arizona.

10. Brown pocket notebook, Photo-Essay Project Files – Spanish Village, folder 2, unpaginated, W. Eugene Smith Archive, Center for Creative Photography, University of Arizona.

11. See chapter 4 for an extended discussion of this incident.

12. Typescript draft of letter from W. Eugene Smith to Red Valens, ca. 1949, p. 4. Correspondence files, 1949 (note 9).

13. Smith was vocal and public about his ideas. He gave lectures at camera clubs about the importance of photojournalistic integrity and was combative in discussions. For example, despite not being included in Edward Steichen's symposium on "Modern Photography," Smith dominated the discussion session. For a critique of the symposium and a discussion of Smith's role see Walter Rosenblum, "What is Modern Pho-

tography?," *American Photography*, XLV/3 (March 1951), pp. 146–153.

Smith also reprinted, with some minor changes, his *Photo Notes* article under the new title "Photographic Journalism: A Great *Life* Photographer Lays Down Some Rules for Honest Reporting that also Makes Good Photographic Sense," *1953 Universal Almanac* (1952), pp. 16–28.

14. Jacob Deschin, "Photography: In Search of Truth; New Show Covers Work of Six Photographers," *The New York Times* (May 25, 1952), section II, p. 13.

15. "W. Eugene Smith," *Camera* (Lucerne), XXXI/6–7 (June/July 1952), pp. 249–251ff.

16. Ted Castle, Smith's assistant, interview with the author, May 2, 1986.

17. Unaddressed and undated letter, Correspondence files (note 9).

18. He began his career using different cameras and formats for his documentation. In his early photo-essays like "Country Doctor," Smith used a 4 × 5 view camera, a $2\frac{1}{4}$, and a 35 mm. For "Spanish Village" he used $2\frac{1}{4}$ and 35 mm formats, and for "Nurse Midwife" and "A Man of Mercy" he limited himself to 35 mm only. For his 35 mm camera work Smith considered 35 mm and 85 mm lenses as basic equipment but often carried several cameras, each with a different lens attached.

19. "A Talk on Photography," a lecture delivered by W. Eugene Smith before the Village Camera Club, January 19, 1954, unpublished typescript by Gus R. Wiemann, p. 10. My thanks to John Loengard for bringing Mr. Wiemann's typescript to my attention and to Mr. Wiemann for allowing me to quote from it.

20. Among the *Life* editors I interviewed this photograph was consistently mentioned as Smith's most memorable.

21. Directorial photography is discussed by the critic A. D. Coleman in "The Directorial Mode," reprinted in Vicki Goldberg (editor), *Photography in Print* (New York: Simon and Schuster, 1981), pp. 480–491.

22. Wilson Hicks, *Words and Pictures* (New York: Harper Brothers, 1952), p. 129. The italicized sentences were underlined by Smith in an annotated copy of the book now in the W. Eugene Smith Archive. In addition to the underlining Smith wrote in the margin: "Perhaps I spoke clumsily but this is not what I thought I said to him during a luncheon."

23. Annotations in margin of *Words and Pictures*, ibid., p. 129.

24. "A Talk on Photography" (note 19), pp. 7–8.

25. Although he was concerned about the quality of his prints, lab printing was an accepted part of Cartier-Bresson's practice. *The Photographs of Henri Cartier-Bresson* (New York: Museum of Modern Art, 1947), see particularly p. 9 and pp. 12–14. Bill Brandt's use of a photo lab is less explicit and is not acknowledged in the literature. Mark Haworth-Booth implies that Brandt made his own prints (*Bill Brandt Behind the Camera* [Millerton, NY: Aperture, 1985], pp. 40–42, and *London in the Thirties* [New York: Pantheon Books, 1984], unpaginated introduction). This may have been true of his late work but the existence of his negatives in the *Picture Post* archives suggests that, like most photojournalists, Brandt turned his negatives over to the magazine for selection and printing.

Conversations with contemporaries of Smith's confirm that no one at *Life* was as interested in the finished print as Smith. In addition to interview sources see discussion of Bourke-White's practice in Vicki Goldberg, *Margaret Bourke-White: A Biography* (Boston: Little, Brown, 1985).

26. This incident is related in "Me and Gene and Photojournalism," an unpublished memoir by Robert Harrah, W. Eugene Smith Archive, Center for Creative Photography, University of Arizona.

27. Bob Coombs, "The Technique of W. Eugene Smith," *Camera 35*, XIV/3 (April/May 1970), pp. 60ff.

28. Elenor Lewis (editor), *Darkroom* (New York: Lustrum Press, 1977), p. 147. Potassium ferrocyanide removed silver salts from the surface of the print, resulting in a lightening of those areas treated with the bleach.

29. On occasion Smith even used the bleaching agent to add information to the photograph. For example, in a photograph of Maude Callen teaching midwives how to make a bedpan out of old newspapers, Smith created the effect of water flowing from the white bowl in Maude's hand by completely bleaching all silver salts from the paper (Center for Creative Photography, W. Eugene Smith Photographs, 82:116:330).

30. "The Technique of W. Eugene Smith" (note 27), p. 69. Because of the laborious handwork that went into finishing the print, for his most popular photographs Smith made a large-format copy negative. This was then used to make contact prints of acceptable quality.

31. For a discussion of this technique applied to four specific negatives, see *Darkroom* (note 28), pp. 149–150.

32. The suggestion that Smith's printing style was a response to the requirements of photo-re-

portage was made to the author by William Johnson in an interview on August 26, 1986.

33. This print was made in 1951 for the republication of the photo-essay in *Amerika*.

34. In an undated draft of a letter Smith wrote: "I, of course, also made my own prints to be sure my intention is carried out as far as is controllable." Family Correspondence files (note 9).

35. "A Talk on Photography" (note 19), pp. 8–9.

**Conclusion**

1. For an analysis of the social impact of television see Erik Barnouw, *Tube of Plenty: The Evolution of American Television* (New York: Oxford University Press, 1975), and *Image World: Art and Media Culture* (New York: Whitney Museum of American Art, 1990), pp. 24–28 and p. 177.

The impact of television was a major topic of discussion among journalism professionals in the 1960s and 1970s. See, for example, the record of the Miami Photojournalism Conferences in R. Smith Schuneman, *Photographic Communication* (New York: Hastings House, 1972).

For a discussion of the issues surrounding the intrusion of television into American homes, see Lynn Spigel, "Installing the Television Set: Popular Discourses on Television and Domestic Space, 1948–1955," *Camera Obscura*, no. 16 (1988), pp. 11–46.

2. It is interesting to note that larger size, increased use of color, and greater emotional intensity were the same techniques employed by popular film makers to try to win back from television the declining audiences for movies in the early 1950s. *Image World* (note 1), p. 28.

3. One way in which this emphasis was signaled professionally was *Life*'s increasing participation and recognition at the Art Directors Association's annual awards.

4. *Photographic Communication* (note 1), pp. 246–247.

5. Telephone conversation with John Loengard, January 4, 1991.

6. For an instructive comparison of the current *Life* magazine with the *Life* magazine of Thorndike, Thompson, and Smith, see Sean Callahan, "What's So New about the New Photojournalism," *Print*, XXIII/4 (July/August 1979), pp. 72–73ff.

7. Conversation with Stefan Lorant, October 22, 1990.

8. For a thorough discussion of the events surrounding Smith's work on the Pittsburgh project, see Jim Hughes, *Shadow and Substance* (New York: McGraw-Hill, 1989), pp. 341–370 and 389–396.

9. "Pittsburgh – W. Eugene Smith's Monumental Poem to a City," *Photography Annual 1959* (1958), pp. 96–133ff. Smith was never able to complete work on the project. The night before the magazine was to go to press he gave up trying to make a layout of his photographs and left the final arrangement to the staff of *Popular Photography*.

10. For a discussion of the events surrounding the completion of the layout and text, see *Shadow and Substance* (note 8), pp. 512–524.

11. W. Eugene and Aileen Smith, *Minimata* (New York: Alskog-Sensorium and Holt, Rinehart and Winston, 1975).

12. One gets a sense of the tremendous significance of Frank's *The Americans* in the interviews conducted by Thomas Dugan and published in *Photography Between the Covers* (Rochester: Light Impressions, 1979).

13. A partial list of other photographers who began as photojournalists publishing in the periodical press but who later saw their work incorporated into the museum context are Bruce Davidson, Garry Winogrand, Lee Friedlander, and Diane Arbus.

14. Robert Frank, *The Americans* (New York: Grove Press, 1959).

15. For an extended discussion of these differences between Smith and Frank see William Johnson, "Public Statements/Private Views: Shifting the Ground in the 1950s," *Observations* (Untitled 35), 1984, pp. 81–92.

16. Evidence of this shift can be found in a comparison of the critical response to Smith's 1971 retrospective *Let Truth Be the Prejudice* with earlier criticism of Smith photographs.

For *Let Truth Be the Prejudice* see David Vestal, "Truth and Prejudice: The Gene Smith Show," *Camera 35*, XV/4 (May 1971), pp. 24ff; Hy Dales, "Overexposure," *Camera Notes* (New York Camera Club), I/1, pp. 21–24; and Gene Thornton, "Photographs: It Was News Then – Is It Now Art?," *The New York Times*, February 21, 1971, section II, p. 23.

For earlier criticism see Barbara Green, "W. Eugene Smith," *The Camera*, LXVIII/9 (September 1946), pp. 20–25; Jacob Deschin, "Photography: In Search of Truth; New Show Covers Work of Six Photographers," *The New York Times*, (May 25, 1952), Section II, p. 13; and Dr. Fritz Neugass, "W. Eugene Smith," *Camera*, XXXI/6 (June/July 1952), pp. 247ff.

The antipathy toward Smith's aesthetic position has been even more pronounced among con-

temporary critics; see, for example, Abigail Solomon-Godeau, "W. Eugene Smith and the Humanist Icon," *Art in America*, LXIX/6 (Summer 1981), pp. 41ff, and Alan Sekula, "Dismantling Modernism, Reinventing Documentary (Notes on the Politics of Representation)," reprinted in *Photography Against the Grain* (Halifax: Press of the Nova Scotia College of Art and Design, 1984), p. 67.

17.  For a contemporary discussion of some of these issues see George and Cora Wright, "One Family's Opinion," *Aperture*, III/2 (1955), pp. 19–23.

18.  "The Walk to Paradise Garden" is repeatedly discussed in reviews of Smith's photographs. In the 1950s, Ford Motor Company had exclusive rights to use the photograph in its advertising. This interest in the photograph was not confined to Smith's contemporaries. It was the subject of a recent book-length monograph: Henning Hansen, *Myth and Vision: On the Walk to Paradise Garden and the Photography of W. Eugene Smith*, ARIS Nova Series No. 3 (Lund, Sweden: University of Lund, 1987).

19.  For a discussion of changes under John Szarkowski see Christopher Phillips, "The Judgement Seat of Photography," *October*, XXII (Fall 1982), pp. 27–63, especially pp. 53–61; and Maren Stange, "Photography and the Institution: Szarkowski at the Modern," an essay in *Photography: Critical Perspectives* (Rochester: Light Impressions, 1978).

20.  Some examples of his approach can be seen in *The Photographer's Eye* (New York: Museum of Modern Art, 1966) and *From the Picture Press* (New York: Museum of Modern Art, 1973).

21.  In his survey of American postwar photography, *Mirrors and Windows*, Szarkowski did not include a single photojournalist. For a criticism of this exclusion see Howard Chapnick, "Markets and Careers," *Popular Photography*, LXXXIII/5 (November 1978), pp. 84ff.

22.  This information was given to me by John Loengard in a conversation on January 9, 1991.

23.  For example, Lee Lockwood cited Smith as a formative influence in a conversation with the author in November 1990 and Mary Ellen Mark mentions Smith as an exemplar in an interview published in *The Photo-Essay: Photographs by Mary Ellen Mark* (Washington, DC: Smithsonian Institution Press, 1990), pp. 5–7.

For a European perspective see "Le Regard de Willy Ronis," *PhotoCinema Magazine*, no. 22 (September 1981), p. 37, and Jean-Claude Gautraud, "Hommage au Reporter: Interview de Eugene Smith," *Photographe*, no. 1364 (October 1979), pp. 164–171.

24.  See, for example, Nan Richardson, "Droit de Regard," *Documentary*, I/2 (1991), p. 1.

25.  Howard Chapnick, "Markets and Careers," *Popular Photography*, LXXXIV/4 (April 1979), p. 52.

26.  Quoted from the 1991 brochure advertising the W. Eugene Smith Memorial Fund.

27.  This exhibition presented the work of the past decade's winners of the W. Eugene Smith Memorial Fund Grant. *The Human Spirit: The Legacy of W. Eugene Smith*, International Center for Photography, November 22, 1991–January 19, 1992.

28.  For a discussion of some of the problematics of this legacy see Gene Thornton, "What Does 'Being Concerned' Really Mean?," *The New York Times*, December 12, 1971.

# Selected Bibliography

## Manuscript Material

HARRAH, ROBERT. "Gene and Me . . . and Photojournalism," an unpublished memoir of Harrah's assistantship with W. Eugene Smith between the spring of 1945 and the summer of 1949.

Interviews with Ted Castle (Smith's assistant for "Spanish Village"), Robert Elson (*Life* magazine, acting managing editor, 1954), Robert Harrah (Smith's assistant for "Country Doctor"), Dick Pollard (*Life* magazine, picture editor, 1962–1972), Peggy Sargent (*Life* magazine, contact sheet editor, 1946–1972), Edward K. Thompson (*Life* magazine, managing editor, 1949–1962), and Joseph Thorndike (*Life* magazine, managing editor, 1946–1949).

Photo-Essay Project Files, W. Eugene Smith Archive, Center for Creative Photography, University of Arizona, Tucson.

Smith Family Correspondence, W. Eugene Smith Archive, Center for Creative Photography, University of Arizona, Tucson.

Smith Contact Sheets, W. Eugene Smith Archive, Center for Creative Photography, University of Arizona, Tucson.

"A Talk on Photography," typescript of a lecture by Smith given at the Village Camera Club, January 12, 1954, transcribed by Gus Wiemann.

## The Development of the Art Form

American Society of Magazine Photographers (editors). *Photo-Graphic 1949.* New York: McGraw-Hill Book Company, Inc., 1948.

BECKER, KARIN. "Forming a Profession: Ethical Implications of Photojournalistic Practice on German Picture Magazines, 1926–1933," *Studies in Visual Communication,* XI/2 (1985), pp. 44–60.

BELLANGER, CLAUDE, et al. *Histoire générale de la presse française, vol. III, 1871–1940.* Paris: Presses universitaires de France, 1974.

BENNION, S. C. "Mass Magazine Phenomenon: the German 'Illustrierte,' " *Journalism Quarterly* (March 1961).

BOURKE-WHITE, MARGARET. "Assignments for Publication," an essay published in *The Complete Photographer,* vol. I. New York: National Educational Alliance, 1942. Pp. 312–318.

BROWN, THEODORE M. *Margaret Bourke-White: Photojournalist.* Ithaca: Cornell University Press, 1972.

———. "The Photographic Essay," *Image,* XX/3–4 (September–December 1977), pp. 11–18.

CAPA, ROBERT. *Slightly Out of Focus.* New York: Henry Holt and Company, 1947.

CLAIR-GUYOT, E. "Un Demi-siècle à L'Illustration," *L'Illustration,* XCI/413 (July 1933), unpaginated.

COHN, JAN. *Creating America: George Lorimer and the Saturday Evening Post.* Pittsburgh: University of Pittsburgh Press, 1989.

*The Concerned Photographer I.* New York: Grossman Publishers, 1968.

*The Concerned Photographer II.* New York: Grossman Publishers, 1972.

*Creative Camera,* special issue: "Fifty Years of Picture Magazines" (July/August 1982).

DICKEY, TOM. "Q and A: John Loengard," *American Photographer,* III/4 (October 1979), pp. 61–65.

DURNIAK, JOHN. "Popular Photography Covers Miami's Photojournalism Conference," *Popular Photography,* XLV/2 (August 1959), pp. 46–47ff.

EAGLE, ARNOLD. "Should Photographers Overshoot?" *Popular Photography,* XLI/3 (September 1957), pp. 60ff.

EDEY, MAITLAND. *Great Photographic Essays from Life.* Boston: New York Graphic Society, 1978.

EDOM, CLIFTON C. *Photojournalism: Principles and Practices.* Dubuque, IA: Wm. C. Brown Company, 1976.

ELSON, ROBERT. *The World of Time Inc.* New York: Atheneum, 1973.

ESKILDSEN, UTE. *Fotografie in deutschen Zeitschriften 1924–1933.* Stuttgart: Institut für Auslandsbeziehungen, 1982.

EVANS, HAROLD. *Pictures on a Page.* New York: Holt, Rinehart and Winston, 1978.

FEINBERG, MILTON. *Techniques of Photojournalism.* London: John Wiley and Sons, 1970.

FELTEN, CHARLES J. *Layout.* New York: Appleton-Century-Crofts, Inc., 1954.

*50 Jahre Ullstein, 1877–1927.* Berlin: Ullstein, 1928.

*Four Hours a Year.* New York: Time, Inc., 1936.

FOUT, JOHN. "The *Berlin Illustrirte* and Photojournalism in Germany 1929–35," an essay in *Picture Magazines before Life.* New York: Catskill Center for Photography, 1982.

FOX, CELINE. *Graphic Journalism in England during the 1830s and 1840s.* New York: Garland, 1988.

FREUND, GISELE. *Photography and Society.* Boston: David Godine, 1980.

FREUDENBERG, FRANK. "Die Legendäre *Berliner Illustrirte* ohne 'e'," *ZV + ZV,* XX/21 (1979), pp. 848–855.

FULTON, MARIANNE. *Eyes of Time: Photojournalism in America.* Boston: Little, Brown and Company, 1988.

GEE, HELEN. *Photography of the Fifties: An American Perspective.* Tucson: Center for Creative Photography, 1980.

GOLDBERG, VICKI. *Margaret Bourke-White: A Biography.* New York: Harper and Row, 1986.

GOULD, LEWIS, AND RICHARD GREFFE. *Photojournalist: The Career of Jimmy Hare.* Austin: University of Texas Press, 1977.

GUIMOND, JAMES. *American Photography and the American Dream.* Chapel Hill: University of North Carolina Press, 1991.

HALL, STUART. "The Determination of Newsphotographs," an essay in *Working Papers in Cultural Studies 3* (1972), pp. 53–87.

——. "The Social Eye of Picture Post," an essay in *Working Papers in Cultural Studies 2* (1972), pp. 70–120.

HARDT, HANNO. *Social Theories of the Press: Early German Perspective*. Beverly Hills: Sage Publications, 1979.

HARRIS, NEIL. "Iconography and Intellectual History: the Half-Tone Effect," an essay in *New Directions in American Intellectual History*. Baltimore: Johns Hopkins Press, 1979.

HASSNER, RUNE. *Bilder för Miljoner*. Stockholm: Sveriges Radio, Rabén and Sjögren, 1977.

HEIFERMAN, MARVIN, AND LISA PHILLIPS WITH JOHN HANHARDT. *Image World: Art and Media Culture*. New York: Whitney Museum, 1990.

Hicks, Wilson. "The Camera in Journalism," *Annual Fifty-Print Exhibition of News and Feature Pictures*, University of Missouri Bulletin, Fourth Annual (1947), pp. 58–59.

————. "Words and Pictures: Freedom or Compromise?" *Popular Photography*, XLVI/5 (March 1960), pp. 16–18.

————. "Words and Pictures: The Penetrating Photograph," *Popular Photography*, XLVI/1 (January 1960), pp. 32–34.

————. "Words and Pictures: Photography as Art," *Popular Photography*, XLVII/1 (July 1960), pp. 24ff.

————. *Words and Pictures: An Introduction to Photojournalism*. New York: Harper Brothers, 1952.

HOPKINSON, TOM (editor). *Picture Post*. London: Hogarth Press, 1984.

HUNTER-SALOMON, PETER. *Erich Salomon: Portrait of an Age*. New York: Collier Macmillan, 1967.

HURLBURT, ALLEN F. "The Editorial Art Director at Work," an essay in *The Art Director at Work*. New York: Hastings House, 1959.

*Infinity* Magazine, Society of Magazine Photographers, 1952–1970.

IRWIN, WILL. "The Swashbucklers of the Camera," *Collier's*, XLVIII/20 (February 3, 1912), pp. 11–13.

JACKSON, MASON. *The Pictorial Press: Its Origins and Progress*. London: Hurst & Blackett, 1885.

JOHNSON, WILLIAM S. "Back to the Future: Some Notes on Photojournalism before the 1870s," *Views*, IX/2 (Winter 1988), pp. 8–12.

JONES, VINCENT S. "Rochester Photojournalism Conference," *Aperture*, II/4 (1953), pp. 4–8.

JUSSIM, ESTELLE. *Visual Communication and the Graphic Arts*. New York: R. R. Bowker, 1983.

KAHAN, ROBERT. "Magazine Photography Begins: An Editorial Negative," *Journalism Quarterly*, XLII/1 (Winter 1965), pp. 53–59.

KALISH, STANLEY E., AND CLIFTON C. EDOM. *Picture Editing*. New York: Rinehart and Company, 1951.

KELLER, ULRICH. "Photojournalism Around 1900: The Institutionalization of a Mass Media," an essay in *Shadow and Substance: Essays on the History of Photography in Honor of Heinz K. Henisch*. Bloomfield Hills, MI: Amorphous Institute Press, 1990.

————. "The Twilight of the Masterpiece," *California Museum of Photography Bulletin*, VI/1 (1987), pp. 6–10.

KERBS, DIETHART. *Die Gleichschaltung der Bilder Pressefotografie 1930–1936.* Berlin: Frölich & Kaufmann, 1983.

KERRICK, JEAN. "The Influence of Captions on Picture Interpretation," *Journalism Quarterly*, XXXII/2 (Spring 1955), pp. 177–184.

KORFF, KURT. "Die 'Berliner Illustrirte,' " in *50 Jahre Ullstein.* Berlin: Ullstein, 1927.

KUNZLE, DAVID. *"L'Illustration,* 1845–53, le premier magazine illustré en France," *Nouvelles de l'estampe,* no. 43, 1979.

LAX, ERIC. "Lorant's Vision," *American Photographer,* XII/6 (June 1984), pp. 60–67.

LOENGARD, JOHN. *Pictures Under Discussion.* New York: Amphoto, 1987.

MACKLAND, RAY. "How *Life* Picks a Cover," *Popular Photography,* XXXI/3 (September 1952), pp. 62–65ff.

MAN, FELIX H. *Man with a Camera.* New York: Schocken Books, 1983.

MANCHESTER, WILLIAM. *In Our Time: The World as Seen by Magnum Photographers.* New York: W. W. Norton, 1989.

*Mass Media Between the Wars: Perceptions of Cultural Tension, 1918–1941.* Syracuse: Syracuse University Press, 1984.

MEISELAS, SUSAN. "Some Thoughts on Appropriation and Documentary Photographs," *Exposure,* XXVII/1 (1989), pp. 10–15.

MENSEL, ROBERT. " 'Kodakers Lying in Wait': Amateur Photography and the Right of Privacy in New York, 1885–1915," *American Quarterly,* XLIII/1 (March 1991), pp. 24–45.

MICH, DANIEL, AND EDWIN EBERMAN. "The Rise of Photo-Journalism in the United States," *Journalism Quarterly* (July 1947), pp. 202–206ff.

———. *The Technique of the Picture Story.* New York: McGraw-Hill Book Company, 1945.

MITCHELL, W. J. T. "The Ethics of Form in the Photographic Essay," *Afterimage* (January 1989), pp. 8–13.

MOTT, FRANK. *A History of American Magazines.* Five volumes. Cambridge: Harvard University Press, 1938–1968.

NEWHALL, BEAUMONT. "Interview with Stefan Lorant and Felix Man," in *Photography: Essays and Images.* Boston: New York Graphic Society, 1980.

NEWHALL, NANCY. "The Caption," *Aperture,* I/1 (1952), pp. 17–29.

———. "Controversy and the Creative Concepts," *Aperture,* II/2 (1953), pp. 3–13.

PELLS, RICHARD. *The Liberal Mind in a Conservative Age.* New York: Harper and Row, 1985.

"The Perils of Photography," *The Nation,* LXXX/2193 (July 11, 1907), pp. 28–29.

PHILLIPS, SANDRA. "Magazine Photography in Europe Between the Wars," *Picturescope* (Fall/Winter 1982).

*Picture Magazines before Life.* New York: Catskill Center for Photography, 1982.

RAY, FREDERIC E. *Alfred R. Waud: Civil War Artist.* New York: Viking Press, 1974.

ROSENBLUM, BARBARA. *Photographers at Work: A Sociology of Photographic Styles.* London: Holmes & Meier, 1978.

ROSENBLUM, WALTER. A Review of "What Is Modern Photography," a symposium at the Museum of Modern Art, New York City, on November 20, 1950, *American Photography*, XLV/3 (March 1951), pp. 146–153.

ROSKILL, MARK. "New Horizons: The Early Life and Times of Photojournalism," *Views*, VIII/2 (Winter 1987), pp. 6–11.

ROSLER, MARTHA. "In, Around, and Afterthoughts (on Documentary Photography)," an essay in *3 Works*. Halifax: The Press of the Nova Scotia College of Art and Design, 1981. Pp. 71–86.

ROTHSTEIN, ARTHUR. *Photojournalism: Pictures for Magazines and Newspapers.* New York: Amphoto, 1956.

————. *Words and Pictures.* New York: Amphoto, 1979.

SCHNEIDER, JASON. "The Ermanox Legend," *Modern Photography*, XLVII (July 1983), pp. 22ff.

SCHUNEMAN, R. SMITH (editor). *Photographic Communication.* New York: Hastings House Publishers, 1972.

SEKULA, ALLAN. "Dismantling Modernism, Reinventing Documentary (Notes on the Politics of Representation)," reprinted in *Photography Against the Grain*. Halifax: The Press of the Nova Scotia College of Art and Design, 1984. Pp. 53–76.

SHORTER, CLEMENT K. "Illustrated Journalism, Its Past and Its Future," *The Contemporary Review*, LXXV (1899), pp. 481–494.

SMITH, C. ZOE. "Black Star Picture Agency: *Life*'s European Connection," *Journalism History*, XIII/1 (Spring 1986), pp. 19–25.

————. "Emigré Photography in America: Contributions of German Photojournalism from Black Star Picture Agency to *Life* Magazine, 1933–1938." Unpublished doctoral dissertation, University of Iowa, 1983.

————. "Germany's Kurt Korff: An Emigré's Influence on Early *Life*," *Journalism Quarterly*, LXV (1988), pp. 412–419ff.

SPENCER, OTHA C. *Twenty Years of LIFE: A Study of Time, Inc.'s Picture Magazine and Its Contributions to Photojournalism.* Ann Arbor: University Microfilm, 1958.

SQUIRES, CAROL. "Looking at *Life*," *Artforum*, XX/4 (December 1981), pp. 59–66.

STEICHEN, EDWARD. "Reporting with a Camera," in *Annual Fifty-Print Exhibition of News and Feature Pictures*, Fourth Annual (1947). Pp. 55–56.

*Study of the Accumulative Audience of "Life."* New York: Time, Inc., 1950.

SZARKOWSKI, JOHN. *From the Picture Press.* New York: Museum of Modern Art, 1975.

————. "Photography and the Mass Media," *Aperture*, XIII/3 (1967), unpaginated.

TEBBE, JENNIFER. "Mass Media and American Culture, 1918–1941: A Bibliographical Essay," in *Mass Media Between the Wars*. Syracuse: Syracuse University Press, 1984. Pp. 221–243.

THORNTON, GENE. "What Does 'Being Concerned' Really Mean?," *The New York Times,* December 12, 1971.

TREBBEL, JOHN. *The American Magazine: A Compact History.* New York: Hawthorn Books, 1969.

*Visual Paraphrases: Studies in Mass Media Imagery.* Stockholm: Almqvist & Wiksell International, 1984.

VITRAY, LAURA. *Pictorial Journalism.* New York: McGraw-Hill, 1939.

WAINWRIGHT, LOUDON. *The Great American Magazine: An Inside History of "Life."* New York: Alfred A. Knopf, 1986.

WEISE, BERND. "Pressefotografie I. Die Anfänge in Deutschland, ausgehend von einer Kritik bisheriger Forschungsansätze," *Fotogeschichte,* IX/31 (1989), pp. 15–40.

———. "Pressefotografie II. Fortschritte der Fotografie – und Drucktechnik und Veränderung des Pressmarktes im Deutschen Kaiserreich," *Fotogeschichte,* IX/33 (1989), pp. 27–62.

WERNEBURG, BRIGITTE. "Foto-Journalismus in der Weimarer Republik," *Fotogeschichte,* IV/13 (1984), pp. 27–40.

WHITING, JOHN R. *Photography is a Language.* New York/Chicago: Ziff-Davis, 1946.

## W. Eugene Smith: Photojournalist

COMBS, BOB. "The Technique of W. Eugene Smith," *Camera 35,* XIV/3 (April/May 1970), pp. 43ff.

COOPER, THOMAS, AND PAUL HILL (editors). "W. Eugene Smith," an interview in *Dialogue with Photography.* New York: Farrar/Straus/Giroux, 1979.

*Eugene Smith Photography.* Minneapolis: University of Minneapolis, 1954.

GAUTRAND, JEAN-CLAUDE. "Hommage au Reporter: Interview de Eugene Smith," *Photographe,* no. 1364 (October 1979), pp. 164–171.

HANSEN, HENNING. *Myth and Vision: On the Walk to Paradise Garden and the Photography of W. Eugene Smith.* ARIS Nova Series No. 3. Lund, Sweden: University of Lund, 1987.

HUGHES, JIM. *W. Eugene Smith: Shadow and Substance.* New York: McGraw-Hill, 1989.

JANIS, EUGENIA PARRY, AND WENDY MACNEIL (editors). "W. Eugene Smith," a statement in *Photography Within the Humanities.* Danbury, NH: Addison House Publishing, 1977.

JOHNSON, WILLIAM S. "Public Statements/Private Views: Shifting the Ground in the 1950s," an essay in *Observations: Essays on Documentary Photography.* Carmel, CA: Friends of Photography, 1984.

———. *W. Eugene Smith: A Chronological Bibliography 1934–1980,* Parts I, II, and Addendum. Tucson: Center for Creative Photography, 1980, 1981, and 1990.

———. *W. Eugene Smith: Early Work.* Tucson: Center for Creative Photography, 1980.

————. *W. Eugene Smith: Master of the Photographic Essay*. Millerton, NY: Aperture, 1981.

————. *W. Eugene Smith: The Middle Years*. Tucson: Center for Creative Photography, 1984.

KOBRE, KENNETH. "An Interview with W. Eugene Smith on the Photographic Essay," an essay in *Photojournalism: The Professionals' Approach*. New York: Van Nostrand Reinhold, 1980. Pp. 284–305.

LEWIS, ELEANOR (editor). "W. Eugene Smith," a statement in *Darkroom*. New York: Lustrum Press, 1977.

MADDOW, BEN. *Let Truth Be the Prejudice: W. Eugene Smith, His Life and Photographs*. Millerton, NY: Aperture, 1985.

MALONEY, TOM (editor). *U. S. Camera Annual – 1952*. New York: U. S. Camera Publishing Corp., 1951.

NEUGASS, FRITZ. "W. Eugene Smith," *Camera* [Lucerne], XXXI/6–7 (June/July 1952), pp. 249–251ff.

RAYFIELD, STANLEY. *How LIFE Gets the Story*. Garden City, NY: Doubleday and Company, 1955.

RICE, SHELLY. "W. Eugene Smith: A Dream of Life," *On Campus*, (March 1986), pp. 14–17.

————. "W. Eugene Smith: A Dream of Life," *On Campus*, (April 1986), pp. 10–13.

SMITH, W. EUGENE. "Photographic Journalism," *Photo Notes* (June 1948), pp. 4–5.

————. "Photographic Journalism: A Great *Life* Photographer Lays down Some Rules for Honest Reporting that Also Makes Good Photographic Sense," *1953 Universal Photo Almanac* (1952), pp. 16–28.

STEICHEN, EDWARD. *Memorable LIFE Photographs*. New York: Museum of Modern Art, 1951.

STETTNER, LOUIS. "Cézanne's Apples and the Photo League: A Memoir by Louis Stettner," *Aperture*, no. 112 (Fall 1988), pp. 14–35.

*W. Eugene Smith: His Photographs and Notes*. New York: Aperture, 1969.

"W. Eugene Smith: Conscience of the Print," *Camera 35*, XIV/3 (April/May 1970), p. 36.

## "Country Doctor" (September 20, 1948)

"Alarming Symptoms," *Time*, LII/24 (December 13, 1948), p. 88.

*America's Health: A Report to the Nation*. New York: Harper Bros., 1949.

ANDERSON, ODIN W. *Health Services in the United States*. Ann Arbor: Health Administration Press, 1985.

"Battle Ahead," *Time*, LIII/1 (January 3, 1949), p. 40.

"Battle of Britain," *American Journal of Public Health*, XXXVIII/5 (May 1948), pp. 711–712.

BUDRYS, GRACE. *Planning for the Nation's Health: A Study of Twentieth-Century Developments in the United States*. New York: Greenwood Press, 1986.

BURROW, JAMES G. *AMA: Voice of American Medicine*. Baltimore: Johns Hopkins University Press, 1963.

CAMPION, FRANK. *The AMA and U.S. Health Policy since 1940*. Chicago: Chicago Review Press, 1984.

CARROLL, MARGARET. "Doctors in Saskatchewan," *Canadian Forum*, XXVII (September 1947), pp. 127–128.

"The Classic Country Doctor – and He Still Is," *Medical Economics* (October 1, 1973), p. 181.

"The Compleat Practitioner," *Time*, XLIX/6 (February 10, 1947), p. 77.

"Country Doctor, 1950," *Time*, LV/2 (January 9, 1950), pp. 29–30.

CUMMING, JOHN, AND EDITH FOWKE. "Dr. King's Panacea," *Canadian Forum*, XXIII (June 1948), pp. 54–55.

DETZER, KARL. "Doc wins a Medal: AMA's First Annual Community Service Medal to Dr. A. C. Sudan, Kremmling, Colo.," *Hygeia*, XXVI/10 (October 1948), pp. 720–721ff.

"Doctors at War," *Time*, LVI/1 (July 3, 1950), pp. 30–31.

"Doctors Increase Faster than U.S. Population," *Science Newsletter*, LIV/9 (August 28, 1948) p. 136.

"Doctor Shortage and Why," *Collier's*, CIX (June 28, 1947), p. 90.

"Doctors Under Socialism," *Newsweek*, XXX/26 (December 29, 1947), p. 38.

EDWARDS, VERNE E., JR. "The American Medical Association As Reported in Six U.S. Dailies," *Journalism Quarterly*, XXVI (1949), pp. 417–423.

ENGEL, LEONARD. "The Bingham Plan," *Scientific American*, CLXXIX/4 (October 1948), pp. 7–13. Reprinted under the title "Rural Medicine Reborn," *The Nation*, CLXVIII/10 (March 5, 1949), pp. 275–277.

"Expensive Operation," *Time*, LIV/25 (December 19, 1949), pp. 77–78.

GRAY, DR. L. P. "Morals and Medicine," *Catholic World*, CLXVII (April 1948), p. 80.

GUMPERT, MARTIN. "Rebirth of General Medicine," *The Nation*, CLXV/24 (December 13, 1947), pp. 646–647.

KRAUSE, ELLIOT A. *Power and Illness: the Political Sociology of Health and Medical Care*. Amsterdam: Elsevier, 1977.

"Letters to the Editors," *Life*, XXV/15 (October 11, 1948), pp. 23–26.

"Lightning Rod," *Time*, LIII/25 (June 20, 1949), p. 50.

"Long Life, Good Pay," *Time*, LII/10 (September 6, 1948), p. 60.

MAISEL, ALBERT Q. "So You Can't Get a Doctor!" *Collier's*, CXIX (May 17, 1947), pp. 16–17ff.

*Medicine and the Changing Order: Report of the New York Academy of Medicine*. New York: Commonwealth Fund, 1947.

"Middle Park Hospital to Be Featured in *Life* Magazine," *The Middle Park Times and Kremmling Record*, LXVIII/7 (July 22, 1948), pp. 1ff.

MUSTARD, HARRY S. *Government in Public Health*. New York: Commonwealth Fund, 1945.

"Norman Rockwell Visits A Family Doctor," *Saturday Evening Post*, LCXIX/41 (April 12, 1947), pp. 30–33.

"Old Doctors," *Life*, XXII/25 (June 23, 1947), pp. 81–84.

"The Price of Health: Two Ways to Pay It," *Time*, LV/8 (February 20, 1950), pp. 19–21.

"The Public's Health: Britain is about to Care for it in a New Way – Not Necessarily the Best for Us," *Life*, XXIII/9 (September 1, 1947), p. 28.

RORTY, JAMES (text), AND W. EUGENE SMITH (photographer). "A Doctor for All of Us," *Collier's*, CXII (August 21, 1943), pp. 29ff.

"Shortages of Medical Men," *U.S. News*, XXIII/9 (August 29, 1947), pp. 20–21.

SMITH, W. EUGENE (photographer). "Country Doctor: His Endless Work Has Its Own Rewards," *Life*, XXV/12 (September 20, 1948), pp. 115–126.

———. *"Derevenskij Vrac. Prijnatel 'nost' bolynyx – nagrada za bolshoj trud"* ("Country Doctor. The gratitude of patients – the reward for his hard work"), *Amerika*, no. 54 (no date, ca. 1951), pp. 3–9.

SPAHR, MARY B., M.D. "The Vanishing Family Doctor," *Saturday Evening Post*, CCXX/8 (August 23, 1947), pp. 25ff.

SPENCER, STEVEN M. "We Need More Country Doctors," *Saturday Evening Post*, CCXXI/15 (October 9, 1948), pp. 36–37ff.

STARR, PAUL. *The Social Transformation of American Medicine*. New York: Basic Books, 1982.

STEVENS, ROSEMARY. *American Medicine and the Public Interest*. New Haven: Yale University Press, 1971.

STOECKLE, JOHN D., AND GEORGE ABBOTT WHITE. *Plain Pictures of Plain Doctoring*. Cambridge: MIT Press, 1985.

STUDT, WARD B., JEROLD G. SORENSEN, AND BEVERLY BURGE. *Medicine in the Intermountain West*. Salt Lake City: Olympus Publishing Co., 1976.

SWART, CHARLES M. "Revolutionary Doctors," *Survey*, LXXXIII/12 (December 1947), pp. 331–334.

TAYLOR, LLOYD. *The Medical Profession and Social Reform, 1885–1945*. New York: St. Martin's Press, 1974.

"U.S. Medicine in Transition," *Fortune*, XXX/6 (December 1944), pp. 156–163ff.

"U.S. Suspends Publication of Russian Language Magazine 'Amerika,' " *The Department of State Bulletin*, XXVII/683 (June 28, 1952), pp. 127–132.

VOGEL, MORRIS J., AND CHARLES ROSENBERG (editors). *The Therapeutic Revolution: Essays in the Social History of Medicine*. Philadelphia: University of Pennsylvania Press, 1979.

"Wanted: G.P.s," *Time*, LII/6 (October 18, 1948), p. 52.

"What It Takes to Make a Doctor," *Look*, XII (August 31, 1948), pp. 63–67.

## "Spanish Village" (April 9, 1951)

"After 7500 Miles, a Wake," *Photography Workshop*, I/3 (1951), pp. 34–35.

ASCOLI, MAX. "If We Must Have Spain," *The Reporter*, II/13 (June 20, 1950), pp. 4–5.

"Attlee Surveys the Ruins of Victory," *Life*, XXIX/10 (March 6, 1950), pp. 21–25ff.

"Bedfellows," *Time*, LVI/22 (November 27, 1950), p. 16.

"Britain's Future is Put Up to Voters," *Life*, XXVIII/8 (February 20, 1950), pp. 29–35.

BUSH-FEKETE, L. "Long Night in Franco's Spain," *Life*, XXV/15 (October 11, 1948), pp. 6–14.

CAPA, ROBERT. *Death in the Making*. New York: Covici Friede, 1938.

"Carta al Editor de 'Life,' " *Mundo Hispanico*, IV/40 (July 1951), pp. 17–20.

"Deleitosa de 'Life,' " *Mundo Hispanico*, IV/40 (July 1951), pp. 21–29.

"A Fee for Franco?" *Time*, LVI/7 (August 14, 1950), p. 9.

FLOREZ, W. FERNANDEZ. "De la Leyenda Negra a la Foto Negra Sobre España," *Semana* (July 24, 1951), unpaginated.

"Foreign Relations," *Time*, LVI/22 (November 27, 1950), p. 16.

GOMEZ DE LA SERNA, GASPAR. "Meditacion ante un Pueblo sin Nombre," *A.B.C.* of Madrid (May 25, 1950). Translation in W. Eugene Smith Archives, Center for Creative Photography, University of Arizona, Tucson.

HARDIMAN, KEITH. "Spanish Village," *Creative Camera*, CXLVI (August 1976), pp. 262–265.

HUNEBELLE, DANIELLE. "The Endless Crucifixion of Spain," *Realities* (English edition), 104 (July 1959), pp. 28–35.

KESSEL, DMITRI (photographer). "Franco's Regime, Slightly Mellowed, Looks West for Friendship and Aid," *Life*, XXVI/14 (April 4, 1949), pp. 111–123.

LIVINGSTON, KATHRYN. "A Classic Reprise," *American Photographer*, VI/4 (April 1981), pp. 50–51.

"Making Sense on Spain," *Time*, LVIII/4 (July 30, 1951), p. 21.

MASSAR, IVAN, AND LEONARD SCHUGAR (photographers). "Franco's Spain: Poorhouse of the West," *Look*, XV/3 (January 30, 1951), pp. 21–26.

"Notes on the Pictures," *Photography Annual* (1954).

SHANNON, WILLIAM V. "The Franco Lobby," *The Reporter*, II/13 (June 20, 1950), pp. 10ff.

SMITH, W. EUGENE (photographer). "Spanish Village: It Lives in Ancient Poverty and Faith," *Life*, XXX/15 (April 9, 1951), pp. 120–129.

"Spain," *Time*, LV/10 (March 6, 1950), p. 32.

"Spain Confronts U.S. with Moral Dilemma," *New York Herald Tribune* (Paris edition) (February 21, 1949).

"Spain: Rising Temper," *Time*, LVII/23 (June 4, 1951), p. 36.

"Spain: 22 Divisions," *Time*, LVII/9 (February 26, 1951), p. 35.

"Speaking of Pictures . . . ," *Life*, XXX/10 (March 5, 1951), p. 19.

UHL, ALEXANDER H. "Franco at the Front Door," *The Nation*, CLXXIII/3 (July 28, 1951), pp. 70–72.

"United Nations," *Time*, LVI/19 (November 6, 1950), p. 25.

WERTENBAKER, CHARLES. "Franco: Fascism and Futility," *The Reporter*, II/13 (June 20, 1950), pp. 6–12.

———. "The Men Who Run Spain," *The Reporter*, III/1 (July 4, 1950), pp. 25–30.

————. "Spain: U.S. Loans and God's Good Rain," *The Reporter*, X/7 (March 30, 1954), pp. 25–29.

"What's in a Picture . . . ," *Life*, XXXI/3 (July 16, 1951), p. 140.

## "Nurse Midwife" (December 9, 1951)

*America's Health: A Report to the Nation*. New York: Harper Brothers, 1949.

AVERY, PETER VAN (editor). *Public Health*. New York: H. W. Wilson Company, 1959.

BARTLEY, NUMAN V. *The Rise of Massive Resistance: Race and Politics in the South During the 1950s*. Baton Rouge: Louisiana State University, 1969.

BASS, JACK, AND WALTER DE VRIES. *The Transformation of Southern Politics: Social Change and Political Consequence Since 1945*. New York: Basic Books, 1976.

BILLINGTON, MONROE L. *The Political South in the Twentieth Century*. New York: Scribner's Sons, 1975.

BIRNIE, CASSANDRA MAXWELL. "Race and Politics in Georgia and South Carolina," *Phylon*, XIII/3 (September 1952), pp. 236–244.

BLACKBURN, LAURA. "The Midwife as an Ally," *The American Journal of Nursing* (January 1942).

————. "The Midwife: As Recorded by a Sincere Observer," *The Trained Nurse and Hospital Review* (September 1935).

————. "Midwife Institutes," *State Board of Health of South Carolina*, VII/10 (October 1950), pp. 3–5.

————. "The Midwife Problem in Rural Areas of the South," *The Trained Nurse and Hospital Review* (August 1939).

————. "A Suitable Substitute for Midwives," *The Trained Nurse and Hospital Review* (June 1941).

BOYD, WILLIAM M. "Southern Politics, 1948–1952," *Phylon*, XIII/3 (September 1952), pp. 226–235.

*Building America's Health*. A Report to the President by the President's Commission on the Health Needs of the Nation. Washington, DC: U.S. Government Printing Office, 1952–1953.

COBB, W. MONTAGUE. *Medical Care and the Plight of the Negro*. New York: National Association for the Advancement of Colored People, 1947.

COGAN, LEE. *Negroes for Medicine: Report of a Macy Conference*. Baltimore: Johns Hopkins University Press, 1968.

CURTIS, JAMES. *Blacks, Medical Schools, and Society*. Ann Arbor: University of Michigan Press, 1971.

"Diogenes with a Camera," press release, Museum of Modern Art, May 21, 1952.

EARLE, VALERIE A. "Post-1935 Developments in Southern State Public Health Programs," *American Journal of Public Health*, XLI/11, Part 1 (November 1951), pp. 1403–1409.

EMERSON, HAVEN. *Local Health Units for the Nation*. New York: Commonwealth Fund, 1945.

GRAHAM, GRACE. "Negro Education Progresses in South Carolina," *Social Forces*, XXX/4 (May 1952), pp. 429–438.

"Human Rights Are Now," *The Nation*, CLXXIII/2 (July 14, 1951), pp. 24–25.

JONES, LEWIS W. "Social Centers in the Rural South," *Pylon*, XII/3 (September 1951), pp. 279–284.

KOBRIN, FRANCES E. "The American Midwife Controversy: A Crisis of Professionalization," an essay in *Sickness and Health in America: Readings in the History of Medicine and Public Health*, Judith W. Leavitt and Ronald L. Numbers, editors. Madison: University of Wisconsin Press, 1978. Pp. 217–225.

LITOFF, JUDY B. *The American Midwife Debate: A Sourcebook on Its Modern Origins*. Westport, CT: Greenwood Press, 1986.

———. *American Midwives: 1860 to the Present*. Westport, CT: Greenwood Press, 1978.

"The Local Health Department – Services and Responsibilities," an official statement of the American Public Health Association, adopted November 1, 1950, *American Journal of Public Health*, XLI (March 1951), pp. 302–307.

MELOSH, BARBARA. *"The Physician's Hand:" Work, Culture and Conflict in American Nursing*. Philadelphia: Temple University Press, 1982.

MITCHELL, HANNAH D., R.N. "Coordinating Maternity Care: The Role of Nursing," *American Journal of Public Health*, XLI/11, Part 2 (November 1951), pp. 10–12.

MORAIS, HERBERT M. *The History of the Negro in Medicine*. New York: Publishers Company, 1968.

MUSTARD, HARRY S. *Government in Public Health*. New York: Commonwealth Fund, 1945.

NEWBY, IDUS A. *Black Carolinians: A History of Blacks in South Carolina from 1895 to 1968*. Columbia: University of South Carolina Press, 1973.

POLLACH, MERRILL. "Childbirth Was Never Safer," *Today's Health*, XXXIV (October 1956), pp. 24–28.

"The Present-Day Problems of Childbirth," *American Journal of Public Health and the Nation's Health*, XLII/5 (May 1952), pp. 585–586.

*The Public Health Service Today*. Department of Health, Education and Welfare. Washington, D.C.: Public Health Service, 1955.

QUINT, HOWARD H. *Profile in Black and White: A Frank Portrait of South Carolina*. Westport, CT: Greenwood Press, 1973.

REITZES, DIETRICH C. *Negroes and Medicine*. Cambridge: Harvard University Press, 1958.

"SCFWC Helps Promote Better Care for Mothers and Babies," *The South Carolina Clubwoman*, II/8 (September 1946), pp. 10–11ff.

"SCFWC Helps Promote Institute for Midwives," *The South Carolina Clubwoman*, II/9 (October 1946), pp. 8–9ff.

"Shortage of Doctors?" *U.S. News and World Report*, XLIV (May 9, 1958), pp. 66–71.

SISK, FELICIA. "Midwifery, Ancient Practice, Now on Modern and Scientific Basis in South Carolina: Deaths Drop," *The Columbia Record* (August 18, 1949).

SMITH, W. EUGENE (photographer). "Nurse Midwife: Maude Callen Eases Pain of Birth, Life and Death," *Life* XXXI/23 (December 3, 1951), pp. 134–145.

"Tax-Supported Medical Care for the Needy," *American Journal of Public Health*, XLII/10 (October 1951), pp. 1320–1327.

WARING, JOSEPH I. "Report of the American Academy of Pediatrics Study of Child Health Services in South Carolina," *The Journal of the South Carolina Medical Association*, XLV/9 (September 1949), pp. 281–288, and XLV/10 (October 1949), pp. 308–317.

WHITMAN, HOWARD. "Babies: Special Delivery," *Woman's Home Companion* (May 1946), pp. 19–21ff.

WHITRIDGE, JOHN, JR., M.D. "Practical Aspects of Coordinating Maternity Care: The Role of Health Departments," *American Journal of Public Health*, XLI/11, Part 2 (November 1951), pp. 5–9.

————, AND EDWARD DAVENS, "Are Public Health Maternity Programs Effective and Necessary?," *American Journal of Public Health*, XLII/5 (May 1952), pp. 508–515.

## "A Man of Mercy" (November 15, 1954)

*Albert Schweitzer*. A brochure for an exhibition of photographs by Erica Anderson at the American Museum of Natural History, New York, January 6–24, 1954.

"Albert Schweitzer: An Anachronism," *Time*, LXXXI/25 (June 21, 1963), p. 35.

ALPERT, HOLLIS. "The Schweitzer Story," *Saturday Review*, XL/1 (January 5, 1957), pp. 25–26.

ANDERSON, ERICA (photographer). "Albert Schweitzer: A Picture Story of the 20th Century's Greatest Man," *Look*, XVIII (June 15, 1954), pp. 34–44.

ANDERSON, ERICA (photographer), and Eugene Exman (text). "The World of Albert Schweitzer," *The Saturday Review*, XXXVIII/3 (January 15, 1955), pp. 10–15.

*Annual of Advertising and Editorial Art*. Number 34. Art Directors Club of New York, 1955.

"An Unusual Choice," *National Council Outlook*, III (December 1953), p. 16.

BLIVEN, NAOMI. "Innocents Abroad," *New Yorker*, XLI (April 24, 1965), pp. 190ff.

CAMERON, JAMES. "Here is Not One Man – but Two," *News Chronicle* (London), December 9, 1953.

————. "Over the Tomtom Comes the Ripple of a Fugue," *News Chronicle* (London), December 7, 1953.

————. "Then Comes that Huge Wink," *News Chronicle* (London), December 8, 1953.

" 'Come and Follow Me . . .'," *Time*, L/24 (December 15, 1947), pp. 53–54ff.

COUSINS, NORMAN. "The Point about Schweitzer," *The Saturday Review*, XXXVII/ 40 (October 2, 1954), pp. 22–23.

FETTER, BRUCE (editor). *Colonial Rule in Africa*. Madison: University of Wisconsin Press, 1979.

"The Greatest Man in the World," *Life*, XXIII/14 (October 6, 1947), pp. 95–96ff.

GUNTHER, JOHN. "The Doctor Darkly," *New York Times Book Review* (July 26, 1964), pp. 3ff.

———. *Inside Africa*. New York: Harper Brothers, 1955.

———. "A Visit to Albert Schweitzer," *Reader's Digest*, LXV/388 (August 1954), pp. 43–49.

JACK, HOMER A. "With Schweitzer in Africa," *The Christian Century*, LXIX/ 29 (July 16, 1952), pp. 823–825.

———. "With Schweitzer in Lambaréné," *The Saturday Review*, XXXVI/18 (May 2, 1950), pp. 16–17.

JOY, CHARLES, AND MELVIN ARNOLD. *The Africa of Albert Schweitzer*. London: Adam and Charles Block, 1949.

KARSH, YOUSUF. "The Camera's Eye," *Atlantic*, CC/6 (December 1957), pp. 94–95.

"Letters to the Editors," *Life*, XXXVII/23 (December 6, 1954), p. 16.

LEWIS, ANTHONY. "Man of Our Century," *Cosmopolitan*, CXXIV (February 1953), pp. 64–71.

MARSHALL, GEORGE, AND DAVID POLING. *Schweitzer*. Garden City, NY: Doubleday, 1971.

McKNIGHT, GERALD. *Verdict on Schweitzer*. London: Fredrich Muller Ltd., 1964.

"Missionary from Lambaréné," *Time*, LXIII/4 (January 25, 1954), pp. 82ff.

MOFFETT, HUGH. "The White Wizard's 90th," *Life*, LVIII/7 (February 19, 1965), pp. 83–92ff.

MURRY, J. MIDDLETON. *The Challenge of Schweitzer*. London: Jason Press, 1948.

"Reverence for Life," *Time* (July 11, 1949), pp. 68–70ff.

ROBACK, A. A. (editor). *The Albert Schweitzer Jubilee Book*. Cambridge, MA: Sci-Art Publishers, 1945.

————. *In Albert Schweitzer's Realms*. Cambridge, MA: Sci-Art Publishers, 1962.

ROSS, EMORY. " 'Inside' No. V," *The Saturday Review*, XXXVIII/40 (October 1, 1955), pp. 18–19.

SARGEANT, WINTHROP. "Albert Schweitzer," *Life*, XXVII/4 (July 25, 1949), pp. 74–80ff.

SCHWEITZER, ALBERT. *On the Edge of the Primeval Forest* and *More from the Primeval Forest*. New York: The Macmillan Co., 1948.

————. *Out of my Life and Thought*. New York: The Macmillan Co., 1949.

————. "The Problem of Ethics for Twentieth Century Man," *The Saturday Review* (June 13, 1953), pp. 9–11ff.

SEAVER, GEORGE. *Albert Schweitzer: The Man and His Mind*. New York: Harper Bros., 1947.

SMITH, W. EUGENE (photographer). "A Man of Mercy: Africa's Misery Turns Saintly Albert Schweitzer into a Driving Taskmaster," *Life*, XXXVII/20 (November 15, 1954), pp. 161–172.

STEERE, DOUGLAS V. "Death at Lambaréné," *The Saturday Review* (June 13, 1953), pp. 11–12ff.

*To Dr. Albert Schweitzer: A Festschrift Commemorating His 80th Birthday*. New York: Profile Press, 1955.

URQUHART, CLARA. "A Visit to the Africa of Dr. Albert Schweitzer," *Phylon* (September 1953), pp. 295–301.

————. *With Dr. Schweitzer in Lambaréné*. London: George G. Harrap, 1957.

VON HABSBURG, OTTO. "Earthbound Messiah," *National Review*, XVI/30 (July 28, 1964), pp. 657–658.

WECHSBERG, JOSEPH. "Our Far-Flung Correspondents Toccata and Fugue," *The New Yorker*, XXX (November 20, 1954), pp. 87–89ff.

WILSON, HENRY S. *The Imperial Experience in Sub-Saharan Africa since 1870*. Minneapolis: University of Minneapolis Press, 1977.

# Index